HOGARTH

and his TIMES

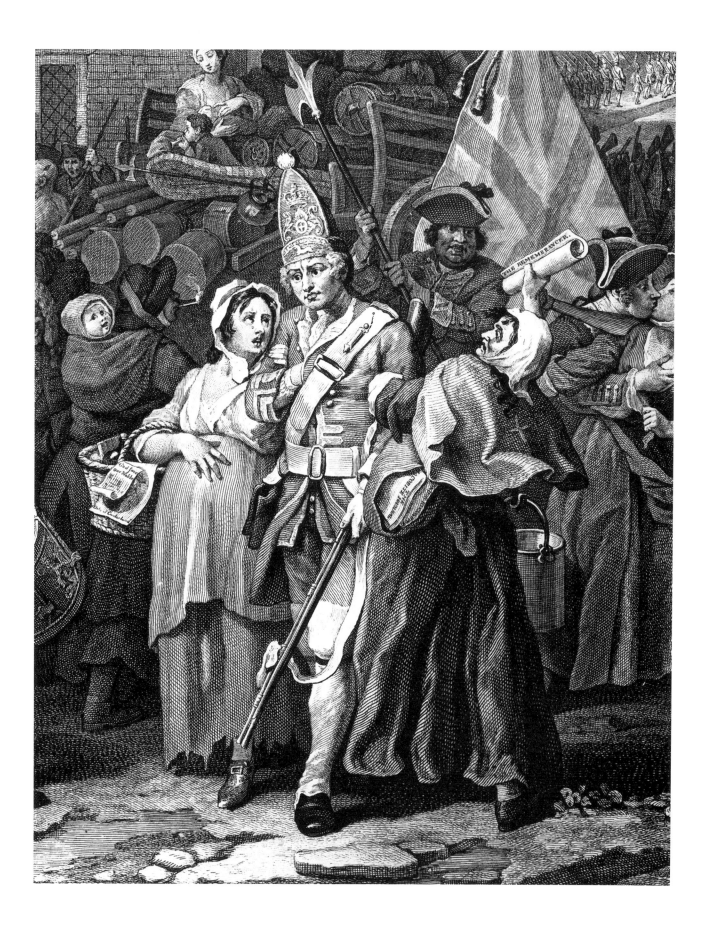

HOGARTH

and his TIMES:

SERIOUS COMEDY

DAVID BINDMAN

UNIVERSITY OF CALIFORNIA PRESS

BERKELEY LOS ANGELES

EXHIBITION DATES

Following its display at the British Museum, London, from 26 September 1997 to 4 January 1998,
the exhibition will be shown in a reduced version at the following North American venues:

Berkeley Art Museum, University of California: 28 January–19 April 1998
National Gallery of Canada, Ottawa: 18 June–23 August 1998
Miriam and Ira D. Wallach Art Gallery, Columbia University, New York: 15 September–21 November 1998

University of California Press
Berkeley and Los Angeles, California

Published in association with British Museum Press and the Parnassus Foundation

Library of Congress Cataloging-in-Publication Data

Bindman, David.
 Hogarth and his times: serious comedy. / David Bindman.
 p. cm.
 Exhibition catalog.
 Includes bibliographical references and index.
 ISBN 0–520–21299–1 (cloth). — ISBN 0–520–21300–9 (pbk.)
 1. Hogarth, William. 1697–1764—Exhibitions. 2. Great Britain
 —Social life and customs—18th century—Exhibitions. I. Title.
NC1479.H613A4 1997
741.5'942—dc21 97–20496
 CIP

Designed by Harry Green

Printed in Great Britain by Cambridge University Press

9 8 7 6 5 4 3 2 1

PHOTOGRAPHIC ACKNOWLEDGEMENTS

All photographs have been provided by the British Museum except for the following:
Figs: 1 The Paul Mellon Centre for Studies in British Art, London;
2 Coram Foundation, London/Bridgeman Art Library, London;
6 Museum Associates, Los Angeles County Museum of Art;
8 The Paul Mellon Centre for Studies in British Art, London;
10 Yale Center for British Art, Paul Mellon Collection, New Haven, Conn.;
11 The Frick Collection, New York; 12 Tate Gallery, London.
Nos: 1 (a–f) Tate Gallery, London; 82d Andrew Edmunds;
87a V & A Picture Library, London; 101 (a–d) The British Library.

FRONTISPIECE

No. 72 *The March to Finchley*, 1750 (detail)

CONTENTS

Foreword *7*

Preface *9*

INTRODUCTION

1. Whose Hogarth? *11*
 Child of Art or Child of Nature? *13*
 Academic Condescension and Romantic Rescue *15*
 Mirror of His Age or Any Age? *24*
 Some Modern Constructions *26*

2. Hogarth's Public: Finding An Audience *29*

3. Politeness and Roman Satire *33*

4. Hogarth and 'The Spirit of Party' *41*
 Under the Ascendancy of Walpole *41*
 National Painter and Placeman *45*

5. Disenchantment: Hogarth,
 God and Science *51*

Appendix: Hogarthomania and the
 Collecting of Hogarth
 (Sheila O'Connell) *58*

Notes *61*

CATALOGUE

Redefining Hogarth: Twentieth
to Eighteenth Centuries *64*
 The Twentieth Century: The Artist as Rake *64*
 The Nineteenth Century: Man of the People *66*
 The Eighteenth Century: Conviviality and Morality *71*
 Midnight Modern Conversation and its influence *71*

Piracies and imitations of *A Harlot's* and
 A Rake's Progress *74*
 The German followers *78*
 Hogarth's Hogarth: A Self-Made Artist *80*

The Satirical Engraver and His Public *84*
 Making the Prints *84*
 The Design Process: Working on the Plate *85*
 Marketing the Prints *87*
 Modes of Satire *90*
 Satire and satyr play *90*
 The vices or the persons? *92*
 Nature and prurience *96*
 The comedy of the streets *98*
 Character and caricature *100*

The Targets of Satire: The Orders
of Society *104*
 Crossing the Class Barriers:
 The Fate of Transgressors *104*
 Aristocrats: Real and Imagined *108*
 The life of luxury *108*
 Taste and connoisseurship *110*
 The Middling Orders *114*
 Merchants and lawyers *114*
 Doctors *117*
 The clergy: Conformist and Methodist *121*
 The Common People: Disorder and Criminality *126*
 The theatre of the streets *126*
 Criminals and harlots *130*
 Charity and the poor: the Foundling Hospital *135*
 Reforming 'some reigning Vices peculiar to
 the lower Class of People' *137*

The Political Stage *148*
 Early Party Satire *148*

CONTENTS

The Great Man: Walpole and the Court *153*

The Politics of the Stage *158*

Patriotism above Party *163*

Intellectual Warfare: *The Analysis of Beauty* and Its Reception *168*

The *Analysis* and Its Origins *168*

Paul Sandby's Campaign against the *Analysis* *174*

Last Battles *182*

Hogarth 'at last entered the list of politicians' *182*

The Times, Plate 1 *182*

Hogarth versus Wilkes *188*

Bathos and Altered States, 1761–4 *193*

Hogarth on the defensive *193*

Relinquishing the self *196*

Chronology *202*

Bibliography *204*

Index of Persons *206*

Index of Hogarth's Works Illustrated *208*

COLOUR PLATES *Between pp. 88 and 89*

FOREWORD

T he year 1997 is the tercentenary of Hogarth's birth. The last Hogarth anniversary fell in 1964, the bicentenary of his death. On that occasion the British Museum, the fortunate possessor of the finest collection in the world of Hogarth's prints and drawings, mounted a large exhibition with a forty-nine-page cyclostyled catalogue. Our ambitions over the past thirty-three years have increased. We now have our own publications company, and for this tercentenary we have planned one of the most ambitious exhibitions of Hogarth's work yet produced.

That we have been able to do so is thanks to David Bindman, who proposed a concept of an exhibition that at once appealed to us. He suggested that neither the exhibition nor the catalogue should be intended as a general introduction to Hogarth – there are a number available including Professor Bindman's own *Hogarth* in the Thames and Hudson World of Art series, first published in 1981 – but as a contribution to the critical debate that has arisen in recent decades over Hogarth himself and the proper understanding of his achievement. Hogarth had an immense reputation as an artist and personality in his own day, and his work has hardly ever gone out of fashion, though perceptions of it have changed from generation to generation. The long introduction to this catalogue discusses some of the myths erected around Hogarth from his own time to the twentieth century, looking particularly at the artist's own self-presentation. The kinds of tradition, literary as well as artistic, from which he arose are considered in a new way, and an attempt is made to account for his immense appeal to his contemporaries and later generations, and also for the hostility towards his work in his last years and those immediately following his death.

It was as a printmaker that Hogarth was primarily known to his contemporaries, and it is on prints that this exhibition concentrates. Hogarth was a printmaker nonpareil, with a breadth of popularity quite new in the history of printmaking. Sir Hans Sloane, the founding father of the British Museum, and no print collector by inclination, was a subscriber to the *Harlot's Progress* series. Consul Joseph Smith in Venice included in his library, along with a collection of Rembrandt etchings, a volume of Hogarth's complete works, 'first impressions, with many alterations and additional prints not in the printed catalogue'.

The key works, which form the centre of Hogarth's entire career, were the four series, *A Harlot's Progress*, *A Rake's Progress*, *Marriage A-la-Mode* and *Industry and Idleness*. In an annexe to the exhibition in the British Museum we will show all four sets complete, together with *The Four Times of Day* and the Election series. But the main sequence of the exhibition – and that described in this catalogue – shows individual plates, many from these series, next to other works that help explain their context better to the modern viewer. The catalogue and the exhibition serve as an extended argument built around the selected works; in the annexe to the exhibition the complete series will make the context visually clear.

We would never have been able to realise an exhibition of such ambition without the help of others, to whom we are very grateful. First among them is of course David Bindman, who has written a text that is both a major contribution to scholarly understanding of Hogarth while being accessible to all interested

readers. We are equally grateful to Raphael Bernstein, who at the very beginning exhorted us to embark on this project and made it possible for us to circulate the exhibition. It is thanks to him and the Parnassus Foundation that we have been able to do a number of things that we have long wanted to do. We have lifted the entire collection of Hogarth prints in the British Museum from their soiled and harmful mid-Victorian boards, and remounted them on proper acid-free mounts; in the process we have recovered much lost information about their provenance from the backs of the prints. We have also been able to produce this catalogue in the way that we wished at a price that is not prohibitive. The tour in North America has been organised by Jacquelynn Baas, the Director of the Berkeley Art Museum in California, and James Steward, the Assistant Director. The exhibition will also be seen in the National Gallery of Canada in Ottawa and the Miriam and Ira D. Wallach Art Gallery at Columbia University in New York City.

Although the great majority of the works on display come from the collection of the British Museum, there are inevitably a few cases where we have had to rely on the generosity of others. On behalf of the Trustees of the British Museum I would like to thank the British Library, the Tate Gallery and Andrew Edmunds.

Within the British Museum my principal thanks are due to Sheila O'Connell, who has not only contributed to the catalogue but taken on all the work of preparing the exhibition. This labour cannot be underestimated; it includes preparing the lifting of over 400 prints, supervising the remounting, sorting out what was needed for the exhibition, arranging the photography and acting as liaison with British Museum Press. We owe warm thanks to all our colleagues who helped with this process. The Department of Conservation, and in particular Jane Pickles, lifted everything with great despatch, and Christina Angelo, Dylan Owen, Annette Pinto and Victoria de Korda mounted what we needed. The photographs were made by Graham Javes and Bill Lewis with their usual concern for quality. Arrangements for the tour are in the hands of Janice Reading, and all the framing and packing in those of Charlie Collinson. The Department is fortunate to have such a highly skilled team, enabling us to undertake so many complicated loan operations with so few staff. I would also like to thank all those from British Museum Press involved in the publication of the catalogue, especially the editor Colin Grant.

ANTONY GRIFFITHS *Keeper of Prints and Drawings*, British Museum

It is an honor for the Berkeley Art Museum, University of California, to host the exhibition *Hogarth and His Times* and to organize the North American tour for this interesting show. The Berkeley Art Museum is known for presenting both contemporary and traditional art in fresh, untraditional ways. David Bindman's thoughtful selection of work by Hogarth, and his intelligent and original essay for the catalogue, will find a receptive audience in Berkeley, as well as in the other two cities on the tour, Ottawa and New York, where we have enjoyed the friendly support of Katherine Jensen and Allen Staley. I would also like to take this opportunity to thank James Christen Steward, Curator and Assistant Director here at the Berkeley Art Museum, who has managed the Berkeley presentation and the tour with his usual aplomb. Jim Clark of the University of California Press has made possible distribution of the book on this side of the Atlantic. Like the British Museum we owe a considerable debt of gratitude to Raphael Bernstein. The Parnassus Foundation has been both an instigator and a partner in this project. Thanks to Raphael Bernstein, North American audiences will have the opportunity to learn from and enjoy splendid examples of Hogarth's work. We extend our thanks to Antony Griffiths and his good staff for sharing them with us.

JACQUELYNN BAAS *Director*, Berkeley Art Museum

PREFACE

T his exhibition commemorates the three-hundredth anniversary of William Hogarth's birth in 1697, and it is built upon the remarkable collections of prints and drawings by Hogarth, and his contemporaries and successors, in the Prints and Drawings Department of the British Museum. Hogarth presents unusual difficulties for an exhibition organiser because of the narrative structure of much of his work. It might seem self-evident that his most famous series of prints, which he called 'Modern Moral Subjects' and which include among others the famous series *A Harlot's Progress*, *A Rake's Progress* and *Marriage A-la-Mode*, should be displayed in the correct sequence and in their entirety, in order to follow the story that they tell. Certainly that has been the normal way of displaying them in previous Hogarth exhibitions. However, this makes it very difficult to take an analytical view of them or provide an appropriate context.

It is a premise of both catalogue and exhibition that Hogarth's moral series are works of fiction, based on a simplified and schematic view of society, divided between three self-contained classes: the wealthy, 'the middling sorts' and the poor. By juxtaposing in this exhibition images from different series with the work of other artists, it becomes possible to highlight and comment on the very artificiality of Hogarth's notions of society, and to present the apparent truth of his social observation as no more (or less) credible than those we might find in a novel or play of the period.

A second theme of the exhibition, which is extensively treated in the catalogue, is the way in which Hogarth's work and significance were defined by contemporaries and redefined by posterity. Given Hogarth's continuous fame and the accessibility of his work through original prints and reproductions, this can only be done sketchily, but it is hoped that something of the contested nature of Hogarth's inheritance will be conveyed through token groups of works from his own century and later, including some by W.P. Frith and David Hockney. Hogarth's intellectual context and his later reputation are perhaps easier to grasp in a discursive text than in a display of objects, but their importance for later generations is indicated by a group of prints and documents centred on his book *The Analysis of Beauty*.

It goes without saying that the catalogue and exhibition present a partial view of Hogarth based on a study of Hogarth's prints rather than his paintings. I have confined the discussion in the introduction to the catalogue to areas that have been relatively little considered by previous writers on Hogarth. Hogarth's reputation, despite, or perhaps because of, the enormous literature he has attracted in the last two hundred years, has hardly been studied at all before, though it is fascinating to see the range of attempts to appropriate him to different causes. In looking at the background to Hogarth's satire, I have focused more on his classical literary antecedents on the grounds that these have rarely been considered. I am particularly aware of not having done justice to Hogarth's relationship with the theatre and the novel, nor to his career as a painter, but I take comfort in the fact that there are many comprehensive accounts of Hogarth available, most notably by Ronald Paulson. Almost every thought that has gone into this catalogue and exhibition has been anticipated or sparked off in some way by his many books on Hogarth, though we have

not come to the same conclusions in every case. I have tried to cite his work wherever appropriate but to do so thoroughly would be impossible.

A great many people have contributed to the exhibition and I owe them an immense debt of gratitude. There can be no greater privilege for an art historian than to work for a period in such a great public institution as the British Museum. Antony Griffiths and the staff in the Department of Prints and Drawings could not have been more warm, enthusiastic and helpful. It would be invidious to single out any individuals with one exception. I owe a great deal to Sheila O'Connell who has used her great expertise as a Hogarth scholar herself to contribute in all sorts of ways to the exhibition, and to write a short section for the catalogue. I would like also to thank my friends at the Yale Center for British Art, the Lewis Walpole Library, and at the London Paul Mellon Centre for Studies in British Art, especially the following who have helped in all sorts of ways: Brian Allen, Anne-Marie Logan, Anna Malicka, Patrick Noon, Joan Sussler and Scott Wilcox. I also learned a lot from teaching a Hogarth course to an excellent group of graduate students in the Art History Department at Yale University. My colleagues and graduate students in the History of Art Department at University College London have contributed an immense amount of intellectual stimulation, especially Matthew Craske, Diana Dethloff, Tom Gretton, Andrew Hemingway and Helen Weston. Others who have helped include Chloë Archer, Raphael Bernstein, John Brewer, Linda Colley, Elizabeth Einberg, Amelia Fearn, Jessica Harrison-Hall, Craig Hartley, Julia Nurse, Susan Palmer, Claude Rawson, Andrew Spira and Simon Turner.

CHAPTER ONE

WHOSE HOGARTH?

William Hogarth (1697–1764) had a unique position in early eighteenth-century London. He was a painter and printmaker in a predominantly literary culture dominated by immensely influential writers like Jonathan Swift, Alexander Pope and, later, Henry Fielding. There was, until Hogarth's later years and shortly after his death, a dearth of institutional structures for teaching and exhibiting art. There were no academies beyond drawing schools and social groups which might have defined art's higher purposes and provided a framework to contain his artistic ambitions.[1] Thus Hogarth was able to indulge without inhibition in activities that would have been denied to him in countries like France or Italy that had such structures. Such activities would also have been denied to the next generations in Britain, who were obliged, whether willingly or not, to define their ambitions against those set by the Royal Academy, which was founded under royal protection in 1768. Within the context of a dynamic and rapidly developing economy Hogarth could take on different roles and associate himself with a wide range of social groups, and in some sense his own advancement mirrors the rise of other upwardly mobile professionals. The mobility he enjoyed in his maturity, largely through his own personal prestige, enabled him to attempt to reconcile roles that would have seemed irreconcilable in a more structured artistic environment. He made popular prints addressed to potential criminals while attempting monumental paintings in the high style of Raphael. He wrote a major work of artistic theory, *The Analysis of Beauty*, which addressed concerns quite outside traditional, classically rooted discourses and was based upon modern theories of perception and upon his own experiences as a painter.

He made occasional attempts to act as spokesman for the concerns of his fellow artists, but in his mature years his circle of friends reached into the church, the theatre, the law, medicine and the landed gentry – indeed, all the groups he satirised seemingly without mercy. Hogarth, as contemporaries like Horace Walpole recognised, was at one level a story-teller in the great tradition of social comedy, whose vision of society could be enjoyed by his apparent victims; aristocrats, merchants and professionals all subscribed to his series with enthusiasm, and many sought his friendship.

Why were Hogarth's pictorial stories, which he called Modern Moral Subjects, so appealing in their printed forms to his contemporaries, and why have they survived changes of taste from his own time to the present day? The answer must lie at least partly in the contradictory expectations that they were able to satisfy. They reconcile a narrative, in which vice is clearly punished in kind, with a seemingly irrepressible relish on the artist's part for the rich contradictions of urban life. The prurient display of the details of a prostitute's life in *A Harlot's Progress* reveals the consequences of such a life to be a lonely

death. But this conventional and predictable story has continued to be entertaining and edifying because of the wit and realism of the story-telling, and the sense, perhaps illusory, that Hogarth is conveying truths about his own time and human nature in general.

These apparent truths need, however, to be set against the tendentiousness of Hogarth's view of his own times, and the schematic view of human nature and society he presents. Writings on Hogarth from the eighteenth to the twentieth centuries almost always make the claim that he possessed exceptional powers of social divination, and that his well-attested irascibility was driven by a laudable rejection of his own society whose ills and injustices he felt deeply. The idea of Hogarth as a figure at odds with the social hierarchies of his time and instinctively sympathetic to its victims, though firmly entrenched in much of the Hogarth literature, would have mystified his own friends and contemporaries. In fact, his ambition to achieve a place in the world was evident to all; he was described by George Vertue as 'often projecting scheems to promote his business in some extrordinary manner'.[2] He was willing enough to seek court patronage, ending his life as a 'placeman' in his offical position of Serjeant Painter to the King. His ambition did not, however, except late in life, diminish the respect in which he was held by his more thoughtful contemporaries.

The different and sometimes contradictory *personae* attributed to Hogarth by himself, by his contemporaries and by posterity have tended to rest on an estimate of his relationship to the dominant culture of his time. Most responses to his work have tended to come down on one side or the other of the divide implied by the following contradictory statements, which can be regarded as distillations of commonly held opinions across two-and-a-half centuries:

1. He was a satirist of high sophistication who sought to bolster the dominant culture, or he challenged it in the name of common humanity.

2. He approached the inequalities and brutality of ordinary life from a position of learned detachment, or he was deeply moved by the cruelties he observed.

3. His art was mediated by a knowledge of the art and literature of the past, or it mainly depended upon a unique and untutored ability to observe accurately the passing scene.

Each set of answers could find a justification in the actual circumstances of Hogarth's origins and upbringing, which could be used either to support or deny his possession of cultural sophistication. He was the son of a schoolmaster whose ambitions to write pedagogical works on grammar came to grief, leading to bankruptcy, and his childhood was undeniably lived in comparative poverty. His written expression suggests someone who had not undergone the privileged classical education of the day, though he presumably learned some Latin from his father.[3] But the question remained and to a degree still remains: did he achieve a level of learning, either in childhood or later, to enable him to construct his satirical works with a conscious regard to classical and other traditions, as did his great contemporaries Jonathan Swift and Alexander Pope, or was he guided more by intuition and observation?

In the nineteenth and twentieth centuries there has been a wide spectrum of views. Romantics like William Hazlitt and Charles Lamb were aware of his sophistication though not above attributing his gifts to 'Nature'; but in the high Victorian period Hogarth emerges as a much more popular figure, an honest, God-fearing tradesman and patriotic Englishman. Twentieth-century views of Hogarth have been equally unsettled, with even academic writers clinging to an idea of him as a populist or an instinctive political radical while being fully aware of his kinship with literary satirists of his time.

The changing and sometimes contradictory perceptions of Hogarth we have inherited should not,

however, be seen as accretions to be cleaned off the surface, leaving the 'real' Hogarth beneath, but as evidence of the continued engagement provoked by his work. Even so there is value in trying to interpret Hogarth in terms of the meanings found in his work by his contemporaries. In order to give a sense of these, and of the demands placed on Hogarth by later generations, the present catalogue and exhibition partly follow a kind of reverse chronology, working backwards from his posthumous reputation to his own time, concentrating on representative figures rather than attempting to be comprehensive, an impossible task in any case. The rest of this chapter briefly and selectively tells the story of the critical response to Hogarth from his own time to the present century, while the first section of the catalogue and the exhibition sketches the responses of selected artists.

CHILD OF ART OR CHILD OF NATURE?

The issue of Hogarth's artistic origins and background came to the fore in the early 1780s with the publication in October 1780 (the book had been printed at the author's private press in 1771 but withheld 'from motives of tenderness')[4] of the fourth volume of Horace Walpole's *Anecdotes of Painting in England*, which dealt with his contemporaries including Hogarth, and of John Nichols's *Biographical Anecdotes of William Hogarth* in 1781. One should also mention the role played by Hogarth's widow after his death in 1764. She seems to have undergone a moral conversion which involved suppressing the 'indecent' prints *Before* and *After* (no. 38) and engaging with the Rev. Dr Trusler to produce a very popular volume called *Hogarth Moralized* in 1768 (no. 15).[5] Mrs Hogarth was evidently displeased with Horace Walpole's caustic criticisms in the *Anecdotes* of Hogarth's attempts to paint in the grand manner,[6] and she had fallen out already with John Nichols. He had claimed that Hogarth's plates had been reworked since his death, something she strongly denied,[7] and she seems to have offered all encouragement to what became the standard account of Hogarth throughout the nineteenth century, John Ireland's *Hogarth Illustrated*, first published in 1785.

Horace Walpole might seem at first to have been an unlikely admirer and friend of Hogarth, and even more unlikely to have shown understanding of his work. Indeed, he was a living example of everything that Hogarth was reputed to despise; a highly privileged gentleman, with a strong cosmopolitan background cultivated at Eton and in Italy, and as well connected as any prime minister's son could be.[8] Hogarth, on the other hand, was, as we have seen, the son of a failed schoolmaster, brought up in demeaning poverty, who entered the profession of art at the lowest rung, as a silver engraver, working his way to fame by talent, astuteness and commercial acumen. Walpole was a connoisseur by upbringing who took for granted that Italian art was superior to anything that could be produced in England, and his *Anecdotes of Painting in England* is notable for its disrespect towards almost all British artists of every period, Hogarth being almost the sole exception. An antiquarian more at home in the past than the present, Walpole usually wrote about earlier masters in his formal writings on art, beginning with his account of the collection of his father Sir Robert Walpole at Houghton, where he makes the conventional claim that 'in my opinion, all the qualities of a perfect Painter, [were] never met but in Raphael, Guido, and Annibal Caracci'.[9]

Walpole had no doubts of Hogarth's greatness as a satirical printmaker, but he dismissed strongly his claims to have been a painter of substance, to be compared in seriousness with the great Italian painters. Instead, he claimed Hogarth to have been more 'a writer of comedy with a pencil, than...a

painter'.[10] Like Molière, he caught 'the manners and follies of an age *living as they rise*', creating comedy 'familiarised by strokes of nature heightened by wit, and the whole animated by proper and just expressions of the passions'. Walpole places morality firmly at the heart of Hogarth's enterprise, emphasising his kinship with his literary forebears: 'Amidst all the pleasantry he observes the true end of comedy, reformation; there is always a moral to his pictures. Sometimes he rose to tragedy…in marking how vice conducts insensibly and incidentally to misery and shame.'[11] Walpole gave him a position in the history of art 'between the Italians, whom we may consider as epic poets and tragedians, and the Flemish painters, who are writers of farce and editors of burlesque nature'. This is not far from Hogarth's own mature estimate of his position as a 'Comic History Painter' in the wake of Fielding's description of him in the preface to *Joseph Andrews*,[12] but the artist was always careful to dissociate himself from Dutch or Flemish art which he affected to despise for its literal-minded representation of nature (see no. 27b).

Walpole, then, anchors Hogarth's Modern Moral Subjects firmly in the satirical literary culture of early eighteenth-century England; Walpole's Hogarth breathes the same air as Swift and Pope, partly through lack of a painterly tradition but also because of the strong moral concerns of his art. Though Walpole was twenty years younger than Hogarth, the great satirical authors were part of his own patrician upbringing. With the publication of John Nichols's *Biographical Anecdotes of William Hogarth* in 1781 and John Ireland's *Hogarth Illustrated* in 1785, this connection was severed, and there emerged a less intellectual and more 'natural' artist, 'the artificer of his own fame and fortune'.[13] One contemporary and self-professed friend of Hogarth, the Earl of Charlemont (see p. 58), writing in 1783, saw Nichols as

> an ill-natured and very conceited author, seeking to traduce [Hogarth's] character by raking up and putting in their worst light those trifling imperfections to which the geatest men are liable… Nay so low does the Hypercriticism descend that the false spelling of some inscriptions in the prints of our author, which candour might have ascribed to the fault of the Graver, are attributed to Hogarth's want of skill in orthography, which is uncandidly construed into general Illiterature[sic].[14]

Instead, Charlemont refers the reader away from 'this wretched compilation' to

> the Work of the candid and truely elegant Mr Walpole [which] will remain to posterity the genuine and admired Portrait of that great moral Satyrist, whom he so justly considers rather as a Writer of Comedy with a Pencil, than a Painter.

For John Ireland Hogarth was not an artist with 'a palette pedigree' who could trace his artistic descent back through a line of painters, but 'the pupil,– the disciple,– the worshipper of nature!'[15] Ireland found in Nichols's *Biographical Anecdotes* a letter by the Westmoreland author Adam Walker which gives a doubtful account of the artist's ancestry in his own county and his descent from yeoman stock.[16] According to Walker, Hogarth's native genius had already been manifested in a paternal uncle's rustic and primitive plays, which he put on for the delight of his Cumbrian fellow villagers. The uncle, supposedly called 'Ald Hogart', was a 'mountain Theocritus' whose 'simple strains…were fabricated while he held the plough, or was leading his fewel from the hills'.[17] The Hogarth family genius thus forced the young William into conflict with his scholarly father Richard, so that he developed 'not much bias towards what has obtained the name of learning...being early

attentive to the appearance of the passions, and feeling a strong impulse to attempt their delineation, left their names and derivations to the profound pedagogue, the accurate grammarian, or more sage and solemn lexicographer'.[18]

John Ireland's strained attempt to make Hogarth 'a child of nature' by emphasising his Cumbrian roots was necessitated, perhaps, by a general eighteenth-century understanding that, while virtue could be attributed to the deferential rural poor, a virtuous urban labouring class could only be brought about by the efforts of their employers and mentors. Hogarth's own Industrious Apprentice in the *Industry and Idleness* series is guided by the literature around him and rises in society through adoption of his master's mercantile values, while the Idle Apprentice responds to less worthy but equally available stimuli. By rooting Hogarth's populism in a rural context, Ireland situates him outside the whole urban panorama he delineates. He becomes an outsider not because he was deliberately excluded, but because he brought a more 'natural' morality to bear on the tottering edifice of fashionability. Yet, as Hazlitt pointed out, 'I know no one who had a less pastoral imagination than Hogarth. He delights in the thick of St Giles's or St James's. His pictures breathe a certain close, greasy, tavern air.'[19] Hogarth's palpable urbanity (in a literal sense) contributed to the partial eclipse of his reputation as an artist at the end of his career and as an art theorist later in the eighteenth century, from which Hazlitt and Lamb sought to rescue him. Nonetheless, this rustic, non-verbal Hogarth has much resonance in later accounts.

ACADEMIC CONDESCENSION AND ROMANTIC RESCUE

Any suggestion that Hogarth lacked intellectual sophistication is extremely difficult to reconcile with the intellectual cogency of his theoretical treatise *The Analysis of Beauty*, which appeared in 1753, became highly influential and was much admired by many, though by no means all, of his contemporaries. Though criticism and ridicule of the *Analysis* usually focused on the theory of the 'Line of Beauty', the underlying objection was to a work that contained the germ of an idea of a British school of painting owing nothing, or very little, to the idealism associated with the art of antiquity and the Italian Renaissance. It implicitly directed the artist to find subject matter not in the Bible or epic literature but in real life and even in the streets of London. For Hogarth's detractors his position was weakened by what were perceived to be his inept attempts at the grand manner in the deliberately Raphaelesque painting of *Paul before Felix* (fig. 1) at Lincoln's Inn and *Moses Brought to Pharoah's Daughter* (fig. 2) for the Foundling Hospital, both of which were in prominent public places in London. For Joshua Reynolds, after his return to England from Rome in 1752, Hogarth was the chief obstacle to his cosmopolitan and compelling vision of an English art based on the 'Great Style' which might rival and even surpass the great continental schools.

Reynolds's three articles in Dr Johnson's 'The Idler' for the months September to November 1759 are clearly directed at Hogarth, though the ostensible object of his ridicule is, mischievously, a 'critick' and connoisseur 'just returned from Italy', who applies bogus rules to the Raphael cartoons then at Hampton Court (fig. 3).[20] Reynolds argues, among other things, that the connoisseur's 'scrupulosity, [and] a servile attention to minute exactness' are wholly inimical to true grandeur. In the second article Reynolds questions Hogarth's notion of the imitation of nature as 'the obvious sense, that objects are represented naturally when they have such relief that they seem real'.[21] Reynolds rejects 'this kind of

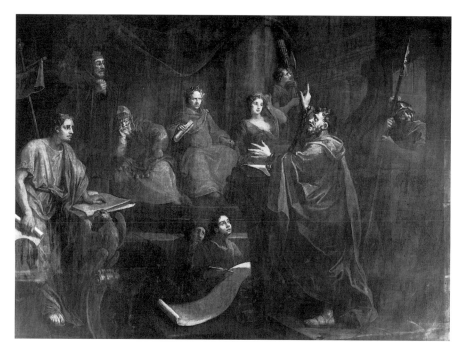

FIG. 1 William Hogarth, *Paul before Felix*, oil on canvas, 1748, Lincoln's Inn, London.

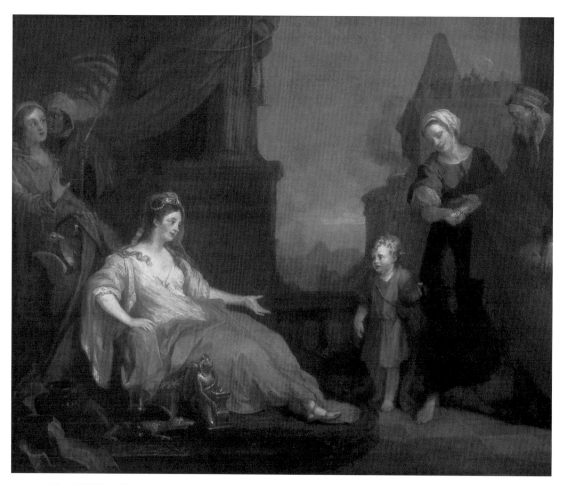

FIG. 2 William Hogarth, *Moses brought to Pharoah's Daughter*, oil on canvas, 1746, Coram Foundation, London.

16

imitation' in favour of the 'grand style of painting' which must avoid 'minute attention' to the visible world. Perhaps partly as a way of irritating Hogarth, Reynolds makes no distinction between Dutch realism and any other kind of real-life painting, including implicitly Hogarth's moral comedy. Hogarth, as would have been well known to Reynolds, had taken pains to dissociate his own art from Dutch painting, going to the extraordinary lengths of producing a hilariously coarse burlesque etching, in 'the true Dutch taste' (no. 27b, colour plate VI), of his own *Paul before Felix* painting. Reynolds dismisses any possibility of reconciliation between Dutch and Italian modes, which might have left an opening for Hogarth, claiming that an art based on observation cannot express 'the invariable, the great and general ideas which are fixed and inherent in universal nature', on the grounds that 'in painting, as in poetry, the highest style has the least of common nature'.[22]

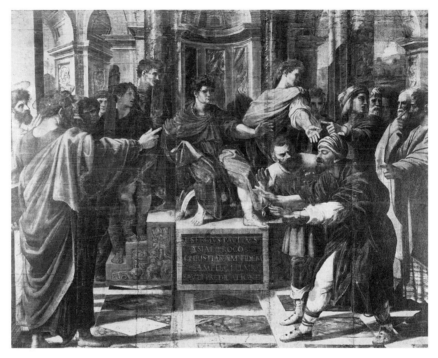

FIG.3 Raphael, *The Blinding of Elymas*, tapestry cartoon, 1515–16, Victoria and Albert Museum, London, on loan from Her Majesty the Queen.

Though couched in a language of high theory, the hidden agenda behind Reynolds's articles for 'The Idler' was, in a nutshell, to keep Hogarthian realism, perhaps more than Hogarth himself, at bay, and make sure that any future organisation – the Royal Academy itself was still nine years ahead when the articles were written – would define its larger objectives in relation to the Great Style as exemplified by the Raphael cartoons and the great monuments of Italy. While Horace Walpole was also clear that Hogarth did not belong within the traditional pantheon of great painters, he did find value in Hogarth's satirical printmaking. For Reynolds, writing *ex cathedra*, as it were, in 'The Idler' papers and the later *Discourses* to the Royal Academy, satire was dangerous because it was attractive to the young, having the power to distract them from the high road to ancient virtue. Hogarth was all the more threatening because of the evidently plausible theoretical underpinning he gave modern-life painting in *The Analysis of Beauty*.

Reynolds in effect defused Hogarthianism by denying its intellectual legitimacy. Portraiture, though an imitative art by definition, was still in the academic hierarchy, but satire had no place at all. In Reynolds's *Discourse XIV*, while a number of artists are praised for being content to excel in the lesser genres, Hogarth is granted 'extraordinary talents' but strongly reproved for 'very imprudently, or rather presumptuously, attempt[ing] the great historical style'.[23] However, in *Discourse III*, when Reynolds spells out the principles of the Great Style, Hogarth is presented as tainted with vulgarity, like the lowest Dutch painters of tavern scenes: 'The painters who...express with precision the various shades of passion, as they are exhibited by vulgar minds, (such as we see in the works of Hogarth) deserve great praise; but as their genius has been employed on low and confined subjects, the praise which we give must be as limited as its object.'[24] James Barry, in his own lectures to the Royal Acad-

emy as Professor of Painting, though aware that 'Hogarth's merit does undoubtedly entitle him to an honourable place among the Artists', took an even harder line, seeing 'Hogarth's method of exposing meanness, deformity and vice...[as] rather a dangerous, or, at least, a worthless pursuit'.[25]

The emphasis placed by Reynolds and others upon the 'lowness' of his subject matter, and their condescension towards Hogarth's attempts at 'History painting' (the painting of heroic subjects in the grand manner) and artistic theory, both prepared the way for and reinforced the picture promoted by Nichols and Ireland in the 1780s of him as an autodidact, an artist of instinctive rather than cultivated

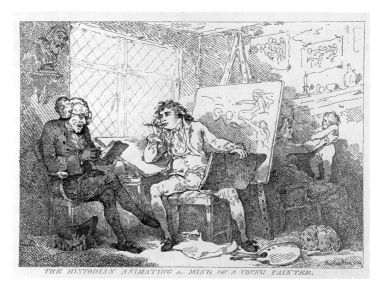

FIG.4 Thomas Rowlandson, *The Historian Animating the Mind of a Young Painter*, etching, 1784, British Museum.

gifts. Such strictures may have kept Hogarth's spirit out of the Academy and discouraged ambitious younger painters, but they did not diminish Hogarth's popularity; as Hazlitt put it, writing in the second decade of the nineteenth century, 'Criticism has not done him justice, though public opinion has.'[26] For the wealthy, like Horace Walpole, collecting and studying Hogarth prints became a pleasant evening entertainment, alongside the volumes of political and social satires that could be bought or hired out for the evening from printsellers, while the mass of reprints of the original plates, piracies and copies at all price levels made Hogarth's moral series part of common experience in an unprecedented way. Such images could be enjoyed, but for scrupulous Royal Academicians they could be regarded neither as socially valuable nor as a vehicle of true wit.

Hogarthianism in the sense most despised by Reynolds lived on vigorously in the world of the visual satirists; it is probably not coincidental that the two most notable practitioners of the later eighteenth century, Thomas Rowlandson and James Gillray, had both studied at and rejected the Royal Academy. The case for the beauty of real rather than ideal life is put most challengingly in a satirical print by Thomas Rowlandson, *The Historian Animating the Mind of a Young Painter* of 1784 (fig. 4),[27] where true

beauty, in the form of the artist's young wife and children, is neglected in favour of the guidance of a fusty academic. Gillray in *Titianus Redivivus*, 1798 (fig. 5),[28] uses the 'minute discriminations' condemned by Reynolds to deflate the pretentions of the Royal Academicians whose pursuit of Italian methods led them to fall for an imposter who offered them the 'secret' of Venetian colouring.

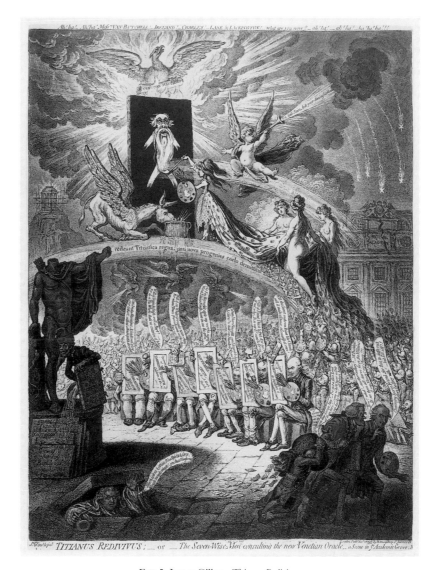

FIG.5 James Gillray, *Titianus Redivivus*,
hand-coloured etching, 1797, British Museum.

Hogarth's critical revival in the early nineteenth century followed from a series of interconnected circumstances and shifts in taste: a renewed interest in and respect for Dutch painting; the rise of a British school of common-life painting under the leadership of David Wilkie, itself under Dutch influence; the growth of interest in the idea of a 'British School' distinct from the continental schools, which culminated in a 'one-man show' of Hogarth's paintings at the British Institution in 1814;[29] and the acquisition of the *Marriage A-la-Mode* series by Julius Angerstein for the founding collection of the National Gallery, which was opened in 1824. The Academy's dismissal of Hogarth was, furthermore,

directly challenged by two young critics associated with the Lake Poets, Charles Lamb and William Hazlitt. Charles Lamb's 'Essay on the Genius and Character of Hogarth', first published in Leigh Hunt's *The Reflector* in 1811,[30] was, significantly, written before the 1814 exhibition, so treats Hogarth essentially as a maker of prints, and in particular of the Rake's and Harlot's Progresses, while Hazlitt's critique is based also on his close examination of the paintings in the 1814 exhibition, especially the *Marriage A-la-Mode* paintings.

Lamb addresses directly the criticisms made by Reynolds and James Barry of Hogarth's 'vulgarity', protesting that to claim that Hogarth is 'an Artist of an inferior and vulgar class' is 'to confound the painting of subjects in common or vulgar life with being a vulgar artist'.[31] Discussing the print *Gin Lane* (no. 81), the essence of all that Reynolds and Barry despised in Hogarth, Lamb argues provocatively that, despite being produced as a cheap plate for the instruction of the poor, it has

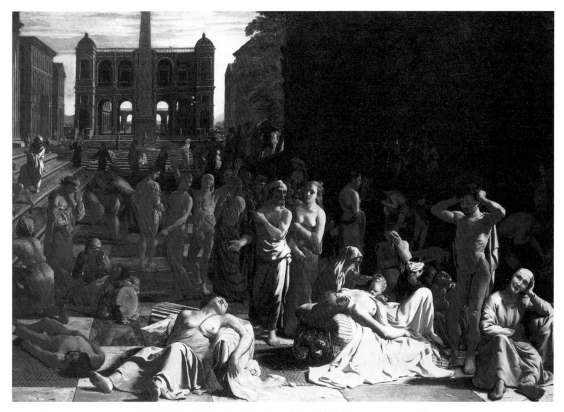

FIG.6 Michael Sweerts, *Plague in an Ancient City*, oil on canvas, *c.* 1652, Los Angeles County Museum of Art, Gift of the Ahmanson Foundation.

more imagination than Poussin's 'Plague at Athens' (now thought to be Michael Sweerts, *Plague in an Ancient City*, fig. 6)[32], because 'Every thing in the Print, to use a vulgar expression, *tells*. Every part is full of "strange images of death".' Lamb seeks to retrieve the true seriousness of Hogarth's comedy by the now familiar analogy with Shakespeare's mingling of tragedy and comedy. The linking of Shakespeare with Hogarth creates a sense of a common English heritage, which Lamb sees in the mingling of 'the ludicrous with the terrible' and in 'a sense of mirth checked by misery, and misery rebuked by mirth'. For Lamb it is not too much to compare *A Rake's Progress* with *Timon of Athens* or

the death of the Rake with the death of Lear, though Hazlitt hinted that he found such analogies a little exaggerated.

Lamb defends Hogarth from the common accusations that his art provokes only laughter and that he wallows too much in the seamy side of life, arguing that his satires 'appeal first and foremost to the very heart of man, its best and most serious feelings'.[33] They are 'severe satires' quite different from frivolous burlesque; though they might begin with laughter, they can end, as in, for example, the Harlot's funeral in the last plate of *A Harlot's Progress*, by being moving in the very heartlessness displayed. Lamb – ironically in view of Reynolds's 'Idler' criticisms of *The Analysis of Beauty* – attributes academic writers' lack of appreciation of Hogarth to the 'extreme narrowness of system alone, and of that rage for classification', calling into question the very idea of a hierarchy of artistic genres with History painting on the highest level:

> We call one man a great historical painter, because he has taken for his subjects kings or great men, or transactions over which time has thrown a grandeur. We term another the painter of common life, and set him down in our minds for an Artist of an inferior class, without reflecting whether the quantity of thought shewn by the latter may not much more than level the distinction which their mere choice of subjects may seem to place between them.

Lamb thus reaffirms Hogarth's own claims, based on Fielding's praise for his 'Comic History Painting',[34] that he 'impressed a thinking character upon the persons of his canvas', but in the most often quoted passage in the essay he also reaffirms Horace Walpole's argument that Hogarth was an essentially literary artist:

> I was pleased with the reply of a gentleman, who, being asked which book he esteemed most in his library, answered, 'Shakspeare:' being asked which he esteemed next best, replied 'Hogarth'. His graphic representations are indeed books: they have the teeming, fruitful, suggestive meaning of *words*. Other Pictures we look at – his Prints we read.[35]

The comparisons made by Lamb with Shakespeare, and indeed the mischievous comparisons with Poussin (to the latter's detriment) and Michelangelo, thus place him, however uncomfortably, on the side of seeing Hogarth as an artist of sophistication and high accomplishment, though, unlike Walpole, in a predominantly English rather than a broad European literary tradition. Furthermore, Lamb absolves Hogarth from the imputation made by James Barry that Hogarth's vulgarity made him inferior to those who depicted the 'tender images of Worth relieved by Charity', by comparing him with the Roman satirist Juvenal, who wrote of 'men's crimes and follies, with their black consequences'. There are, he argues, touches of virtue which balance goodness against the sordid, and though many of the prints contain sordid scenes, the impression given is essentially good-natured, like the works of Fielding and Smollett.

Hazlitt's lecture, on the 'English Comic Writers', refers back favourably to Lamb's essay. Originally the seventh in a series delivered at the Surrey Institution in 1818,[36] the lecture was subtitled 'on the grand and familiar style of painting', though, like Horace Walpole and Lamb, Hazlitt also places Hogarth predominantly within literary traditions of the comedy of manners: 'He belongs to no class, or if he does it is to the same classes as Fielding, Smollett, Vanbrugh and Molière.'[37] Hazlitt, however, was more involved in both the theory and practice of art than Lamb. He had learned a reverence for

Italian art from viewing the great Orleans Collection in London in 1798–9, and he had trained as a painter.[38] He had already examined the inheritance of Reynolds in a closely argued critique of the *Discourses*, challenging in particular Reynolds's notion that an artist should rise above the particularities of nature as it is perceived and paint the ideal 'central form', the Platonic essence of all things in nature, where the imperfections of observed nature should be avoided and objects should be represented in a generalised way rather than depicted in their individuality. Hazlitt argued that, on the contrary, particularity was compatible with the ideal and that it was possible to find in Raphael not only sublime ideas expressed in general forms of a grandeur beyond nature but also very precisely delineated expressions of human emotion, which may be taken to extremes.[39]

If Raphael can show precision in the depiction of emotion, then it might follow that artists of exact observation may also be able to achieve grandeur. The fascination of Hogarth's paintings and prints, it was agreed by all, lay in minute discriminations and in what Hazlitt calls 'the familiar style' as opposed to the 'grand style' of Raphael, but does this mean that Hogarth's art necessarily lacks seriousness? Hazlitt argues that Hogarth's reputation has been the victim of a series of false polarities which insist too dogmatically on the separation into different worlds of the familiar and the grand:

1. *Imitation versus invention* But Hogarth is undeniably inventive; a close study of the works reveals 'a mind capable of seizing the most rare and transient coincidences of things, of imagining what either never happened at all, or of instantly fixing on and applying to its purpose what never happened but once'.

2. *Gentility versus vulgarity* But Hogarth is just as adept at genteel comedy as he is at representing low life. No one is better at depicting 'affectation verging into idiotcy'; indeed, 'Many of Hogarth's characters would form admirable illustrations of Pope's Satires.' 'Hogarth was a painter, not of low but of real life,' capable of real elegance when it made an appropriate point.

3. *Beauty versus ugliness* But 'there are as many pleasing faces in his pictures as in Sir Joshua.' Even the prostitutes in his pictures are pleasing, but this is especially true of the young women who dominate a number of his paintings and prints.

4. *Comedy versus tragedy* But 'Hogarth is quite at home in scenes of the deepest distress, in the heart-rending calamities of common life.' This is most fully exemplified in the later prints of *A Rake's Progress*, where one finds represented 'silent despair,…moody madness, enhanced by the tenderest sympathy, or aggravated by the frightful contrast of the most impenetrable and obdurate insensibility'.[40]

Instead of seeing Hogarth, then, as representing one side of these polarities, we should see, as Lamb has already suggested, his strength precisely in reconciling them and embodying both the serious and the ludicrous: 'these contradictory faculties were reconciled in Hogarth, as they were in Shakspeare,[and] in Chaucer', both, of course, English writers. Hogarth's vision, then, is not to be confused with Dutch realism, or strictly speaking with realism at all, for his art does not purport to be an unmediated view of the world, like that of Hazlitt's own contemporary, David Wilkie. Hogarth is, by comparison, a History painter, who depicts the 'manners and humours of mankind in action',[41] with emotions, bodies and faces always represented as if in transition.

Hogarth had, furthermore, a higher purpose than mere pleasure. His compositions are 'works of science as well as of amusement', research towards a natural history of mankind, based on truthful delineation of character in all its variety. This is emphatically not the case with Wilkie, who, Hazlitt

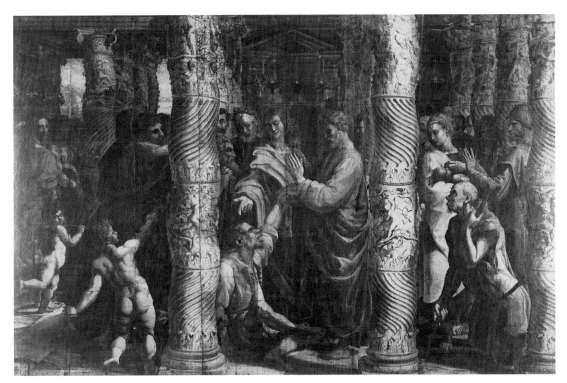

FIG.7 Raphael, *The Healing of the Lame Man*, tapestry cartoon, 1515–16,
Victoria and Albert Museum, London, on loan from Her Majesty the Queen.

informs us, was described by a superficial critic as having 'united the excellencies of Hogarth to those of Teniers'. 'Mr Wilkie is a serious, prosaic, literal narrator of facts... Hogarth, on the contrary, is essentially a comic painter...[of] rich, exuberant moral satires, exposing vice and folly... Hogarth paints nothing but comedy or tragi-comedy. Wilkie paints neither one nor the other.'[42]

Lamb's critique of Hogarth specifically rejects the whole idea of the hierarchy of genres advocated so strongly by Reynolds, setting the artist against Poussin and comparing the pathos of the Rake's decline with Michelangelo. In fact, Hazlitt does not draw the Old Masters into invidious comparisons and, having refuted the academic case against Hogarth, he ends the lecture by emphatically contradicting Lamb and reaffirming the superiority of Raphael and the Italian painters after all, dismissing Hogarth's attempts at the Great Style in terms very close to Horace Walpole's; Hogarth simply cannot conceive that 'there is another mightier world, that which exists only in conception and in power, the universe of thought and sentiment, that surrounds and is raised above the ordinary world of reality'. In Raphael's cartoons we find 'faces imbued with unalterable sentiment, and figures that stand in the eternal silence of thought'.[43] A comparison between Raphael's cartoon of *The Healing of the Lame Man* (fig. 7) and Hogarth's enormous wall-painting of *The Pool of Bethesda* (fig. 8) at St Bartholomew's Hospital obliges us to admit that 'there is not the same expansive, elevated principle in Hogarth'. Finally, Hazlitt himself admits that 'with all my admiration of Hogarth, I cannot think him equal to Raphael'.

Hazlitt, then, is profoundly sensitive to Hogarth's merits and prepared to defend him fiercely against academic criticism. He accords him the status of a national figure and a profound student of human nature, but in the end his own knowledge and experience of Italian painting enables him to

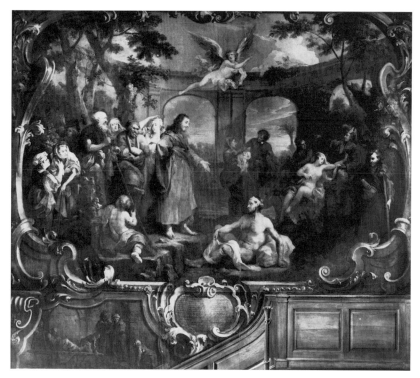

FIG.8 William Hogarth, *The Pool of Bethesda*, oil on canvas, 1736,
St Bartholomew's Hospital, London.

see limitations in Hogarth's art in its inability to adumbrate the metaphysical. Hogarth may not have been of the stature of Raphael for Hazlitt, but this was not a reason for denying him the respect and admiration he deserves, or the knowledge of humanity contained within the paintings and the prints. In one sense, then, Hazlitt's view still adheres to the idea familiarised by Horace Walpole that Hogarth, despite his immense gifts – and no one was more sensitive to Hogarth's painterly skills than Hazlitt – really belongs where Hazlitt's lectures placed him: between the 'English novelists' and the 'Comic Writers of the Last Century'. Furthermore, Hazlitt, by omission as much as anything, repudiates the Nichols–Ireland view of Hogarth as simple moralist and outsider. Though Hazlitt's notion of Hogarth as a kind of scientist providing an anatomy of mankind is very much of his own age, there is a sense in which Hazlitt, despite his radical credentials, breathes new life into the patrician view of Hogarth.

MIRROR OF HIS AGE OR ANY AGE?

It was taken for granted in Hogarth's own time, and indeed by Hogarth himself at the end of his life, that his prints gave a picture of the age in which he lived; but was his work universal enough to be a lesson for all ages, or was it only of historical or nostalgic interest? The Rev. Dr Trusler took the view, possibly encouraged by Hogarth's widow, that with judicious suppression of the sordid elements Hogarth's designs could be made fit for the moral edification of adults and children.[44] Walpole, writing probably shortly before Hogarth's death, had already signalled the ways in which the settings served to define character but also gave a particular insight into Hogarth's own times: 'It was reserved

to Hogarth to write a scene of furniture. The rake's levee room, the nobleman's dining-room, the apartments of the husband and wife in Marriage a la Mode, the alderman's parlour, the poet's bedchamber, and many others, are the history of the manners of the age.'[45] Hogarth himself, writing towards the end of his life, also made claims in his *Autobiographical Notes* for the value of his collected prints 'as descriptive of the peculiar manners & characters of the English nation, the curious of other Countries frequently send for them in order to be informed and amused with What cannot be conveyed to the mind with Such precision and truth by any words whatsoever'.[46]

Georg Christoph Lichtenberg (1742–99), the German scientist and author, writing towards the end of the eighteenth century, was, unlike Walpole, distanced from Hogarth in culture as well as time. His very successful commentaries on Hogarth's engraved series appeared between 1784 and 1796 in the *Göttinger Taschenkalender*, and were revised and enlarged for separate publication between 1794 and 1799.[47] Lichtenberg was a classic figure of the German Enlightenment, interested in the natural sciences and in human behaviour. England for him was the home of Shakespeare, Hogarth and Garrick, the great observers of human behaviour. Such knowledge was ultimately a means to social improvement, and his own project had as one of its underlying ambitions the provision of enlightened and humane attitudes for the modern German bourgeoisie, as a corrective to the self-indulgent court life of the German princes.[48] In this endeavour he found a fellow spirit in the Berlin engraver Daniel Nikolaus Chodowiecki (1726–1801), who had already before their association produced an explicitly Hogarthian series of prints, *Leben eines Lüderlichen* (Life of a Rake), in 1774 (no. 16), which clearly owes much to *A Rake's Progress*.[49] Lichtenberg analysed Hogarth's observation of character and city life in minute detail in his commentaries, but his collaboration with Chodowiecki led him towards the schematic contrasts of good and evil to be found in Hogarth's work of the late 1740s and early 1750s, like *Industry and Idleness* and *Stages of Cruelty*, and in such works as Chodowiecki's *Der Fortgang der Tugend und des Lasters* (The Progress of Virtue and Vice) of 1777 (no. 17).

For Lichtenberg Hogarth was a master because of his observation of human variety, but also because of the possibility of the social effectiveness of his work. The Hogarthian work of Lichtenberg and Chodowiecki is more prescriptive, containing models of behaviour and good manners in typical situations. In *Der Fortgang der Tugend und des Lasters* a reduced and schematic idea of moral growth and decline is expressed through the new 'science' of physiognomy developed by Johann Kaspar Lavater (1741–1801) in his *Physiognomische Fragmente zur Beförderung der Mennschenkenntnis und Menschenliebe* of 1775–8; the marks of virtue and vice are to be seen clearly on the contrasting faces of the virtuous and vicious protagonists. It is not coincidental that Hogarth is often used by Lavater as a repository of physiognomic types. Lavater's concern was not with transitory expression, but with the enduring features of the face and their relation to the moral character behind them.

Lichtenberg is at the same time the most sensitive and open-minded observer of Hogarth's own powers of observation, for he was able to bring to his consideration of Hogarth an outsider's appreciation of the London street-scene as an expression of a society that was politically more open and less hierarchical than the Germany of his own day. For Lichtenberg the tension in Hogarth between observation and moralising intent, and the unprescriptive nature of his visual language that might allow a variety of interpretations, were precisely his strengths; his works provided a vision of a more spontaneous and interesting society as well as showing the consequences of vice.

SOME MODERN CONSTRUCTIONS

Despite Hazlitt's and others' recognition of Hogarth's place in traditions of literary comedy, a view of Hogarth as an essentially ordinary man and plain-speaking moralist gained ground in the nineteenth century. Hogarth as the epitome of rustic virtue gave way to a more urban construction, in which his honesty and uprightness were vested in his experience as an apprentice, who, like Francis Goodchild in *Industry and Idleness*, took the route of social betterment but never succumbed to extravagance or pretension. The *locus classicus* of such a view was to be found in the mid-century writings of George Augustus Sala.[50] For Sala Hogarth was a representative Englishman, a man of a 'healthful, sanguine

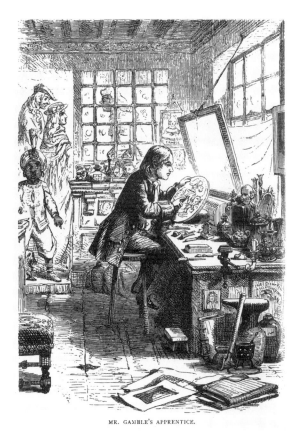

MR. GAMBLE'S APPRENTICE.

Fig.9 Anonymous, *Mr Gamble's Apprentice*, frontispiece
to George Augustus Sala, *William Hogarth: Painter, Engraver,
and Philosopher*, 1866, private collection.

constitution, and…great powers of will and self-reliance backboning an unflagging industry'. His heroism is not that of a life of action but of a productive but undramatic commitment to a craftsman's task. Though his virtues were those of a hard-working city apprentice (fig. 9), they were underpinned by his rural background, which tied him ultimately to the supposed Saxon ancestry of his Cumbrian forebears. He was the 'descendent of a long line of north country yeomen, of whom the prime progenitor is presumed to have kept pigs and to have gone by the rude name of "Hogherd"'.[51]

Despite the banal opinions and arch tone reminiscent of Thomas Carlyle, Sala was well read in the

Hogarth literature, and it is not surprising that he should favour John Ireland above all others: 'Among commentators on Hogarth, Ireland is the best; Trusler, the worst.' He is at pains to emphasise the popular nature of Hogarth's art, specifically (and unhistorically) dissociating it from any taint of foreigness:

> Most at home would be many of his works, perhaps, in low tap-rooms and skittle-alleys; but he was
> no Boucher or Fragonard to paint alcoves or *dessus de portes*… He was vulgar and ignoble frequently,
> but the next generation of his countrymen forgave him these faults – forgave him for the sake of
> his honesty, his stern justice, his unbending defence of right and denunciation of wrong. This
> philosopher ever preached the sturdy English virtues that have made us what we are.[52]

By contrast, Sala fiercely denounced Horace Walpole, addressing him as someone incapable of truly understanding Hogarth: 'You were not fit to be an Englishman. Fribble, your place was in France… You were good enough to admire Hogarth, but you didn't quite understand him. He was too vigorous, downright, virile for you.' Walpole's supposed Frenchness made him quite alien from English culture, a man of the effeminate culture of the *ancien régime*.

Sala develops Ireland's emphasis upon Hogarth's lack of learning: 'He was not deeply learned in anything save human nature,' and 'His knowledge of books was defective.' But Sala gives the account a particular turn by setting up Hogarth as a national role-model, a figure, despite a certain coarseness, fit to act as an example to the youth of England. Sala's Hogarth is unfailingly respectable, an upholder of King and Church, faithful to his wife, patriotic and hard-working. In fairness to Sala, however, his Hogarth is not quite the grim moralist of Trusler's creation, for he locates the moral force of his art not in the message or social efficacy of the prints but in the personal character of Hogarth himself. The underlying concept is of the 'healthiness' of Hogarth's character, from which the moral value of the works must flow.[53] He represents, as did so many heroes of the past for Victorian improvers, the ideal of an English racial character which might transcend historical periods, enduring from a mythical Saxon past through the ages, though often concealed or diverted by 'alien' influences.

There is some irony in the fact that the seemingly watertight Victorian construction of Hogarth as an honest, plain Church-and-King man should provide a basis for the demotic Hogarth favoured by some of the political left in more recent times. Francis Klingender in his brilliant pamphlet *Hogarth and English Caricature* of 1944 made the striking claim that Hogarth's art had a central place, not within literary traditions, but within a European-wide tradition of popular art. This popular art of woodcut broadsides and visual satire was based, he claimed, on 'a common civilization expressing the moods and aspirations and the way of life of the broad masses of the people'. This current, according to Klingender, went back at least to the early history of printing and was vigorous enough to allow for the possibility of revival in current society. This led Klingender to emphasise the centrality for Hogarth of his moral prints of the 1740s and 1750s, and put the two woodcut versions of plates in *The Stages of Cruelty* (nos 82d and f) at the heart of his enterprise.[54] Even so, Klingender does not deny him elements of fantasy derived from the inheritance of Hieronymus Bosch and particularly Pieter Bruegel, artists who belonged to the popular stream, which was by definition opposed to the Baroque, which Klingender associated with 'the final triumph of the counter-reformation and of absolutism'. Hogarth, on the contrary, expresses 'the point of view of the most progressive elements' in British society, the craftsmen and improvers laying the ground for the Industrial Revolution.

It is no coincidence that Klingender's book was written in 1944, when the emphasis of a wide spectrum of the Left was on national unity in the face of the fascist enemy. It is easy to see in retrospect, however, the schematic nature of Klingender's view, despite the productive quality of his insights. Hogarth's enterprise cannot simply be associated with traditions of political and comic satire from which he distanced himself so vocally. Nor is there any justification in the context of the eighteenth century for presenting Hogarth as a champion of 'the people' in opposition to reactionary forces. The contradictions implicit in any idea of popular art make it impossible to see it as a unified tradition, particularly if it has to find common ground between Hogarth's prints and the caricatures, broadsides and prints of his contemporaries as well as Bosch and Bruegel.

Yet the belief that Hogarth was, if not a practitioner of popular art, at least in some sense a 'man of the people' instinctively on the side of the underdog against those of wealth and rank, with an uncorrupted insight into the power structure of his own time, not only retains some force in recent scholarly writings on Hogarth but has achieved something of a revival in recent years. Ronald Paulson wrote in his preface to the most recent edition of his biography of Hogarth, published in three volumes in 1991–3, that for him over the years 'Hogarth has changed from being an elitist Augustan satirist to a subversive popular artist and then to something more complex than either'.[55] David Dabydeen, writing in 1985, argues that Hogarth was 'the first English artist to represent on canvas the lives of the common people in a serious and sympathetic way' and that his 'championing of the common people which violated the spirit of the age earned him the rebuke of connoisseurs of art and gentlemen of taste'.[56]

If such views at one level represent the inheritance of Hogarth's late eighteenth-century admirers, like Nichols and Ireland, who succeeded brilliantly in establishing Hogarth as a 'popular' artist ready for reclamation by future generations, this catalogue and the exhibition it accompanies make a case, and it claims no originality in so doing, for reclaiming a Hogarth who worked, however uncomfortably, *with* the grain of society rather than against it, and whose picture of society did more to reassure those in power than perturb them. Though Hogarth's view of human nature was often bleak, though he was challenging in conversation and overly sensitive to slight and criticism, and though he increasingly saw his own miseries reflected in the state of the nation, it will be argued that these are not grounds for supposing that he was possessed of a proto-revolutionary or even a mildly radical view of the world.

HOGARTH'S PUBLIC: FINDING AN AUDIENCE

G eorg Christoph Lichtenberg described the world in which he and Hogarth flourished as 'this Paper Age of the world' (*dieses papiernen Alters der Welt*), in which, 'since the Universe has become subject to the book and picture market, thousands of writers and artists have grown blind to the direct light of Nature, but see quite satisfactorily if its beams are reflected from a sheet of paper.'[57] Lichtenberg is referring here to the emergence in the Germany of his time of a 'Paper Culture': the immense production of printed material of all kinds, from documents for the new bureaucracies to novels, magazines and newspapers for the ever-expanding literate bourgeoisie of the German towns and principalities.[58] Lichtenberg was himself, of course, a classic figure of this new German enlightenment, involved in the business of conveying improving ideas in attractively packaged forms, like illustrated pocket calendars (see p. 78).

One might compare this, as Lichtenberg himself did, with Hogarth's experience some fifty years earlier, for Hogarth also inhabited a Paper Culture, and an extremely vigorous one. He, too, was involved in producing paper products, from simple trade cards and book plates to book illustrations and elaborate large-scale engraved plates. Hogarth's age was dependent upon advertisement; as his contemporary George Vertue observed, his astute and ingenious manipulation of the means of publicity available to him in London made him a public figure.[59] The Paper Culture which united Hogarth and Lichtenberg can be associated with what Jürgen Habermas has called the 'Bourgeois Public Sphere', which replaced feudal forms of society, as exemplified by Louis XIV's France, in which culture emanated from a court and was designed to reinforce the mystery surrounding 'Lordship'.[60] In the Bourgeois Public Sphere an urban bourgeoisie both creates, and is created by, a Paper Culture which allows its members to communicate with each other without reference, and sometimes in opposition, to the court. As a consequence this bourgeoisie might develop ideas subversive of rank, becoming an increasingly independent, powerful and, in certain circumstances, revolutionary sector of society.[61]

For Habermas the London of Hogarth's period was precisely the locus of the emergence of this public sphere, and printmaking of the kind practised by Hogarth was in that sense the quintessential bourgeois art form. It was by definition urban and commercial, depending upon the creation of a repeatable commodity which could attract a public to itself. In this it contrasts, in theory at least, with individual paintings commissioned from an artist as an act of patronage, though, of course, in reality Hogarth benefited from both forms of sale. The desire for novelty is also a feature of a commercial society, and Hogarth's prints were advertised to their public on the strength of their innovative

character. The Modern Moral Subjects were, as Hogarth put it himself, 'still a more new way of proceeding...a Field unbroke up in any Country or any age'.[62]

Even so, Hogarth's marketing procedures were not always innovative, nor should it be assumed that Hogarth was operating consciously within a Bourgeois Public Sphere as Lichtenberg was in a certain sense. His first production of a set of his own designs, the *Hudibras* series of 1725 (see p. 39), was initially based on an arrangement with a book publisher and the production of a subscription list (see no. 26) accompanied by public advertisement, a method that was more usually practised by publishers of expensive volumes directed towards wealthy gentlemen but was already used occasionally for highly finished engravings of literary and historical subjects. The subscription list contained 192 names, and was dedicated strategically to the well-known Edinburgh poet and bookseller, Allan Ramsay, and to a landowner, 'William Ward, Esq; of Great Houghton in Northamptonshire'. The choice of dedicatees was evidently calculated to appeal to Tory country gentlemen, themselves large consumers of the products of the city, who might not have been dismayed by Ramsay's Jacobitism. Hogarth advertised the set several times in the *Evening Post* and the *Post-Boy*, describing the engravings enticingly as 'most Diverting Prints'.[63] The classical references in the frontispiece to *Hudibras* (see no. 30) established the work as both by and appealing to persons of traditional learning. The prints themselves are engraved in a style associated with the reproduction of History paintings, and the allusions to canonical artists like Annibale Carracci would have also contributed to the air of probity.[64]

The size of the subscription list and the number of surviving copies suggest that Hogarth did reasonably well out of the series, though not well enough to free himself from hack work, nor make himself independent of the publishers, or indeed encourage him to try anything similar for the next six years. True independence came with the publication of *A Harlot's Progress* which appeared in April 1732.[65] Though the series was also sold by subscription, the method of marketing was new and ingenious. The basis was a series of painted versions which were available for viewing in his studio in Covent Garden; 'there being no day but persons of fashion and Artists came to see these pictures',[66] for Hogarth was assiduous in making his studio part of the urban spectacle. Contributions were raised initially by means of an engraved subscription ticket (no. 37), as a way of getting half the payment in advance for the series. Hogarth was, in fact, extremely slow to finish the prints, and subscribers could have waited for over a year before they received their set, on payment of the other half of the subscription.

According to George Vertue, a rival engraver and chronicler of the period, the artist's motives in producing *A Harlot's Progress* were cynical, seeking to exploit the erotic potential of the subject matter in the life of a prostitute, and this would have been in keeping with other works of the early 1730s. Vertue notes that the series originated in an enticing painting of 'a common harlot, supposd to dwell in drewry lane, just riseing about noon out of bed' and that 'this whore's desabille careless and a pretty Countenance & air'[67] had proved attractive to visitors who urged him to add other paintings to it. For whatever reasons the subscription was an extraordinary success and Vertue notes that 'persons of fashion and Artists' took out 1240 subscriptions at one guinea each. No analysis of Hogarth's subscribers has yet been undertaken, but 'persons of fashion and artists' would be a reasonable preliminary guess at the audience who actually bought his prints. However, he did allow a cheaper set of copies to be produced (see no. 11), which suggests that he already had a sense of a potential audience for his Modern Moral Subjects beyond those who came to his studio or who knew of *A Harlot's Progress* through word of mouth.

The Latinate mock-seriousness of the ticket for *A Harlot's Progress* (no. 37) was not to be repeated; subsequent tickets are almost always light-hearted and witty, as if promising more entertainment than moral instruction in the plates to be purchased. *A Rake's Progress* is signalled by the *Laughing Audience* (no. 27a), which alludes to the idea that the viewer should see her/himself in the image of the audience and perhaps in the world of the prints themselves. Most of the predominantly middle-aged and moderately respectable audience seek only to be amused, except for one sternly disapproving face, while two gentlemen in the box above ignore the play in favour of attempting to seduce the orange-sellers. The scene suggests an awareness on Hogarth's part that the public for *A Rake's Progress* might be like the audience in a theatre, with 'the great folk' in privileged boxes or seats on the stage, but tradesmen and professional people in the seats below. Just as Gay's *Beggar's Opera* had become a popular success almost despite its origins as a satire of Italian opera, so the Modern Moral Subjects could begin to free themselves a little from the classical culture which had brought them into being.

A Harlot's Progress had been very successful, but the fame of *A Rake's Progress* developed a dynamic beyond Hogarth's control. The success of *A Harlot's Progress* had probably made Hogarth fearful of piracy, and he had authorised copies by Giles King for a mere two shillings and sixpence, nearly a tenth of the price of the originals (no. 11).[68] The Giles King copies were mainly intended to undercut piracies, but they contributed to the further spread of his designs beyond the 'persons of fashion and Artists'. With *A Rake's Progress* the problem of piracy became more intense, beginning even before the prints were produced.[69] A set of the eight prints was one and half guineas to subscribers, compared to a guinea for the six prints of *A Harlot's Progress*, and two guineas after publication. It is interesting that King, and also Thomas Bakewell who made authorised copies of *A Rake's Progress*, again probably with Hogarth's approval, added explanatory captions, giving mundane details that are not always clear from the prints themselves or, in the latter case, from John Hoadly's high-flown verses under Hogarth's own prints. Thus in describing the last scene in Bedlam, Hoadly invites us to see in the Rake 'Death grappling with Despair', but in Bakewell's account we are told that the Rake 'is afterwards confin'd down to his Bed in a dark Room where he miserably expires'.[70] Ironically, the Act of Parliament which Hogarth arranged through political contacts to protect *A Rake's Progress* seemed only to have encouraged printmakers to print piracies before the Act came into force, but their authors, in some cases well-known printmakers, thought it best to incorporate deliberate differences from their prototype (see no. 13b). Pirated series include plates of incidents only hinted at in the originals, like a street brawl, and versions of the scene in the brothel make sexually explicit what is only implied in Hogarth's original design (no. 76).[71]

The effect of all these manoeuvres was to give Hogarth a fame that seemed to transcend social class, and made his work available in forms which could be assimilated by a broader public. This public might have included small shopkeepers and artisans who would have found a guinea a high price but two shillings and sixpence within reach. But Hogarth, as his ambitions from the late 1730s turned towards a more elevated conception of his art, seems to have been more embarrassed than gratified at the thought of his designs passing into the hands of the general population. The elaborate preparations he made for the engraving of the *Marriage A-la-Mode* series completed in 1745, and his insistence on their 'French' elegance, suggest a desire positively to exclude the uneducated public. In his advertisement of 2 April 1743 in the *Daily Post & General Advertiser* he emphasised that the prints would be 'engrav'd by the best Masters in Paris, after his own Paintings; representing a Variety of Modern

Occurrences in High-Life… Particular Care will be taken, that there may not be the least Objection to the Decency or elegancy of the whole Work.'[72] The implication is that the work was targeted with some precision at those cultivated enough to be able to recognise high-quality engraving, and indeed to recognise themselves in the images. Furthermore, in the same advertisement he explicitly renounced the possibility of producing cheap copies, on the grounds that cheap engraving would *ipso facto* lose an essential part of the meaning of the prints.

This evident narrowing of his intended public seems at odds with the overt populism of the series of prints of the later 1740s and 1750s, like *Industry and Idleness* and *The Stages of Cruelty*, which are specifically directed towards apprentices and those who might become criminals. But it can be argued that, like *Marriage A-la-Mode*, they are targeted at precisely defined sections of society, as a means of promoting social improvement in a manner appropriate to a public-spirited gentleman. It is true that Hogarth issued these prints on 'better Paper for the curious',[73] 'the people of fashion and Artists', and they formed part of the volumes of his collected works from the 1740s onwards, but Paulson's suggestion that they also contain knowing references to appeal to a sophisticated audience seems overly contrived.[74]

As Hogarth's fame increased towards the end of his life and especially afterwards, so his work attracted the phenomenon called by Edmund Malone (writing to the Earl of Charlemont, who suffered from it himself) 'Hogarthomania' (see p. 58). This was the frenetic pursuit by collectors of impressions of all his plates, even the least attractive and most ephemeral ones, and rare states and trial proofs. At the other end of the social scale imitation continued apace, and versions of his moral designs, through debased copies and piracies, and even copies of piracies, seem to have been extremely widespread by the end of the eighteenth century.[75] Hogarth's own sense of his audience was probably quite limited, but a public for his work continued to grow without his intervention through the Paper Culture he inhabited and through subsequent generations hungry for stories in visual and acquirable form.

POLITENESS
AND ROMAN SATIRE

Under disadvantages thus obvious, such was the fire, such the native genius of Hogarth,
that he has delineated, clothed, and embodied the ideas of almost every Roman poet, before,
after, and at the Augustan age.
(Anon. [Edmund Ferrers], *Clavis Hogarthiana, or Illustrations of Hogarth,* 1815)[76]

In the view of the authors of *The Spectator*, writing in the first two decades of the eighteenth century, any satire which implied personal or political invective or contributed to 'the spirit of party', as found in pamphlets and caricatures, was by definition 'impolite'. Joseph Addison in *The Free-Holder* spoke especially strongly of raillery directed against 'Persons and Things of a sacred and serious Nature', but he did defend the place of 'Such Productions of Wit and Humour, as have a Tendency to expose Vice and Folly, [and so] furnish useful Diversions to all kinds of Readers'.[77] Politeness required the satirist to use his weapons not against individuals but against vices in general, though Dryden had allowed the possibility of directing satire against 'public nuisances… 'Tis an Action of Virtue to make Examples of vicious Men;'[78] in practice, virtually all satirists from antiquity to Swift and Pope had used satire to attack individuals.

Addison's larger objective was to encourage the formation of a national temperament which would avoid the poles of Puritan 'Enthusiasm' and Restoration libertinism, and impose order and politeness on a potentially unruly commercial society. Humour could 'refute the common Objection against Religion, which represents it as only fit for gloomy and melancholy Tempers'.[79] Laughter was thus a weapon against the destructive fanaticism of 'that stubborn Crew of Errant Saints' to which Samuel Butler's Hudibras belonged. It was also a weapon against vice and thoughtlessness. Humour might in addition help to make serious thoughts palatable, for, as Addison noted from his own experience, 'No Periodical Author, who always maintains his Gravity, and does not sometimes sacrifice to the Graces, must expect to keep in vogue for any considerable time.'[80]

It seems beyond argument that Hogarth's enterprise was Addisonian,[81] in that his moral series implicitly advocate a middle way between vice and excessive virtue, but it is equally clear that his satiric vision must have been nourished by a wide range of literary sources. The 'middle way' was not new to Addison; indeed, it was a staple of Roman thought and particularly associated with the poet Horace. Equally, Addison did not provide in his own works any satisfactory iconography or setting for the work of a visual artist. If, as Horace Walpole claimed, Hogarth was an artist of social comedy within literary rather than artistic traditions, then it is appropriate to return to the question of his literary knowledge and culture.

The epigraph to this chapter is taken from a strange book by an anonymous classical scholar, who combed Hogarth's main series for classical parallels and echoes of passages from Roman poets. These

he found in great profusion. Horace was the most frequently cited with Juvenal second, but the exercise was premised on the assumption that these borrowings were entirely coincidental, for he assumed Hogarth to have been virtually illiterate; indeed, the subtitle of the book was 'Hogarth Illustrated from passages in authors he never read, and could not understand'.[82] Yet there is nothing implausible in the idea that Hogarth might have read Horace in one of the innumerable translations available in his time, or read Juvenal, if not in the original Latin, at least in Dryden's popular translation.[83] Nor, indeed, is it unthinkable, to take up Charles Lamb's comparison with Shakespeare, that he had *King Lear* in mind in conceiving the Bedlam scene in *A Rake's Progress* .

Hogarth's 'realism' has usually been attributed by art historians to the 'Northern' inheritance from Dutch paintings of commmon life by such masters as Jan Steen, and was thus opposed to 'Southern' or predominantly Italian idealism, which had its roots in classical antiquity and set moral fables within contexts remote from common life.[84] Such an idea of classical antiquity rests partly on the accident of the survival of ideal marble figures, which were, from at least the sixteenth century, treated primarily as aesthetic objects, detached from specific physical or historical settings. Paintings and other representations of common life that had existed in antiquity were, in most cases, lost, disregarded or treated as exceptional. In literature, by contrast, it was unavoidable that many of the most high-minded Greek and Latin authors, especially Horace and Juvenal, revelled in common life, and were unblinking in the face of political crookedness and all the characteristic vices of a competitive urban society. For Hogarth's literary contemporaries, then, there was no paradox in being true to, and even imitating closely, the great classical authors while using them as a means to look critically at contemporary life.

Analogies between the crowded, disorderly and infinitely varied cities of Rome and London were part of the normal currency of ideas in popular literature from at least the early seventeenth century and throughout the eighteenth century. Descriptive or poetic accounts of London life were very often framed by openly cited precedents from Horace and Juvenal, and the many translations and imitations of those authors from the seventeenth century onwards would, almost as a matter of course, translate the descriptions of Roman life into recognisable London settings. Pope's most trenchant poetic commentaries on his times are 'Imitations' of Horace's *Satires and Epistles*, and Samuel Johnson's *London* of 1738 was, as its title page notes, 'a Poem, In Imitation of the Third Satire of Juvenal'.[85] Hogarth's depiction in *A Harlot's Progress* of notorious contemporaries like Mother Needham and Colonel Charteris in identifiable London settings was, therefore, entirely in keeping with the methods of Roman satirists as inherited by his contemporaries; not only the high-minded but also 'Grub Street' poets cited Horace and Juvenal in opportunistic descriptions of the sordid aspects of London life. The effect was to make it difficult to distinguish elevated from demotic poetry, and Hogarth exploits, as did others, the lack of clear boundaries between the two. Though Hogarth might well have taken the moral purposes of *A Harlot's Progress* seriously, it is also clear from George Vertue's account of its origins in a painting of a half-naked prostitute, that he did not wish to put off those attracted by the erotic appeal of a prostitute's life.[86]

Horace and Juvenal were usually seen to represent the poles of Roman satire; in Dryden's words 'the Contention betwixt these two great Masters, is for the Prize of Satyr.'[87] Dryden defined the difference between them in terms of Profit and Delight: Horace had a universality of mind which enabled him to be instructive in all moral and social situations, but Juvenal's energy and passion made him more exciting and engaging to read. The works of both contain set-pieces of commonplace

description, but Horace claimed to 'tell the truth laughing' and cure ignorance by wit. Juvenal's satire, on the other hand, was perceived as being at home in times of particular moral decay when it was unsafe to name names. Juvenal's kind of truth might be beneficial but it could also be hurtful and dangerous to the author.[88] If Horace emphasises compromise and locates ideal human conduct at the point of balance between extremes, then Juvenal offers a bleaker view of humanity. Horace was also more naturally a poet of the established order: he was in favour at the court of Augustus with a rich and enlightened patron, and able to look upon the city from the detachment of his farm, just as a Whig gentleman could shake his head at city ways from the security of his great estate.[89] Juvenal, by contrast, was believed to have been himself part of the teeming street life of Rome.

In the Preface to the second edition of *Love of Fame, the Universal Passion: In Seven Characteristical Satires* of 1728 the poet and clergyman Edward Young claims Horace as the master of 'laughing Satire': 'Of this delicacy Horace is the best master: He appears in good humour while he censures; and therefore his censure has the more weight, as supposed to proceed from Judgement, not from Passion.'[90] That Hogarth subscribed to such an idea in the years that followed and probably associated it specifically with Horace is evidenced by *A Midnight Modern Conversation*, published in March 1733 (no. 6), perhaps the most deliberately good-humoured seeming of his satirical prints. The verse caption in the first state admonishes the viewer not to expect the print to depict real people:

> Think not to find one meant Resemblance there
> We lash the vices but the Persons spare.

It goes on to claim that

> Prints should be prized as Authors should be read
> Who sharply smile prevailing Folly dead.

This last line is, in fact, directly quoted from Young's first satire in *Love of Fame*, as part of an explicit call for a revival of Horatian satire. Young laments the decline of satire after the Restoration wits, noting that Congreve is silent and Pope, 'who leads the tuneful train', appears to slumber. He calls, therefore, for a new Horace to raise his satirical voice:

> Doubly distrest, what author shall we find
> Discreetly daring, and severely kind,
> The courtly Roman's [Horace] shining path to tread,
> And sharply *smile* prevailing Folly dead?[91]

If the caption to *A Midnight Moral Conversation* makes the implicit claim that the print follows Horace's 'shining path', then it is also possible to see Hogarth's advocacy of the middle way between extremes in the 'Progresses' as consciously Horatian. In Satire 1 of the first book of *Satires* Horace denounces at length the miser who endures only misery from his pursuit of wealth, alienating himself from his wife and son. But the answer is not to go to the opposite extreme and become a spendthrift like Naevius or Nomentanus, but to remember:

> est modus in rebus, sunt certi denique fines,
> quos ultra citraque nequit consistere rectum.

(There is a measure in things; there are fixed and stated bounds,
on either side of which virtue cannot be found.)[92]

The deceased and therefore absent miser Rakewell is represented metonymically in the first plate of *Rake's Progress* (no. 13a) by an infinite variety of signs of his miserliness. He is set against his own creation, the Rake, for his miserliness has engendered its opposite in the spendthrift ways of his son. The way of righteousness is between these extremes, and the true path is one in which a balance is achieved. A contemporary verse commentary on *A Rake's Progress*, published in 1735, attributes to the series precisely this way of moderation:

> Virtue when strain'd, and over nice,
> Is very near ally'd to Vice;
> …The Vessel that sails close to Shore
> Is the most likely to set o'er:
> Whilst that does ever smoothly swim
> That keeps i'th Middle of the Stream.[93]

The unstated middle way is, as it were, an absent presence in Hogarth's satirical works, defined by the representation of extremes of character and conduct, as it is so often in Horace's and Pope's satires. When the foolish innocent, like the future Harlot in *A Harlot's Progress*, plate 1 (no. 32), arrives in London, she confronts an excess of experience in Mother Needham; and when, in the third plate (no. 10), she becomes dissolute as a Drury Lane prostitute, she is condemned by the equivocal figure of the prurient Sir John Gonson. Similarly, an elderly prude confronts the rabble of harlots and rakes outside Tom King's Tavern in Covent Garden in *Morning* (no. 40a) from *The Four Times of Day* series. Prudes and libertines, like harlots and moral zealots, are deviants from the ideal harmony between mind and body, and from the 'natural' relationship between moral rigour and self-indulgence.

The most imitated of all Roman satires was Juvenal's Third Satire, which contains the bitter lament of the poet Umbricius, driven by a sense of injustice and the horrors of city life to leave for the small country town of Cumae. In Dryden's words he tells of the false values of Rome where 'none but Flatterers make their Fortunes there…[and] Grecians and other Foreigners raise themselves by those sordid Arts which he describes'.[94] The bigoted description of the Greeks, perhaps intended ironically by Juvenal, as 'Quick-witted, Brazen-fac'd, with fluent Tongues', bringing with them 'their crooked Harps and Customs', provided a model which was applied in eighteenth-century England to Italian and French immigrants and visitors, and later to Scots. In Samuel Johnson's *London: A Poem, In Imitation of the Third Satire of Juvenal* of 1738 Juvenal's Greeks are transformed into stock French types:

> Obsequious, artful, voluble and gay,
> On Britain's fond Credulity they prey.
> No gainful Trade their Industry can 'scape,
> They sing, they dance, clean Shoes, or cure a Clap;
> All Sciences a fasting Monsieur knows,
> And bid him go to Hell, to Hell he goes.[95]

The continued enthusiasm for Juvenal's Third Satire, which goes back well into the seventeenth century, must have been due to the vivid picture it gives of the perils of city life, and the gap between rich

and poor daily visible on the streets. The analogy between Juvenal's jaundiced picture of Rome and a London in which the wealth generated in the city was becoming ever more evident and overbearing proved irresistible to writers, Grub Street or otherwise, and the descriptions of street life, the violent meeting of strangers and confrontation between different classes, were echoed endlessly in descriptions and views of London.[96] In Juvenal's Rome the streets are permanently congested and contested; despite the arrogance of rank and wealth, even those with coaches or on horseback must fight their way through and be forced to endure the derision, slights and plain aggression of the crowd, as in the case of a gentleman who tries to push his way through the throng:

> The Crowd that follows crush his panting Sides,
> And trip his Heels; he walks not, but he rides.
> One elbows him, one justles in the Shole:
> A Rafter breaks his Head, or Chairman's pole:
> Stockin'd with loads of fat Town Dirt he goes;
> And some Rogue-Soldier, with his Hob-nail'd Shoes,
> Indents his Legs behind in bloody rows.[97]

Though Horace also remarked on the vulgar distractions of city life, Juvenal undoubtedly contributed more decisively to the realistic representation of London street life which emerges in the late seventeenth and early eighteenth centuries, mainly in literature but also in the work of painters like Balthazar Nebot, active from 1730 onwards.[98] Juvenal's influence can be observed in the Progresses and in much of Hogarth's later work, firstly in the precise delineation of place: almost every image is set within an identifiable location, itself imbued with symbolic meaning. To take one example, the Harlot in the third episode of *A Harlot's Progress* is shown to plie her trade in Drury Lane, because of a tankard in the corner from the notorious Rose Tavern (no. 10). This evokes Gay's description of Drury Lane in *Trivia*,[99] and it defines the Harlot as having now descended to the level of street-walker, working on a street notorious for prostitution. Secondly, Hogarth's city is populated not by identifiable individuals, except in a number of special cases like Charteris and Needham (see nos 32–4), but by representatives of occupations and social classes who act according to stereotypes. Lawyers help themselves to coins when no one is looking or use their eloquence unscrupulously like Silvertongue in *Marriage A-la-Mode*, doctors dispute while the patient dies, and so on. Thirdly, the city is a place of meetings. The Harlot's fate in the first plate of *A Harlot's Progress* begins with a meeting which is also a kind of confrontation between rural and urban cultures which can only happen on a city street; urban culture in the form of the Bawd Mother Needham and the lecherous Colonel Charteris transforms the rural into its own degraded currency.

The physical contact between the rich and the poor and between the great and the humble who have to share the streets makes things happen that can be invested with symbolic meaning. In *Southwark Fair* (no. 68) urban spectacle and disorder meet violently: there are accidents like the collapse of the scaffolding on the left, people jostle each other, and the noise and distraction allow pockets to be picked and petty swindles to take place. There are, however, other themes in *Southwark Fair*, like the ironical interplay between theatrical illusion and life, for the collapsing stage is about to cause havoc in the real world. There is also the sense, given by the profusion and variety of people, that one is observing the whole world, the *Theatrum Mundi* in which all human life is displayed. This may be contrasted

with the other great crowd scene in Hogarth's work, *The March to Finchley* of 1750 (no. 72), which, as will be argued in a later chapter (see p. 48), attempts, in conformity with Hogarth's later concerns, to picture the disorderly state of the nation and perhaps suggest remedies.

The Rake is represented on the street only once in *A Rake's Progress*, in the arrest scene in plate 5, where the orderly procession to court is broken by the uncouth bailiffs who accost him. Contingency comes to his rescue by the accidental appearance of Sarah Young who happens to be passing, because she too, though a humble seamstress, is able to share the space of the city streets with those on their way to court. Hogarth's Progresses share with Juvenal a sense of the inevitability of class confrontation in the city; just as the gentleman forcing his way through the crowds picks up blows and dirt, so the Rake as he emerges from his carriage suffers the accidental misfortune of having oil poured on his head by the simple-minded lamplighter, who, distracted by the noise of the arrest, continues to pour the oil into his overflowing lamp.

The four prints based on the paintings of *The Four Times of Day* (see nos 25 and 40a and b),[100] which followed soon after *A Rake's Progress*, in a sense represent the high point of Hogarth's engagement with Juvenal, though there are also signs of a rejection of the bleakness of the latter's vision. The prints show London as a city of strangers, with all the minor conflicts and forced proximity of those who confront each other daily in the teeming streets; rich and poor, prudish and lustful, tavern and chapel, native and foreign, child and adult, drunk and sober, respectable and coarse. But whereas in Juvenal the buildings – the 'tow'ring houses tumbling in the night' – are a correlative of moral decay, in Hogarth's scenes the gleefully observed instability of the human interactions, verging on chaos and hysteria, is anchored by upstanding structures which emphasise continuity with the historical past. The louche and comic confrontations in Covent Garden in *Morning* (no. 40a) are presided over by the noble portico of Inigo Jones's St Paul's Church; in *Noon* (no. 40b) the rooflines of the tavern and the Huguenot chapel point to the spire of St Giles-in-the-Fields in the distance; in *Evening* (no. 25) an inn-sign showing the great urban improver Sir Hugh Middleton, who brought a consistent supply of water to London in the seventeenth century, stands prominently over the unhappy central couple of the dyer and his wife, while in *Night* the statue of Charles I by Le Sueur at Charing Cross closes the vista beyond the chaos of the street.

These elements express the continuities of London life among all the frenetic change, and suggest a world beyond the scenes represented. In the Progresses the numerous incidents contribute to the narrative and act as building blocks in the moral edifice; in the *Times of Day* random but also typical incidents are set within the larger frame of London itself. While Hogarth's *Times of Day* are not altogether a celebration of the city, they are far from the systematic disenchantment that moves Juvenal's Umbricius to abandon Rome for ever in favour of peaceful Cumae. For Umbricius Rome is a ruined place, a world in which all virtues are turned upside-down; it is dominated by those of low birth and great pretentions, and by Greeks who pander to them. In Hogarth a sense of the picturesque variety of the urban scene mitigates the evident bleakness of the moral vision.

Hogarth reflects on the broader meaning of his social comedy in the surprising context of his subscription ticket for *A Harlot's Progress* (no. 37), where he playfully shifts to the language of classical allegory, larding the image with Latin tags. This print acts as a kind of framework, or parergon, for our perception of the series, as Peter Wagner has put it, 'to control our vision by putting things into a particular perspective'.[101] Three putti and a faun surround a many-breasted figure of Nature as Diana of

Ephesus, identified mock-portentously by a quote from Virgil: *Antiquam exquirite Matrem* (Seek out your ancient mother [i.e. Nature]).[102] The caption from Horace's *Ars Poetica* implies a justification for the newness of *A Harlot's Progress*:

> But (if you write of things abstruse or new)
> Some of your own inventing may be us'd,
> (So it be seldom and discreetly done)…[103]

The newness of *A Harlot's Progress*, then, requires new methods, but Hogarth asks to be trusted not to go beyond discretion or Horatian moderation in practising them. An artist putto paints the head and breast of Nature on a canvas while another appears to engrave a copperplate, but in the middle a putto fends off a faun seeking to peep under Nature's skirts. The different aspects of the artist, represented by the putti, are devoted to Nature but seek to keep out the prurience represented by the faun and preserve Nature's decency. The allusiveness and wit of this image serve as an introduction and a filter to purchasers of *A Harlot's Progress*, who are by implication warned to take its moral claims seriously, while expecting them to be expressed in a way pleasing to the eye and senses.

The ticket for *A Harlot's Progress* is not the only or even the first time that Hogarth sought to frame his satire in classical terms. His first meditation on the nature of satire is to be found in the complex allegorical frontispiece (no. 30) to his series of twelve plates illustrating Samuel Butler's *Hudibras*, a witty rewriting of *Don Quixote* satirising the Puritans of the seventeenth century. The frontispiece shows a kind of mausoleum with a bas-relief representing a satyr in a chariot, who stands for Butler's genius, lashing Hudibras and Ralph at the front, and Hypocrisy, Ignorance and Rebellion at the back. The bas-relief represents the permanent, eternal nature of folly, while Britannia seeing her face in the mirror held by a faun suggests that the poem is a mirror of Britain in the present time, that the Puritanism Hudibras represents is still with us.

The role of the satyrs in the print might suggest an alternative Greek origin for satire and an implicit rejection of its Roman origins. This would have been an excusable assumption in the period, because satire was normally then spelt 'satyr', so an association with the satyrs of Greek myth, the followers of Dionysus, would have seemed obvious. However, the word 'satire' in modern usage comes not from the Greek but from the Latin word *satura*, meaning a mixture of foods or salad on a platter (*lanx*).[104] This derivation was perfectly well known in Hogarth's time, for it was also asserted in Dryden's *Discourse Concerning the Origin and Progress of Satyr* of 1692, published as an introduction to the much reprinted edition of Juvenal's satires. Dryden remarks that the scholar Scaliger claimed satire's origins to be Greek 'and derives the Word Satyr from Satyrus, that mixt kind of Animal…made up betwixt a Man and a Goat', but notes that the seventeenth-century scholar Isaac Casaubon had settled the matter definitively by discovering its origin in the Roman *satura*.[105]

It might seem a solecism on Hogarth's part to have associated Hudibras with satyrs, but in fact it seems to have been common in the early eighteenth century to make such a connection. Editions of Juvenal with Dryden's introduction published in the 1720s had a frontispiece showing satyrs presiding over Juvenal's Rome, and Hogarth himself, in illustrating Gildon's *New Metamorphosis* (no. 29), an adaptation of Apuleius, in 1724, had adapted the frontispiece from the 1708 edition. It shows two satyrs holding up lintels inscribed Apuleius and Lucian, pointing and grinning archly at an Italian street scene. The suggestion here, and it is confirmed by the satyr in the earlier *Masquerades and Operas* (no. 51)

who leads the revellers towards the masquerade, is that satyrs, as followers of Dionysus, took a sardonic pleasure in human and especially sexual weakness; they are nature, not as Mother, but as unrestrained appetite.

The play between Roman and Greek ideas of satire in the *Hudibras* frontispiece suggests then not etymological confusion but, on the contrary, a sophisticated knowledge on Hogarth's part of satire's meanings and origins. In the *Hudibras* frontispiece the notion of satire as a mirror held up to society by a satyr recalls Horace's account in the *Ars Poetica* of satyrs as brought in by the early Greek playwrights because the 'first Tragedians found that serious Stile To[o] grave for their uncultivated Age'.[106] Later versions of the *Beggar's Opera* paintings (no. 31) carry the tags 'Utile dulci', from Horace's *Ars Poetica* (meaning that to combine usefulness with pleasure is to win the most approbation),[107] and 'Veluti in Speculum' (as if in a mirror).[108] The idea of the mirror as a satirical device is, of course, double-edged. It signifies that satire gives a detached image of society's follies, but it also holds up a mirror to the viewer him- or herself. The phrase 'Veluti in Speculum' on the rim of the curtain implies that the play and its caricatured audience are a reflection of real life, and that viewers of the painting are themselves also open to such scrutiny.

HOGARTH AND
'THE SPIRIT OF PARTY'

UNDER THE ASCENDANCY OF WALPOLE

If in a very broad sense the government of Sir Robert Walpole stood for the interests of trade and the merchant class, and the opposition for those with wealth in land, then it was impossible in Hogarth's period to represent society without raising political issues. To satirise the pretensions of the aristocracy might suggest sympathy with Walpole's government, and to satirise the greed of merchants, sympathy with the opposition, while satirising both would be evidence of a studied neutrality. The tendency of most recent scholarship has been to assume nonetheless that Hogarth's sympathies, at least in the years before the fall of Walpole in 1742, were firmly with the opposition, in the company of other great satirists like Swift and Pope for whom he showed overt admiration, on the reasonable grounds that Walpole's use of bribery and influence was in itself both a sign and a cause of the corruption of society as a whole.

Such a connection between the inadequacies of social behaviour and the influence of Walpole was not, however, a necessary one, and though it was affirmed by the opposition, it was denied by government apologists. If we return to Edward Young's *Love of Fame* of 1725, we can see that the poet's desire to satirise the pursuit of fame by means of a Horatian 'laughing satire' was in reality perfectly compatible with an almost grovelling support of Walpole. Young was a court poet and chaplain to George II, and the seventh of the satires in *Love of Fame* is dedicated to Walpole himself. In brief, the theme concerns the achievements of the court and the role of Walpole as 'the pilot of the realm' in the present happy state, in which the 'arts [are] triumphant in the Royal smile, Her publick wounds bound up, her credit high'.[109] Yet general recognition of this is denied because of 'the madness of ambitious men', who seek fame in all fields and pursue private ends.

According to this logic, a benign ruler cannot change human nature or necessarily command the admiration of all his subjects, many of whom will continue to be worthy subjects of satire. Indeed, Dryden put forward the view in his *Discourse Concerning the Origin and Progress of Satyr* that under a benign polity a satirist was more likely to devote himself to satirising human nature by virtue of the very absence of political grievances. Again Dryden contrasts Horace and Juvenal in this respect; Juvenal was a 'zealous Vindicator of Roman Liberty' while Horace was a 'Well-mannered Court-slave'.[110] Horace as 'a mild admonisher, a Court-Satyrist, [was] fit for the gentle Times of Augustus', while Juvenal lived in a time 'when Oppression was to be scourg'd instead of Avarice'. If Horace avoided political invective because of his position at the court of Augustus, he could claim that there was little need for it. On the other hand, according to Dryden, Juvenal's ferocity was appropriate to his age under the tyranny of Domitian, who directly threatened Roman liberty. Satire, therefore, which concentrated on

human vices like avarice was, Dryden implies, only justifiable in settled times when liberty was not under threat, while tyranny invited more strident and dangerous measures. If this logic is applied to Hogarth, it does not follow that his satiricial vision of society is *ipso facto* critical of Walpole or of the political culture of his day; Hogarth would have been able to devote himself to the excoriating of human vice without necessarily challenging either the government itself or the political system under which he lived. On the other hand, whatever claims to detachment a satirist might make, it was impossible to avoid political implications being read into the work, given the highly charged and cynical political culture of the day.

Hogarth's adult life spanned the years from before the initial ascendancy of Sir Robert Walpole as prime minister in the 1720s to his fall in 1742, and beyond to the 1760s and the turbulent beginnings of the breakup of the order which Walpole had created and which survived him. Walpole's government, in recognition of its dependence on the Crown, was known from the 1720s as the 'Court party',[111] while the 'Country party' was the ideological heir to the Tories who had been out of power since 1711. As is well known, Walpole presided over a period of unusual prosperity and stability by keeping the king, first George I who died in 1727 and then George II, firmly behind him, and by controlling a system of patronage made possible by royal support. In effect, that system of patronage remained in place until the 1760s, leaving the Tories and their allies in the opposition firmly out of power, despite the powerful intellectual and ideological support they were able to gather.

In opposition ideology, defined by writers like Swift, Pope, and Bolingbroke, Walpole's government represented *arrivisme*, the triumph of 'paper credit' and materialism over older and more stable values based on land and lineage. Walpole supposedly ruled over a meretricious and self-seeking urban culture, which had quite destroyed the 'natural' control of men of learning and public spirit, excluding them from office and influence.[112] Court supporters, on the other hand, could look back to Whigs like Addison, who had proclaimed the value and even the beauty of Public Credit in *The Spectator*.[113]

In practice, the boundaries between Court and Country were often blurred; ideology was one thing, 'the spirit of party' another. The opposition, in its political impotence in the face of Walpole's evertightening political control, became in effect defined by the satire it produced in such profusion. Hogarth's satirical prints of the 1720s are suffused with its attitudes and language, and opposition writers on occasions claimed Hogarth as one of their own.[114] His earliest independent print, *The South Sea Scheme* (no. 83) dating from 1721, is a fierce attack on the system of credit and paper money. Walpole is unmistakably the target of the 1728 engraving *Henry VIII and Ann Boleyn* (no. 88) with Cardinal Wolsey looking on in dismay; it was a commonplace of opposition satire to liken Walpole's assumption of royal authority to that of Wolsey, and to look forward hopefully to the day when the king would assert his royal will over his presumptious servant.[115]

It is likely that Hogarth intended the overtly anti-Walpole message of the Henry VIII print to be a sign of identification with the assault, led by Pope and Swift, on the anaemic culture of the court, though in 1728 even they had lingering hopes of court preferment. This was true also of their associate John Gay, and his sensationally successful ballad opera *The Beggar's Opera*, first produced in January 1728. Hogarth chose it as the subject for one of his earliest paintings (fig. 10), and it was universally, though not necessarily correctly, assumed to be a veiled attack on Walpole.[116] With the gentlemanliness of its highwayman-hero Macheath contrasted with the criminality of the lawyer Peachum and the gaoler Lockit, it was at the very least an exposé of the inverted morality of current society.[117]

Fig. 10 William Hogarth, *The Beggar's Opera*, *III*, *xi*, oil on canvas, 1729,
Yale Center for British Art, Paul Mellon Collection, New Haven.

Even so, Hogarth seems not to have been on social terms with the opposition, but he did develop identifiable connections with the Walpole government through his father-in-law, the Serjeant Painter to the King, Sir James Thornhill, whose daughter he married in 1729. He was also involved in a number of portrait commissions to do with the court and government, until he was manoeuvred out of them by the Earl of Burlington in 1735.[118] Thornhill had been elected one of the four Members of Parliament for Weymouth and Melcombe Regis in 1722, and remained in Parliament until his death in 1734. According to Romney Sedgwick, Thornhill 'voted regularly with the government', even supporting Walpole over the Excise Bill of 1733, an extreme test of loyalty.[119] Thornhill's Dorset constituency was of considerable importance to the government because of the local customs service and the Portland quarries; one may surmise that Thornhill was able to gain through Walpole some contribution towards the rebuilding of his ancestral home at Thornhill in Dorset.

This experience would have given Hogarth an intimate knowledge of Walpole's use of patronage, and George Vertue's judgement of him as 'a good Front and a Scheemist'[120] suggests that he was known to have been adroit in exploiting his court connections, without putting off those who detested and were excluded by Walpole. His extensive clientele for portrait groups included prominent members of the government and court, like Walpole's son-in-law Viscount Malpas and Lord Hervey, and city sympathisers with the opposition like Sir Francis Child. There is also evidence, admittedly somewhat partisan,

that Hogarth deliberately distanced himself from the opposition. According to Horace Walpole in his *Anecdotes of Painting*, 'he had all his life avoided dipping his pencil in political contests, and had early refused a very lucrative offer that was made to engage him in a set of prints against the head of a court-party'.[121] In a manuscript note to his own copy of the privately printed edition of 1771 Walpole notes next to that passage: 'Sr Robert Walpole. After Hogarth published *A Harlot's Progress*, the Opposition offerred him a large Subscription, if He woud paint the Progress of a Minister. He refused.'[122]

This lofty attitude can be explained as a desire to distance himself from the 'low' genre of political satire, but it may also have been an astute strategy to ensure that he did not offend potential patrons of either persuasion; the opposition may have been politically impotent but had many wealthy supporters. Even though it has been claimed that both *A Harlot's Progress* and *A Rake's Progress* had an anti-Walpole agenda,[123] it can be argued that they adroitly sidestep any overt political partisanship or 'taint of party', despite the scathing critique of contemporary society. In political terms the story of the Rake could conform to the opposition claim that in these bleak times of commercial dominance a person of acquired wealth and no breeding could find a social apparatus ready and willing to support his social climbing. The Rake's rise rests on the premise that he is able to *buy* his way to an enhanced social status. However, the seeming inevitability of his fall consequent on such presumption could be taken to mean that society does after all retain a self-righting mechanism. If Tories could feel reassured that the Rake would get his come-uppance, then supporters of a commercial society might have found comfort not only in the relish with which Hogarth exposes aristocratic vices but in the idea that even in the city vice is inevitably punished.

However, there is nothing in the Modern Moral Subjects to suggest, nor would one expect there to be in the 1730s, that such vices are *inherent* to aristocratic ascendancy or that all merchants are self-serving parvenus. The aristocrats represented through the Rake's emulation of their vices are the libertine extremities of their social class, the transgressors of their collective ideals. The Rake, in terms of the ideology of civic humanism,[124] unfailingly chooses private interest over public virtue and therefore abdicates the duties of the governing class to which he aspires so foolishly to belong. That he exists at all may suggest the weakness of that governing class, but then even opposition thinkers were mournfully aware that most men of rank did not live up to the ideals upon which their ascendancy was based, just as merchants often abused their claims to honesty and plain-dealing. The miserly father of the Rake, depicted *in absentia* in plate 1 of *A Rake's Progress* (no. 13a), can be seen as an antitype of the honest merchant who, exemplified in *The Spectator*'s Sir Andrew Freeport, contributes directly to the prosperity and improvement of the nation.[125] Similarly the young Earl of Squanderfield in the *Marriage A-la-Mode* series is on a par with Pope's picture of the vulgar aristocrat Timon, and the latter is set against the figure of the Earl of Burlington, who is presented, in the Epistle dedicated to him, as acting with exemplary public spirit but also with reticence and taste.[126]

Hogarth's challenge, then, is not to the social order, which was believed by most social commentators to rest on the assumption that the highest political power was safest in the hands of gentlemen of rank; nor does he challenge the wealth of the prosperous merchant class. In the *Marriage A-la-Mode* paintings of 1743 the tragedy of the young couple stems from a marriage imposed upon them by an extravagant, dissipated and rank-conscious aristocrat living in the West End of London, acting in collusion with a miserly and vulgar merchant who lives in the commercial heart of the city. Absent from these images of high life, but firmly present in their absence, are those great gentlemen who uphold

the social order by earning the respect of their social inferiors, and those merchants who increase the wealth of the nation through honest trading.

While Hogarth's satires of the 1730s and early 1740s make the implicit claim that the morals and manners of society were shameful and getting worse by the day, they do not contain any discernible rejection of Walpole's system of patronage, from which he had, as the son-in-law of the Serjeant Painter to the King, much to hope for; indeed, such reverses as his family had suffered, particularly the virtual destruction of Thornhill's career in the mid-1730s, had come about through the intrigues of opposition supporters like the Earl of Burlington.[127] If it would be an exaggeration to see Hogarth as, in Dryden's description of Horace, a 'court-slave', there is nothing to suggest a Juvenalian sense of disgust at the destructive tyranny of his country's rulers. The influence of Juvenal, in so far as Hogarth would have been conscious of him as a distinctive satirical voice, would have not appeared as an encouragement to see Walpole or George II as a Domitian-like tyrant. His importance for Hogarth was as the originator of a mode of describing and giving meaning to the chaotic life of the streets of a great city.

NATIONAL PAINTER AND PLACEMAN

The 1740s saw Hogarth emerge as a self-consciously English artist, and in this he reflects the emergence of opposition 'patriotism' and its eventual adoption by all political interests. Nationalism can rest as much on a nation's presumed difference from others as on a claim of special virtues.[128] In Hogarth's satirical works before about 1740, and this would be true of others in the period, a sense of Englishness tended to reside primarily in a xenophobic representation of the foreign, which was by implication unnatural and invasive. In *Masquerades and Operas* (no. 51) of 1724 the meretricious arts and entertainments of London are attributed to a taste for foreign things, while native virtue is represented only by the names of English playwrights whose works are being carted off as waste paper. In Gay's *Beggar's Opera* Italian opera, with its highly paid castrati, air of sexual ambiguity and fashionability, is satirised by contrasting it with the plain-speaking manliness of Captain Macheath, the play's demotic language of feeling, and the appealing simplicity of its music.[129]

Though the Harlot and the Rake do follow foreign ways, the former in her acquired taste for fine clothes and masquerades, and the latter in his employment of a French dancing master and a composer of Italian operas, these are incidental attributes. By contrast the *Marriage A-la-Mode* series of the early 1740s brings art and taste to the fore. The old and young Earl are not parvenus, though they are, like Pope's Timon, vulgar and pretentious in their tastes. The young Earl Squanderfield is, as his name suggests, a rakish spendthrift, but he is also a gentleman of rank. He aspires to be a 'man of taste' in letter if not in spirit, and lives, like his father, in a house in a fashionable Italianate taste, filling it with doubtful antiquities of all kinds, and paintings of questionable taste and propriety.

The character of the young Earl can find parallels in the satirical literature of the 1730s and 1740s, where there emerges a new kind of rake, who may pursue idle pleasure and go to brothels, but who is primarily defined by cultural pretentions, often acquired on the Grand Tour. Like Hogarth's Rake, James Bramston's narrator in *The Man of Taste, Occasion'd by an Epistle of Mr Pope's On that Subject* of 1733 lacks breeeding. He has 'a taste for buildings, musick, men' and freely expresses glib and ignorant opinions on architecture:

Sure wretched Wren was taught by bungling Jones,

To murder mortar, and disfigure stones!

Who in Whitehall can symmetry discern?

I reckon Convent-garden Church a Barn.

Nor hate I less thy vile Cathedral, Paul!

The choir's too big, the cupola's too small.[130]

Bramston's man of taste is, however, essentially a creation of sophisticated circles sympathetic to the Earl of Burlington; he is a provincial who despises those who have gone abroad, and revels in his narrow-mindedness. The rake in James Miller's *Of Politeness* of 1738, on the other hand, has, like Horace Walpole, been to Eton before going on the Grand Tour to bring back the spoils of Italy:

Once more by Goths poor Rome is spoil'd,

High! Mountain high! the pretious Plunder pil'd.

Coins so antique, so very rusty grown,

That neither Stamp, nor Metal could be known;

Such curious Manuscripts as ne'er were seen,

you could not guess what Language they were in;

Bustoes that each a Nose or Chin had lost,

And Paintings of much Worth, for much they cost.[131]

This transformation of the rake into a man of taste can be seen to parallel a larger turn in Hogarth's thought and practice in the 1740s. In broad terms simple contrasts of virtue and vice give way in the *Marriage A-la-Mode* series (though not, of course, in the series directed towards the common people like *Industry and Idleness* and *The Stages of Cruelty*) to the interplay between authenticity and affectation, and Englishness and foreignness. Vice still invites retribution, but the relatively crude 'wages of sin' model in the Harlot's and Rake's Progresses is refined into a more nuanced and more tragic view of the path from prosperity to ignominious end. Though the Grand Tourists and later visitors to Italy known as 'Macaronis' remained an object of satire in England into the 1770s, the 'other' was increasingly perceived as French rather than Italian. The notion of the French as a 'nation', presenting a threat to England's prosperity as well as to its morals, contributed also to the more general and positive notion of Englishness which began to emerge in the 1740s. In *Noon* (no. 40b) from the *Times of Day* series of 1738 a ditch divides the pictorial field into a left 'English' half with a riotous tavern and a right 'French' half with an elegantly dressed Huguenot congregation greeting each other after a service. The English half is seen not with affection but as a kind of correlative of the Rake: disorderly, lustful, greedy and drunken. The French half, by contrast, is absurdly controlled and formal, filled with affectation and concern with appearances. Neither side has achieved true Horatian balance; the English behave without restraint, while the French and their children are imprisoned within a painful and restrictive formality.

One might argue from this example that the English are more 'natural' than the French, but it is impossible to read any kind of heroism in the scene, any more than there is in *Southwark Fair* (no. 68) of 1734. In the 1740s, however, Hogarth's paintings and engravings on occasions show the influence of the new 'Patriot' ideology in shifting the defining social model for current society from republican or

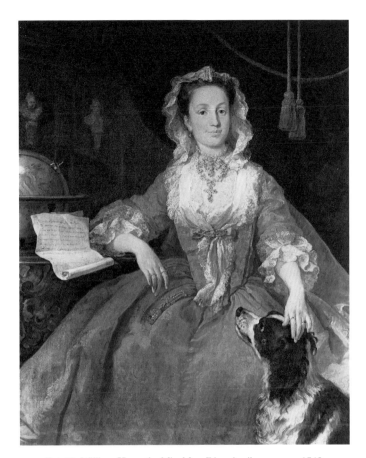

FIG.11 William Hogarth, *Miss Mary Edwards*, oil on canvas, 1742,
The Frick Collection, New York.

Augustan Rome to the age of Elizabeth 1 and Shakespeare.[132] Viscount Bolingbroke, a survivor from the last Tory government, had claimed in historical works that Elizabethan England had represented the golden age of English liberty, when culture flourished under a benevolent and patriotic monarch, surrounded by a court of public-spirited gentlemen.[133] This was given a particular edge by the deterioration of relations with Spain in the late 1730s and Walpole's insistence on a policy of peace. Elizabeth I, by implied contrast, had been resolute in the defence of the country, confronting the Spanish Armada head on and destroying it.

Such neo-Elizabethan ideals are unmistakeably present in Hogarth's grand portrait of Miss Mary Edwards of 1742 (fig. 11). She is depicted, with busts of Queen Elizabeth and King Alfred in the background, reading from Elizabeth's defiant address to the English troops as they went out to fight the Spaniards at Tilbury:

> Remember Englishmen the Laws the Rights The generous plan of power deliver'd down from age to age by your renown'd Forefathers So dearly bought the price of so much contest Transmit it carefully to Posterity Do thou great Liberty inspire their Souls And make their lives in thy possession happy or die glorious in thy Just defence.

Though the painting's iconography probably owed more to the patron's desires than to the painter, it confirms Hogarth's familiarity with Patriot ideology, but then Walpole's government was becoming

increasingly embattled in the years before its final fall in 1742, and there were ever fewer to support it. The threat of a Scottish invasion in 1745 also encouraged defiant displays of patriotism, and it is surely significant that the great self-portrait painting, *The Painter and his Pug* (Tate Gallery), should be dated to the same year. Hogarth rests his fictive portrait on volumes by great English authors, Shakespeare, Milton and Swift, though he omitted these names in the engraving (no. 23). In fact, only the last could be considered a major influence on his work to date, so his claim to an exclusively English literary ancestry should be treated as little more than patriotic rhetoric.[134]

The fall of Walpole in 1742 and the advent of the Pelhams as prime ministers did little at first to change the system of patronage; too many beneficiaries had too much at stake to wish to destroy it. To a large extent the king's support for Walpole and his successors had been dependent upon the Jacobite threat, and the belief that Tories were not committed to the Hanoverian succession. For Hogarth the defeat of the Scots in the 1745 Rebellion was undeniably a national triumph, and plate 6 of *Industry and Idleness* (no. 58) of 1747, by including the viciously anti-Catholic inscription on the Monument, expresses a sense of the '45 as the triumph of Protestant solidarity over 'the treachery of the Popish Faction'. Yet the victory had been perceived as a close-run thing, and the fact that London had been at one point under threat from the army of rebels remained an issue, particularly in the relative political turbulence of the late 1740s.

Such thoughts plainly lay behind the painting and the print of *The March to Finchley* of 1750 (no. 72), which may be seen as the first of his major compositions to address the state of the nation. At one level it is a comic work, shaking its head at the depravity of the common people and the chaos of city life. The signs of political engagement are, however, unavoidable, from the dedication on the print to the King of Prussia to the dim soldier torn between two women in the foreground, and the more orderly troops in the background. Though the events in the painting and the print are displaced to a precise historical moment, some five years before in 1745, the current issue was the real one of army discipline within the broader context of the moral health of the nation. The Duke of Cumberland, the third son of George II and victor of Culloden, was notoriously a believer in imposing Prussian discipline on the British army, especially in the light of military defeats subsequent to the '45. The foreground shambles of drunken and undisciplined soldiery contrasts with the well-drilled troops in the middle distance, ready to go forward to defend the approaches to the city.

The main issues appear to be crystallised in the central group, in which a grenadier, standing indecisively and hopelessly, is presented with a dilemma by two women entreating him on either side. He appears to be a representative citizen, a John Bull figure, whose dilemma is also his country's. On his right the young pregnant woman, an ideal Hogarthian beauty, seems to represent the way of patriotism and loyalty to the king (and perhaps nature), for she carries in her basket a print of the Duke of Cumberland and a ballad 'God save our Noble King'. The woman on the right, on the other hand, is a vicious hag with a crucifix, threatening the soldier with a copy of the anti-Cumberland newspaper, *The Remembrancer, or, A Weekly Slap on the Face for the Ministry*. She is evidently a newspaper seller, and she carries an anti-Jacobite paper, *The Jacobite's Journal*, and the pro-Jacobite *London Evening Post*, as well as the *The Remembrancer*. The political variety of these newspapers suggests that she stands for factional journalism, which, as John Brewer has argued, emerged as a radical and unruly force in favour of reform well before popular political movements came into being in the 1760s.[135] Hogarth's apparent demonisation of the political press and elevation of the Duke of Cumberland, and the dedication to

the King of Prussia, suggest that he is siding with those who believed that faction was weakening national resolution and that 'Prussian' discipline was necessary to restore it.[136] It is possible that, as Jean André Rouquet, the contemporary Hogarth commentator, suggested with some irony, Hogarth has some sympathy with the disorderly rabble, seeing the well-drilled soldiers as slaves, noting that 'ce qui s'apelle license par tout ailleurs s'arroge ici l'auguste nom de liberté' (what would be called licence by everybody else goes here under the august name of freedom).[137] What is unavoidable, however, is the implicit claim of the painting to provide an anatomy of the nation, and as such it foreshadows the Election series and also the alternative views of the nation as *Beer Street* or *Gin Lane* (no. 81).

National themes are also at the forefront of Hogarth's series of four paintings and prints of an election (nos 98a–d) of 1754–8. The series might seem to be primarily a rejection of 'the spirit of party' and 'faction', but, looked at in a 'national' perspective, this is clearly an oversimplification. Certainly Whig and Tory are represented as equally corrupt, and their opposition to each other is reduced to petty squabbling and crude opportunism, with each party bribing the deeply degraded common people. In *Canvassing for Votes* (no. 98b) the state of the nation is represented by two inns, one Tory and the other Whig, whose publicans seek to bribe a cunning farmer who takes money from both. Sitting apart from the political mêlée, two old sailors relive the great naval triumph of Porto Bello in 1739. We can read this scene in national terms as meaning that the nation is sunk in the mire of party politics, and patriotism is thereby reduced to nostalgia and the replaying of old victories. The young farmer can thus be seen to be a representative Englishman, a John Bull figure like the hapless grenadier in *The March to Finchley*, reduced by party politics to gleeful corruption, pocketing money from both sides and consigning national glory to the reminiscences of old men.

The note of national anxiety is picked up in the third scene, *The Polling* (no. 98c), where, in a rare excursus into allegorical imagery, Hogarth shows in the background a coach containing a figure of Britannia; the coach is becoming detached and is about to overturn, but the coachman and footman (the contending parties?) are too absorbed in their game of cards to hear Britannia's cry. Though the Election series refers in some detail to the 1754 general election and the campaign for Oxfordshire, the first held there since 1710, it is nonetheless surprising that Hogarth should focus on electoral corruption as emblematic of the nation, for such contests were in steep decline and had been under Walpole and the succeeding government; by 1754 it was not at all common for parliamentary seats to be contested. In 1705 65 per cent of counties went to the poll; by 1747 only 7.5 per cent did so.[138] Nor had it been realistic for many years to think of the country's divisions in the simple terms of Whig and Tory, given that the Tories had not been the governing party since 1711. The election for 'Guzzledown' (a name used by Fielding in a play which formed part of *Pasquin* of 1736; see no. 95) is probably meant to be seen from a historical distance or even as a dramatic fiction, but also, like the *March to Finchley*, as a kind of allegory of contemporary national politics.

It is also surprising at first that each of the Election prints should be dedicated to a Member of Parliament or a holder of high office. If the series is an attack on the 'spirit of party' and faction, then surely to dedicate it to elected representatives and placemen, members of the 'Old Corps' of Whigs, must have been intended ironically? Three of the four – Henry Fox, Sir Charles Hanbury Williams and Sir Edward Walpole – were, after all, closely associated with Sir Robert Walpole as either active politicians or placemen, while the fourth, George Hay, was a Commissioner of the Admiralty, a highly political if not elected office. We might on the other hand assume, from 'the plague on both your

houses' viewpoint in the series, that Hogarth is following opposition ideology, and certainly, on the face of it, the appalling behaviour and corruption of the Guzzletown election does seem to illustrate the idea expressed in Bolingbroke's *Letters on the Spirit of Patriotism*, published in 1749 but written some years before, that 'party is a political evil, and faction is the worst of all parties'.[139] Bolingbroke argues for an end to opposing parties in favour of a 'Patriot King' to transcend factionalism, as the great British monarchs Alfred and Elizabeth 1 had done before him.

The answer is probably that Hogarth did not see 'the spirit of party' or faction in the conduct of government or in the old Walpolian system of patronage, but in the squabbles of the press and the ideological in-fighting that had broken out among the Whigs in the later 1750s. While Bolingbroke had Walpole and the Old Corps in mind as the fomentors of faction, Hogarth may have seen the politicians who ran the machine that Walpole had created as the guarantors of stability and royal authority against the faction and the propaganda that was threatening to destroy it. He could have seen what remained of the Walpole system in the late 1750s, with the court supported by experienced and worldly politicians, as upholding an ideal of national unity that would enable national regeneration to emerge, perhaps under the future king, George III, who came to the throne in 1760.

It seems then that Hogarth, at least in his later years, was not opposed to the prevailing system of patronage; on the contrary, he was happy to become part of it with his appointment in 1758 as Serjeant Painter to the King in succession to his brother-in-law John Thornhill, who had succeeded his father Sir James Thornhill, and he proudly proclaimed his title in the late self-portrait print (no. 126) published in the same year. His relationship with the dedicatees of the Election series was in any case a cordial one, and three of the four are known to have commissioned portraits from him, as did the Lord Chamberlain, the Duke of Devonshire. The problem for Hogarth and his well-placed friends and patrons was that on his accession in 1760 George III no longer saw the Old Corps as his natural supporters against the Tories as his father had done, because, among other things, the Jacobite threat had receded. As a keen royalist with high hopes of George III as a redeemer of the arts in England[140] and scourge of the 'Connoisseurs' (see p. 53), Hogarth found himself in the predicament of supporting the king's favourite, the Earl of Bute, against the popular figure of William Pitt. This clearly separated him from those of the Old Corps who detested and were threatened by Bute, but it also brought him up against the 'new politics' not only of William Pitt but of the populist John Wilkes who sought to reform or destroy the Walpolian system by appealing to people outside the political elite. The enmity of Wilkes and his friends not only exposed Hogarth to ridicule and vicious satire, which he loathed, it also put into question his moral position as a placeman. Being Serjeant Painter to the King, in distant succession to his father-in-law, was no longer a position of respect near the pinnacle of a stable national orde; it was now tainted with the very kind of factional politics and invective he had satirised so strongly in paintings and prints. The emendations that he made to his own face and the title in the self-portrait print, *Wm. Hogarth Serjeant Painter to His Majesty* (nos 126a–c), are not just the tragic traces of a disturbed psyche, they are also an expression of a deep sense of political failure. In his last and deeply pessimistic print, *The Bathos* (no. 129), nature is bankrupt, but the institutions of state have also failed him, and a broken crown lies among the debris with all the other vain repositories of hope.

CHAPTER FIVE

DISENCHANTMENT:
HOGARTH, GOD AND SCIENCE

There is nothing to suggest, despite Hogarth's at times uncontainable irascibility, that he was a man of extreme views, even at the end of his life. His attitudes to religion and science, and the company he kept, place him firmly on the side of what can be called the English Enlightenment,[141] among those who saw the dramatic developments in the science of mankind as providing the possibility of reconciling as never before the material world with the divine. There is no contradiction in the fact that throughout his career Hogarth was on close terms with clergymen in good standing in the Church of England. Some, like Bishop Hoadly and Dr Thomas Morell, became close friends, and he consulted others on matters to do with his moral series. The Rev. Dr John Hoadly, the son of the bishop, wrote the verse commentaries under the *Rake's Progress* engravings, and the Rev. Arnold King chose the Biblical quotations under the *Industry and Idleness* plates.[142] These associations give weight to the seriousness of Hogarth's moral concerns; they also suggest a desire for respectability.

Dr Thomas Morell (1703–84), a clergyman who produced libretti for Handel and a Greek thesaurus, for which Hogarth designed the frontispiece, was, according to Lord Lyttelton, an 'acute critic and profound grammarian…impelled rather by love of science, than the desire of gain',[143] a classic example of the kind of Latitudinarian clergyman who was at home, though not always uncritically, with the new intellectual and theological world created by John Locke and Sir Isaac Newton. Morell had been responsible in the mid-1730s for tutoring Caroline von Anspach, the intellectually engaged wife of George II, and helping her with her famous grotto in Richmond Park, a retreat which contained busts of clergymen and thinkers.[144] He annotated Locke's *Essay Concerning Human Understanding* for her,[145] and his commentary is explanatory but also highlights ways in which Locke might be 'corrected' by playing down some of his explicit challenges to Christian orthodoxy.

Bishop Hoadly had been a vigorous controversialist, at the rational end of the Church of England spectrum: a fervent Newtonian, a proponent of good works and upholder of the royal prerogative in relation to the Church.[146] His association with Queen Caroline ensured steady preferment, and he became Bishop of Winchester in 1734 and Prelate of the Order of the Garter in 1738, both of which are alluded to in Hogarth's majestic portrait of 1741 (fig. 12). Hoadly's open rationalism led to the frequent accusation of Deism or the denial of the metaphysical dimensions of Christianity, but this was a common accusation levelled at those in the period who followed Newton in believing that God revealed himself in the wonder of creation. Hogarth's rigorous exclusion of the metaphysical in his moral series and in *The Analysis of Beauty*, published in 1753, does not mean, therefore, that he was thereby rejecting Anglican orthodoxy.[147]

Hogarth's circle in the 1750s was made up of both clergymen and scientists, who were united by a belief in Natural Religion,[148] the belief that science was the study of God's revelation in creation and that Newton had strengthened the Christian faith by revealing the awe-inspiring wonders of the universe. Though these were conventional beliefs in the Church of England of the time, from the late 1730s they had come under increasing challenge within the Church from the Methodist proclamation of new birth and the supremacy of faith over works.[149] In the 1740s and 1750s Hogarth tended to

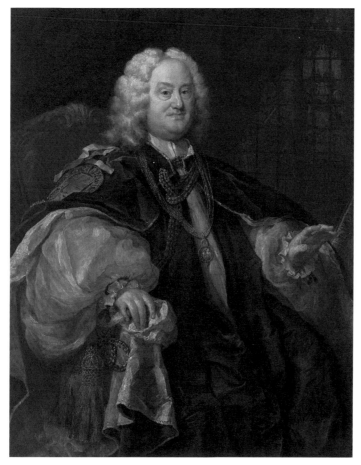

FIG. 12 William Hogarth, *Benjamin Hoadly, Bishop of Winchester,*
oil on canvas, 1741, Tate Gallery, London.

move away from conventional representations of dissolute clergy, like the vicar of Marylebone Church in *A Rake's Progress*, plate 5, to focus on the dangers of 'Enthusiasm' represented by Methodists. *Enthusiasm Delineated* of *c.* 1761 (no. 66) was dedicated to the Archbishop of Canterbury, and the reworked version of the following year, titled *Credulity, Superstition and Fanaticism* (no. 67), shows Hogarth in effect challenging the avant-garde of the Church of England in the name of the older order which distrusted the new emotionalism and populism of Wesley and Whitefield.

The Analysis of Beauty as an enquiry into the physical world, and as an attempt to define beauty on an empirical rather than metaphysical basis, was entirely compatible with the theology of Natural Religion. According to the preface, Hogarth was 'particularly indebted to one gentleman for his

corrections and amendment of at least a third part of the wording'.[150] This was certainly Morell, and the presence of his handwriting in the drafts for the *Analysis* in the British Library supports Hogarth's estimate of his contribution.

The following discussion will seek briefly to place the *Analysis* within the context of a number of long-standing debates. The insistence on the principle of variety, as opposed to unity and proportion, was an important rejection of traditional academic principles, but even more fundamental were Hogarth's views on the question of authority in matters of taste. The Earl of Shaftesbury, writing in 1711,[151] assumed taste to be synonymous with virtue and a defining attribute of the gentleman. The cultivated landowning amateur, the 'Connoisseur', was implicitly to be the ultimate arbiter of, say, Raphael's stature and, later, as the art market developed, to be the judge of whether a particular painting was *by* Raphael or not. Hogarth had been a pioneer in challenging the supremacy of the Connoisseurs on the grounds of their lack of expertise as artists, and Hogarth in the *Analysis* specifically dissociates himself from amateur theorists. Gentleman investigating beauty are, he claims, bound to fall back on 'discoursing of effects instead of developing causes' because 'it actually requires a practical knowledge of the whole art of painting…and that too to some degree of eminence, in order to enable any one to pursue the chain of this enquiry through all its parts'.[152]

'Those ingenious gentlemen' who have written treatises on beauty have, as Hogarth observes, tended to consider it in terms of the 'more beaten path of moral beauty'. Hogarth, on the other hand, detaches the issue of beauty from morality in order to ground it in human perception. His treatise is concerned to explain the workings of beauty by reference to fixed principles based on precept and observation. These principles are discussed empirically without any reference to the higher ends of art, or its didactic aims, though they obviously do not preclude such aims. In making an explicit separation between beauty and morality Hogarth appears to take an extreme position in the aesthetic debates of the period, though his phenomenological stance was possibly a way of avoiding issues which bothered connoisseurs more than artists. The *Analysis* conspicuously avoids the claim of the treatise on beauty most recently published before it, Joseph Spence's *Crito* of 1751, that in some sense 'Virtue is the supreme Beauty'.[153] Nor does Hogarth take a position on the vexing problem of the beautiful woman who is not virtuous, or the virtuous but ugly sage. Yet there are clear enough signs in Hogarth's art of the period, for example the brutalised physiognomy of Tom Idle contrasted with the regularity of Francis Goodchild's features in *Industry and Idleness*, to suggest that the relationship between virtue and beauty, and especially between vice and ugliness, was in other contexts an issue to him.

The Analysis of Beauty is Lockeian in basing its arguments not on the authority of the past but on observation and rational enquiry into the workings of the human mind. The beauty which Hogarth seeks to analyse is demystified and Hogarth condemns all previous writers for assuming it to be ultimately inexplicable. Hogarth's treatise, then, is based on what Max Weber called 'the disenchantment of the world',[154] the belief that the world works in ways that are subject to rational explanation, without the need for the assumption of divine mystery or, in aesthetic terms, what Hogarth calls the 'Je ne scai quoi'.[155] Beauty can be explained not by reference to the Creation or to the untainted beauty of the Garden of Eden, but by enquiry into the principles that can be derived from observation and the application of knowledge and experience. This knowledge and experience are not the province of the learned or virtuous, but of the common perceptions of mankind. In Lockeian terms the perception of beauty is part of the world of sensation and not a privileged form of knowledge.

Hogarth's much challenged and caricatured premise in the *Analysis* that 'Beauty' and 'Grace' are always dependent on a waving line is grounded in remarks made by authorities like Michelangelo and Lomazzo, but the 'Line of Beauty' derives its ultimate authority not from tradition or from divine dispensation but from its observable properties: 'Fitness', 'Variety', 'Uniformity', 'Simplicity', 'Intricacy' and 'Quantity'. Though such an argument is post-Lockeian, it does not require Hogarth to have been thoroughly steeped in Locke. He is best thought of as, in Michael Baxandall's sense, a 'vulgar Lockeian',[156] who is unlikely to have done more than absorb, perhaps at second hand, those parts of Books I and II of *An Essay Concerning Human Understanding* which deal with the psychology of perception.

In Chapter XII of Hogarth's *Analysis*, on 'Light and Shade', there is a clear reference to 'Molyneux's problem'.[157] Locke had argued that we would perceive a globe of uniform colour as a flat surface, had experience not enabled us to see its convexity;[158] in other words, we have no innate tendency to see it in the round but have learned to do so. William Molyneux, a Dublin philosopher, raised the question of whether a blind man, used to distinguishing shape by touch, would, on suddenly regaining his sight, be able to perceive the globe in the round or not. Locke and Molyneux thought he would not, but Hogarth argued that the blind man's ability to distinguish by touch would help him to see the difference between the two forms.[159] Here Hogarth seems to be picking up from Morell's observation that there might be a connection between the sense of touch and visual perception: 'Quaere, ...whether there be not constituted in nature a necessary connexion between a certain motion upon the organ of touch, and a certain perception, and a certain figure at the bottom of the eye, and the same perception[?]'[160] In other comments on Locke Morell showed, along with many in the Church of England, a consciousness of the threat Locke's rejection of authority might present to institutional religion, and the dangers in the idea that 'there are no truths but what are acquired'. He is particularly disturbed by Locke's suggestion that there is no foundation in human nature, i.e. before sense impressions take hold, for distinguishing between virtue and vice, which he believes to have been bestowed on mankind by the 'Author of Nature'.[161]

Hogarth's emphasis in the *Analysis* on line in the Line of Beauty (see no. 99) *ipso facto* sets it apart from theories of beauty based on the ideal proportions of the human body or on mathematical proportion. This was in Hogarth's mind from the beginning; Vertue noted as early as 1745 that 'Hogarth (in opposition to Hussey. scheem of Triangles.) much comments on the inimitable curve or beauty of the S undulating motion line, admired and inimitable in the antient great Sculptors and painters.'[162] This refers to the painter Giles Hussey, who had spent time in Italy measuring ancient statues and claimed that they were based on proportions determined by 'an Harmonical Scale'.[163] The Line of Beauty was, therefore, a direct challenge to the mystical properties of number which gave a metaphysical justification for the supremacy of ancient art.[164]

Though the Line of Beauty is applied to all forms from the human body to chair legs, Hogarth claims that, by contrast with the Connoisseurs, his theory is based on the observation of nature rather than art, with the human figure as the primary focus, as it is in all eighteenth-century aesthetic theories. But there remains the important choice as to whether the male or the female body was the locus of the highest expression of beauty. Broadly speaking, the eighteenth century saw a progressive shift away from defining beauty according to the male figure and its proportions towards associating beauty with the female, eventually reserving sublimity or more active qualities for the male.[165] Hogarth certainly allows for the possibility of male beauty, seeing its highest expression in the canonical Roman

sculpture of Hadrian's Antinous, but it conforms less naturally than female beauty to the idea of the Line of Beauty; the Serpentine Line 'will always give the turn of the female frame, represented in the Venus, in preference to that of the Apollo'.[166] If female beauty is superior to the male, then the beauty of real females is plainly superior to the antique, as nature is superior to culture: 'Who but a bigot, even to the antiques, will say that he has not seen faces and necks, hands and arms in living women, that even the Grecian Venus doth but coarsely imitate?'[167] Though the development towards the association of the male with sublimity rather than beauty was not a consistent one – Winckelmann was soon to try to reclaim the male body for beauty[168] – Hogarth broadly stands on the cusp of the development towards the near-exclusive association of beauty with the female body.[169]

FIG. 13 William Hogarth, *Analysis of Beauty, plate 2, fig. 71,* etching and engraving, 1753, British Museum.

The play in the *Marriage A-la-Mode* series between curved and straight lines in the figures and their interconnections, suggests that the idea of the Line of Beauty was partly a response to the problem of finding a visual language to express the relationship between elegance and vice in the depiction of individuals. Thus the old Earl and his reprobate son attempt elegance, but this is belied visually by deviation from the Line of Beauty. In the first scene, *The Marriage Contract* (no. 47), the old Earl's elegant and disdainful attitude is broken by the gouty leg which sticks out straight, and his son's overdressed self-regard is undermined by the diamond shape formed by his legs. This notion of a line which can be expressive of a whole figure or a group of people, as well as parts of the body and inanimate objects, is clearly related to Hogarth's much vaunted shorthand method of memorising the poses and shapes of people observed in the street by reducing them to a few lines.[170] This is made explicit in plate 2, fig. 71 (fig. 13 above), of the accompanying plates to the *Analysis* (no. 100b), where the figures in *The Country Dance* are reduced to tiny ideograms, the ideal couple on the left represented by lines of beauty, while all the other dancers represent deviations from it.

Line, then, was for Hogarth not only a means of defining contour but also a kind of irreducible essence which could prompt memory into reconstituting the whole figure. The Line of Beauty itself is essentially a median form, at the point of balance between full curvilinearity and straightness. Though Hogarth explicitly dissociates his treatise from a concern with 'moral beauty', the Line of Beauty is nonetheless moral in the sense that it expresses the idea that there is a virtuous balance to be achieved between what we might see as the excessive display implicit in the curvilinear and the excessive self-effacement implicit in straightness. The elegant figures at the far left of *The Country*

Dance in *Analysis* plate 2 fall 'naturally' into the Line of Beauty because they have achieved a perfect balance in their own lives between display and reticence, and their graceful manners are visibly appropriate to their elevated station in life. All the others, whether the country people on the floor or the kings and grandees in the paintings on the wall, fall short of the grace which comes from internal harmony.

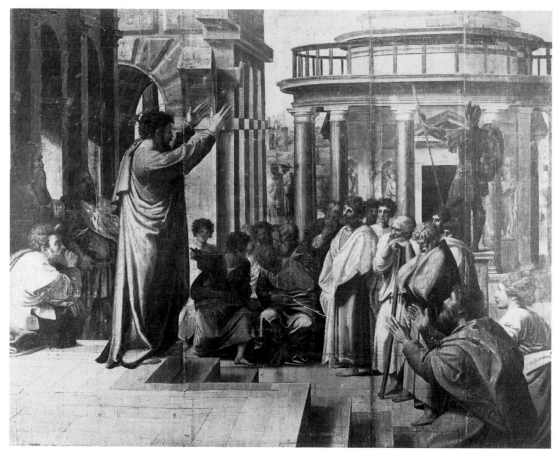

FIG. 14 Raphael, *St Paul Preaching in Athens*, tapestry cartoon, 1515–16,
Victoria and Albert Museum, London, on loan from Her Majesty the Queen.

The critical reception of the *Analysis* was inevitably mixed. There were respectful reviews, and among serious theorists Edmund Burke referred to it as an authority for his own work.[171] Objections tended to focus upon Hogarth's claim that the Line of Beauty was a universal and inalienable property of beauty, and its corollary that all deviations from it could not be regarded as beautiful. Paul Sandby wittily applied the Line of Beauty in his caricatures to unlikely objects, like a hunchback's hump (no. 109), but the most cogent objections came from Joshua Reynolds in his essays in 'The Idler' in 1759. Reynolds puts Hogarth's point of view, as we have seen, in the mouth of the bumptious 'Critick' recently returned from Italy, who 'judges by narrow rules, and those too often false'.[172] Hogarth's idea of the Line of Beauty is thus presented as a kind of wrong-headed academicism, which leads him to look condescendingly even upon Raphael. Discussing *St Paul Preaching in Athens* (fig. 14), the 'Critick' applies the Line of Beauty to demonstrate that Raphael was ignorant of the true principles of beauty:

What nobleness, what dignity, there is in that figure of St. Paul! and yet what an addition to that nobleness could Raffaele have given, had the art of contrast been known in his time! but, above all, the flowing line which constitutes grace and beauty! You would not have then seen an upright figure standing equally on both legs, and both hands stretched forward in the same direction.[173]

In the discussion about Raphael's 'Charge to Peter' (*Christ Handing the Keys to St Peter)* the 'Critick' refers to Hogarth's belief in the relationship between the Line of Beauty and the pyramid on the title page of the *Analysis*, exclaiming, 'What a pity it is that Raffaele was not acquainted with the pyramidical principle!'[174]

In the final 'Idler' paper of 10 November 1759 Reynolds takes on Hogarth's vesting of the principle of beauty in nature in 'an invariable general form', against which everything else we see is a deformity. Reynolds argues that the perception of beauty proceeds not, as Hogarth claims, from a notion of certain forms which are inherently beautiful, but from the association of ideas:

> He who gives preference to the dove [over a swan], does it from some association of ideas of innocence that he always annexes to the dove; but, if he pretends to defend the preference he gives to one or the other by endeavouring to prove that this more beautiful form proceeds from a particular gradation of magnitude, undulation of a curve, or direction of line...he will be continually contradicting himself, and find at last that the great Mother of Nature will not be subjected to such narrow rules.[175]

Hogarth undoubtedly left himself open to criticism by the dogmatism of his insistence on the aesthetic properties of his Line of Beauty, but this does not detract from the importance or originality of his theory. *The Analysis of Beauty*, as Hogarth well understood, was not meant to be prescriptive, but was intended to provide some of the intellectual foundations for a different kind of British School, to be based predominantly on the painting of contemporary life, with a clear sense of moral purpose, allowing for comedy as well as tragedy. In the end, as we have seen (see p. 00), the cosmopolitan forces of the Academy prevailed, and 'Hogarthianism' was institutionally marginalised, but it lived on in visual satire and as a popular force, to rise again in the next century.

If there is a common theme running through all Hogarth's varied activities, from painting and printmaking to the theory of beauty, it is the search for a middle way between extremes: the fear of excess in life and in art. In moral and religious terms Puritanism and libertinism were anathema to him, as were Deism and Methodist Enthusiasm. In aesthetic terms he sought neither the high style as exemplified by Raphael (except perhaps to demonstrate that he could do it if he were so minded) nor what he considered to be the banal vulgarity of the Dutch. The ideal of beauty was a line that was neither too curved nor too straight. However, despite his moderation of purpose, his temperament was anything but moderate. He has often been misunderstood during his own later years and after his death, because the nature of his role as a satirist in the particular period and milieu in which he lived required him to pillory vice rather than display virtue, as writers and artists like Samuel Richardson and Joseph Highmore, and others of the following generation, were to do. As a consequence, and perhaps it is the eternal fate of the true satirist, what he stood for and what he hoped to bring about exist primarily, and perhaps can only exist, in their absence.

HOGARTHOMANIA AND THE COLLECTING OF HOGARTH

SHEILA O'CONNELL

On 18 June 1781 Edmund Malone, the Shakespeare scholar and member of the Dr Johnson circle, wrote from London to the Earl of Charlemont in Dublin:

People here are all seized at present with an Hogarthomania. How have you escaped at the other side of the water? Mr Walpole's book [*Anecdotes of Painting in England*] first gave rise to it, and a new life of Hogarth [John Nichols, *Biographical Anecdotes of William Hogarth*] that is just published will probably greatly add to the disorder. Some small prints of his that were originally sold for a shilling now sell for fifteen and twenty, either as first impressions or because they contain some slight variations.[176]

Charlemont, replying on 29 June 1781, turned out to be suffering from 'Hogarthomania' himself:

That men of taste should wish for good impressions of Hogarth's prints is not at all surprising, and I look upon him to have been, in his way, and that too an original way, one of the first of geniuses, neither am I much surprised at the rage you mention, as I am, by experience, well acquainted with the collectors' madness.[177]

The starting point for the great, late eighteenth- and early nineteenth-century boom in Hogarth collecting was, then, the catalogues that provided supposedly complete check-lists for collectors. The rage for Hogarth coincided with the English taste for collecting historical portraits encouraged by catalogues produced by James Granger and Henry Bromley;[178] collectors pursued rare prints with an obsession that drove prices rapidly upwards. Among those who collected both English portraits and Hogarth was Joseph Gulston (fig. 15), who spent most of an inheritance of £250,000 'in the funds' and an estate worth £1,500 a year on acquiring a collection of over 70,000 prints. Before he reached the age of forty he was obliged to sell up. His sale at the beginning of 1786 lasted forty days and included 4,440 lots.[179]

John Nichols gave the credit for the catalogue published with his *Biographical Anecdotes* to the Shakespeare scholar George Steevens, reputed to be 'the wisest, most learned, but most spiteful of men', who had amassed a definitive collection of Hogarth's prints: 'a complete set of the first and best impressions of all his plates, but also the last and worst of the retouched ones, by way of contrast, to show at the same time all the varieties, and to set the value of the former in a more conspicuous light'.[180] Juvenilia and rare states usually fetched higher prices at auction than mature finished works in

good condition. It is possible that Hogarth deliberately encouraged the collecting of his own rarities: he introduced into an intermediate state of the subscription ticket for *Paul before Felix* (see no. 27b) a tiny devil sawing the leg of the stool on which St Paul stands, and he removed the lion's teeth in later states of *Canvassing for Votes* (no. 98b). The collector Ingham Foster annotated an impression of the *Paul before Felix* ticket with the opinion that Hogarth 'glances at Collectrs who give great Prices for such

FIG.15 Elizabeth B. Gulston, *Joseph Gulston*,
etching, 1772, British Museum.

rarities'.[181] In Mrs Hogarth's posthumous sale in 1790 Lot 7, 'Paul before Felix, without the divel', sold for the high price of 13s., and Lot 8, 'The 2d plate of the election set, with the lion's teeth', for 15s. 6d. References to these 'variations' are always couched in familiar terms, which implied that collectors recognised them immediately.

After Mrs Hogarth's death the copper plates were acquired by the great print-publishing entrepreneur John Boydell, who added plates from other sources, and published three editions of the complete works; by 1795 the price for a set had risen to £21 from 10 guineas in 1754 (no. 28), and early impressions were selling for proportionately far greater amounts. In 1799 the satirical printmaker James Sayers purchased from Boydell's associate John Ireland 'A collection of Hogarth's works, consisting of 407 prints in the 1st and 2d state, with the variations, etc, etc, and 39 prints relative to his works' for £210.[182]

The 'prints relative to his works' would have included those commissioned by Mrs Hogarth from Richard Livesay after her husband's drawings, and prints from Samuel Ireland's two volumes of *Graphic Illustrations of William Hogarth*, 1794–7, chiefly by his daughter Jane after drawings in his own collection, many of which were of doubtful authenticity. Although Ireland certainly owned a number of genuine works which he had purchased from Mrs Hogarth, for instance *Orator Henley Christening a*

Child (no. 35), his extreme gullibility is attested by the Shakespeare forgery scandal. His seventeen-year-old son William Henry Ireland announced that he had been given, by a man who wanted his identity kept secret, a group of papers in William Shakespeare's hand, including drafts of passages in the plays. Samuel Ireland did not suspect that the boy had written these himself on sheets of paper he had torn from old volumes in the lawyer's office where he worked, and set about publishing and publicising his son's 'discoveries'. They were initially believed by prominent authorities, and when they were eventually exposed the Irelands were the subject of widespread mockery.

The collection of Hogarth prints at Windsor Castle demonstrates the different approaches of two generations on either side of the 'Hogarthomania' boom. George III had accumulated a straightforward collection of early impressions of Hogarth's main *oeuvre*,[183] but George IV added numerous marginal prints acquired at sales of the earlier generation of Hogarth collectors. The British Museum's almost complete collection of Hogarth's prints also has its origins in Hogarthomania, being based on a collection of 661 prints purchased for 300 guineas in 1823 from William Packer. The then Keeper J. T. Smith, himself an authority on Hogarth, reported to the Trustees that Packer had built up his collection by buying 'at all the best sales for the past forty-six years'[184]. One of Packer's rival collectors H. P. Standly added further prints to the collection by a combination of sale and gift over the next five years.

Hogarthomania fizzled out in the 1830s, when there was a general slump in the art market. Many of the highly prized 'rarities' have not stood the test of time and are not to be found in Ronald Paulson's most recent catalogue of 1989. The tiny *Rape of the Lock* which fetched the huge sum of £33 in Gulston's sale is no longer thought to be by Hogarth, and the dozens of coats of arms supposedly from his youthful period as an apprentice silversmith have been reduced to a tiny handful of possible attributions. Doubtful attributions and outright forgeries eventually discredited the market, but it is worth pointing out that the original 'Hogarthomaniacs' were the subject of cynical comment almost from the beginning. A correspondent writing to the *Gentleman's Magazine* for April 1786 about the absurd prices in Gulston's recent sale, ended his letter by remarking:

> Let me hope, however, that, for the future, every sensible collector will think his assemblage of Hogarth's prints sufficiently complete, without the foolish adjuncts already described and reprobated; for, the authenticity of these trifles being obvious to no kind of proof, they only tend to expose their purchasers to the fraud of designing people, who will laugh at their credulity, while they pocket their cash.[185]

NOTES

1 For a full account of all the artistic groups in Hogarth's time and before, see I. Bignamini, 'George Vertue, Art Historian, and Art Institutions in London, 1689–1768', *The Walpole Society*, London, vol. 54, 1988.

2 Vertue, III, 156.

3 See Paulson, *Hogarth*, I, 1–37.

4 Walpole, v.

5 There are many signs of collaboration with Mrs Hogarth, including the publication of a price list of the prints available for purchase from her.

6 Horace Walpole, letter to Mrs Hogarth, 4 October 1780 (W.L. Lewis, ed., *The Correspondence of Horace Walpole*, New Haven, 1980, vol. 41, 416–17).

7 Nichols contended that Hogarth's copper plates had been 'injudiciously and unmercifully worked' and were thus severely damaged, a suggestion denied by Mrs Hogarth who got eminent engravers to speak up for them. See Nichols, xvii–xviii.

8 See Wilmarth S. Lewis, *Horace Walpole*, New York, 1961.

9 Horace Walpole, *Aedes Walpolianae*, London, 1747, 24.

10 Walpole, 357.

11 Walpole, 358.

12 Paulson, *Hogarth*, II, 194–6.

13 Nichols, 8.

14 This and the following quotation from the Earl of Charlemont are taken from the autograph manuscript title page to his two-volume collection of Hogarth's prints belonging to Christ's College, Cambridge, and presently kept in the Fitzwilliam Museum, Cambridge. For the Earl of Charlemont as a Hogarth collector see p. 58.

15 Ireland, 13.

16 Printed in full in Nichols, 1–4.

17 Apparently the only modern scholar to have followed the trail of 'Ald Hogart' has been Jack Lindsay in *Hogarth: His Art and His World*, London, 1977, 1–2.

18 Ireland, 16–17.

19 Hazlitt, 292.

20 'Idler', no.76, 305.

21 'Idler', no.79, 317.

22 Ibid., 319.

23 *Discourses XIV* (Wark, 254–5).

24 Wark, 51.

25 Quoted by Lamb, 74 .

26 Hazlitt, 274.

27 BMC 6724.

28 R. Godfrey, ed., *English Caricature 1620 to the Present*, Victoria and Albert Museum, 1984, cover illustration.

29 *A Descriptive Catalogue of the Works of Hogarth, placed in the Gallery of the British Institution; selected and abridged from Mr Ireland's Illustrations, and Mr Nicholls's Biographical Anecdotes of Hogarth, by Mr Young, Keeper of the British Gallery*, London, 1814.

30 It was reprinted in Nichols and Steevens, III, 63f.

31 Lamb, 62.

32 This could be a mistake for Poussin's painting of *The Plague of Ashdod* in the Louvre, but it is more likely to refer to a painting by Michael Sweerts, *Plague in an Ancient City*, which had been attributed to Poussin in England in the early nineteenth century. The painting was sold at Christie's in 1801 and belonged to the collections of Horton Longstone of Leigh Court, and Henry Hope. It was sold from the Saul Steinberg Collection, New York, on 30 January 1997 and bought by the Los Angeles County Museum of Art. See Rolf Kultzen, *Michael Sweerts*, Davaco, 1996, cat. no. 63.

33 Lamb, 58.

34 Paulson, *Hogarth*, II, 194–7.

35 Lamb, 58.

36 It came between lectures 'On the English Novelists' and 'On the Comic Writers of the Last Century'.

37 Hazlitt, 275.

38 Herschel Baker, *William Hazlitt*, Cambridge, MA, 1962, 128–34.

39 See Hazlitt's essays on Reynolds in *The Champion*, 1814–15, reprinted in Wark, App. II, 320–36.

40 Hazlitt, 299–300.

41 Hazlitt, 301.

42 Hazlitt, 289–90.

43 Hazlitt, 306.

44 J. Trusler, *Hogarth Moralized*, London, 1768, viii.

45 Walpole, 361.

46 Burke, 201.

47 Georg Christoph Lichtenberg, *Schriften und Briefe*, Darmstadt, 1972, III, 660–1060. For a convenient translation into English, see I and G. Herdan, *Lichtenberg's Commentaries on Hogarth's Engravings*, London, 1966. See also R. Wehrli, *G.C. Lichtenbergs ausführliche Erklärung der Hogarthischen Kupferstiche*, Bonn, 1980.

48 Herdan, *Lichtenberg's Commentaries*, xiii–xiv.

49 See A. Griffiths and F. Carey, *German Printmaking in the Age of Goethe*, British Museum Press, 1994, 56–62.

50 George Augustus Sala, *William Hogarth: Painter, Engraver, and Philosopher*, London, 1866. The essays which make up the book were first published in the *Cornhill Magazine*, Feb.–Oct. 1860.

51 Sala, *Hogarth*, 9.

52 Sala, *Hogarth*, 7–8.

53 For the idea of 'healthiness' see Rosemary Treble, *Great Victorian Pictures: Their Paths to Fame*, Arts Council exhib. cat., 1978, 84–5.

54 Klingender, iii–iv.

55 Paulson, *Hogarth*, I, xvi.

56 D. Dabydeen, *Hogarth's Blacks: Images of Blacks in Eighteenth Century English Art*, Kingston, Surrey, 1985, 11–15.

57 Lichtenberg, *Schriften*, III, 773; Herdan, *Lichtenberg's Commentaries*, 3.

58 See Griffiths and Carey, *German Printmaking*, 56–62.

59 Vertue, III, 156.

60 J. Habermas, *The Structural Transformation of the Public Sphere*, Cambridge, MA, 1989, 10f.

61 Ibid., 31f.

62 Burke, 216.

63 See Paulson, p. 58.

64 See Paulson, no. 88, *Hudibras and the Skimmington*.

65 See Paulson, pp. 76–7.

66 Vertue, III, 58.

67 Ibid.

68 Paulson, p. 76.

69 For a pioneering account of piracies of Hogarth see Kunzle.

70 Paulson, p. 90.

71 Kunzle, 326f.

72 Paulson, p. 114.

73 Paulson, p. 129.

74 R. Paulson, *Emblem and Expression*, London, 1975, 58–78.

75 An excellent sense of the sheer diversity and extent of copies after Hogarth in the eighteenth and nineteenth centuries can be gained from the twenty-four volumes of Hogarth material belonging to Christ's College, Cambridge, and now deposited in the Fitzwilliam Museum, Cambridge. The first two volumes are the Earl of Charlemont's own collection.

76 This work is reprinted in Nichols and Steevens, III, 58–86.

77 *Free-Holder*, 258.

78 Juvenal, lxvii.

79 *Free-Holder*, 259.

80 *Free-Holder*, 260.

81 This has been argued by David Solkin in *Painting for Money*, New Haven and London, 1992, 96f., and Jules Lubbock, *The Tyranny of Taste: The Politics of Architecture and Design in Britain 1550–1960*, New Haven and London, 1995, 109f. and 193f.

82 Nichols and Steevens, III, 162.

83 For the full title see the Bibliography, p. 205. The book remained in print well past the middle of the eighteenth century.

84 See F. Antal, *Hogarth and his Place in European Art*, London, 1962, 50f.

85 Samuel Johnson, *London: A Poem, In Imitation of the Third Satire of Juvenal*, London, 1738.

86 Vertue, III, 158.

87 Juvenal, lxvi.

88 Juvenal, lxx.

89 Juvenal, lxvi.

90 Edward Young, *Love of Fame*, 2nd edn, 1728, Preface, not numbered.

91 Ibid., Satire I, 6. The 'courtly Roman' is identified as Horace in a footnote to the original text.

92 Horace, *Satires*, Book 1, Satire 1, ll. 106–7. Translation by D. Watson, revised by W. Crakelt, *The Works of Horace, Translated into English Prose*, London, 1792, II, 13.

93 Anon., *The Rake's Progress; or, the Humours of Drury Lane. A Poem. In eight Canto's. In Hudibrastick Verse. Being the Ramble of a Modern Oxonian; which is a Compleat Key to the Eight Prints lately published by the celebrated Mr Hogarth*, London, J. Chettwood, 1735, 6.

94 Dryden, in 'The Argument to Juvenal's Third Satire', Juvenal, 22.

95 Johnson, *London, A Poem*, 10. Johnson cites the passages from Juvenal he has adapted here.

96 For a useful survey of classical echoes in texts of the period see W.H. Irving, *John Gay's London*, Cambridge, MA, 1928 (reprinted Hamden, CT, 1968)

97 Juvenal, Satire III, 35.

98 See, for example, his view of *Covent Garden Market*, 1737, in the Tate Gallery (see E. Einberg and J. Egerton, *The Age of Hogarth*, Tate Gallery Collections, vol. 2, Tate Gallery, 1988, no. 138, 183).

99 Irving, *John Gay's London*, 89–90.

100 See Sean Shesgreen, *Hogarth and the Times-of-Day Tradition*, Ithaca and London, 1983

101 Peter Wagner, *Reading Iconotexts*, London, 1995, 37–9.

102 Virgil, *Aeneid*, III, 96.

103 Earl of Roscommon, trans., *Horace: of the Art of Poetry*, London, 1709, 4.

104 Juvenal, xxxiiif.

105 Juvenal, xxxiii.

106 Earl of Roscommon, *Horace*, 9.

107 Horace, *Ars Poetica*, l. 343.

108 According to A. Henderson (*Latin Proverbs and Quotations*, London, 1869, 455), *veluti in speculo* is a Latin proverb, though no source is given. A more intriguing possibility is that the phrase is a mistake for *tamquam in speculum*, which has the same meaning and would refer to one of Terence's comedies, *Adelphi*, or *The Brothers*. There the phrase is part of a speech made by the harsh and Polonius-like father Demea: 'Denique inspicere, tamquam in speculum, in vitas omnium' (In fine I tell him to look into all men's ways of living as into a looking-glass, and draw from others a model for himself). (Terentius, *Adelphi* [*The Brothers*], Loeb Classical Library, Cambridge, MA, 1983, 260–61.)

109 Young, *Love of Fame*, 162f.

110 Juvenal, lxxiii–lxxiv.

111 See W.A. Speck, *Society and Literature in England, 1700–60*, 1983.

112 Speck, op. cit., 25f.

113 *Spectator*, 3 March 1711, no. 3. See also no. 56.

114 See Swift's 'The Legion Club', 1736, ll. 219–34, in Harold Williams, ed., *The Poems of Jonathan Swift*, Oxford, 1958, vol. 3, 839.

115 The method adopted was advocated by Swift: 'I have therefore since thought of another expedient, frequently practiced with great safety and success by satirical writers; which is, that of looking into history for some character bearing a resemblence to the person we would describe and with it the absolute power of altering, adding or suppressing what circumstances we please.' (I. Kramnick, *Bolingbroke and His Circle: The Politics of Nostalgia in the Age of Walpole*, Princeton, NJ, 1975, 22.)

116 See Andrew Jacobson in *Among the Whores and Thieves*, 69–79.

117 Ibid.

118 Vertue, III, 55–6.

119 *House of Commons 1715–54*, vol.2, 468.

120 Vertue, III, 78.

121 Walpole, IV, 79.

122 Copy in the Lewis Walpole Library, Farmington, CT.

123 See D. Dabydeen, *Hogarth, Walpole and Commercial Britain*, London, 1987, 91f.

124 For civic humanism see J.G.A. Pocock, *The Machiavellian Moment: Florentine Republican Thought and the Atlantic Tradition*, Cambridge, MA, 1970.

125 *The Spectator*, 2 March 1711, no.2.

126 Alexander Pope, *Moral Essays, in Four Epistles to Several Persons*, Epistle IV, to Richard Boyle, Earl of Burlington, 17.

127 See Vertue's account of the court intrigues; Vertue, III, 139.

128 For the rivalry with France see Linda Colley, *Britons*, New Haven and London, 1992, 24–5.

129 Diane Waggoner in *Among the Whores and Thieves*, 41–55.

130 James Bramston, *The Man of Taste*, London, 1733, 9–10.

131 James Miller, *Of Politeness*, London, 1738, 12.

132 For Patriot ideology see Kramnick, *Bolingbroke and His Circle*.

133 According to Lord Lyttleton, one of the 'boy-patriots', who speaks through the words of a fictive Persian visitor, 'Thou will be surprised to hear that the period when the English nation enjoyed the greatest happiness was under the influence of a woman… It was not until the Reign of Queen Elizabeth that this government came to an equal balance, which is the true perfection of it.' (Kramnick, *Bolingbroke and His Circle*, 231.)

134 He painted one picture of a Shakespearean subject, the scene from *The Tempest* (Private Collection; Lawrence Gowing, *Hogarth*, exhib. cat., Tate Gallery, 1971–2, no. 88) and *Satan, Sin and Death* from Milton (Tate Gallery), both probably in the late 1730s.

135 J. Brewer, *Party Ideology and Popular Politics at the Accession of George III*, Cambridge, 1976, 9.

136 Other explanations are certainly possible. Rouquet, for instance, sees Hogarth as hesitating between the 'unEnglish' discipline of the Prussians and the free spirit of the shambolic troops in the foreground enjoying 'liberty'. See also Bonnell Thornton in *The Student* for 20 Jan. 1751.

137 Paulson, pp.143–4.

138 Brewer, *Party Ideology*, 6.

139 Henry Saint John, Viscount Bolingbroke, *Letters on the Spirit of Patriotism: on the idea of a Patriot King...*, London, 1749, 148.

140 See Paulson 236.

141 For a discussion of whether there was such a thing, see Roy Porter, 'The Enlightenment in England', in R. Porter and M. Teich, eds, *The Enlightenment in National Context*, Cambridge, 1981, 1–18.

142 Paulson, pp. 91 and 129.

143 Quoted in Morell, Preface.

144 Judith Colton, 'Kent's Hermitage for Queen Caroline at Richmond', *Architectura: Zeitschrift für Geschichte der Architektur*, 1974, 181–91.

145 These were printed for the first time in Morell's *Notes and Annotations on Locke on the Human Understanding, written by Order of the Queen*, 1794.

146 Norman Sykes, *The Social and Political Ideas of Some English Thinkers*, Oxford, 1928, 55.

147 I am not persuaded by the argument that Hogarth was ever tempted by the Deism of Woolston. See Paulson, *Hogarth*, II, 87f.

148 See D. Bindman and M. Baker, *Roubiliac and the Eighteenth-Century Monument*, New Haven and London, 1995, 29–31.

149 D. Bindman in Bindman and Baker, *Roubiliac*, 29–33.

150 *Analysis*, 3.

151 Earl of Shaftesbury, *Characteristics of Men, Manners, Opinions and Times*, London, 1711–14.

152 *Analysis*, 1.

153 Sir Harry Beaumont, pseud. (Joseph Spence), *Crito: or, a Dialogue on Beauty*, London, 1752, 59.

154 See Reinhard Bendix, *Max Weber: An Intellectual Portrait*, London, 1966, 69.

155 *Analysis*, XV.

156 See Michael Baxandall, *Patterns of Intention*, New Haven and London, 1983, 76f.

157 See Hans Aarsleff in Vere Chappell, ed., *The Cambridge Companion to Locke*, Cambridge, 1994, 266.

158 John Locke, *An Essay Concerning Human Understanding*, 19th edn, 1793, Book 2, 8, 123–6.

159 'So far as we have already gone, the sense of feeling, as well as that of seeing, hath been apply'd to; so that perhaps a man born blind, may, by his better touch than is common to those who have their sight, together with the regular process that has been here given of lines, so feel out the nature of forms, as to make a tolerable judgment of what is beautiful to sight.' *Analysis*, Ch. XII, 'Of Light and Shade', 93.

160 Morell, 33.

161 Morell, 3f.

162 Vertue, III, 126.

163 For a full account of Hussey and Hogarth's response to his work in the *Analysis*, see Sheila O'Connell, 'An explanation of Hogarth's "Analysis of Beauty", Pl. 1, Fig. 66', *Burlington Magazine*, vol. CXXVI, no. 970, Jan. 1984, 33.

164 See George Hersey, *The Evolution of Allure*, Cambridge, MA, 1996, Ch. 3, 42–59.

165 Judith Feyertag Hodgson, 'Human Beauty in Eighteenth-Century Aesthetics', Ph.D. thesis, University of Pennsylvania (University Microfilms), 1973, passim.

166 *Analysis*, 66.

167 *Analysis*, 66.

168 See Alex Potts, *Flesh and the Ideal: Winckelmann and the Origins of Art History*, New Haven and London, 1994.

169 See Hodgson, 'Human Beauty', 205f.

170 Nichols, 63. The illustration is also reproduced in D. Bindman, *Hogarth*, World of Art Series, London, 1981, 31.

171 Edmund Burke, *A Philosophical Enquiry into the Origin of our Ideas of the Sublime and Beautiful*, 7th edn, 1773, 216.

172 'Idler', no. 76, 304.

173 Ibid., 306.

174 Ibid

175 'Idler', no. 82, 331–2.

176 Historical Manuscripts Commission, Twelfth Report, Appendix, Part X. *The Manuscripts and Correspondence of James, 1st Earl of Charlemont, Vol.1, 1745–83*, 1891, 382–3.

177 Ibid., 384.

178 James Granger, *A Biographical History of England from Egbert the Great to the Revolution, consisting of Characters dispersed in different Classes, and adapted to a Methodical Catalogue of Engraved British Heads*, London, 1769–74, with four subsequent editions and a continuation up to the end of the reign of George I, 1806; Henry Bromley, *A Catalogue of Engraved British Portraits*, London, 1793.

179 *The Dictionary of National Biography* gives a highly amusing account of Joseph Gulston's life.

180 The references by Samuel Parr and Edmund Malone to Steevens's character and to his collecting are among a number of unflattering comments by his contemporaries quoted in *The Dictionary of National Biography*.

181 Annotation in Vol. II of the Foster/Crickett collection at Chiswick Public Library.

182 Manuscript receipt in British Museum, Department of Prints and Drawings, N.7.1.

183 Buckingham House inventory, 1816. I am grateful to Henrietta Ryan for showing me this inventory and explaining its significance for an understanding of how the royal collection was acquired.

184 Central Archives, Copies of Reports to Trustees, p.78.

185 *Gentleman's Magazine*, April 1796, 299–301. Horace Walpole himself cut the article out of a copy of the magazine and put it in a scrapbook (Lewis Walpole Library, Farmington, CT).

REDEFINING HOGARTH: TWENTIETH TO EIGHTEENTH CENTURIES

Hogarth's moral series have been well enough known since his own time to have become the vehicle for countless imitations and variations in a wide range of media, ranging from pottery to grand opera. Inevitably, we approach Hogarth through layers of association accumulated over two centuries. It is impossible, given the physical scope of the present exhibition, to do more than indicate some of the themes which have kept Hogarth alive to the present day, concentrating on a small number of works rather than attempting a survey. Unless stated otherwise, all the following listed works are by Hogarth and come from the Department of Prints and Drawings, British Museum.

THE TWENTIETH CENTURY: THE ARTIST AS RAKE

A great many artists in the twentieth century in Britain and especially Germany have been influenced by Hogarth. They are represented here by one work, David Hockney's *Rake's Progress*, which makes explicit reference to Hogarth's series of the same name but with a completely different and essentially twentieth-century emphasis. Unlike in Hogarth's series, the rake represents the artist as outsider not as social-climbing reprobate. Hockney uses the idea of the rake to show his own progress in the urban world of New York in the 1960s, as a kind of innocent fascinated, threatened and alienated by it.

DAVID HOCKNEY

1 *A Rake's Progress*, 1961–3

Six etchings, approx. 300 x 400mm

Lit.: Nikos Stangos, ed., *David Hockney by David Hockney: My Early Years*, London, 1976; David Hockney, *That's the Way I See It*, London, 1993, 20–31

a) *Receiving the Inheritance*
P07030
b) *The Start of the Spending Spree*
P07033
c) *The Drinking Scene*
P07035
d) *Marries an Old Maid*
P07036
e) *Disintegration*
P07041
f) *Bedlam*
P07044
Lent by the Tate Gallery

According to Hockney, who began the work when he was a student at the Royal College of Art, 'My original intention was to do eight etchings, to take Hogarth's titles, and somehow play with them and set it in New York in modern times', but in the end the series consisted of sixteen images. The scenes chosen here correspond most closely to scenes in Hogarth's *Rake's Progress*. On the strength of these etchings Hockney was later invited to design the sets at Glyndebourne for Stravinsky's opera, *The Rake's Progress*, loosely derived from Hogarth's engravings, with libretto by W.H. Auden and Chester Kallman. Hockney based his sets on designs from Hogarth, using a cross-hatching technique deliberately taken from Hogarth's as a unifying stylisation. Among other contemporary artists to have based series of designs on Hogarth's work, Jörg Immendorf and Peter Howson may be mentioned (see *Rake's Progress*, Soane Museum, nos 70–73).

1a

1b

1c

1d

1e

1f

2

THE NINETEENTH CENTURY: MAN OF THE PEOPLE

The mid-nineteenth century absorbed Hogarth into popular culture, making him an archetype of self-improvement, a London apprentice who had made good by exceptional abilities but still remained true to the plain manners and unsparing honesty of his class. He was claimed as an archetypal Englishman, a countryman of Shakespeare, impatient of pretence and foreign ways, and essentially unlearned. The engravings of Hogarth's moral series continued to be reprinted and copied endlessly, and they were given renewed currency by updated reworkings, like Frith's *Road to Ruin*, and by popular translations of the images. Following George Augustus Sala's biography of 1860 (see p. 26), Hogarth's art was thought to be not only morally improving but also 'healthy' and fit for wide dissemination.

W.P. FRITH
2 *Hogarth before the Commandant at Calais*, 1860
Engraving by W.E. Edwards, line and stipple, 640 x 821 mm
Lit.: W.P. Frith, *My Autobiography and Reminiscences*, London, 1889, 138
1866-10-13-1040

According to Frith's autobiography he began the original painting in 1850 as 'a commission from a Lancashire worthy, who repudiated his order, and the picture was transferred to a firm of publishers, by whom an engraving from it was produced, without much success either as a print or a publication'. Frith got the subject from a melodramatic account of Hogarth's arrest while sketching in Calais, which led to his own painting of the incident, *O the Roast Beef of Old England* ('The Gate of Calais') (see no. 22). According to Frith, 'He was taken before the Governor, who informed him that "if peace had not been signed between France and England a few days previously, he would have been hanged on the ramparts."' The composition contrasts the haughty and affected French officials with the English artist among the common people behind the barrier. Hogarth is presented as a plain and direct Englishman for whom observation is second nature.

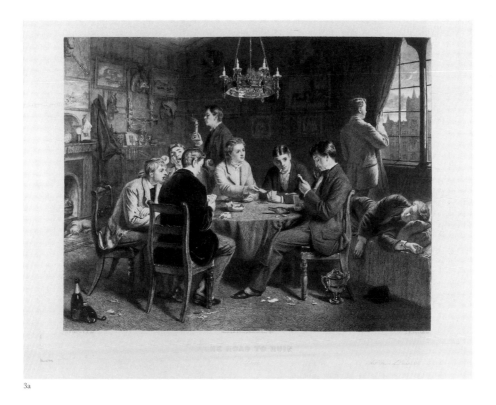

3a

W.P. FRITH

3 *The Road to Ruin*, 1889

Five engravings by L. Flameng, line and stipple

1913-2-13-18 to 22

(Descriptions below taken from Frith's *My Autobiography and Reminiscences*,
 London, 1889, 343–4)

a) *College*

445 x 535 mm

'In the first scene my hero is entertaining a party of friends in his college
room, who have played cards all night.'

b) *Ascot*

440 x 531 mm

'In the second picture my youth has grown to manhood, and is engaged
in far more dangerous play than three-card loo; for he is the centre of
attraction in the Royal Enclosure at Ascot to a horde of betting-men,
who are offering him chance after chance of immediate or prospective
ruin.'

c) *Arrest*

443 x 531 mm

'The young man is seen in his ancestral home – with his wife and
children – in the hands of bailiffs who have arrested him for debt.'

d) *Struggles*

441 x 530 mm

'We find him away from his native land endeavouring to earn a

subsistence by writing plays; whilst his wife devotes herself to painting in
water-colours in the hope of selling her work, and thus adding to their
slender means. A French landlady presses for her rent, the wife appeals
to the woman, and the husband is in despair.'

e) *The End*

436 x 526 mm

'Driven to desperation, my luckless hero is seen...fastening the door of a
miserable attic, with an expression on his face that, assisted by a pistol
ready to his hand, admits of but one interpretation – death by his own
hand.'

The paintings of the *The Road to Ruin* date from 1877, but
the prints were evidently not produced for the Art Union
until 1889. In his account of the series in his autobiography
(*My Autobiography and Reminiscences*, London, 1889, 343) Frith
notes the importance of Hogarth for the project but denies
satirical intent: 'Without any pretention to do my work on
Hogarthian lines, I thought I could show some of the evils
of gambling; my idea being a kind of gambler's progress,
avoiding the satirical vein of Hogarth, for which I knew
myself to be unfitted.' The result is a kind of *Rake's Progress*
but without the humorous touches, and with a deliberate
modernism of reference; the hero's downfall takes place on
the racecourse, and he ends his life with a pistol. There are

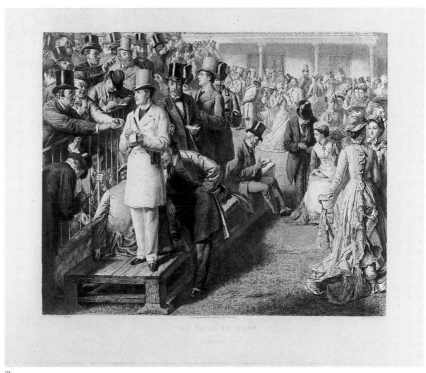

3b

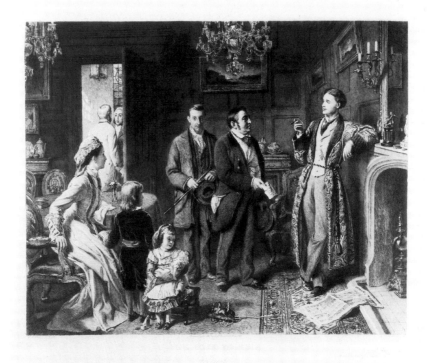

3c

numerous echoes of Hogarth's compositions, and the images are profoundly Hogarthian in the way that the material objects and physical attitudes of the actors work together to express changing social situations and emotions.

The success of the paintings of *The Road to Ruin* was such that Frith embarked immediately on a companion series, *The Race for Wealth*, 'representing the career of a fraudulent financier, or promoter of bubble companies'. This series is

68

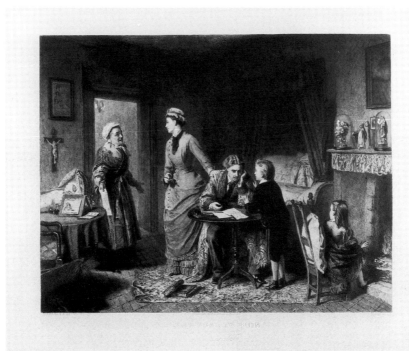

3d

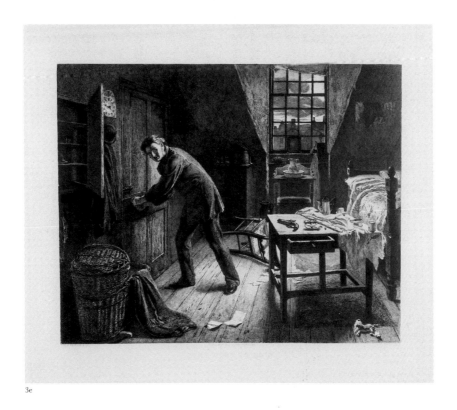

3e

equally Hogarthian, and Tom Taylor in his catalogue account of the series (*The Race for Wealth by W.P. Frith*, King Street Galleries, 1880) notes that the painter 'follows in the track of Hogarth'.

4

Joice after Hogarth

4 *London Spy, with Hogarth's Plates, c.* 1840

Cover of volume of Hogarth's prints, 426 x 550 mm (image), 450 x 550 mm (sheet)

1842-10-8-3a, presented by John Fillinham

This vigorous image shows the transformation of a Hogarth design (see no. 126) into the idiom of the popular woodcut broadside. It illustrates the fact that Hogarth's work in the Victorian period had an appeal to a mass market, quite beyond the market for fine prints.

Anonymous after Hogarth

5 *The Curse of Mammon! Or, The Earl's Son & the Citizen's Daughter! Forming a Fac-Simile Embodiment of Hogarth's justly celebrated Pictures: Marriage à la Mode*

Illustrated handbill with wood engravings after *Marriage A-la-Mode*, as performed at Davidge's Royal Surrey Theatre, 580 x 453 mm

1842-10-8-3c, presented by John Fillinham

A further illustration of the enduring popularity of Hogarth's moral series in mid-Victorian England. Hogarth is extravagantly praised as on the level of Shakespeare and as the 'great moral painter of mankind'.

5

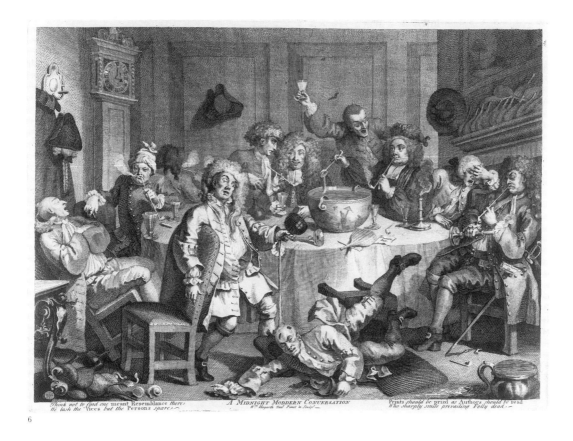

Think not to find one meant Resemblance there, *A MIDNIGHT MODERN CONVERSATION* *Prints should be priz'd as Authors should be read*
We lash the Vices but the Persons spare. *W.ᵐ Hogarth Inv.ᵗ Pinx.ᵗ et Sculp.ᵗ* *Who sharply smile prevailing Folly dead.*

6

THE EIGHTEENTH CENTURY: CONVIVIALITY AND MORALITY

Hogarth's moral prints, from the publication of *A Midnight Modern Conversation* in 1733 and the two Progresses of the following years, gave him a reputation quite unprecedented for a British artist and perhaps never surpassed. This reputation was expressed in frequent references to him in literature and the press, and in imitations of his work by other engravers. Imitations of *A Midnight Modern Conversation* and *A Rake's Progress* are evidence of the effectiveness of moral tales expressed in an intriguing, humorous and sometimes slyly erotic narrative, allowing the imitators to emphasise either their libertinism or their cautionary value as they wished.

MIDNIGHT MODERN CONVERSATION AND ITS INFLUENCE

6 *A Midnight Modern Conversation*, 1733

Etching and engraving, 341 x 468 mm
Lit.: BMC 2122; Paulson 128, state 1
1855-4-14-171

Hogarth's most popular and most widely imitated print, it led to versions in a wide variety of media throughout Europe, including punchbowls produced in China and Holland, and Meissen porcelain ware for the Dresden court. Though the print is often assumed to be approving of the conviviality depicted and to be of identifiable people, Hogarth's own inscription suggests that it was intended to 'lash the Vices' and not individuals. No one in the print acts with dignity or self-control, with revolting or dangerous consequences; the 'Politician' on the far right, for instance, is in danger of setting himself on fire. As has frequently been observed (Paulson 84), it is a kind of conversation piece in reverse, with the familial and social harmony of Hogarth's own paintings of portrait groups reversed, as civility falls into excessive behaviour under the influence of drink. For discussion of the print as a 'laughing satire' see p. 35.

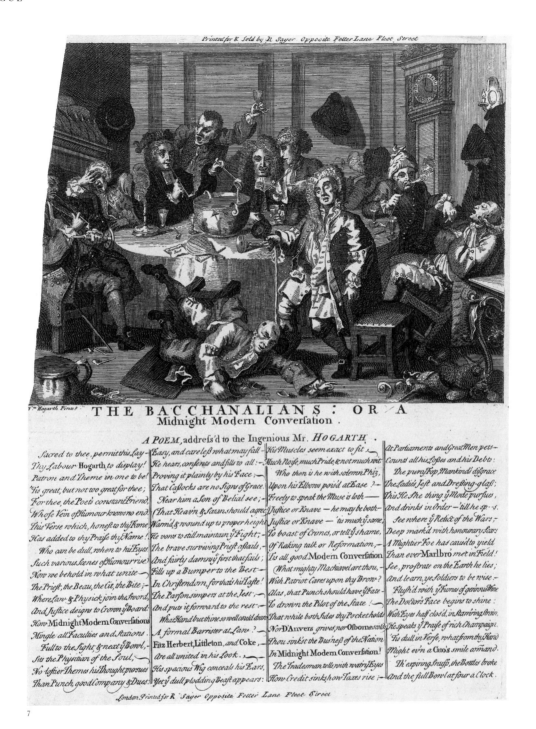

7

ANONYMOUS AFTER HOGARTH

7 *The Bacchanalians: Or a Midnight Modern Conversation*, 1734

Etching and letterpress, 210 x 260 mm (plate), 355 x 263 mm (sheet),
 published by R. Sayer

Lit.: BMC 2124; Paulson 128

1975.u.1598

One of a number of copies and versions produced in the London print trade by respectable publishers and printmakers, including George Bickham and Elisha Kirkhall, before the advent of Hogarth's Act of 1735 (see no. 14). There is no reason to suppose that Hogarth resented these versions at first; he may have consented to them in the justifiable expectation that they would increase his own fame.

Chaque Peuple a son goût, tout Païs a sa mode, | Si pour faire éclater sa joye, un François chante,
Chacun se rejouit ou pleure à sa façon ; | Si les Italiens se plaisent aux Concerts,
Mais, fut-on plus severe et serieux que Caton, | Si l'Allemand cherit la Table et les Desserts,
Il faut qu'au train public un chacun s'accommode. | L'Anglois s'en tient au Ponch, et la Pipe l'enchante.

8

CREITE AFTER HOGARTH

8 Copy of *A Midnight Modern Conversation*

Engraving, 262 x 416 mm (image), 309 x 485 mm (sheet)
Cc.2-105

Not dated but probably produced within a few years of Hogarth's original print. The copyist describes the scene as epitomising the English way of celebration: the French sing, the Italians enjoy concerts, the Germans stuff their faces, while the English settle down to a punchbowl and tobacco – an early example of the desire to see in Hogarth some general truth about national character.

ANONYMOUS AFTER HOGARTH

9 Tankard with panel copied from *A Midnight Modern Conversation*

Salt-glazed stoneware, 210 x 197 mm
Department of Medieval and Later Antiquities, British Museum
1887,0308.4, presented by Henry Willett

Despite Hogarth's moralising intentions, the print quickly became associated with uninhibited enjoyment and readily became attached to drinking vessels, especially punchbowls, not only in England but also in Holland and Saxony.

9

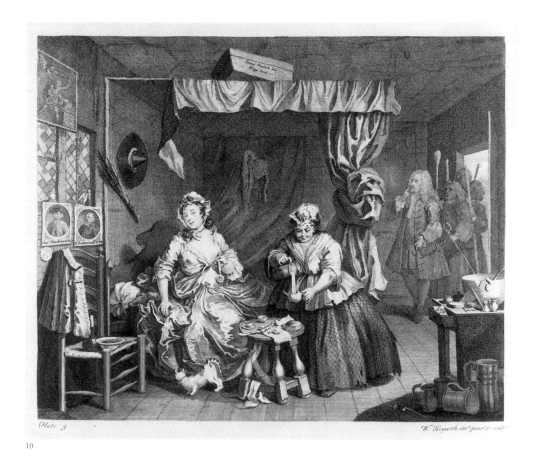

10

PIRACIES AND IMITATIONS OF *A HARLOT'S PROGRESS* AND *A RAKE'S PROGRESS*

A Harlot's Progress suffered from some fairly open piracies, and a number of mildly pornographic 'explanatory' texts. Hogarth mitigated their effect by commissioning the engraver Giles King to produce reduced and decorated copies on two sheets. The series, possibly with Hogarth's approval, was reproduced as fan designs. Piracies of *A Rake's Progress* began to appear even before its actual publication, largely because Hogarth delayed for nearly a year the publication of the series in order to allow the Engravers' Act, protecting his copyright, to become law. In the meantime imitators came to 'Mr. William Hogarth's House, under pretence of seeing his RAKES PROGRESS, in order to pyrate the same, and publish base Prints thereof before the Act commences, and even before Mr. Hogarth himself can publish the true ones' (*London Evening Post*, 17–19 June 1736, cited in Paulson, *Hogarth*, II, 42–3).

10 *A Harlot's Progress*, 1732, plate 3

Etching and engraving, 319 x 384 mm

Lit.: Paulson 123

1858-4-17-546

According to Vertue, this design was the starting point from which Hogarth developed the series (see p. 30). It gives a good idea of the attractions of Hogarth's prints for the eighteenth-century public. They are full of entertaining and topical details which illuminate human character and advance the story. The character of the Harlot and the contradictions upon which her life is based are signalled in many ways. She gloats over a stolen watch but is waited on by a 'bunter'. Her world is defined by highwaymen, real (James Dalton) and fictional (Captain Macheath), and she is blithely unaware of the entry of the vigilante Sir John Gonson and the watch, who will take her off to face hard labour in Bridewell. The Harlot is shown as still attractive in her negligée, and this is evidently noted by the prudish Gonson. The print is full of humour but is also part of a cautionary tale which can claim to be 'improving'.

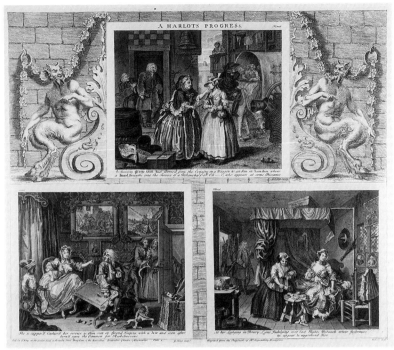

11

GILES KING AFTER HOGARTH

11 *A Harlot's Progress*, 1732

Etching, 476 x 557 mm

Lit.: Paulson, p.76

1848-7-8-19 to 21

Giles King, who had been George Vertue's apprentice, was authorised by Hogarth to produce reduced versions of the series on two plates. They came out very shortly after the publication of Hogarth's own, and the first, shown here, reproduces Hogarth's plates 1–3. They are distinguished from the originals by being in reverse, by the satyrs surrounding them giving the impression of an elaborately decorated mantlepiece, and by the brief descriptions, which here identify the figures of Colonel Charteris in the first plate and Sir John Gonson in the third (see p. 93).

ANONYMOUS AFTER HOGARTH

12 Fan design with five scenes from *A Harlot's Progress*

Etching on chickenskin(?), 255 x 544 mm

1891-7-13-519, presented by Lady Charlotte Schreiber

Lit.: *Schreiber Fans*, unmounted, 151; Paulson, p.77

Printed as a fan but not folded into shape. Probably the type of fan advertised in *The Craftsman*, 1 July 1732. According to Paulson, Hogarth gave such fans to his family's maidservants.

12

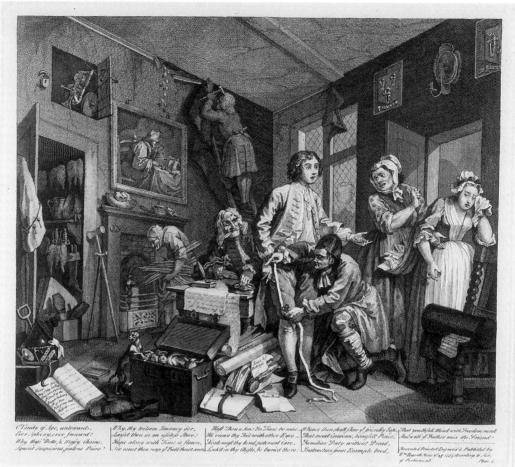

O'Vanity of Age, untoward, / Ever sphering, ever froward? / Why these Bolts, & Massy Chains, / Squint Suspicions, jealous Pains? | Why, thy toilsom Journey o'er, / Layst thou on an useless Store? / Hope along with Time is flown, / Nor canst thou reap y.e Field thou'st sown. | Hast Thou a Son? In Time be wise, / He views thy Toil with other Eyes: / Needs must thy kind, paternal Care / Lock'd in thy Chests, be buried there? | Whence then shall flow y.t friendly Ease, / That social Converse, honest Peace, / Familiar Duty without Dread, / Instruction from Example bred: | That youthfull Mind with Freedom ment / And with y.e Father mix the Friend: // Invented Printed Engrav'd & Published by / W.m Hogarth June y.e 25. 1735 According to Act. / of Parliament. Plate: 1.

13a

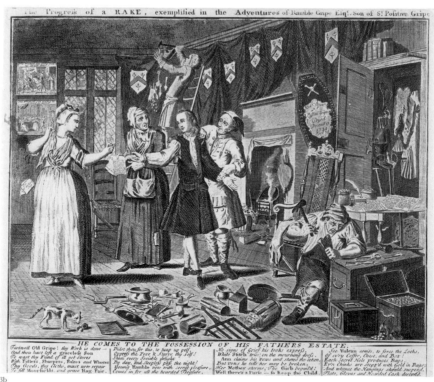

The Progress of a RAKE, exemplified in the Adventures of Ramble Gripe Esq.r. Son of S.r Positive Gripe

HE COMES TO THE POSSESSION OF HIS FATHERS ESTATE.

Farewell Old Gripe; thy Work is done / And then hast left a graceless Son / To waste thy Fund of ill got Stores / With Taylers, Sharpers, Rakes and Whores / Thy Goods, thy Cloths, must now repair / To all Moorfields, and grace Rag Fair. | Didst thou, for this, to heap up pelf, / Oppress the Poor & Starve thy Self! / Shun every Sociable delight / By day, And Auspsit pass the night; / Young Rambles now with Secret pleasure / Comes in for all the hoarded Treasure. | No signs of Grief his looks express'd, / While Stitch tricks on the mourning dress; / Ann claims his vows and shews the letter, / But vows he tells her may be broken, / Her Mother storms, The Girls beguiled; / Well there's a Purse — to Keep the Child. | See Vulcan comes to force the Locks, / Of every Coffer, Chest, and Box; / Each Secret Hole produces Bags, / Erin Chinks are stopp'd with Gold in Rags, / And whence the Savings should suspect, / Plate, Gloves and Hoarded Cash detect.

13b

13a *A Rake's Progress*, 1735, plate 1

Etching and engraving, 355 x 410 mm
Lit.: Paulson 132
1858-4-17-558

The first plate in the series. The Rake Tom Rakewell is introduced as the son of the recently deceased merchant in whose house the scene is set. The father was a miserly money-trader in the City, and the son reveals himself as a spendthrift, preparing himself to use his inheritance to enter the pleasurable world of London society, seeking social advancement. He repudiates his pregnant fiancée, Sarah Young, who nonetheless comes to his rescue later.

ANONYMOUS AFTER HOGARTH

13b *The Progress of a Rake, exemplified in the Adventures of Ramble Gripe Esqr. Son of Sr Positive Gripe*, 1735

Etching, 270 x 327 mm
Lit.: BMC 2172; Kunzle, 316f.; Paulson, p.90
1878-9-14-1

One of the piracies which appeared before the actual publication of Hogarth's series and which roused Hogarth's ire. It is an example of the 'base prints [published] before the Act commences, and even before Mr Hogarth himself can publish the true ones'. This print is from the series advertised in June 1735 as 'the Progress of a Rake, exemplified in the Adventures of Ramble Gripe, Esq.: Son and Heir of Sir Positive Gripe'. There is some possibility that these were the original names intended by Hogarth and that he changed them to Rakewell after the publication of the piracies, but the evidence is inconclusive. Despite being overt piracies they were advertised as if they were original works 'curiously design'd and engrav'd by some of the best Artists', and the publishers themselves – Henry Overton, John King, and Thomas and John Bowles – were all well known and seemingly reputable. The differences can be mainly accounted for by the fact they were, in Kunzle's phrase, 'plagiaries-by-memory', remembered from visits to Hogarth's studio and verbal descriptions, and by the need to differentiate them from Hogarth's own designs.

14 *An Act for the Encouragement of the Arts of Designing, Engraving, Etching &c.* (*Hogarth's Act*), 1735

Printed document
Lit.: Paulson, *Hogarth*, II, 35-46
Lent by Andrew Edmunds

The Act was intended to protect the copyright of engravings on the model of the literary copyright Act of 1709, by vesting it in the artists rather than the printsellers. Its aim was also to protect the quality of the image by preventing cheap copies. Hogarth seems to have been instrumental in getting the Act through Parliament but he was supported by a number of other well-known engravers. The Bill was brought in early in 1735 and was finally enacted by 25 June, enabling Hogarth to release the *Rake's Progress* prints under the Act's protection. The fact that the Act went through so smoothly is a demonstration, if it were needed, that Hogarth was not regarded by Walpole as a threat. The Act forbade unauthorised copies for a period of fourteen years.

14

JOHN TRUSLER

15 *Hogarth Moralized*, 1768 (not illustrated)

Printed book
Private Collection

If the imitations and piracies of *A Midnight Modern Conversation* and *A Rake's Progress* presented Hogarth as an artist of conviviality and good fellowship, colluding with his creations, Dr Trusler emphasised the stern morality implicit in the fate of the Harlot and the Rake. He was on close terms with Mrs Hogarth after the artist's death, and perhaps encouraged her to take a prudish view of her husband's work. Trusler explained his method in the Preface: 'While I *moralised*, I studied to *explain*; and, while I *explained*, I studied to *moralise*.' Trusler, later to be author of *The Way to be Rich and Respectable*, fell out famously with William Blake (see G.L. Keynes, *The Letters of William Blake*, Oxford, 1980, pp. XX and 6-11).

THE GERMAN FOLLOWERS

Of all European countries, Germany took most enthusiastically to Hogarth's prints. They had a particular appeal to intellectuals concerned to liberate the middle classes from the narrow provincialism engendered by the independent principalities which largely made up the country. They tended to see England as a model of commercial prosperity and intellectual liberty, with Hogarth as part of the apparatus of consent which enabled a relatively liberal government to function without repression.

DANIEL CHODOWIECKI

16 *Leben eines Lüderlichen* (Life of a Rake), from the *Berliner genealogischer Kalender* for 1774

Twelve etchings on two uncut sheets, each subject (not in order)
 85 x 50 mm, 1773
Lit.: W. Engelmann, *Daniel Chodowieckis sämtliche Kupferstiche*, Leipzig,
 1857, no. 90
1863-6-13-172 to 183
1) *Sorgfältige Grundlage zu kunftiger Erziehung* (Careful foundations for future upbringing)
2) *Fürtreffeliche Bildung des Geistes und des Hertzens* (Excellent formation of the spirit and the heart)

3) *Vorbereitung zur Universität* (Preparation for university)
4) *Universitäts Studien* (University studies)
5) *Begierde nach Kenntnis der Welt* (Eagerness for knowledge of the world)
6) *Praktische Kenntnis der Welt* (Practical knowledge of the world)
7) *Übung der Gedult und der Verachtung des Reichtums* (Practising patience and contempt for wealth)
8) *Veranlassung zu Einsamkeit und Nachdenken* (Cause for loneliness and reflection)
9) *Anfang der Häuslichen Glückseeligkeit* (Beginning of domestic happiness)
10) *Folgen der praktischen kenntnis der Welt* (Consequences of practical knowledge of the world)
11) *Das Glück des häuslichen Lebens* (The joys of domestic life)
12) *Ende des wohlgenossenen Lebens* (The end of a life of good fellowship)

Despite the ironically positive titles, the derivation of the series from Hogarth's *Rake's Progress* is obvious and the series predates Chodowiecki's close association with Georg Christoph Lichtenberg, which led to further Hogarthian works (see p. 25).

DANIEL CHODOWIECKI

17 *Der Fortgang der Tugend und des Lasters* (The Progress of Virtue and Vice), 1777

Twelve etchings on four sheets, each subject 85 x 48 mm
Lit.: Engelmann, 188; A. Griffiths and F. Carey, *German Printmaking in the
 Age of Goethe*, British Museum Press, 1994, no. 22, 56–7
1863-6-13-389

This series was made under the direction of Lichtenberg (see p. 25) and his intentions and the role played in them by Hogarth are made explicit in a letter of 23 December 1776 (quoted at length in Griffiths and Carey, 56–7). His aim was to combine the moral narratives of Hogarth, applied to representative male and female lives, with the newly fashionable theory of J.C. Lavater that the moral character is expressed in physiognomy. He found precedents for this in Hogarth, in particular the transformation of the Rake's appearance as he descends from the brothel to the prison. For this reason the series is confined to the heads and expressions of the protagonists, creating simple contrasting stories in which goodness is rewarded by happiness and dissoluteness by misery.

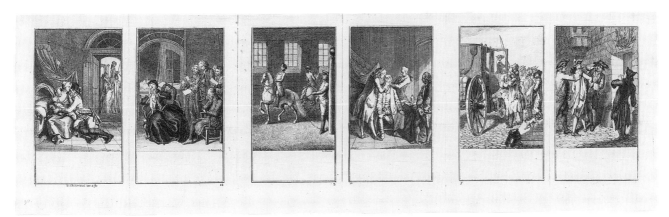

16 (from the left: nos 1, 12, 3, 10, 5, 8)

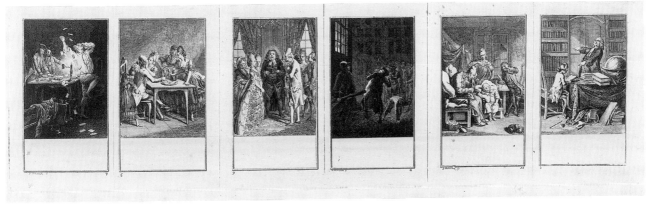

16 (from the left: nos 7, 6, 9, 4, 11, 2)

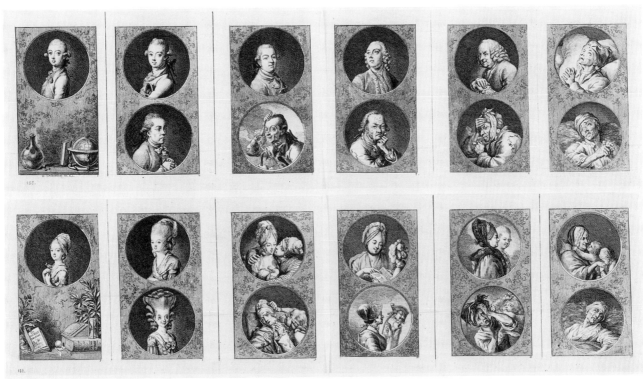

17

A *Tho. Fisherman Shaving.*
B *Mr Thornhill*
C *Mr Tothall Shaving himself*

D *Mr Hogarth Drawing this Drawing*
E *Mr Forrest at Breakfast*
F *Mr Scott Finishing a Drawing*

18

HOGARTH'S HOGARTH: A SELF-MADE ARTIST

Hogarth exploited without inhibition the means of publicity available to him in increasingly commercial times. In so doing he tended to cultivate different personae, some mutually contradictory, which were variously taken for the 'real' Hogarth by contemporary and later commentators. In earlier years he tended to cultivate 'clubbability', emphasising his own sociability and robust good humour, and an 'English' directness which explicitly distanced him from Italian and French affectation. In some satires he follows Pope in mocking the 'Grub Street' or hack author and his unreal dreams of fame, but in the 1740s he began increasingly to claim his art to be a high calling, resting its claims on great British authors of the past. By the end he became desperate to establish the seriousness of his pursuit of the 'Comic Muse' in the face of the increasingly successful opposition of those attempting to set up an academy on principles of reverence for antiquity and drawing from casts.

18 *The Five Days Peregrination*, 1732

Manuscript volume with ten drawings: six by Hogarth, two by Samuel Scott, one by Hogarth and Scott, and the map by John Thornhill (open at p. 6, drawing 4, *Breakfast at the Nag's Head: Hogarth drawing the company*), drawings approx. 206 x 320 mm

Lit.: Charles Mitchell, ed., *Hogarth's Peregrination*, Oxford, 1952
1847-3-20-1 to 10

This is an account of an apparently spontaneous five-day tour of the Kent Coast made by Hogarth in the company of four friends at the end of May 1732. The four were Samuel Scott, the marine painter and the only other artist; John Thornhill, son of Sir James Thornhill and Hogarth's brother-in-law; Ebenezer Forrest, a lawyer; and William Tothall, a woollen-draper. The account of their doings shows the trip to have been an engaging mixture of heavy drinking and eating, singing, sightseeing and horseplay, which included playful fights using cow-dung. The peregrination suggests that Hogarth in the early 1730s identified himself with middle-ranking professionals, self-consciously distinct in aspiration from, for instance, the aristocratic Burlington circle. Though the work was not published until

well after Hogarth's death, in 1781, it is hard to believe that publication was not in the minds of the group. It would have confirmed most of his contemporaries in the belief that Hogarth was anything but a stern moralist.

19 *A Chorus of Singers*, ticket for *A Midnight Modern Conversation*, 1732

Etching, 200 x 163 mm
Lit.: Paulson 127
1857-5-9-19

An ideal of genial sociability is expressed in this spirited scene of lightly caricatured singers performing William Huggins's oratorio *Judith*. Though appropriate to its role as a ticket for *A Midnight Modern Conversation*, it is also an elaborate private joke, for Huggins, the son of the notorious governor of the Fleet Prison, John Huggins, was a close friend of Hogarth and tireless dilettante.

19

ANONYMOUS

20 *A Poet* or *Ready Wit no trust*

Etching, 235 x 208 mm
Lit.: BMC 1851
Cc.3-199

This mysterious print probably dates from the 1730s, but a later state (private collection) is captioned 'A Poet' and has a publication date of February 1753; the alternative title is taken from the sign above the shop on the right. It appears to show a poet trying to represent himself as a gentleman of wisdom (Minerva's owl hovers above with a wreath), while the 'real' world offers him only demeaning Grub Street outlets for his noble gifts: hanging broadsides, love songs and funeral odes. The imagery must derive from Alexander Pope's famous attacks on Grub Street poets in *The Dunciad* and *The Grub Street Journal*, published 1730–40. The poet has not been identified; it may not be a real poet but a generic Grub Street hack of the kind satirised by Hogarth (see no. 21).

20

Studious he Sate, with all his books around, ⟶ Plung'd for his sense, but found no bottom there ;
Sinking from thought to thought, a vast profund ! ⟶ Then writ, and flounder'd on, in more despair.

DUNCIAD. Book I. line III.

21

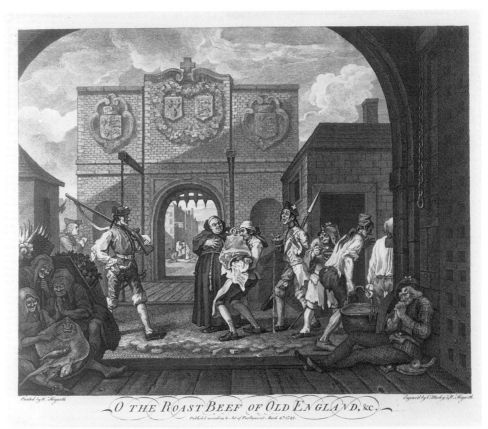

Painted by W. Hogarth Engraved by C. Mosley & W. Hogarth

O THE ROAST BEEF OF OLD ENGLAND, &c.

Publish'd according to Act of Parliament. March 6.ᵗʰ 1748.

22

21 *The Distrest Poet*, second state, 1737

Etching and engraving, 360 x 410 mm
Lit.: Paulson 145, state 2
1868-8-22-1541, bequeathed by Felix Slade

The first version of the composition, this was partly re-engraved in 1740 to become one of a series which was to include *The Enraged Musician* (no. 71) and a scene from the life of a painter which was announced but not engraved. This earlier version is an explicit homage to Alexander Pope whose *Dunciad* provides the caption and possibly the prototype of the distressed poet in Lewis Theobald. The kind of poet represented, lacking talent (he seeks inspiration from Bysshe's *Art of English Poetry*, a rhyming crib) but of limitless pretentions, despite the utter poverty into which he drags his hapless family, was a familiar satiric type by the mid-1730s (see no. 16 above). Though Hogarth's own background, with a father who was a literary schoolmaster, was essentially Grub Street, he adopts a lofty view of that condition here, in effect dissociating himself from it.

22 *O the Roast Beef of Old England*, 1749

Etching and engraving, 382 x 458 mm
Lit.: Paulson 180
S.2-113

The tale of Hogarth's arrest and deportation from Calais on suspicion of being a spy has often been told, most notably by the artist himself (*Autobiographical Notes*, 227–8; see also no. 2 in this catalogue for a Victorian version of the follow-up to the arrest). Though Hogarth claimed that the incident depicted actually happened, and he shows himself at the point of arrest with a French soldier's hand emerging from behind a building on the left to grab his shoulder, the scene is little more than a rehearsal of anti-French (and anti-Scots) clichés of the period after the defeat of the '45 Rebellion. The beef, which is on its way to an inn, is denied to the covetous local inhabitants, and Hogarth represents himself as a plain-speaking Englishman, appalled at the evidence so near to Dover of what he called 'a farcical pomp of war, parade of riligion and Bustle with little very little bussiness...in short poverty slavery and Insolence with an affectation of politeness'. It is a remarkable sign of his own self-importance that he should make an incident in his own life into a History painting, albeit a comic one.

23 *Self-Portrait with Pug: 'Gulielmus Hogarth'*, 1749

Etching and engraving (proof before letters), 372 x 271 mm (sheet)
Lit.: Paulson 181, state 2
1860-7-28-60

This commanding image, which Hogarth has taken from the famous painted self-portrait (Tate Gallery), presents him as a bluff Englishman whose art rests upon his great forebears Shakespeare, Milton and Swift (the titles are visible on the volumes in the painting), implicitly denying foreign or even classical influences on his work (see p. 48). He is shown in 'undress', in informal clothes, but the painting in an earlier version showed him as bewigged, in his public face as a gentleman. The books and the palette referring to the 'Line of Beauty' (see no. 99a) give an intellectual foundation to his rejection of artifice, though he shows his own mastery of pictorial illusion in setting his head within a fictive, unframed canvas.

23

THE SATIRICAL ENGRAVER
AND HIS PUBLIC

An engraving, like any other commodity produced in a commercial society like eighteenth-century London, had to find sufficient members of the public willing to pay for examples to reward the labour involved in its production. The principal stages in the production of a print run were as follows: applying the design to the matrix (the copper plate); the transference of the design on the copper plate to the paper many times over; and then the marketing of the impressions, which in Hogarth's case was almost always in the hands of the artist. The spread of the prints and the continued existence of the copper plate might involve repeated printings from the plate, but also, in the case of Hogarth's most popular designs, a rich inheritance of copies on different types of object, from printed adaptations and fans to the adornment of pottery of various kinds.

Each one of these stages in making the print involved critical decisions for the artist. It was even problematic for an artist to make prints after his own designs, for printmaking carried with it the aura of a craft rather than an art, and several artists of eighteenth century avoided making prints on the deeply held principle that it would mark them as mere 'mechanicks'. Hogarth's own equivocation is demonstrated in his claim that he was too lazy to excel in the craft, and the fact that he often employed other engravers when he was able to afford their services. Hogarth had, of course, no reason to be modest about his skills, but there is no doubt that he regarded painting as a more elevated calling. Nonetheless, he was equally clear that the *moral* impact of his prints made them more important in the social sense, and he claimed to have been prouder to have produced the *Stages of Cruelty* than he would have to have been the author of the Raphael cartoons (*Autobiographical Notes*, 222).

MAKING THE PRINTS

The process of making a print is illustrated by charting the progress of a single design from preliminary drawings through the copper plate to the finished print, with samples of adaptations of the design for other purposes.

24 *Industry and Idleness*, 1747, plate 9:
The Idle 'Prentice betray'd by his Whore & taken in a Night Cellar with his Accomplice

In general, drawings by Hogarth for his moral subject paintings have rarely survived, if they were even made in the first place. It is perhaps significant that there are no drawings known for the series like the Progresses, where the engravings were preceded by paintings, but they exist in relative profusion for those which were not, like the *Hudibras* series, *Stages of Cruelty* and *Industry and Idleness*. All the known drawings for the last series, including two rejected designs, are in the British Museum, as are also the original copper plates.

a) Composition sketch (COLOUR PLATE II)
Pen and wash over pencil, 210 x 289 mm
Lit.: Oppé, no. 58
1896-7-10-20

This drawing with its free pen work represents a stage in the working-out of the final composition. The inn at this point seems more benign than the ghastly underground place in Blood-bowl Alley in the final version. The idea of betrayal by 'his Whore' has not yet entered in, and the large female innkeeper seems more louche than threatening.

b) Final drawing (COLOUR PLATE III)
Pencil, heightened with white on blue paper, 215 x 283 mm
Lit.: Oppé, no. 59
1982-2-27-3

This drawing is very close to the final composition. A layer of black chalk on the back and fine indentations on the surface of the drawing made by a sharp point are evidence that it was used to transfer the design on to the actual copper plate, serving as a guide for the artist to follow in etching and engraving it.

c) The copper plate (COLOUR PLATE IV)
276 x 351 mm
1990-12-15-18

Contrary to the legend that Hogarth's copper plates were melted down for use in shell casings in the First World War, many of them have survived, though heavily worn and reworked after over at least a century's continual printing. This plate seems to be unusually deeply etched and was done in a deliberately simplified manner, as Hogarth tells us (see p. 37), in order to allow for a great many impressions, and perhaps also to make them more accessible to their artisan consumers. Prints taken recently from this plate show how damaged it has been by excessive use. At some time in the late eighteenth or nineteenth century the words 'by his Whore' have been burnished off the title on top of the plate, and the inscription extended to cover the space left. This was no doubt done for prudish reasons, perhaps at the time and under the influence of Dr Trusler (see no. 15), or later.

d) The print (COLOUR PLATE V)
Etching and engraving, 265 x 350 mm
Lit.: Paulson 176
1896-7-10-21

For a discussion of the *Industry and Idleness* series see no. 80 and page 32. This plate shows the final degradation of the Idle Apprentice and the betrayal which leads to him being brought in the next plate before the magistrate, who turns out to be his fellow apprentice Francis Goodchild.

THE DESIGN PROCESS: WORKING ON THE PLATE

Though composition drawings for prints have survived, it is probable that Hogarth habitually made alterations on the copper plate as he went along. This would have been achieved by hammering the back of the plate in the part to be replaced, burnishing it smooth and starting afresh. As a guide, Hogarth would have taken impressions from the plate as he progressed (progress proofs), and sometimes he made alterations in pen on a proof to indicate the recutting. Though such progress proofs were pursued by late eighteenth-century collectors with a zeal bordering on obsession (see p. 58), very few have survived, as Hogarth himself evidently did not value them.

25

25 *Evening*, from *The Four Times of Day*, 25 March 1738

a) Working proof

Etching and engraving by B. Baron and Hogarth, 480 x 400 mm

Lit.: Paulson 148, state 1

1860-7-28-62

This first state lacks, among other things, the scolding girl who causes the child to cry, which appears in the later states. The circumstances in which Hogarth added the figure of the girl are described in an early manuscript note on the print, which, unlike most inscriptions of this kind, seems entirely plausible: 'This proof was Deliver'd by Mr Baron to Mr Hogarth, & it being told him, this Boy has no Apparent Cause to Wimper, he put in his Sister, threatning him to deliver his Gingerbread King, now he put in a Cause. The Charactor [sic] Hogarth altered where he is Crying.' Hogarth would have had to hammer the back of

the plate in the area to contain the girl, and then burnish out some of the vegetation and the figure behind. The cramped and summary quality of the new figure compared to the others reflects the need to fit it into a confined space. Hogarth also added the figure to the original painting (Grimsthorpe Castle, Lincolnshire) as an afterthought. This state of the print is possibly typical of Hogarth's working process, but in most other cases the evidence of his early thoughts is lost or was destroyed by Hogarth himself.

b) An early published impression (COLOUR PLATE I)

Etching and engraving by B. Baron and Hogarth, 485 x 405 mm

Lit.: Paulson 148a, state 2

1868-8-22-1548, bequeathed by Felix Slade

The scolding girl has now been added, as have the words 'SADLERS WELLS' over a door and 'Sr Hugh Middleton' on the signboard. Hogarth (or possibly Baron) has also

THE SATIRICAL ENGRAVER AND HIS PUBLIC

taken the opportunity to alter the boy's expression slightly. In a number of impressions of this state red ink has been printed on to the woman's face and neck, to imply the heat of lust, and her husband's profession of dyer is indicated by blue ink on his hands, added in watercolour. There is a further state in which Hogarth, probably late in life, has adjusted some of the cross-hatching and no longer employs the colouring.

MARKETING THE PRINTS

Hogarth's work on the prints would have been to no avail if he had not applied himself with exceptional ingenuity to finding ways to market them effectively. He was an energetic self-publicist and from the very beginning he advertised in the newspapers and used imaginative ways of getting advance commitments from potential buyers. Many of his more flamboyant gestures, often reported by George Vertue, fit within the diverse patterns used by printmakers to advertise their works, and his own strong public presence was both a cause and consequence of his success in spreading the fame of his prints. His late *Autobiography* is full of evidence of his careful assessment of the market and his search for more profitable ways of captivating sections of his public; it is characteristic of him that the few misjudge-

ments that he made, as, for instance, in the case of the *Sigismunda* painting (see no. 123), caused him extreme anguish.

26 Title page to the large *Hudibras* series, 1726

Letterpress, 262 x 350 mm
Lit.: Paulson, p.59

This letterpress double-sided sheet was issued as a title page for the series of 'TWELVE Excellent and most Diverting PRINTS, Taken from the Celebrated POEM of HUDIBRAS, Wrote by Mr. SAMUEL BUTLER. Exposing the Villany and Hypocrisy of those TIMES'. Hogarth astutely dedicated the series to a famous poet and bookseller in Edinburgh, Allan Ramsay (father of the painter of the same name), and a Northamptonshire country gentleman, William Ward of Great Houghton. The list on the verso contains the names of 192 subscribers. The large *Hudibras* series was, unlike his later moral series, put out by a regular publisher, but it was his first attempt to launch a series of what he called 'Historical' prints. He used the subscription method as a way of raising enough cash to proceed beyond the seven plates he had already completed, and he announced the proposal in early October 1725 for publication the next February. See no. 30 for the frontispiece to the series.

26

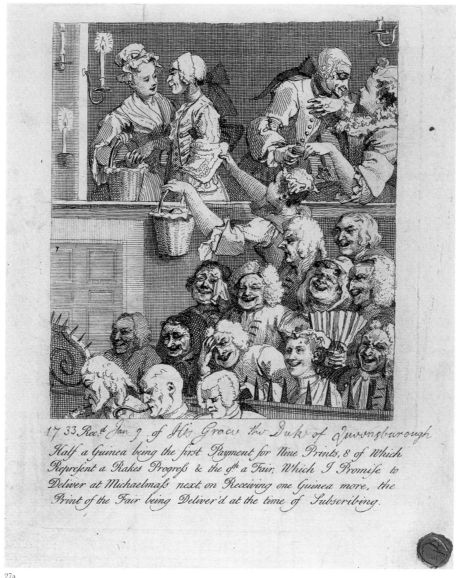

27a

27 Subscription tickets

a) *The Laughing Audience* (receipt for *A Rake's Progress* and
Southwark Fair), 1733
Etching, 233 x 173 mm
Lit.: Paulson 130
1857-5-9-20

Inscribed '1733...Jan 9...His Grace the Duke of Queens-
borough [sic]', presumably Charles Douglas, Third Duke of
Queensberry (1698–1778). The purchaser would have to
wait for over two years to receive the set of the prints of *A
Rake's Progress* because Hogarth waited for his Act to pass
through Parliament (see no. 14) before releasing them. The
audience in the theatre is possibly meant to mirror the
potential audience for the series of prints. The 'gentlemen'

are shown as inattentive, more interested in chatting up the
serving girls; the ordinary people are convulsed with laugh-
ter (all except one grim-faced Puritan). Perhaps both are
missing the point, in being either inattentive or seeing only
the humour of the series.

b) *Paul before Felix: Design'd and scratch'd in the true Dutch taste by
Wm Hogarth* (receipt for *Moses brought to Pharoah's Daughter*
and *Paul before Felix*), 1751 (COLOUR PLATE VI)
Etching, 260 x 400 mm
Lit.: Paulson 191
1857-6-13-13

Inscribed 'June 5 1751' and made out to 'Mr. Fazakerley',
this ticket represents one of the most bizarre incidents in

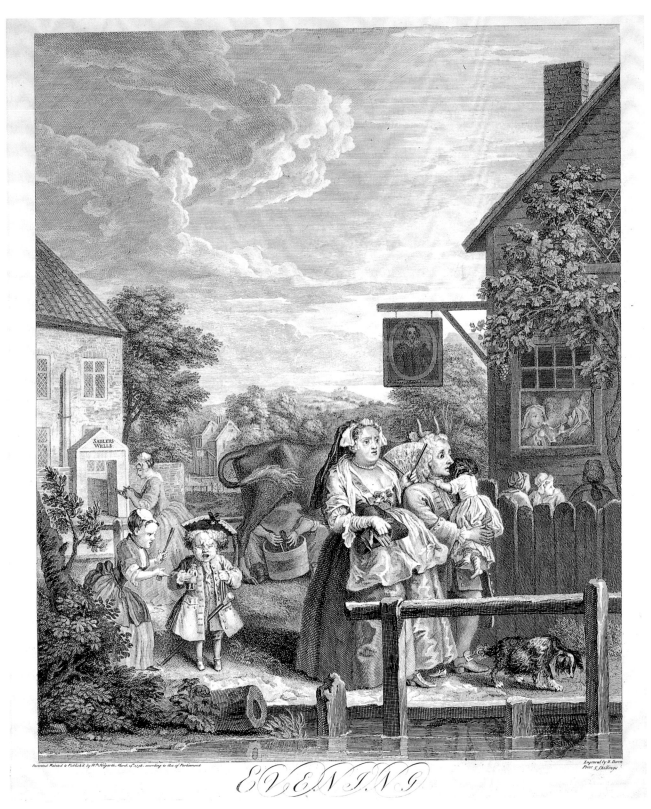

PLATE I No. 25b *Evening*, from *The Four Times of Day*, 25 March 1738, an early published impression.

PLATE II No. 24a *Industry and Idleness*, 1747, plate 9, composition sketch.

PLATE III No. 24b *Industry and Idleness*, 1747, plate 9, final drawing.

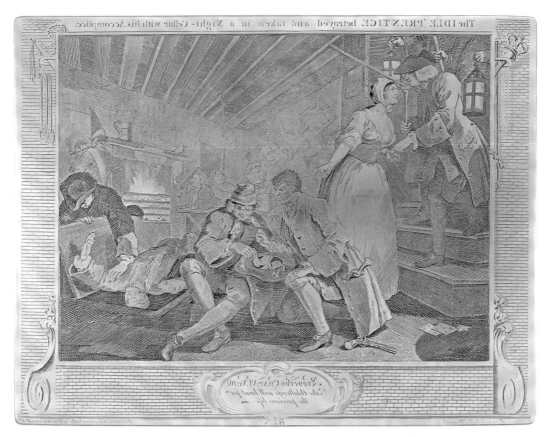

PLATE IV No. 24c *Industry and Idleness*, 1747, plate 9, the copper plate.

PLATE V No. 24d *Industry and Idleness*, 1747, plate 9, the print.

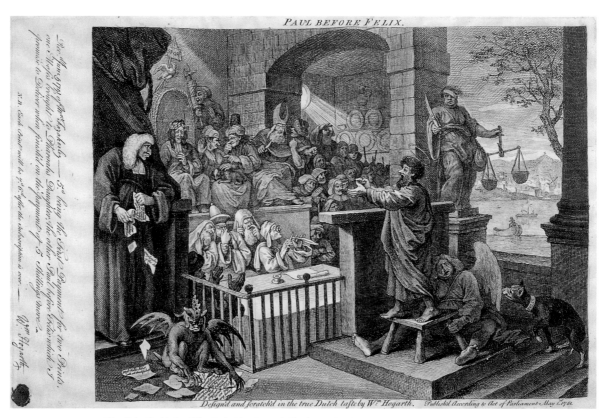

PLATE VI No. 27b *Paul before Felix: Design'd and scratch'd in the true Dutch taste by Wm Hogarth*, 1751, subscription ticket.

PLATE VII No. 107 Paul Sandby, *The Magic Lantern*, 1753.

Hogarth's career. In response to the new taste for Rembrandt etchings, and wishing to make the point about the difference between his own 'Comic History' designs and Dutch art, he made this version of his own *Paul before Felix* painting (fig. 1) as a deliberately coarse parody of a Dutch artist attempting a Biblical subject without any understanding of the elevated style. The Dutch and more specifically Rembrandt (later states are captioned 'Design'd & Etch'd in the rediculous manner of Rembrant, by William Hogarth') are shown to lack propriety (the priests are holding their noses at the smell emitted by Felix) and grandeur (Paul has to stand on a stool to gesture over the witness-box), and to be addicted to homely detail (the plates on the wall in the back room and the 'Dutch' landscape seen through the window). Hogarth presumably hoped that this print would draw attention by contrast to his own successful grasp of the elevated style in the print after the painting of *Paul before*

Felix, but for many it was a further sign of his essential vulgarity to have attempted such a composition in the first place, and it was itself the subject of much ridicule (see nos 103 and 107).

28 *Prints Publish'd by W. Hogarth, and are to be had at his House in Leicester Fields, 1754*

Price list, 265 x 180 mm

1892-4-11-110

Hogarth was by this time offering sets of his prints, or at least the ones for which he still owned the copper plates, in bound volumes. There is a marked difference in price, as one might expect, between the earlier moral series and those directed specifically towards the lower orders. *A Rake's Progress* is also more expensive than the other series, perhaps in reflection of its popularity.

Prints Publish'd by W. HOGARTH, and are to be had at his House in Leicester Fields, 1754.

	l.	s.	d.
Marriage a-la-mode in six prints	1	11	6
Harlot's Progress, in six prints	1	1	0
Rake's Progress, in eight prints	2	2	0
Four times of the Day, in four prints	1	0	0
Strolling actresses dressing in a Barn	0	5	0
Midnight Conversation	0	5	0
Southwark Fair	0	5	0
Before and After, two prints	0	5	0
Distress'd Poet	0	3	0
Enraged Musician	0	3	0
Various Characters of Heads, in five groups	0	2	6
Beer Street and Gin Lane, two prints	0	3	0
Four Stages of Cruelty, four prints	0	6	0
Moses brought to Pharoah's Daughter	0	7	6
Calais, or the Roast Beef of Old England	0	5	0
Paul before Felix	0	7	6
Paul before Felix in the manner of Rembrant	0	0	0
Bishop of Winchester	0	3	0
The effects of Idleness and Industry, exemplified in the Conduct of two Fellow-Prentices, in twelve prints	0	12	0
Lord Lovat	0	1	0
Country-Inn Yard	0	1	0
Sleeping Congregation	0	1	0
March to Finchley	0	10	6
Mr. Garrick in the Character of King Richard the third	0	7	6
Columbus breaking the Egg	0	1	0
Frontispiece	0	3	0

N. B. If any one purchases the whole together, they will have them deliver'd bound, at the Price of ten Guineas, and a sufficient Margin will be left for Framing.

Where likewise may be had,

The ANALYSIS of BEAUTY, with two explanatory Prints, price 15 Shillings.

28

MODES OF SATIRE

The practice of visual satire had developed long before Hogarth a typology which distinguished between political and more general types of moral satire. He seems to have been acutely conscious from the beginning of his career of the work of contemporary literary satirists like Pope and

29

Swift, who were aware of satire's ancient origins (see p. 39). Yet satire, whatever its traditions, was by definition topical and therefore directly responsive to living persons as well as vice in the abstract. Hogarth's period also saw the emergence of humorous caricature as a distinctive mode involving the exaggeration of individual features, and its development as a political weapon.

SATIRE AND SATYR PLAY

It was well understood in Hogarth's time that the word 'satire' did not derive from the Greek *satyr*, or cloven-hoofed follower of Dionysus, but satyrs often play a part in the satire of the period in mocking the barely restrained lust and self-delusion that lie behind human desires.

29 Frontispiece to Charles Gildon, *New Metamorphosis*, 1724

Etching, 146 x 82 mm
Lit.: Paulson 45
Lent by the British Library, 1079.d.18

Gildon's *New Metamorphosis* is an updating of Apuleius's *Golden Ass*, 'Altered and Improved to the Modern Times and Manners' but transposed to an Italian city rather than contemporary London. Here the satyrs act as curtain-raisers (see no. 31) but also leer cynically at the lechery which lies behind the facade of a Catholic society. The 'author' is 'a fine Bologna Lap-Dog' rather than Apuleius's ass. The design is not Hogarth's but is based on the frontispiece to the edition of 1708.

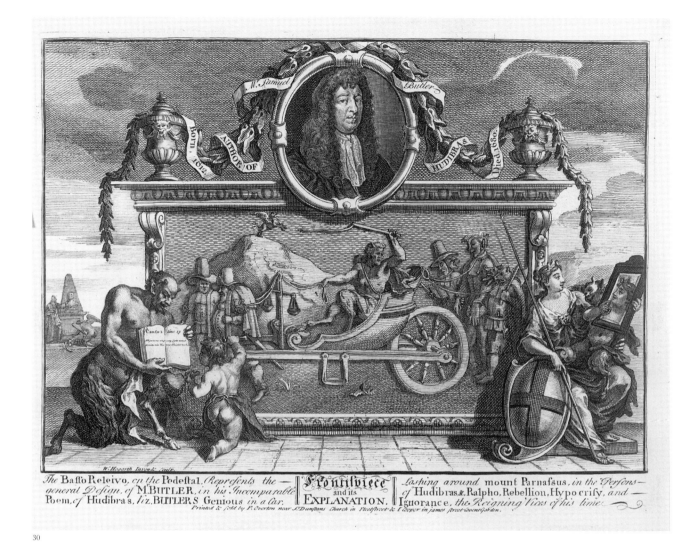

The Baſſo Releivo, on the Pedeſtal, Repreſents the — Frontiſpiece Laſhing around mount Parnaſsus, in the Perſons — general Deſign, of M.BUTLER, in his Incomparable and its of Hudibras, & Ralpho, Rebellion, Hypocriſy, and — Poem, of Hudibras, Viz.BUTLERS Genious in a Car, EXPLANATION. Ignorance, the Reigning Vices of his time

Printed & ſold by P. Overton near S.Dunſtans Church in Fleetſtreet & I. Cooper in james ſtreet Coventgarden.

30

30 Frontispiece to the large *Hudibras* series, 1726

Etching and engraving, 265 x 350 mm

Lit.: Paulson 82

1847-5-8-8

The sarcophagus in the centre represents Hudibras and his adventures allegorically on a fictive bas-relief, perhaps in reference to the lines on the title page addressed to Samuel Butler:

Thy Verse all monuments does far surpass,

No Mausoleum's like thy Hudibras.

'Butler's Genious [sic]' is represented by a satyr in a chariot lashing 'Rebellion, Hypocrisy and Ignorance'. This satyr symbolises nature as opposed to the repressive Puritanism represented by Hudibras and Ralpho, the anti-heroes of the poem, who pull the chariot. A satyr on the left holds a volume of *Hudibras* open for the cherub carving the bas-relief, while on the other side a grinning faun seated on Britannia's knee holds a mirror to her face, pointing to her reflection. The implication is that Hudibras and his ilk are still a presence and that the poem is relevant to present times and not just the previous troubled century.

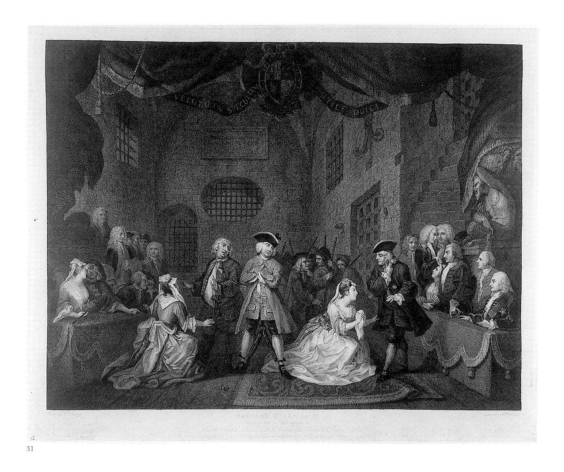

31

THE VICES OR THE PERSONS?

Hogarth, in common with other satirists, claimed to attack vices rather than persons (see p. 33), but in practice few satirists could avoid identifying vices with particular individuals, living or dead. Dryden justified assaults on 'public nuisances', a category which would certainly have included Colonel Charteris and Mother Needham (see no. 32).

31 *The Beggar's Opera*, 1790

Etching and engraving by William Blake, 447 x 570 mm, published by
 Josiah Boydell

Lit.: R. Essick, *William Blake's Commercial Book Illustrations*, Oxford, 1991,
 no. XX; *Among the Whores and Thieves*, nos 37–9

1858-4-17-473

This print was engraved by William Blake from one of five versions of the painting of *The Beggar's Opera* made by Hogarth between 1728 and 1731. Hogarth effectively

exploited the sensation caused by John Gay's famous ballad opera, which opened in January 1728, by adding in, in the later versions of the painting, an audience in which well-known personalities could be identified. In the two last versions (Tate Gallery and Yale Center for British Art, New Haven; the latter, dated 1729, is the version copied by Blake) Hogarth has brought in the Duke of Bolton on the far right (wearing the Order of Bath). He stares intently at Polly, played by Lavinia Fenton who became his mistress at this time and eventually his duchess. The satyr holding the curtain above, evidently derived from ones actually in the Lincoln's Inn Theatre, points towards him, perhaps signifying the power of lust (see p. 40). *The Beggar's Opera* itself was taken by many to be an attack on the Prime Minister Sir Robert Walpole, but is now generally thought to be a broad critique of the corruption of society, reversing the roles of all the protagonists: the highwayman is a noble gentleman and the upholders of the law are shown as more crooked and self-seeking than the criminals themselves.

32 *A Harlot's Progress*, 1732, plate 1

Etching and engraving, 315 x 393 mm

Lit.: Paulson 121

1858-4-17-544

The Harlot, still an innocent country girl, is met from the York stage not by a stereotypical bawd but by Mother Needham, owner of a fashionable brothel who was known to dress in a ladylike manner and who features widely in the satirical literature of the period. Standing in a doorway, witnessing and presumably encouraging the meeting, is Colonel Francis Charteris (see nos 33 and 34 below), a notorious seducer known as the 'Rape-Master of Great Britain'. Needham had died in May 1731 and Charteris in February 1732, and for contemporary authors like Pope and Fielding they were convenient exemplars of the corruption of social life in the period. Both were known for concealing behind a respectable facade a relish for vice, both sexual and financial. Charteris was believed to have profited from, and to have had his neck saved by, his support of Walpole. They were, then, both 'real people' and at the same time symbols of the corruption of the times.

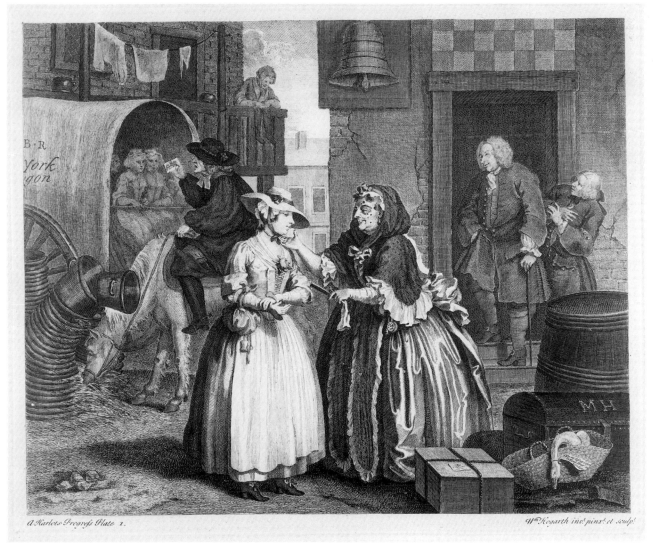

32

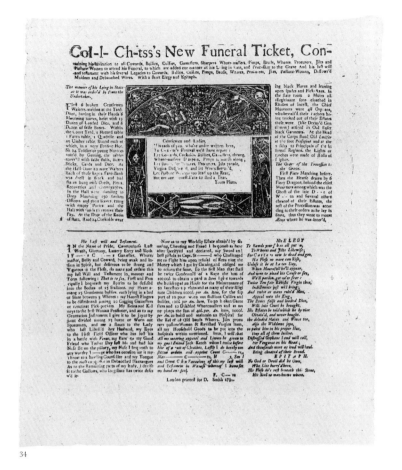

33

34

ANONYMOUS

33 Colonel Francisco [Charteris], 1740

Mezzotint, 337 x 238 mm

Lit.: BMC 1840

1864-8-13-46

The medium of the mezzotint, with its evocation of Kneller portraits, implicitly makes the point that Charteris was a 'respectable' figure, a man of gentlemanly birth though a crook and a rapist. The artist is unknown but was possibly one of the highly skilled mezzotinters who provided prints after portrait painters of the period.

ANONYMOUS

34 Col-l- Ch-tss's New Funeral Ticket, 1731/2

Broadside with woodcut 'funeral ticket', 440 x 370 mm (sheet), 345 x 276 mm (text); published for D. Smith

1953-4-11-71, bequeathed by E.H.W. Meyerstein

Such ephemeral broadsides have barely survived from the early eighteenth century, though they must have been a staple of life on the London streets. It is a comic and scurrilous description of Charteris's funeral, complete with mock funeral ticket in woodcut.

35

36

35 *Orator Henley Christening a Child, c.* 1729

Oil sketch on canvas, 312 x 233 mm

Lit.: E. C.-M. 7; Lindsay Stainton and Christopher White, *Drawing in
 England from Hilliard to Hogarth*, British Museum Press, 1987, no. 199;
 Graham Midgley, *The Life of Orator Henley*, Oxford, 1973

Oo.5-3, bequeathed by Richard Payne-Knight

The Orator Henley, Pope's 'great Zany of the Age', was a
notorious clergyman who set up a private chapel where he
prided himself on his oratory. He had also been a Whig
polemicist and informer for Walpole, so he became to the
opposition an example of the way in which religion had
been brought into disrepute by the Walpole government.
This oil sketch is for a painting in a private collection (Beck-
ett, pl. 16), and an early mezzotint was made of it by Joseph
Sympson (Burke and Caldwell, pl. 133). The orator is evi-
dently distracted by the young woman to his left, adding
lust to his other weaknesses.

ANONYMOUS

36 *Orator Henley Preaching*

Ivory plaque, 94 x 115 mm

Department of Medieval and Later Antiquities, British Museum
1878, 1101.42

This rare work in ivory, despite its luxurious material,
belongs to the same satirical world as the works above.
Apart from showing the orator in his full absurdity,
it also makes reference to Charteris on a memorial tablet
on the floor.

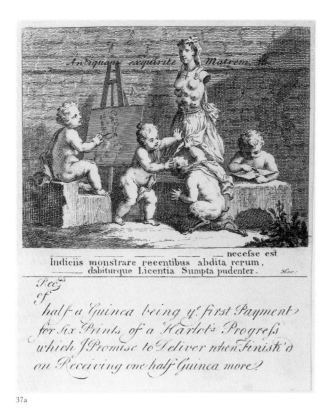

37a

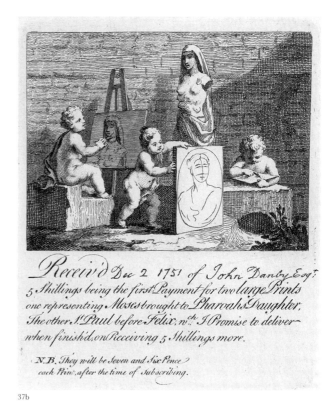

37b

NATURE AND PRURIENCE

Satire which purported to look unsparingly at sexual vice was almost bound to be at the same time titillating, and this was well understood and frequently exploited in the early eighteenth century. Satirists, and this was true of Hogarth especially in the early 1730s, often deliberately walked the line between making vice 'loathsome' while knowingly offering images that exploited its visual appeal. Hogarth's ticket for *A Harlot's Progress* is perhaps a disingenuous attempt to clothe the series in the high-minded terms of nature and antiquity, while the *Before* and *After* engravings, though full of moralising references, are more obviously exploitative.

37 *Boys Peeping at Nature*

a) First version, 1731
Etching, 148 x 121 mm
Lit.: Paulson 120, state 1
1857-5-9-17
b) Second version, 1751
Etching, 150 x 125 mm
Lit.: Paulson 120, state 4
1857-5-9-18

The first state of this print was designed as a ticket for *A Harlot's Progress*, but its iconographic language is strikingly different from the series itself (see p. 39), belonging more with the allegorical traditions of the frontispiece, particularly those to art treatises. Paulson cites the frontispiece to

De Lairesse's *Art of Painting*, 1707, a work that would have been known to Hogarth. The many-breasted statue of Nature is having her skirts raised by a faun who represents animal sexuality, but he is pushed away by one of the three putti, the other two evidently standing for painting and printmaking (one seems clearly to be applying a burin to a copper plate). The implication seems to be that the arts are aware of the hidden side of nature but do not approach it lustfully, i.e. *A Harlot's Progress* should be seen as a work which faces up to nature but not with prurient intent.

The plate was subsequently used as a ticket for *Strolling Actresses Dressing in a Barn* (no. 96) and *The Four Times of Day*. It was then reworked substantially about 1750, removing the faun, and used as a ticket for the prints of *Moses brought to Pharoah's Daughter* (no. 79) and *Paul before Felix* (see fig. 1).

38a & b *Before* and *After*, 1736

Etching and engraving, (a) 405 x 325 mm, (b) 403 x 328 mm
Lit.: Paulson 141–2
1826-3-13-18 & 20

Though there are signs of moralising (the volumes 'novels' and 'Rochester', the distorted face of the lover in *Before*, and the motto 'Omne animal post coitum triste' in *After*), it would be disingenuous to regard this pair of prints as primarily moralistic. There are two versions of the paintings, an indoor scene (Getty Museum, Los Angeles) and an outdoor scene (Fitzwilliam Museum, Cambridge), and both sets were sold to wealthy patrons. Such 'libertine' paintings and prints had a clientele in Hogarth's time, and, as Vertue noted in connection with the origins of *A Harlot's Progress* (see p. 30), Hogarth was not always in a position to scorn it. The emphasis on the physical untidiness of the sexual act is perhaps also intended as a comment on the more oblique and idealised sexuality of the French pastoral.

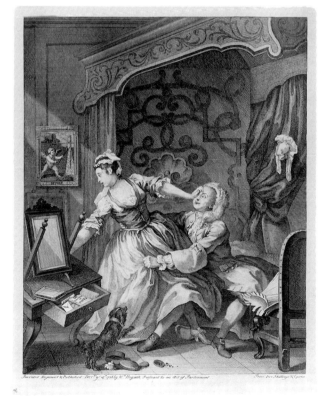

38a

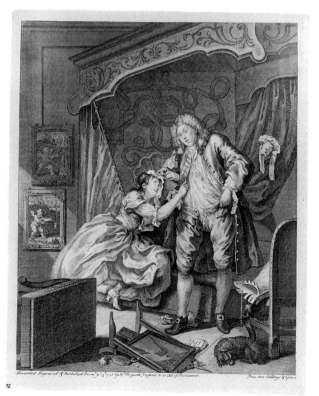

38b

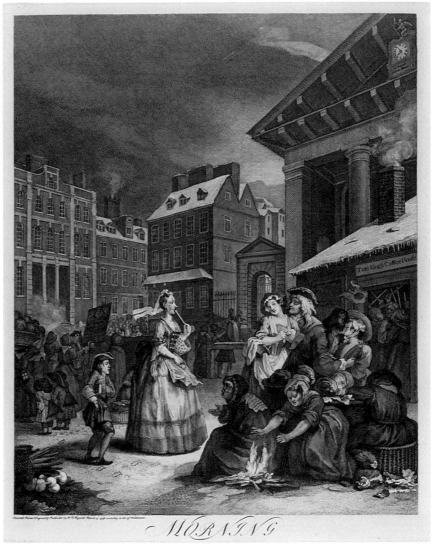

40a

THE COMEDY OF THE STREETS

———————

The tradition of the poet/satirist as observer of life on the streets, with its chance meetings and altercations, goes back at least to Juvenal in the first century. Moralising accounts of the incidents and injustices of city life were readily transposed from Rome to London in satirical literature from the seventeenth century onwards. Hogarth's scenes of street life can be related directly to such literary traditions (see p. 37).

(see p. 37)

JOHN GAY

39 *Trivia, or the Art of Walking the Streets of London*, 1716 (not illustrated)

Printed book

Lit.: S. Copley and I. Haywood, 'Luxury, Refuse and Poetry: John Gay's *Trivia*', in P. Lewis and N. Wood, *John Gay and the Scriblerians*, London, 1988, 62–82

Lent by the British Library, 11626.f.4

The poem purports to be a realistic account of the cityscape of London, but it is full of echoes of earlier poetry and its moral concerns, owing much to Juvenal's Third Satire (see p. 36). Nonetheless, it faces squarely the hazards of walking in London, and the filth and waste attendant on prosperity and luxury, a theme common in the literature of the time.

(see p. 36)

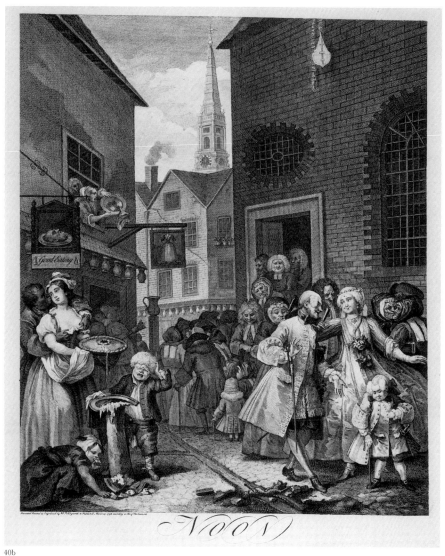

40b

40 *The Four Times of Day*, 1738

Etching and engraving
a) *Morning*
488 x 397 mm
Lit.: Paulson 146
1868-8-22-1546, bequeathed by Felix Slade
b) *Noon*
488 x 406 mm
Lit.: Paulson 147
1868-8-22-1547, bequeathed by Felix Slade

Both these images give views of 'typical' street scenes, and something of the confusion and variety of incident in an average day in the city. Yet the groups are organised artfully to convey moral confrontations: in *Morning*, between the prudishness and callousness of the churchgoing lady, accompanied by her freezing footboy, and the dissolute crowd outside Tom King's Coffee House; and in *Noon* between English disorder on the left and French formality on the right (see p. 38).

(see p. 38).

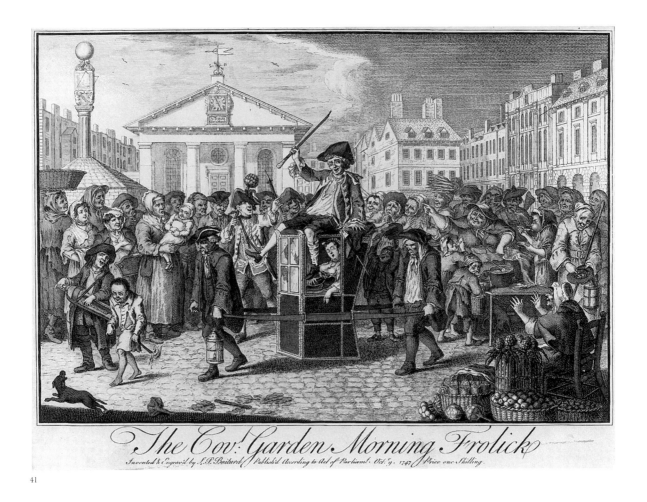

The Cov.^t Garden Morning Frolick

Invented & Engrav'd by L.P. Boitard / Publish'd According to Act of Parliam.^t Oct.^r 9. 1747 / Price one Shilling.

41

L.P. BOITARD

41 *The Cov[ent] Garden Morning Frolick,* 1747

Etching and engraving, 246 x 321 mm

Lit.: BMC 2877; Döring, 158 & 168

1860-6-23-29

Covent Garden Piazza in the eighteenth century was one of the prime sites of class confrontation, where the wealthy in their carriages might encounter notorious low-life and criminal characters. In this case a sleeping lady in masquerade dress is oblivious to the jeers she attracts, the disturbance caused and the humiliation of her carriers. Boitard's image may owe something to Hogarth, though a tradition of painting the activities of Covent Garden goes back at least to the 1720s. It is notable that a number of the inhabitants can be identified: the small boy leading the procession, for instance, is the infamous 'Little Casey', a legendary nine-year-old pickpocket.

CHARACTER AND CARICATURE

Caricature, the exaggeration of a single element of an individual's physiognomy for comic effect, was by no means a new form in the eighteenth century, but it was given new life in Rome by the Grand Tour. It was brought back to England by gentlemen and artists who had learned from the example of Italian artists like Pier Leone Ghezzi, and were able to achieve comic results without training or unusual skill in drawing.

42 *Characters and Caricaturas,* 1743

Etching, 258 x 204 mm

Lit.: Paulson 156

1848-11-25-209

This *tour de force* of etching, originally designed as a subscription ticket for the *Marriage A-la-Mode* series, demon-

strates the difference between the depiction of 'character', in which, as Fielding put it in the Preface to *Joseph Andrews*, figures express 'Affections' and 'appear to think', and that of 'caricaturas', where the artist paints 'a Man with a Nose, or any other Feature of a preposterous Size, or to expose him in some absurd or monstrous Attitude'. The lowest level of heads makes the contrast explicit by contrasting 'characters' from the Raphael Cartoons with 'caricaturas' derived from Ghezzi, Carracci and Leonardo; a graffiti head in the background emphasises the reductive and mindless nature of caricature. The heads above demonstrate not only the com-

plexity of character but also its variety, as against the necessarily formulaic and limited possibilities of caricature. Hogarth's vehemence on the subject stems from his appreciation of Fielding's highly flattering description of him as a 'Comic History Painter' but also from his dislike of caricature as a pastime of the 'Connoisseurs', who picked up the technique in a rudimentary form on the Grand Tour. The success of the Marquess of Townshend as a political caricaturist in the mid-1750s (see no. 44) was further to darken Hogarth's later years.

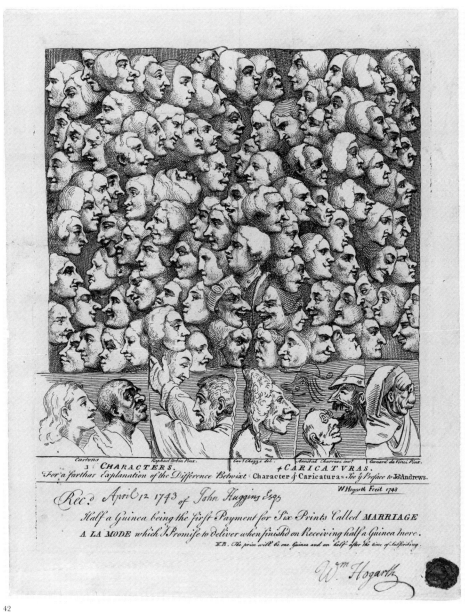

42

43

P.L. GHEZZI

43 *Thomas Bentley*, *c.* 1725–6

Etching, 340 x 220 mm

Lit.: Dictionary of National Biography

1873-7-12-643

It is not clear whether Hogarth simply chose this head randomly for his *Characters and Caricaturas* (no. 42) as an example of Ghezzi's caricature or whether he was aware of the identity of the subject. He was Thomas Bentley (1693?–1742), classical scholar and nephew of the famous and notoriously cantankerous academic, Richard Bentley, who was master of Trinity College, Cambridge. Thomas was a prolific and well-respected scholar of Greek and Latin authors who spent the years 1725–6 travelling through Europe, including Rome. Ghezzi, who was a professional painter as well as caricaturist, was important not only for the example of his caricatures but for his particular relationship to English gentlemen on the Grand Tour. They bought caricatures of themselves and their friends from him, and were evidently encouraged by him to try their hand at caricature themselves. Certainly caricature as an aristocratic fashion originated in Rome; Hogarth claimed that it needed none of the drawing and intellectual skills demanded by the representation of character, though he does in *The Analysis of Beauty* betray a fascination with its methods.

GEORGE TOWNSHEND, FOURTH VISCOUNT AND FIRST MARQUESS

44 *The Recruiting Serjeant or Brittanniais* [sic] *Happy Prospect*, 1757

Etching, 197 x 30 mm, published by M. Darly

Lit.: BMC 3581; Donald, 49

1868-8-8-4057

Townshend was typical of the gentleman amateurs who learned to make caricatures on the Grand Tour. His enduring importance came from the fact that he applied the technique to his fellow politicians, using caricature to lampoon those he opposed, in this case, among others, Lord Winchelsea, Henry Fox, Bubb Doddington and the Duke of Cumberland. Townshend was clearly responsible only for providing drawings of the outlines of the main figures; the background and colouring were done by the Darly workshop. Hogarth was enraged by Townshend, to whom he ironically dedicated the first state of the print *The Bench*, 1758 (Paulson 205), though there are indications that Hogarth was interested in the comic effects achieved by a purely linear method. It is signed jokingly 'Leonardo da Vinci invt', a recognition of Leonardo's role as 'inventor' of caricature.

44

THE TARGETS OF SATIRE:
THE ORDERS OF SOCIETY

Hogarth's satirical series rest upon the assumption that society is made up of three separate and distinct orders: the aristocracy and landed gentry; the professional and commercial classes; and the poor. Other constructions of the English class system were made by social commentators in the period, but the tripartite scheme can be taken as conventional, though it gives an unrealistically rigid picture of a society notable more than anything for fluidity of social movement in a period of growing prosperity. Hogarth, it needs to be said again, despite the 'truth effect' of his work, for the most part depicts not individuals but stereotypes familiar from other types of fiction, with a few 'real' people, like notorious criminals and opera singers, to give an air of authenticity.

CROSSING THE CLASS BARRIERS: THE FATE OF TRANSGRESSORS

In Hogarth's vision of society those who seek to move out of their own social class by any other means but hard work and conspicuous virtue come to a bad end. The Harlot and the Rake both reach nemesis at the point at which their social ambitions are about to be realised. Aristocrats whose pursuit of luxury forces them to sell out to the middle classes are also damned. Yet upward mobility is possible for the apprentice who works hard and virtuously; he can, like the Industrious Apprentice, become a workshop owner and have a respectable place in the City of London, while his idle counterpart falls lower into the criminal underworld. In the Progresses and *Marriage A-la-Mode* repudiation of one's social class is an act which leads inevitably to the loss of innocence and ultimate catastrophe.

45 *A Harlot's Progress*, 1732, plate 2

Etching and engraving, 310 x 378 mm

Lit.: Paulson 122

1858-4-17-545

The Harlot has been transformed from fresh country girl to kept mistress of a Jewish merchant. She has by now, and much time must have passed since her seduction by Colonel Charteris (see nos 32–4), wholly adopted the manners and way of life of a feckless woman of the aristocracy, and these are signalled by objects around her. She has become addicted to masquerades (see no. 51), owns a pet monkey and a black pageboy, and has a young lover. She is nonetheless bored and dissatisfied, hence her petulant disruption of her keeper's house to allow her lover to escape. The Jew is also an *arriviste*, an ape of his social superiors, for he adopts genteel customs like taking tea and collecting Old Master paintings, though his claims to gentility are based only on wealth. The transgression of class barriers, Hogarth warns us, leads to boredom and insecurity, and then to social catastrophe.

46 *A Rake's Progress*, 1735, plate 2

Etching and engraving, 355 x 408 mm

Lit.: Paulson 133

1858-4-17-559

In the first plate of the series (no. 13) the Rake is revealed as a merchant's son whose spendthrift ways follow from his father's miserliness. The Rake's dismissal of his pregnant fiancée as he is measured for a suit announces his intention to enter the social world of London. In this plate we see his

45

46

wholesale adoption of aristocratic modes like the Levée, where petitioners may, like the subjects of the French king, offer their wares during the Rake's rising in the morning. The parade of potential hangers-on, ranging from dancing masters and landscape gardeners to bodyguards and Grub Street hacks, is both a satire of aristocratic tastes and pastimes and a critique of those who, like the Rake, seek to rise above their 'true' station in life.

47

47 *Marriage A-la-Mode*, 1745, plate 1

Engraving by G. Scotin, 383 x 462 mm

Lit.: Paulson 158

1857-2-28-63

The transaction between the Earl of Squanderfield and the merchant, to sell the Earl's son in marriage to the latter's daughter, is the result of the unfortunate collusion of the characteristic vices of each class; the merchant seeks to raise his social standing by offering wealth in order to acquire the prerogative of birth and manners, and the aristocrat is obliged to enter into the unsavoury agreement because of his extravagance and addiction to foreign architecture and art.

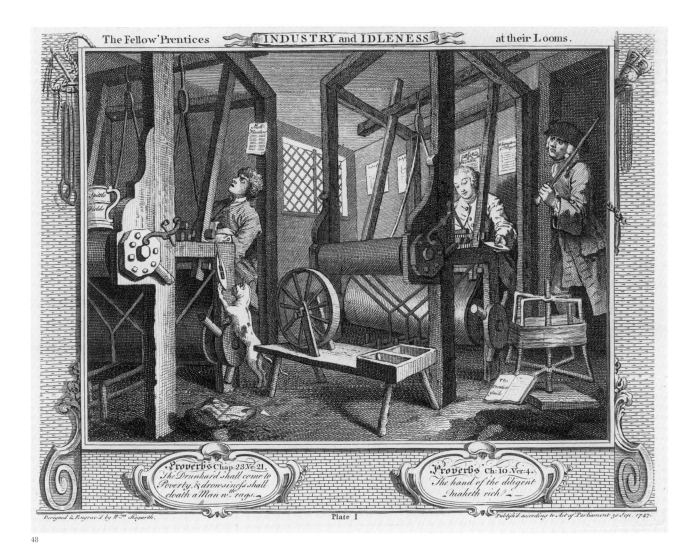

48

48 *Industry and Idleness*, 1747,
plate 1: *The Fellow 'Prentices at their Looms*

Etching and engraving, 265 x 350 mm

Lit.: Paulson 168

1896-7-10-3

In this, the first plate of the series, the social destination of
the two apprentices is seen as a matter of choice. Choosing
to work hard can lead to steady advancement through the
City of London to reach the pinnacle of Lord Mayor of
London; idleness leads with greater inevitability to crimi-
nality and the gallows.

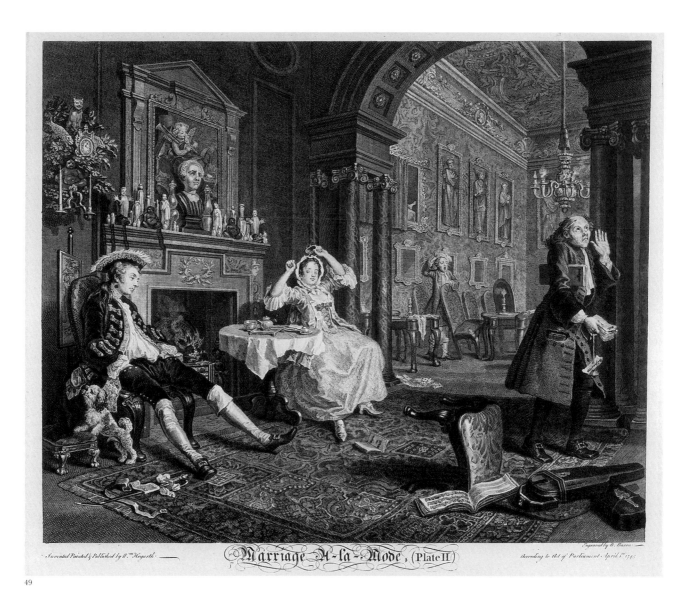

49

Invented Painted & Published by W.m Hogarth — *Marriage-A-la-Mode*, (Plate II) *Engraved by B. Baron* *According to Act of Parliament. April 1.st 1745.*

ARISTOCRATS: REAL AND IMAGINED

THE LIFE OF LUXURY

The high life in Hogarth's moral subjects is always described through possessions. Hogarth's aristocrats are depicted as living empty lives amid the display of expensive consumer goods and the presence of hangers-on. They are seen in their London houses, not in the more 'natural' setting of their rural estates. Their very presence in fashionable London suggests their renunciation of their duties and alienation from their fellow countrymen. Their lack of public spirit is expressed in a taste for foreign goods and the adoption of foreign habits.

49 *Marriage A-la-Mode*, 1745, plate 2

Etching and engraving by B. Baron, 385 x 464 mm
Lit.: Paulson 159
Cc.2-139

The aristocratic life is expressed in the wealth and fashionability of the grand setting in a Palladian house in the West End of London. In this breakfast scene every object and its juxtaposition tells of extravagance and ignorance, and of the adoption of false values by those who fail to live up to their rank and its responsibilities. The Viscount feels only the ennui of the physically sated as he slumps in his chair; his bourgeois wife by contrast exults in the role of aristocratic lady of leisure, her sleepless night leaving her triumphant. Their lives are presented as worthless, but the disapproving steward with a sheaf of bills and a Methodist

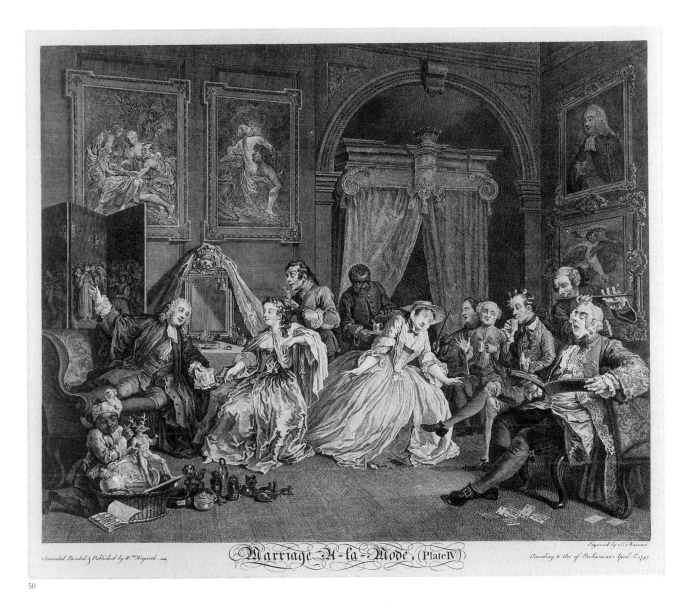

50

sermon protruding from his pocket offers no alternative; his joylessness is equally remote from a balanced attitude towards the world.

with the lawyer Silvertongue, as indicated by the masquerade tickets in his hand and the screen behind. She also consorts with effeminate foreign dancing masters and castrati.

50 *Marriage A-la-Mode*, 1745, plate 4

Engraving by S. Ravenet, 386 x 465 mm

Lit.: Paulson 161

1857-2-28-67

The new Countess, like the Rake, has transcended her bourgeois origins to act out a fantasy of the aristocratic life. Her morning Levée itself is an aristocratic affectation (see no. 46), but here her pursuit of the high life is given a strong sexual element; though a wife, she has become a harlot, betraying her husband to arrange an assignation

Could new dumb Faustus, to reform the Age,
Conjure up Shakespear's or Ben Johnson's Ghost,
They'd blush for shame, to see the English Stage
Debauch'd by foolries, at so great a cost.

What would their Manes say? should they behold
Monsters and Masquerades, where usefull Plays
Adorn'd the fruitfull Theatre of old.
And Rival Wits contended for the Bays.

Price 1 Shilling.1724

51

TASTE AND CONNOISSEURSHIP

Old Master paintings were an integral part of the furnishings of the homes of Hogarth's aristocrats and their parvenu imitators. They signify in his work wealth, detachment from real life, preference for Italian and French art, and the consequent rejection of British painters like Hogarth himself. The standing of Old Master paintings among the kind of gentlemen who had been on the Grand Tour rested on the idea that the exercise of artistic discrimination was allied with moral judgement. The art to be acquired by what the Earl of Shaftesbury called 'the Well-bred Man' would appeal to reason and not merely to the senses, and would be based on a close study of antique sculpture and the great monuments of Italy. In practice these ideals were often reduced to the fevered pursuit by the wealthy of often dubious antique sculptures and paintings for their country houses. This led to the rise of art experts and dealers who, in Hogarth's jaundiced view, passed on dubious knowledge and doubtful paintings to ignorant aristocrats, whom they flattered as 'Connoisseurs' or persons of fine discrimination.

51 *Masquerades and Operas (The Bad Taste of the Town)*, 1724

Etching and engraving, 130 x 176 mm (image)
Lit.: Paulson 44
1857-5-9-13

One of Hogarth's earliest satires and the first on the subject of 'foreign' taste and the failings of the leaders of taste, represented in this case by the Earl of Burlington and his assistant William Kent. The portico of the 'Accademy of Art' in the background is surmounted by a standing figure of Kent, who was a painter, architect and designer, with Michelangelo and Raphael as supporting figures. In bundling together Burlington's Italianate taste with the taste for Italian opera, masquerades and Harlequin adaptations of classic plays, Hogarth was expressing solidarity with old English playwrights consigned to waste paper, and perhaps also with Sir Christopher Wren and his followers, who had effectively been supplanted by the influence of Burlington. The more immediate occasion for the print may have been a desire to support his future father-in-law Sir James Thornhill in his growing rivalry with the Burlington circle over architectural and wall-painting commissions.

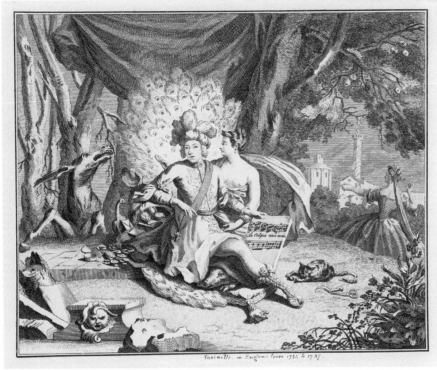

52

ANONYMOUS

52 *Farinelli and His Gifts*

Etching, 230 x 277 mm

Lit.: BMC 2337; Diane Waggoner in *Among the Whores and Thieves*, 41–55;
Döring, 96 (after Gravelot)

1868-8-8-3587

The fame of Farinelli, the great castrato singer was enormous, and he was the most admired singer of his time in his brief English period between 1731 and 1737. From the very advent of Italian opera in England in 1709 there had been a continuous barrage of complaint from periodical authors, including Joseph Addison, who remarked on the use of Italian, the elaborate staging and supposed incoherence of the plots, and the complexity and foreignness of the productions. Audiences, given the calibre of composers like Handel, were captivated, and remained faithful into the 1730s, despite the brilliance of such satires as Gay's *Beggar's*

Opera (see no. 31). The association of opera with aristocratic taste made it particularly vulnerable to satire, and an opera composer plays a part in the apparatus of the Rake's assumption of the high life (see no. 46). Much schoolboyish ribaldry was focused on the castrati, who were evidently adored by aristocratic women, but were regarded by hostile writers as unmanly. This print, almost certainly engraved by a French engraver near in style to Hubert-François Gravelot, plays outrageously on the obvious sexual innuendos. Farinelli leans against a cornucopia filled with gifts from admirers, a donkey brays and a peacock alludes to his vanity. A muse beside him, in the coy words of the Victorian cataloguer F.G. Stephens, 'holds, with one hand, a part of his person, and with the thumb and fore-finger of the other, indicates the smallness of its dimensions', while a cat plays with the singer's cut-off testicles.

PAUL SANDBY

53 *The Vertu Scavenger, c.* 1757

Etching, 278 x 202 mm

Lit.: BMC 3647; Iain Pears, *The Discovery of Painting: The Growth of Interest
in the Arts in England*, New Haven and London, 1988, 92–6

1868-8-8-4092

A satire on Robert Bragge, a gentleman-dealer in Old
Master paintings, who represented everything that Hogarth
despised about the art trade. Bragge held auctions continu-
ously through the 1740s and 1750s, importing paintings in
great numbers from abroad and publicising them exten-
sively for sale to those who aspired to gentility. As Pears
notes, Bragge's expertise was based on a claim to taste as
the prerogative of the gentleman, while Hogarth (*Analysis*,
iii–v) claimed that true discrimination came only from the
painter's superior knowledge. Bragge attracted particular
animosity and satire, perhaps because of his claim to be a
gentleman. It is ironical that this caricature should have
been made by Paul Sandby, who had made several of
Hogarth himself around this time (see nos 103–9).

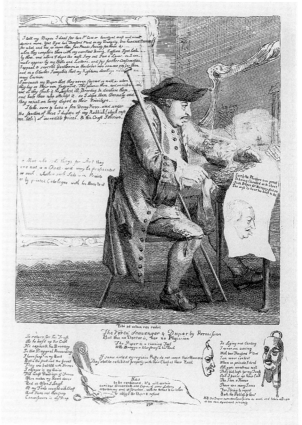

53

54

54 *The Battle of the Pictures*, 1745

Etching, 201 x 214 mm

Lit.: Paulson 157

Cc.1-137

A witty reprise of the literary conflict between Ancients and Moderns, here shown as a battle of pictures rather than books. The print was issued as a ticket for the private auction Hogarth held in 1745 to sell his stock of paintings,

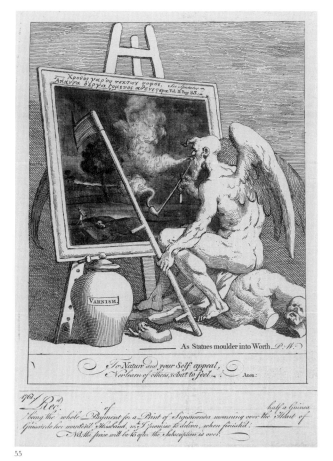

55

mainly works from which he derived his prints, including the Harlot's and Rake's Progresses and the *Times of Day*. The elaborate system of advanced bids was in itself a criticism of the doubtful practices of auctioning Old Master paintings, and an attempt to find a way of marketing modern paintings. Hogarth distances himself from the taste for old paintings, claiming his own paintings to be contemporary equivalents of earlier types. The breakfast scene from *Marriage A-la-Mode* is attacked by the ancient Roman wall-painting *Aldobrandini Wedding*, *Midnight Modern Conversation* by a Rubensian Bacchic procession, the brothel scene from *A Rake's Progress* by a *Feast of the Gods*, while plate 3 of *A Harlot's Progress* set in Drury Lane is speared by a *Penitent Magdalen*, and the Prude in *Morning* is sliced in two by a monastic saint. The ranks of the Old Master paintings on the left suggest the mass production of dubious Old Masters for ignorant Connoisseurs, and the essential speciousness of the market presided over by auctioneers such as Christopher Cock and dealers such as Robert Bragge.

55 *Time Smoking a Picture*, 1761

Etching and mezzotint, 263 x 185 mm

Lit.: Paulson 208

1857-5-9-15

Originally issued by Hogarth as a subscription ticket for an engraving of *Sigismunda* after his painting (Tate Gallery), though the engraving was never completed (no. 123). This is Hogarth's most consciously learned image, using quotations from quite obscure classical texts to support his challenge to the 'gentlemanly' taste for old and darkened Italian paintings. From the 1730s onwards he had railed consistently against the taste for dubious Old Master paintings, authenticated by such Connoisseurs and dealers as Robert Bragge (see no. 53).

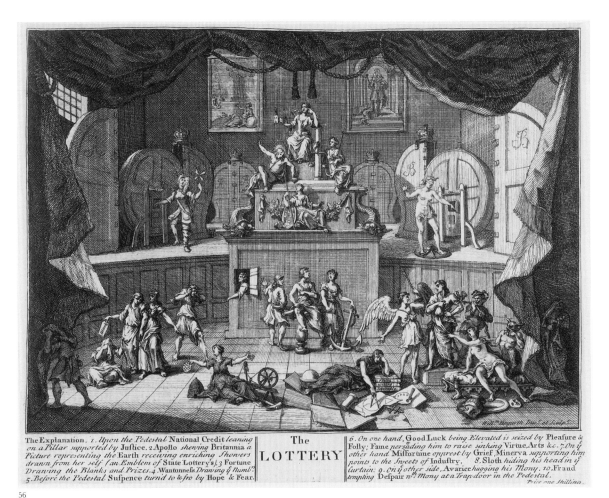

The Explanation. 1. Upon the Pedestal National Credit leaning on a Pillar supported by Justice. 2. Apollo shewing Britannia a Picture representing the Earth receiving enriching Showers drawn from her self (an Emblem of State Lottery's). 3. Fortune Drawing the Blanks and Prizes. 4. Wantonness Drawing ye Numb?. 5. Before the Pedestal Suspence turn'd to & fro by Hope & Fear.

The LOTTERY

6. On one hand, Good Luck being Elevated is seized by Pleasure & Folly; Fame persuading him to raise sinking Virtue, Arts &c. 7. On ye other hand Misfortune opprest by Grief, Minerva supporting him points to the Sweets of Industry. 8. Sloth hiding his head in ye Curtain. 9. On ye other side, Avarice hugging his Mony. 10. Fraud tempting Despair ne Mony at a Trap-door in the Pedestal.

Price one Shilling.

56

THE MIDDLING ORDERS

Just as Hogarth's aristocrats exhibit vices which are particularly tempting to their class, so the middling orders – merchants, lawyers, doctors and clergymen – are all represented by the vices associated with their professions; Hogarth's lawyers in his satires are grasping and deceitful, merchants are greedy and dishonest, and doctors are self-regarding and callous towards their patients.

MERCHANTS AND LAWYERS

56 *The Lottery*, 1724

Etching and engraving, 255 x 322 mm
Lit.: Paulson 53
1856-6-14-289

An elaborate satire on the national lottery, which took place in London's Guildhall, in general imitation of Raphael's *School of Athens*. The scene has a generic resemblance to Addison's famous vision of Public Credit in the Great Hall of the Bank of England in *The Spectator* of 3 March 1711. 'National Credit' presides over the scene; she represents the system of banking which in Addison's account allows for prosperity so long as she is accompanied by the Acts of Uniformity and Toleration, but she disappears should Anarchy and Tyranny enter the Hall. In Hogarth's image National Credit is a more neutral figure, presiding over an allegory in which chance offers the paths of vice or virtue. Taken together with *The South Sea Scheme* (no. 83), with which it may have been paired, the print suggests on Hogarth's part a conventionally equivocal acceptance of the new commerce as contributing to national prosperity but also carrying with it the danger of speculation.

57 *Marriage A-la-Mode*, 1745, plate 6

Etching and engaving by G. Scotin, 385 x 464 mm

Lit.: Paulson 163

1857-2-28-69

This scene, showing the death of the Countess in her father's house on the Thames within sight of old London Bridge, should be read against the first plate of the series (no. 47). In contrast to aristocratic extravagance, we have here bourgeois miserliness, epitomised in the merchant's concern to remove the wedding ring from his dying daughter's finger. The scene also contrasts interestingly with the first plate of *A Rake's Progress* (no. 13) where the house of another miser, the Rake's father, is represented. Both mer-

chants' rooms are filled with emblems of miserliness and are in a plain and old-fashioned taste, but in the Countess's father's house the paintings on the wall are parodies of Dutch paintings, emphasising their coarseness of sentiment and demotic literal mindedness (see no. 27b), by contrast with the cosmopolitan pretentiousness of the Earl's Italianate taste. Both extremes deviate from the true mean, implying perhaps that only an English artist can achieve a middle way, as in 'Comic History Painting' of the kind represented by the *Marriage A-la-Mode* paintings themselves (see p. 21).

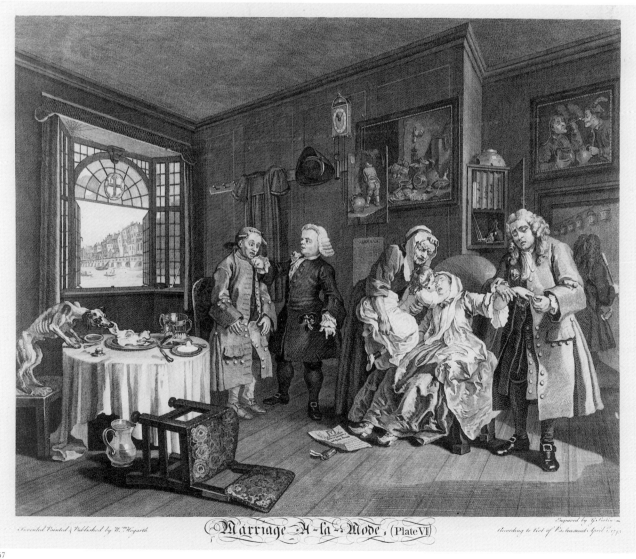

57

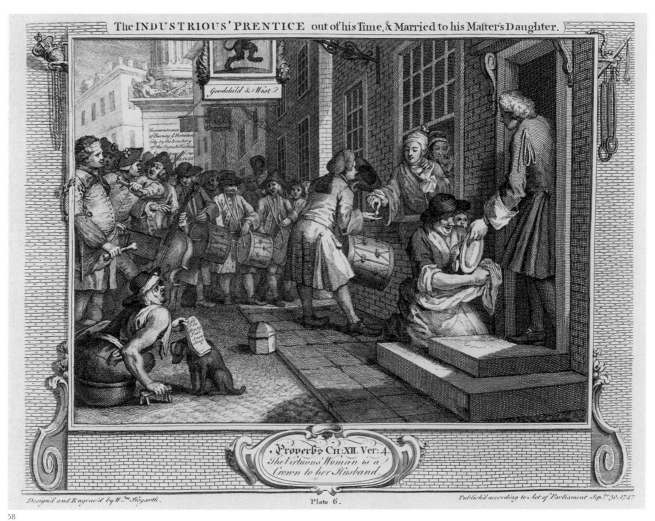

58 *Industry and Idleness*, 1747, plate 6:
The Industrious 'Prentice out of his Time,
& Married to his Master's Daughter

Etching and engraving, 263 x 350 mm

Lit.: Paulson 173

1896-7-10-15

Plate 6 shows the Industrious Apprentice at the mid-point of his fortune. This design represents Hogarth's most complete image of the ideal bourgeois life, and it can be contrasted with its moral opposite in the previous image of a miserly merchant. As a partner with his father-in-law in a Spitalfields cloth-making company, the former apprentice can now live a life of gentility in a plain but substantial house. His social if not physical distance from the life of the street is emphasised by his display of charity to the musicians and the poor mother at the stoop. The street is closed at the end by the Monument to the Fire of 1666, and Hogarth tellingly reproduces part of its bigoted inscription attributing the Fire to 'the treachery of the Papist Faction'. Industry is thus associated with Protestantism and the reference is perhaps also to the failure of the '45 Rebellion in the face of the Protestant cause. If Protestant and commercial order cohabit with unruly and quarrelsome street life, there is also a disorderly humour in the crowd which, whether intentionally or not, might suggest that the newly wealthy bourgeois is playing up to his new role rather than showing true compassion for the poor.

DOCTORS

ANONYMOUS

59 *The Triple Plea, c.* 1725

Etching, 308 x 209 mm, published by J. Jarvis

Lit.: BMC 1775

J.7-43, presented by Lady Dorothea Banks (collection of Sarah Sophia
Banks)

The print shows a lawyer, a doctor and a clergyman

arguing about their superiority over each other. But, as the
caption explains, none will do anything without a fee:

> Without a Fee, the Lawyer's Dumb;
>
> Without a Fee, the Doctor – Mum;
>
> His Rev'rence says, without his Dues,
>
> You must the Joys of Heaven lose
>
> Then be advis'd: In none confide;
>
> But take Sound Reason for your Guide.

The print is an early assault on the growth and institution-
alisation of the professions and their self-importance.

59

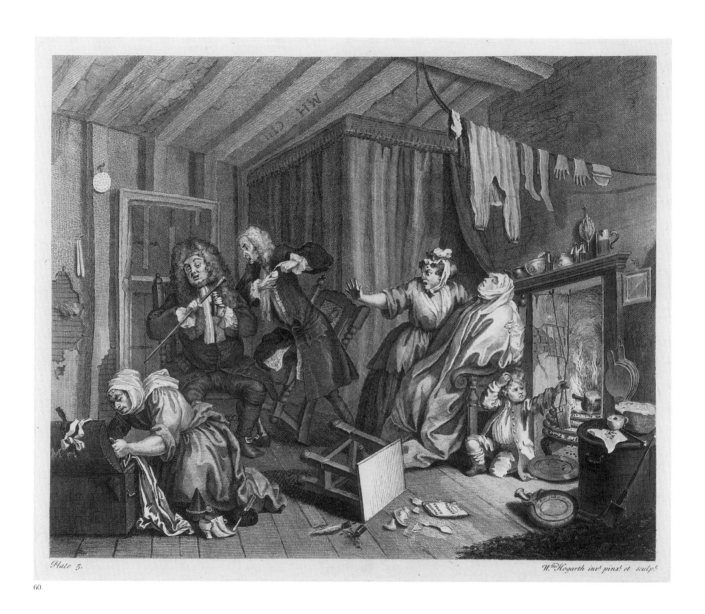

60

60 *A Harlot's Progress*, 1732, plate 5

Etching and engraving, 320 x 390 mm

Lit.: Paulson 125

1858-4-17-548

The doctors, who quarrel while the patient dies, are deliberately contrasted: one is stolid and complacent and the other thin and excitable. The stolid doctor is identified as the infamous Doctor Rock, the inventor of 'the famous Anti-Venereal, Grand, Specifick Pill' and, like Orator Henley and others, a frequent target of literary satire in the period. The other doctor is not identified but is almost certainly meant to be Dr Jean Misaubin (see no. 61), an emigré French doctor who was also associated with a cure for venereal disease.

Prenez des Pilules, prenez des Pilules.

D.ᵣ Misaubin

61

ARTHUR POND AFTER JEAN-ANTOINE WATTEAU

61 *Prenez des Pillules, prenez des Pillules.*
Dr Misa[u]bin, 1739 (after a drawing of
c. 1719–20)

Etching, 279 x 200 mm

Lit.: BMC 1987; K.T. Parker and J. Mathey, *Antoine Watteau: catalogue*
 complet de son oeuvre dessiné, Paris, 1957, II, 379, no. 919

1868-8-8-3615

Supposedly after a drawing by Watteau, this print by
Arthur Pond caricatures the notorious Jean Misaubin (d.
1734), the French doctor who appears in *A Harlot's Progress*,
plate 5 (no. 60). He is shown with the traditional enema in a
landscape of death, by implication his province as a doctor.
The drawing by Watteau appears to be lost but, according
to Parker and Mathey, would have been done in London in
the last years of the artist's life, 1719–20, when he was
treated unsuccessfully for tuberculosis by Dr Misaubin.

62 *The Company of Undertakers*, 1737

Etching and engraving, 260 x 178 mm

Lit.: Paulson 144

1868-8-22-1542, bequeathed by Felix Slade

An elaborate heraldic joke on the more sensational physicians of the day, including the identifiable features of three still practising at the time the print appeared. At the top from the left: John Taylor the oculist, Sarah Mapp the bone-setter and Joshua Ward, inventor of a famous pill.

The other physicians are shown as pompous grotesques grouped around a urinal, holding their gold-headed canes (a mark of office which normally contained a pomander) close to their noses to avoid smells. The heraldic device and the doctors' pomposity serve to satirise the emerging professionalisation of physicians, implying that they are pretentious and lethal quacks; the first announced title for the print was 'Quacks in Consultation'.

Invented Engraved & Published October 26: 1736 by W.ᵐ Hogarth Pursuant to an Act of Parliament. Price One Shilling.

63

The Clergy: Conformist and Methodist

Despite his satires on clergymen, Hogarth was on the best of terms with prominent members of the Church of England (see p. 51). His own beliefs were essentially in harmony with the Latitudinarian compromise between reason and revelation, which dominated the Church throughout most of the first half of the eighteenth century. Unlike many of his younger contemporaries, he strenuously resisted Methodism with its assertion of the primacy of revelation over charity and good works. He attacked Methodists as fanatics and covert Roman Catholics on a number of occasions.

63 *The Sleeping Congregation*, 1736

Etching and engraving, 263 x 208 mm

Lit.: Paulson 140

1868-8-22-1540, bequeathed by Felix Slade

A conventional satire on the deficiencies of the clergy and the worshippers, who have been lulled to sleep. The temptations of the flesh are signalled in the sidelong glance of the clerk at the young girl's exposed bosom as she dreams of marriage. Variations on the theme of physical and spiritual sleep fill every part of the image, but it is not a radical critique of the Church of England; inadequate clergymen, along with tedious professors, rapacious lawyers and quack doctors were all part of the traditional apparatus of satire from at least the Middle Ages.

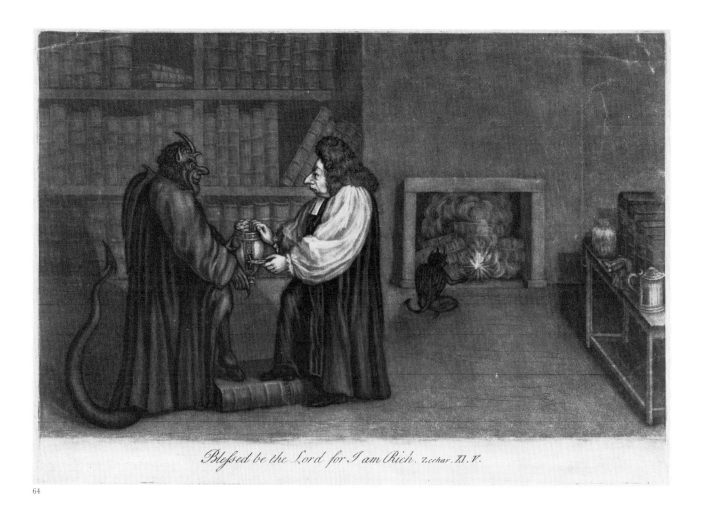

64

ANONYMOUS

64 *Blessed be the Lord for I am Rich. Zechar.XI.V.*

Mezzotint, 227 x 326 mm
Lit.: BMC 2139
1868-8-8-13138

This is believed to refer to Thomas Sherlock, appointed as Bishop of Salisbury in 1734. He is shown standing on the Bible as the Devil gives him a mitre filled with coins in exchange for a crucifix. A smaller devil burns books in the fireplace, including one titled 'Hoadly'. Criticism of the wealth and power that often accompanied high ecclesiastical office was commonplace at the period. Hogarth was, of course, a close friend of Bishop Hoadly (see p. 51). Mezzotint satires are uncommon because of the difficulty of printing a long run from the plate, which would tend to wear quickly.

THE TARGETS OF SATIRE: THE ORDERS OF SOCIETY

ROBERT PRANKER AFTER JOHN GRIFFITHS

65 *Enthusiasm Displayed, c.* 1755

Etching and engraving, 410 x 503 mm

Lit.: BMC 3339

1868-8-8-3619

This extremely gentle satire of a Methodist, possibly George Whitefield, preaching in Upper Moorfields to an audience most of whose attention is elsewhere, pictures the dramatic innovation of outdoor preaching practised by the early Methodist preachers. Such preaching to the common people alarmed orthodox Anglicans like Hogarth. In this print the people of means and those who really need help, like the drunk, the blind and the crippled, are oblivious to the preacher, and there may be a satirical point in the conspicuous presence of 'St. Lukes Hospital for Lunaticks' in the background.

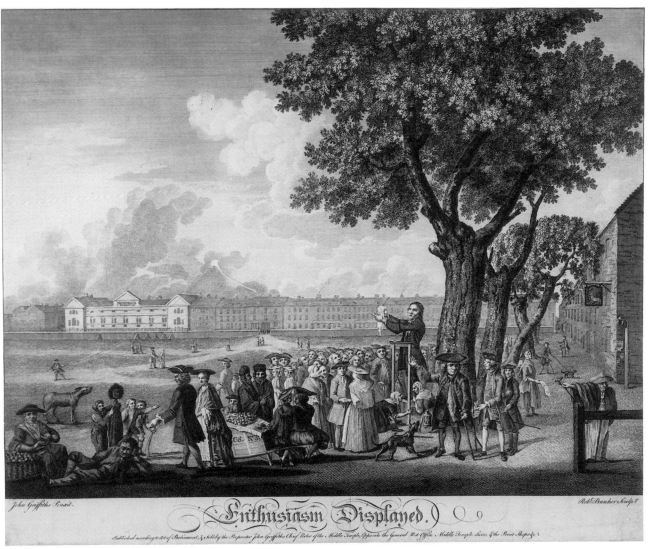

John Griffiths Pinxit.

Enthusiasm Displayed.

Rob.t Pranker Sculp.t

Published according to Act of Parliament, & Sold by the Proprietor John Griffiths Chief Porter of the Middle Temple, Opposite the General Post Office Middle Temple Lane, & the Print Shops &c.

65

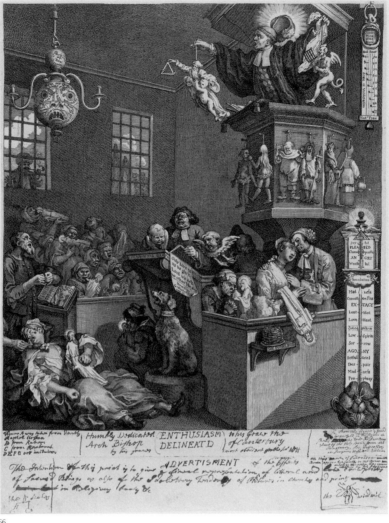

66

66 *Enthusiasm Delineated, c.* 1761

Etching and engraving, 375 x 326 mm

Lit.: Paulson 210, state 1; Bernd W. Krysmanski, *Hogarth's*
 Enthusiasm Delineated: Nachahmung als Kritik am Kennertum, Hildesheim,
 1996

1858-4-17-582

The first state of this unpublished print has survived in only
two impressions (the other is in the Aschenbach Founda-
tion, San Francisco), both annotated by Hogarth. The plate
was then altered extensively and published (see no. 67). It is
an elaborate satire on the growth of Methodism within the
Church of England and its success with common people.
The underlying premise, expressed in the preacher's

monastic tonsure revealed under his wig and in countless
other emblems, is that Methodism is nothing more than a
covert revival of Catholicism at its most assertive and
crudely populist. The 'Enthusiasm' of the Methodists is the
other side of the coin from *The Sleeping Congregation* (no. 63),
both being at unacceptable extremes in the spectrum of
religious belief. This print is dedicated to the Archbishop of
Canterbury as an expression of loyalty but perhaps also as
a warning of the dangers besetting the Church. The refer-
ences to painters hanging round the pulpit suggest also an
attack on the enslavement of Italian and Flemish painters
to the Catholic Church, something Hogarth believed had
been ignored by the Connoisseurs or secretly relished by

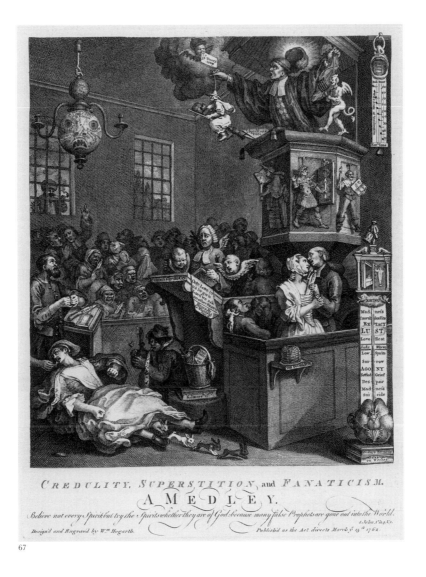

67

the Jacobites among them. There is also the implication, brought out by Krysmanski, that the preacher has a secondary function as an auctioneer of Old Master paintings, associating him with two types of charlatan. The turbaned oriental looking in amazement at the scene derives from the literary topos of the non-European astonished at the ways of the supposedly civilised caught up in a consuming mania. The extraordinary richness of reference in this print has been brought out exhaustively by Krysmanski.

67 *Credulity, Superstition and Fanaticism*, 1762

Etching and engraving, 378 x 330 mm

Lit.: Paulson 210, state 2

1868-8-22-1624, bequeathed by Felix Slade

In this reworking of the first state (no. 66) Hogarth has eliminated the Eucharistic Christ figures, replacing them in some cases with models of the Cock Lane Ghost, referring to a famous incident in which a haunting was rigged by an aggrieved landlord as an act of revenge, leading to a sensational trial in 1762. The Christ figures may have been discarded on grounds of taste, and the references to the Cock Lane Ghost would have given the print an added topicality.

THE COMMON PEOPLE: DISORDER AND CRIMINALITY

Hogarth's interest in the disorderly fabric of street life is part of a tradition going back to at least the sixteenth century, in which street criers were seen as a distinctive feature of London life. Hogarth extends this concern with trades and their distinctive dress and cries into a more full-blooded sense of the theatrical and carnivalesque. At the same time he was involved from early in his career in the problems of crime and punishment. He shared the literary fascination with criminality and its ambiguities, but from the 1740s onwards, partly under the influence of the novelist Henry Fielding and his brother John, both Bow Street magistrates, he began to see his art as an active weapon in the fight against crime. He was also involved in a number of institutions concerned with charity towards and rehabilitation of the poor and helpless, like St Bartholomew's Hospital, the Foundling Hospital and Bedlam Hospital.

THE THEATRE OF THE STREETS

Southwark Fair and *The Enraged Musician* both express the idea that daily life in the city is a form of theatre in which people going about their business act out roles in the dramas of human confrontation.

68 *Southwark Fair (The Humours of a Fair)*, 1733–4

Etching and engraving, 361 x 473 mm
Lit.: Paulson 131
1868-8-22-1515, bequeathed by Felix Slade

The theatrical performances are shown to be in a continuum with other forms of display and street life involving ordinary people. Audience and actors are not separated but intermingle and in effect swop roles; the collapse of the stage on the left causes damage and injury within the real world. Though the scene is precisely localised as the great fair held in Southwark every September, it is also the *The-*

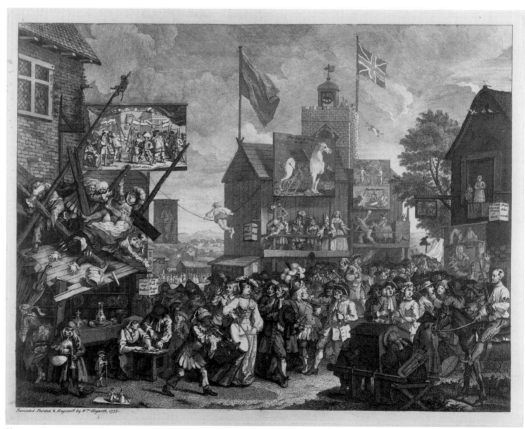

68

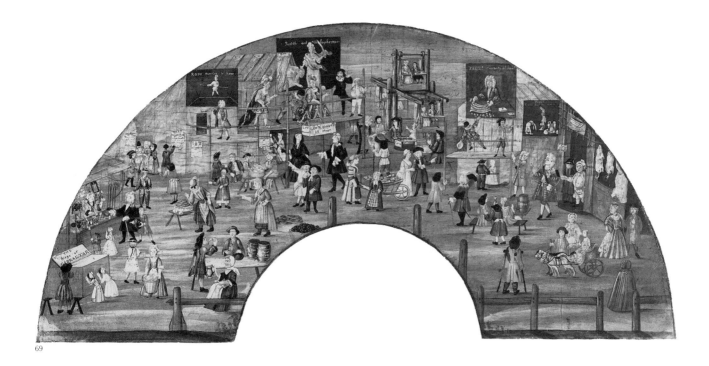

69

atrum Mundi, or Theatre of the World, revealing the whole spectrum of human vices and illusions, with all ages and conditions represented. The common people, whose life is on the streets, are perpetually open to accident and temptation, and the one figure of unalloyed beauty, 'the beautiful Drummeress' leading her troop, is a hint of a better world, but she attracts only the apparent lust and envy of a couple beside her, and is otherwise ignored. Some of the dramas hover on the edge of the apocalyptic; the theatrical group on the left, 'Ciber and Bullock', are on a collapsing stage which will destroy the neatly stacked china below and then presumably devastate the crowd as well, too preoccupied with their private desires to see what is happening, with the possible exception of a small boy behind his father who is arguing with the dice-thrower. The show-cloth above the collapsing stage is taken from the print, *The Stage Mutiny* by John Laguerre, which is in the present exhibition (no. 93).

ANONYMOUS, FORMERLY ATTRIBUTED TO THOMAS LOGGON

69 *Bartholomew Fair, c.* 1730

Fan leaf, body colours, 260 x 535 mm

Lit.: E. C.-M., 1

1941-7-12-2

This fan design, according to the shows and plays on offer, must date from about 1730, a few years before Hogarth's *Southwark Fair*. There are references on the right to Fawkes the conjuror, who died in 1731. Illustrating another great London fair, which took place in Smithfield, it gives a more benign and picturesque view of such events than Hogarth's print.

MARCELLUS LAROON (LAURON)

70 *The merry Milk Maid*, from *The Cryes of the City of London Drawne after the life*, 1687

Etching, 270 x 161 mm

Lit.: S. Shesgreen, *The Criers and Hawkers of London: Engravings and Drawings of Marcellus Laroon*, Aldershot, 1990

1972.u.370

The most famous and most elaborate of the books and series which record the street-criers of London, *The Cryes of the City of London*, was reprinted well into Hogarth's time and Hogarth would certainly have known it. It was undoubtedly an influence on *The Enraged Musician* (no. 71), which in a sense itself belongs to the genre of London cries but is organised into a composition instead of separate figures.

71 *The Enraged Musician*, 1741

Etching and engraving, 357 x 412 mm

Lit.: Paulson 152

1868-8-22-1554, bequeathed by Felix Slade

Perhaps the most richly comic of all Hogarth's prints, with its limitless variations on the theme of noise but also with intimations of more characteristic themes. The musician with his elaborate coat and wig is surely foreign, and his alienation is signalled by the bill outside his window advertising the definitively English *Beggar's Opera* (see no. 31). His music is in direct opposition to the music of the streets, and he sees in it only disturbance and threat, like an artist who looks only to Italy and not to the life around him. The vulgarity and clashing din of those preoccupied with their own purposes are set against the elegant figure of a young woman with a pail of milk on her head, crying her wares, another example of Hogarth's ideal of beauty, 'the blooming young girl of fifteen', who is to be preferred to 'the stony features of a venus' (*Analysis*, 66).

72 *The March to Finchley*, 30 December 1750

Etching and engraving by Luke Sullivan, 431 x 554 mm

Lit.: Paulson 184

1858-6-26-369

The March to Finchley is a 'historical' print, for it refers to events which took place in 1745 (though Hogarth at some points makes it 1746), more than five years before publica-

tion. With characteristic creative marketing, Hogarth offered special subscribers to the print a chance to enter a lottery for the original painting. There were nearly 2000 tickets offered, but he gave 167 tickets to the Foundling Hospital, which won the lottery and has the painting to this day. The composition is the richest of Hogarth's crowd scenes in the comic mode, and it is full of topical allusions to political issues of the day. The dedication to the King of Prussia, the great military disciplinarian, is undoubtedly a comment on the shambles presented by the British army gathering to defend London against the Jacobites. The Duke of Cumberland was, at the time of the painting and the print, seeking to bring the British army up to Prussian standards of discipline, represented by the orderly troops in

The merry Milk Maid
La Femme au Lait
Allegra Cantadinella

M.auron delin· P.Tempest exc:
 Cum Privilegio

70

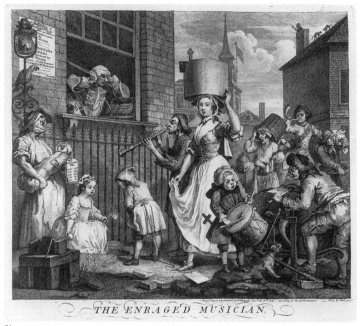

THE ENRAGED MUSICIAN.

71

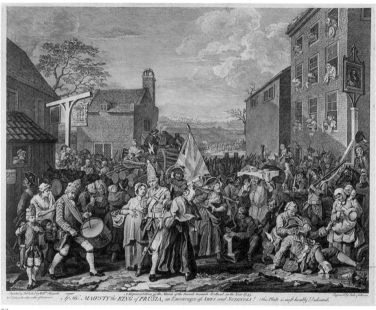

72

the distance. (See also *The Invasion*, plate 2, Paulson 203, for an inn sign of 'The Duke of Cumberland'.) The grenadier between two women in the foreground (see frontispiece) is torn between the pregnant woman's simple patriotism and support for the Duke of Cumberland, expressed in a portrait held by her, and the rabid and threatening 'faction' represented by the older woman, who carries a copy of the opposition newspaper, *The Remembrancer*, as well as other newspapers, including *The Jacobite's Journal*, an anti-Jacobite

paper (see p. 48). Hogarth has dwelled on the unedifying spectacle presented by the soldiers and the common people in the picture; drunkeness, theft, prostitution and selfishness abound. Though there are a few redeeming figures, especially the as yet uncorrupted figure of a boy grenadier on the far left, there is nothing in the work to suggest much sympathy for the common people.

73

CRIMINALS AND HARLOTS

The fascination exerted by highwaymen and murderous criminals was fully expressed in comic form in *The Beggar's Opera* (see no. 31), and the latest murder or execution achieved a particular topicality in a culture increasingly influenced by periodical literature. Hogarth's and Thornhill's portraits of criminals should probably be seen as attempts to cash in on sensational crimes during the period between sentencing and execution.

SIR JAMES THORNHILL

73 *John Sheppard*, 1724

Mezzotint by George White, 365 x 251 mm
Lit.: Dictionary of National Biography; Chaloner Smith 42
1851-3-8-593

Jack Sheppard (1702–24) was one of the most remarkable criminals of the day and undoubtedly contributed to the portrayal of Macheath in *The Beggar's Opera*. He escaped from several prisons, most sensationally from Newgate, following which he drove past the prison in a coach, wear-

ing smart clothes. Like Macheath, he was associated with two women, Poll Maggot and 'Edgeworth Bess', and he was informed against by Jonathan Wild, the 'thief-taker' and model for Gay's Mr Peachum. After his final capture the turnkeys in Newgate charged visitors to view him in prison, and it was in the days before his execution on 16 November 1724 that Thornhill sketched him. The mezzotint after the drawing would have been made for rapid distribution. The artist's motives were presumably commercial, but it is also the most romantic representation of a real criminal of the period and helps to explain the cult of the highwayman which lies behind the figure of the 'gentlemanly' Macheath. For the highwayman James Maclaine see no. 82e.

74 *Sarah Malcolm*

a) Hogarth's version, 1733
Etching and engraving, 194 x 179 mm
Lit.: Paulson 129
1868-8-22-1512, bequeathed by Felix Slade
b) Anonymous copy with clergyman and execution scene
Etching, 171 x 125 mm
Lit.: BMC 1906
Cc.1-113 (1825-2-12-25)
c) Anonymous copy from the *Gentleman's Magazine*,
3 March 1733
Woodcut and letterpress, 65 x 60 mm (image)
1996-9-29-16

Sarah Malcolm was the author of a particularly brutal murder in the course of a robbery; she killed two elderly women and their maid, and was tried soon after and hanged. She was only twenty-two and her beauty helped the case to attract enormous attention. Hogarth is recorded as having visited her in prison a few days before the execution, and he made a painting (National Gallery of Scotland, Edinburgh) upon which the print is based. This type of print had already been attempted recently by Thornhill (see no. 73), though evidently not preceded by a painting. This print was to suffer the honour of much piracy: (b) is perhaps the most interesting one, with the addition of a clergyman in the background and the scene of hanging, emphasising the need for penitence. It may also express clerical worries that such prints as Hogarth's might serve to glamorise crime rather than discourage it. In (c) Hogarth's design had found even wider circulation, with part of it used to illustrate a news report in the *Gentleman's Magazine*.

74a

74b

74c

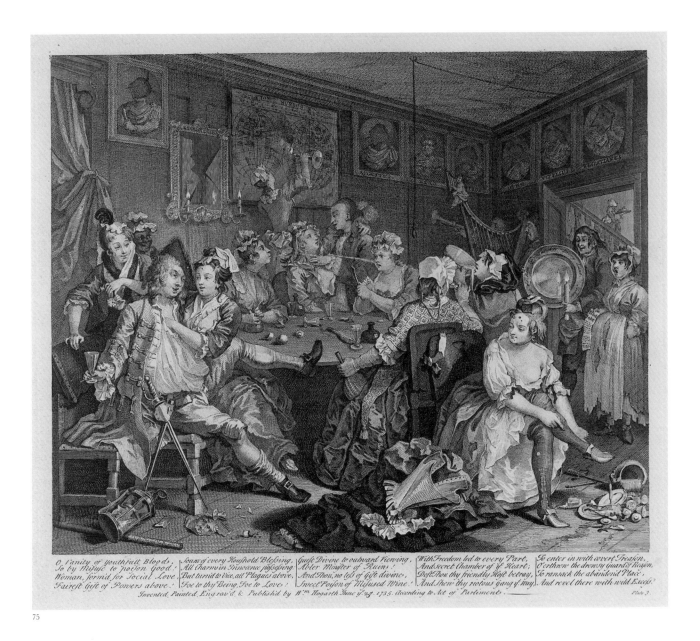

75

75 *A Rake's Progress*, 1735, plate 3

Etching and engraving, 355 x 408 mm

Lit.: Paulson 134

S.2-40

Prostitution, crime and hatred of authority are all inter-linked in this brothel scene and set in motion by the Rake's foolishness. The harlots pay attention to the Rake only for

the purposes of stealing his watch, and the realm of lust is focused wholly on the pursuit of pleasure and self-interest. The scene is full of witty episodes, like the harlot spitting into another's face, and these serve only to give an effect of truthful observation. The chamber pot overflowing onto the discarded food is probably intended as an emblem of disgust.

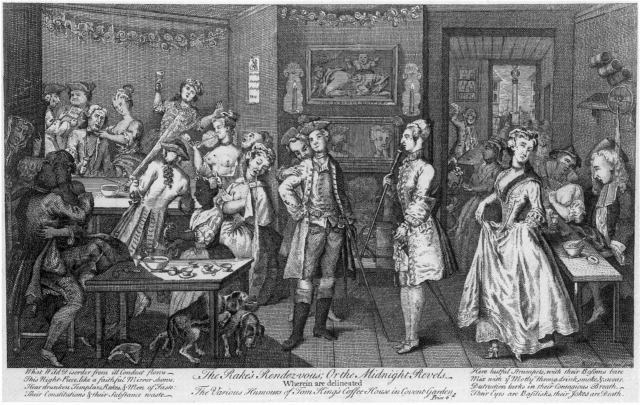

What Wild Disorder from ill Conduct flows,
This Night-Piece, like a faithful Mirror shows.
Hear drunken Templars, Rakes, & Men of Taste:
Their Constitutions & their Subsistance waste.

The Rake's Rendez-vous; Or the Midnight Revels.
Wherein are delineated
The Various Humours of Tom King's Coffee-House in Covent-Garden.
Price 6.ᵈ

Here lustful Strumpets, with their Bosoms bare
Mix with ye Motly throng, drink, smoke, & swear.
Destruction lurks in their Contagious Breath.
Their Eyes are Basilisks, their Jokes are Death.

76

GEORGE BICKHAM

76 *The Rake's Rendez-vous; Or the Midnight
Revels. Wherein are delineated The Various
Humours of Tom King's Coffee-House in Covent-
Garden*

Etching, 213 x 348 mm
Lit.: BMC 2201; Kunzle, 328-31; Döring, 84 & 140
1860-6-23-35

Clearly owing much to Hogarth's print opposite, this
picture is more deliberately obscene in detail, despite the
shrill moralising of the poetic caption, making Hogarth's
brothel seem tame by contrast. For the exterior activities of
Tom King's Coffee House in Covent Garden Piazza, see
Hogarth's *Morning* (no. 40a). The lack of address, though it
is signed, suggests that it appeared before Hogarth's Act
(no. 14) became law.

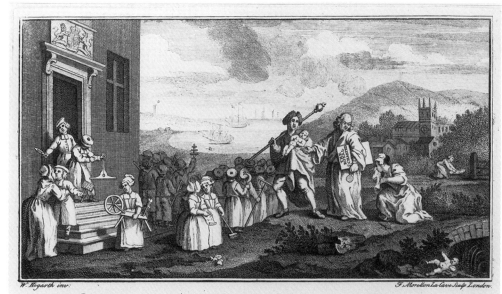

W. Hogarth inv. F. Morellen La Cave Sculp London.

𝕿𝖔 𝖆𝖑𝖑 *to whom these* Presents *shall come.*

𝖂𝖍𝖊𝖗𝖊𝖆𝖘 *our Sovereign Lord the King hath been graciously pleased to take into His Princely and tender Consideration the deplorable Case of great Numbers of Newborn Children daily exposed to Destruction, by the cruelty or poverty of their Parents, and having by His* **Royal Charter** *bearing date the 17ᵗʰ day of October 1739, constituted a Body Politick and Corporate, by the Name of* The Governors and Guardians of the Hospital for the Maintenance and Education of exposed and deserted young Children; *which Corporation is fully impowered to receive & apply the Charities of all compassionate Persons who shall contribute towards erecting & establishing the same,* 𝕬𝖓𝖉 𝖂𝖍𝖊𝖗𝖊𝖆𝖘 *His Majesty for the better & more successful carrying on the said good Purposes,* 𝕳𝖆𝖙𝖍 *by His said* **Charter** *granted to the said Corporation and their Successors full & ample Power to authorize such Persons as they shall think fit to take Subscriptions, and to ask and receive of all or any of His Majesty's good Subjects, such Monies as shall by any Person or Persons, Bodies Politick and Corporate, Companies and other Societies be contributed and given for the Purposes aforesaid.* 𝕹𝖔𝖜 𝖐𝖓𝖔𝖜 𝖄𝖊 *that We the said Governors & Guardians being well assur'd of the great Charity & Integrity of*

and that

greatly desire the Success & Accomplishment of so excellent a Work, 𝕳𝖆𝖛𝖊 *by Virtue of the said Power granted to Us, authorized & appointed, and by these Presents* 𝕯𝖔 *authorize & appoint the said to take Subscriptions and to receive gather & collect such Monies as shall by any Person or Persons, Bodies Politick & Corporate, Companies & other Societies, be contributed & given for the Purposes aforesaid, and to transmit with all convenient speed, the Monies so Collected and Received, into the Bank of England for the use of this Corporation, And the Receipt for the same to our Treasurer for the time being, Together with the Names of the Contributors, except such as shall desire to be concealed, and in that Case to insert the Sums only, in order that We the said Governors & Guardians may be enabled from time to time to Publish perfect Accounts of such Benefactions. Given under our Common Seal the Day of 17*

𝕭𝖞 𝕺𝖗𝖉𝖊𝖗 *of the said Governors & Guardians.*

77

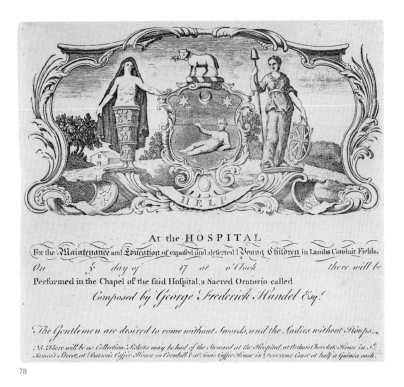

78

CHARITY AND THE POOR:
THE FOUNDLING HOSPITAL

From the mid-1730s onwards Hogarth increased his connections with the world of charity, especially St Bartholomew's Hospital and the Foundling Hospital, of which he was an active governor. Though he undoubtedly saw these institutions as public spaces in which his own work and that of other artists could be displayed to wealthy visitors, Hogarth was also much involved in urban philanthropy. He seems to have been in sympathy with the view held by other philanthropists of the time, that foundlings and orphans should be trained to become useful citizens: the boys for trade, agriculture, or the army or navy, and the girls for domestic service.

77 *The Foundlings*, 1739

Engraving by F. Morellon la Cave, 362 x 218 mm
Lit.: Paulson 225
1868-8-22-1552, bequeathed by Felix Slade

Intended as a headpiece for a document authorising the collection of subscriptions to the Foundling Hospital in the year of its founding, Hogarth's design encompasses both

the myth of foundation, Thomas Coram's distress at the sight of a desperate mother by the wayside with her baby abandoned, and Coram's philanthropic purposes. From the baby carried in the arms of the beadle the youthful foundlings walk in procession, all carrying emblems of a trade, while in the distance a church, signifying religion, and ships in a bay, signifying trade, reveal the commitment to useful labour and religion.

ANONYMOUS AFTER HOGARTH

78 *Arms of the Foundling Hospital*, 1747

Engraving, 195 x 203 mm (sheet)
Lit.: Paulson 230
1858-4-17-578

The foundling is supported on one side by the many-breasted figure of Nature and on the other by a Britannia with shield and cap of liberty signifying trade. The work of the Hospital was to fit the foundlings for productive labour in agriculture or in trade, as well as the army and navy.

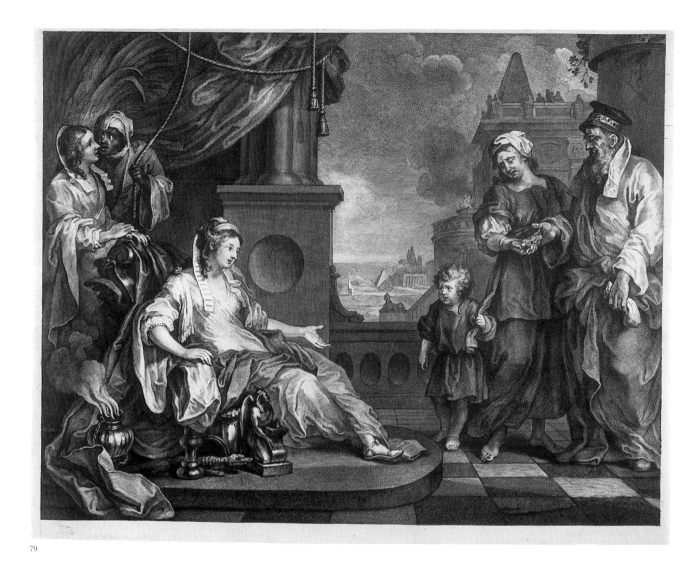

79

79 *Moses brought to Pharoah's Daughter*, 1752

Engraving by Hogarth and Luke Sullivan, 404 x 518 mm (sheet)

Lit.: Paulson 193 (proof before letters)

1860-7-28-61

Engraved from Hogarth's large painting, still in the Found-
ling Hospital, as part of a scheme for the board room
involving another three matching paintings by contempo-
raries. This scene, which shows Pharaoh's daughter and her
charity to the infant Moses, idealises both the charity of
'Great Folk' and the mother's renunciation of the infant, as
she parts with her son in the hope of a better life for him.

REFORMING 'SOME REIGNING VICES PECULIAR TO THE LOWER CLASS OF PEOPLE'

In the 1740s, partly under the influence of Henry and John Fielding's social concerns, Hogarth began to direct series of prints towards specific groups in society who were supposedly potential perpetrators of crime and vice. *Industry and Idleness* was aimed at apprentices and, unusually for Hogarth, shows the rewards of virtue as well as the consequences of vice. Hogarth claimed to have adopted for the series a simplified and easily readable style of engraving, what Vertue called 'a slight poor strong manner', with the intention also of making them affordable to the less educated. The same may be said for *Gin Lane* and *Beer Street*, but in *The Four Stages of Cruelty* Hogarth went a stage further by commissioning from J. Bell woodcut versions of two of them. Hogarth's *Autobiographical Notes* make his philanthropic intentions explicit: the series was 'done in the hopes of preventing to some degree that cruel treatment of poor Animals which makes the streets of london more disagreeable to the human mind, than any thing what ever'.

Making woodcut versions would have helped to simplify the style and make it more like the art of the popular broadside; it would also make the prints cheaper because longer runs could be produced from a woodblock than a copper plate.

80 *Industry and Idleness*, 1747

a) Plate 3: *The Idle 'Prentice at Play in the Church Yard, during Divine Service*
Etching and engraving, 265 x 350 mm
Lit.: Paulson 170
1896-7-10-8

This scene is the counterpart to the previous episode (not illustrated in the catalogue) of the Industrious Apprentice attending church and sharing a hymnbook with his master's daughter. The Idle Apprentice is shown here not only as self-interested but as a 'scorner' heedless of his latter end and oblivious to the grave he defiles by his activity. He is also a cheat, covering coins with his hat. The older players with their signs of disease and the skulls represent the Idle Apprentice's inevitable physical decay.

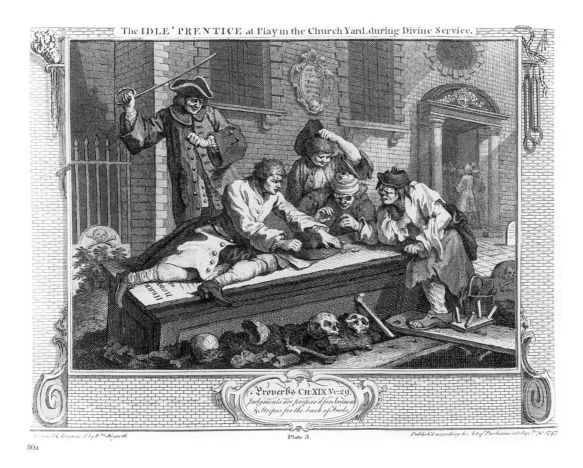

80a

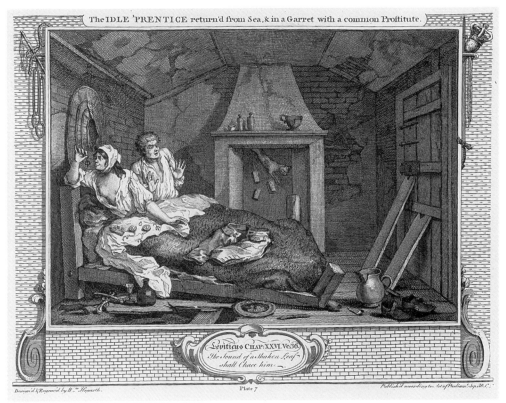

The IDLE 'PRENTICE return'd from Sea, & in a Garret with a common Proftitute.

Leviticus Chap: XXVI. Ve:36.
The Sound of a Shaken Leaf
shall Chace him.

Defign'd & Engrav'd by W.m Hogarth. Plate 7 Publifh'd according to Act of Parliamt Sep.t 30.t

80b

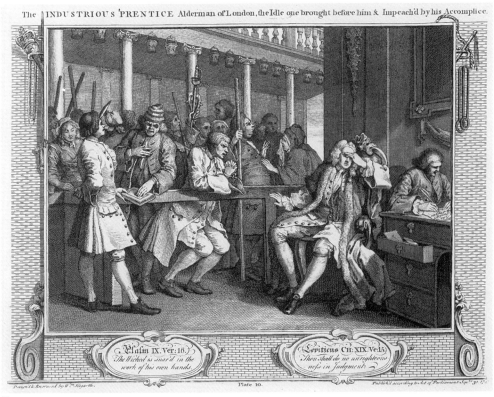

The INDUSTRIOUS 'PRENTICE Alderman of London, the Idle one brought before him & Impeach'd by his Accomplice.

Pfalm IX. Ver: 16.
The Wicked is snar'd in the
work of his own hands.

Leviticus Ch: XIX. Ve:15.
Thou fhalt do no unrighteous
nefs in Judgment.

Defign'd & Engrav'd by W.m Hogarth. Plate 10. Publifh'd according to Act of Parliament Sep.t 30.t 17

80c

138

b) Plate 7: *The Idle 'Prentice return's from Sea, & in a Garret with a common Prostitute*
Etching and engraving, 264 x 350 mm
Lit.: Paulson 174
1896-7-10-17

The Idle Apprentice, having returned from the sea, has now set up with a common prostitute and accomplice in his thieving. Their booty, taken from both men and women, and the pistols suggest highway robbery far from the romantic world of Macheath. The Idle Apprentice's fear of imminent arrest is signalled by his terror at a sudden noise. The Industrious Apprentice, meanwhile, is now married, set up in his house near the Monument and on the way to becoming an alderman (no. 58).

c) Plate 10: *The Industrious 'Prentice Alderman of London, the Idle one brought before him & Impeach'd by his Accomplice*
Etching and engraving, 264 x 348 mm
Lit.: Paulson 177
1896-7-10-24

Following his descent into criminality, the Idle Apprentice has been betrayed by the prostitute; he now comes up before his fellow apprentice, who has become an alderman and magistrate. The contrast between their fates is obvious, the

Industrious Apprentice is one stage from becoming Lord Mayor and the Idle Apprentice one step from the gallows. The former agonises over the decision, but like a Roman statesman renounces his personal feelings for the sake of the common good. Idle's responsibility for his own actions is emphasised by the biblical quotation beneath his feet.

d) Plate 11: *The Idle 'Prentice Executed at Tyburn*
Etching and engraving, 273 x 406 mm
Lit.: Paulson 178; Wendie Schneider in *Among the Whores and Thieves*, 57–67
1896-7-10-26

There is no reason to doubt Hogarth's own belief in the efficacy of capital punishment; indeed, he would have been extremely unusual in his day if he had been opposed to it. It was important to his contemporaries that judicial execution should be as public and theatrical as possible, so that the sense of it as a logical consequence of crime was experienced by all potential felons, though abhorrence is perhaps expressed at the unheeding attitudes of so many spectators. The humour of the foreground situations (and the large emotional lady in the high cart) acts as a lure to the viewer of the prints, who might shrink from the exclusively horrific.

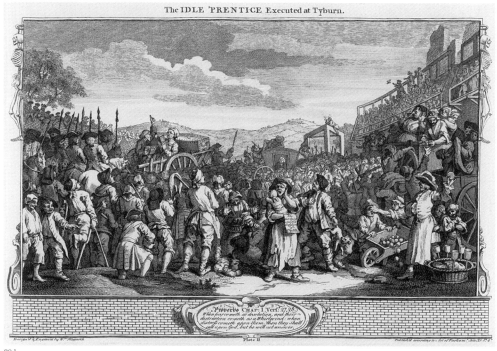

80d

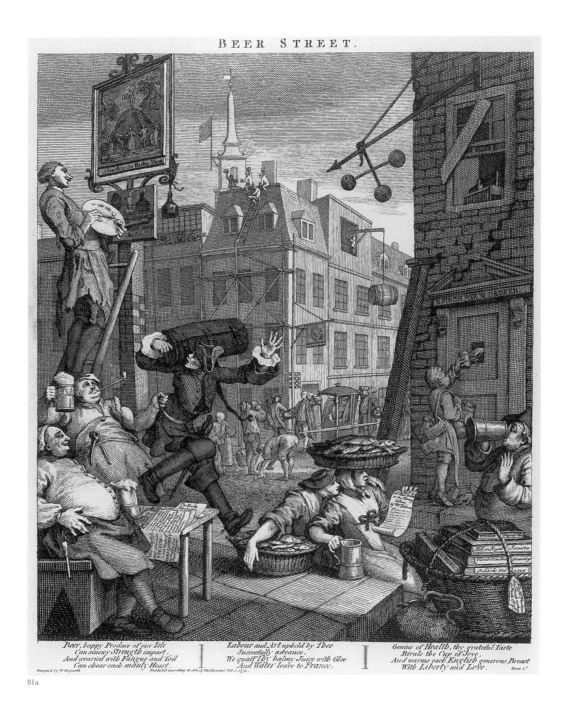

BEER STREET.

Beer, happy Produce of our Isle
Can sinewy Strength impart.
And wearied with Fatigue and Toil
Can chear each manly Heart.

Labour and Art upheld by Thee
Successfully advance.
We quaff Thy balmy Juice with Glee
And Water leave to France.

Genius of Health, thy grateful Taste
Rivals the Cup of Jove,
And warms each English generous Breast
With Liberty and Love.

Design'd by W. Hogarth. Published according to Act of Parliament Feb.1.1751. Price 1.ˢ

81a

81 (a)*Beer Street* and (b)*Gin Lane*, 1751

Two etchings and engravings, (a) 383 x 325 mm, (b) 379 x 319 mm

Lit.: Paulson 185–6

1868-8-22-1593 and 1595, bequeathed by Felix Slade

Along with *The Four Stages of Cruelty* (see no. 82), Hogarth made the claim for these prints that 'the Subjects…are calculated to reform some reigning Vices peculiar to the lower Class of People'. *Gin Lane* was, of course, a response to the belief in the circle of the Fielding brothers that gin was a cause of the increase in robbery; Hogarth's prints were an instrument in the latter's successful attempt to get the Gin Act passed later in 1751. The thirst for gin was, it was believed, a function of idleness, and the two prints reiterate in different terms the polarities of *Industry and Idleness*. *Beer Street*, by contrast, represents an urban pastoral where industry has allowed 'the lower Class of People' prosperity,

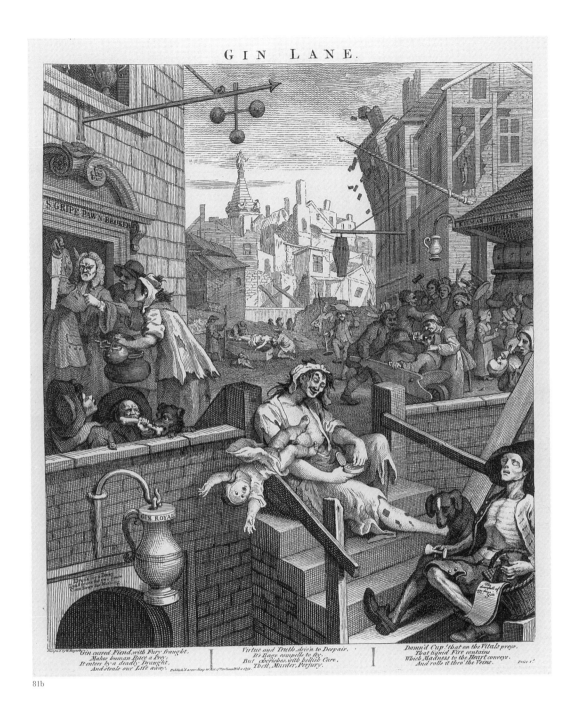

GIN LANE.

81b

leisure and good eating and drinking, and in the second state amorous dalliance, too. Hogarth has provided a conventional mercantile view of the country's prosperity, which is based on rural productivity (note the inn sign of 'The Barley Mow') and the harvest of the sea, expressed in the overflowing baskets of the fishwives who are looking at a ballad by 'the Herring Poet' John Lockman, publicist for the herring industry and a friend of Hogarth. The scene is

tied to national politics by the newspaper on the blacksmith's table, which reports a speech by the king recommending 'the Advancement of Our Commerce and cultivating the Arts of Peace'. Beer Street, then, is England as it should be and can be, if gin and its causes were eliminated. It may also be compared with the less than ideal pictures of the nation to be found in *The March to Finchley* (no. 72) and the Election series (no. 98).

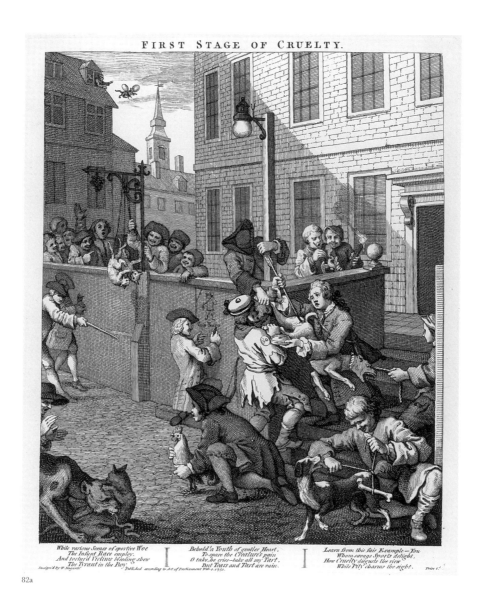

FIRST STAGE OF CRUELTY.

While various Scenes of sportive Woe
The Infant Race employ.
And tortur'd Victims bleeding shew
The Tyrant in the Boy.
Design'd by W. Hogarth.

Behold a Youth of gentler Heart.
To spare the Creature's pain
O take, he cries—take all my Tart.
But Tears and Tart are vain.
Published according to Act of Parliament Feb. 1. 1751.

Learn from this fair Example—You
Whom savage Sports delight.
How Cruelty disgusts the view
While Pity charms the sight.
Price 1s.

82a

82 *The Four Stages of Cruelty*, 1751

The Four Stages of Cruelty were made, as Hogarth tells us, with 'neither great correctness of drawing or fine Engraving' (*Autobiographical Notes*, 223) in order to make them affordable to 'those for whom they were cheifly intended'. The engravings are certainly in a broad style, but Hogarth also commissioned woodcut versions of the third and fourth plates – nos 82d and f – in order to reach a still wider audience, though he did not complete the set. He would have had good reason, from observation of the popular broadsides emanating from the famous printsellers in Aldermary Churchyard in the City of London, to assume

that the woodcut was the 'natural' technique for reaching the common people. Such a consistent determination to be understood by the potential criminal classes is rare in the eighteenth century.

a) *First Stage of Cruelty*
Etching and engraving, 384 x 320 mm
Lit.: Paulson 187
Cc.2-166

Tom Nero, the boy in the centre with the hat and badge indicating that he is in the care of the Parish of St Giles, is the subject of the four stages. He begins by joining in the

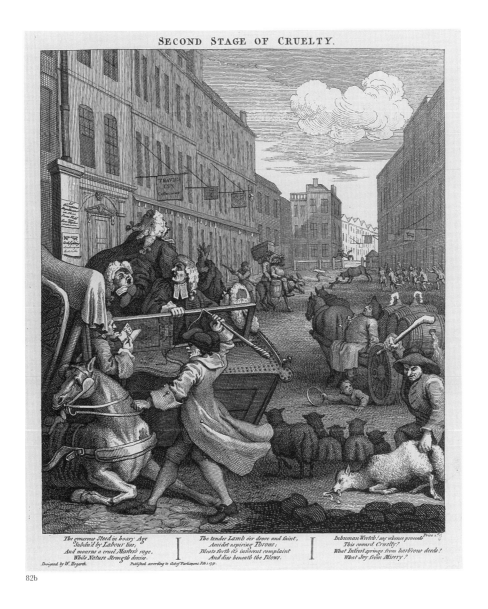

SECOND STAGE OF CRUELTY.

The generous Steed in hoary Age
Subdu'd by Labour lies,
And mourns a cruel Master's rage,
While Nature Strength denies.

The tender Lamb o'er drove and faint,
Amidst expiring Throws,
Bleats forth its innocent complaint
And dies beneath the Blows.

Inhuman Wretch! say whence proceeds
This coward Cruelty?
What Intrest springs from barbrous deeds?
What Joy from Misery?

Designed by W. Hogarth. *Publish'd according to Act of Parliament Feb.1 1751.*

82b

common childish sport of torturing animals, and he is undeterred from pushing an arrow into a dog's anus by entreaties and a tart proffered by 'a Youth of gentler Heart'. Cruelty to animals is the first stage of a career devoted to crime but it is also an evil in itself, as Hogarth claimed: 'That cruel treatment of poor Animals...makes the streets of London more disagreable to the human mind than any thing what ever.' (*Autobiographical Notes*, 226–7.)

b) *Second Stage of Cruelty*
Etching and engraving, 385 x 320 mm
Lit.: Paulson 188
Cc.2-167

As Paulson notes, conscious and unconscious cruelty are juxtaposed. Tom Nero beats 'the generous Steed in hoary Age Subdu'ed by Labour', while a good citizen takes down his name. The accident is evidently caused by the weight and number of the Welsh attornies from Thavies Inn stuffed in the coach. Their unwitting cruelty is matched by the drayman who in falling asleep allows his cart to run over a boy. The scene is Holborn on the route to Smithfield Market.

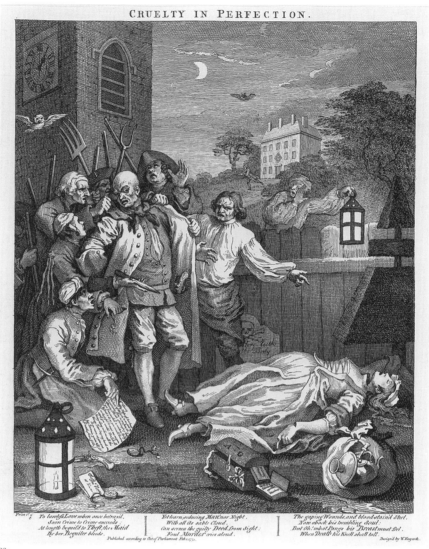

CRUELTY IN PERFECTION.

82c

c) *Cruelty in Perfection*
Etching and engraving, 386 x 319 mm
Lit.: Paulson 189
Cc.2-168

Tom Nero, now a fully fledged highwayman and thief, has committed the ultimate crime of murder. He has seduced the hapless Ann Gill, whom he has made pregnant, to steal plate and other valuables for him from the house in the distance. Ann Gill's note to him expresses her sense of guilt, and it is presumably fear of betrayal that leads him to murder her, but he cannot hope to escape retribution for such a horrible crime. His physiognomy shows him to be entirely brutalised (cf. Tom Idle in *Industry and Idleness*),

though perhaps with some horror at his deed. The two lamps have the rhetorical effect of lighting the darkness of the deed. Paulson notes that the wounds are like mouths crying aloud and that Henry Fielding was writing on the intervention of providence in the detection of murder at the time Hogarth was working on the print.

d) Woodcut of *Cruelty in Perfection*, first state
Woodcut by J. Bell, 453 x 380 mm
Lit.: Paulson 189, state 1 copy; Klingender, iii–iv
Lent by Andrew Edmunds

The first of two woodcuts made from Hogarth's designs by J. Bell, a woodcutter who worked for the publisher John

Newbery on children's illustrations. Hogarth's intention seems to have been to enable a wider distribution of the *Stages of Cruelty* by producing cheaper versions. He may also have assumed that woodcut would have been a more familiar and accessible medium as it would have been associated with broadsides and popular moralising prints. It is perhaps significant that they are about two inches larger than the engravings, and Hogarth may have thought of them as wall placards, with the broad woodcut technique giving them a strong carrying power at a distance in, say, a workshop or an inn. It is clear from the fact that only two were produced that the project failed. Producing a woodcut and printing it would have been cheaper than using a copper engraving, but only if the print run was large. It is possible that there was a problem in the printing of such a large woodblock, and Hogarth and Bell may not have had access to presses that would have allowed him to produce sufficient numbers. This is a contemporary impression from the first state; with minor alterations, it was reprinted by Boydell after Hogarth's death.

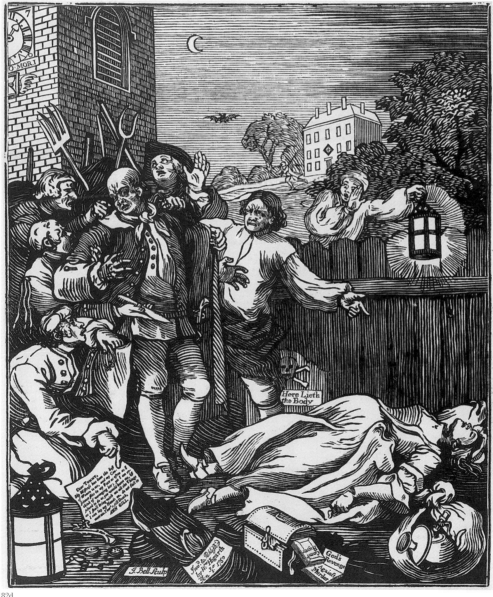

82d

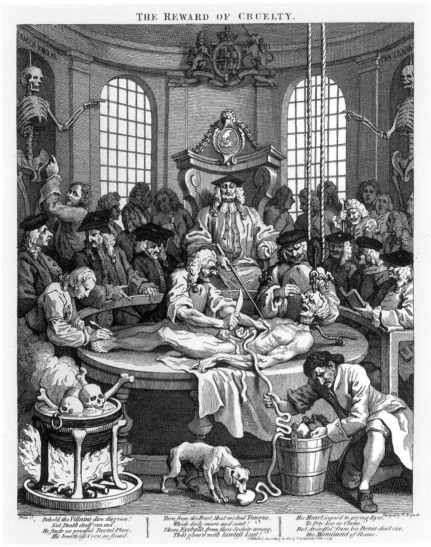

82e

e) *The Reward of Cruelty*

Etching and engraving, 385 x 318 mm

Lit.: Paulson 190; *Among the Whores and Thieves*, 52 and 96

Cc.2-170

After his hanging at Tyburn Tom Nero is now at the mercy of the surgeons, who are satirised as pompous, callous and in some cases inattentive. The scene is presented as a ghastly parody of the 'Good Death' in which a Christian lies on his deathbed mourned by friends as his soul departs for heaven. Here Nero is reduced to his grossest physicality, and his afterlife is represented by the skeletons of criminals in niches. One of these is the 'Gentleman Highwayman' James Maclaine, executed in 1750, who had been regarded as the living embodiment of Macheath. His presence here may have been intended by Hogarth as a specific rejection of the still fashionable romanticisation of dashing criminals. It is possible that Tom Nero is represented as still alive, for it was a particular fear of criminals that they would survive the hanging and be conscious at their dissection (see P. Linebaugh in D. Hay, ed., *Albion's Fatal Tree*, London, 1975, 65–118).

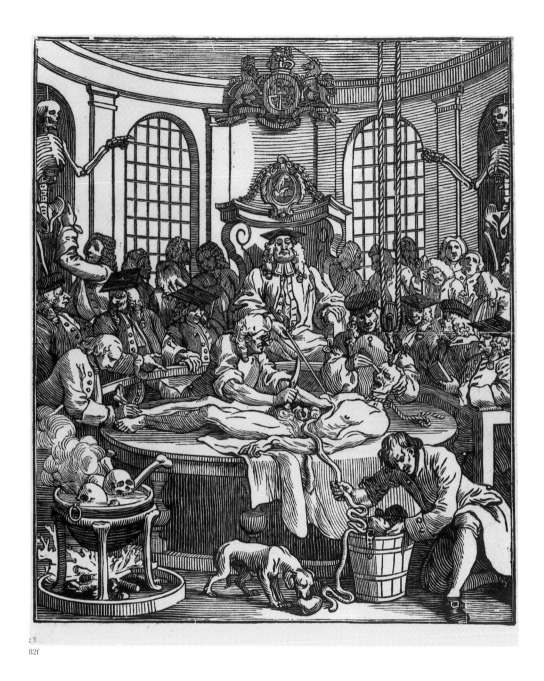

82f

f) Woodcut of *The Reward of Cruelty*

Woodcut by J. Bell, 455 x 382 mm

Lit.: Paulson 190, state 1 copy

Lent by Andrew Edmunds

An early impression from the block before the Boydell
edition.

THE POLITICAL STAGE

It is possible to find in Hogarth's early imagery examples of a broad adherence to the claims of the opposition to the court and the government of Sir Robert Walpole that the country's moral problems were a consequence of the corruption associated with a system based on paper credit and the dominance of financiers. On the other hand, he had court connections, which he exploited determinedly. Nonetheless, he sought for most of his career to avoid the taint of 'Party' (see p. 44). Politics, however, pervaded all public spectacles, especially the theatre, and it was commonplace to think of politicians as themselves actors on the public stage.

EARLY PARTY SATIRE

Hogarth's earliest works as an independent printmaker were political satires, taking a broadly Tory line against financial speculation and paper credit. They do not probably represent deep personal conviction but are exercises in a mode of satire popularised by Dutch engravers at the time of the South Sea Bubble crisis of 1720. Hogarth was also evidently much taken with the Tory satire of Jonathan Swift, though his own associations from the late 1720s onwards tended to be more with the court through his father-in-law Sir James Thornhill.

83 *The South Sea Scheme*, 1721?

Etching and engraving, 264 x 325 mm
Lit.: Paulson 43
S.2-4

The broad and, in terms of contemporary discourses, conventional theme is of the baleful effects of 'Monys magick power', which causes 'Honour & honesty [to become] Crimes, That publickly are punish'd by Self Interest, and Vilany'. Hogarth's print is a venture in a well-known type of print of Dutch origin (see no. 84) satirising commercial speculation and often using elaborate crowd and genre scenes and allegory. Such attacks on 'Paper Credit' became essentially oppositional, but it is likely that for Hogarth at this date they were simply an established satiric mode which did not demand a specific party allegiance.

See here ÿ Causes why in London,— | Trapping their Souls with Lotts & Chances | Leaving their strife Religious bustle, | (E) Honour, & Honesty, are Crimes,—
So many Men are made & undone, | Shareing oft from Blue Garters down | Kneel down to play at pitch & Hussle, (C) | That publickly are punish'd by
That Arts & honest Trading drop—| To all Blue Aprons in the Town.—| Thus when the Sheepherds are at play, | (G) Self Interest and (F) Vilany;—
To Swarm about ÿ Devils Shop, A | Here all Religions flock together,—| Their flocks must surely go astray; | So much for Monyÿ magick power
Who cuts out (B) Fortunes Golden Haunches | Like James & Wild Fowl of a Feather, | The woeful cause ÿ in these Times. | Guess at the Rest. you find out more
| | | price 1 Shilling

83

84

B. PICART

84 *A Monument Dedicated to Posterity in Commemoration of the incredible Folly transacted in the Year 1720*

Etching by B. Baron, 247 x 348 mm, published by Thomas Bowles
Lit.: BMC 1629; Döring, 227
1868-8-8-3479

This print is a copy in reverse of a print by Picart of the same year (BMC 1627; reproduced Döring, pl.4), which was originally set in Amsterdam but then transposed to London, with identifiable locations like 'Jonathan's' coffee house. It is a good example of the mixture of crowds and identifiable locations with allegorical elements which tends to characterise Dutch satire.

ANONYMOUS

85 *The Bublers Mirrour: or England's Folley*, 1720

Mezzotint and letterpress, 348 x 248 mm, published by Thomas Bowles
Lit.: BMC 1620
1868-8-8-3484

By contrast with the previous example, the concept is relatively simple: a leering 'Bubler' points to a money bag, containing the ill-gotten gains of speculation. It is printed in mezzotint (perhaps in deliberate imitation of prints of solid citizens by Kneller), and it is set within an imitation newspaper, both a product and an emblem of an urban, competitive and corrupt society. The 'Bubler' is precisely identified in the caption as a member of the distressed gentry whose fortunes have been redeemed by the South Sea Bubble:

Thus Fortune's Darling Glories in Success,
And boasts his Riches with a smiling-face;
South Sea he bought when low, for little Gold,
And luckily Sold out for Seven fold;
Paid off the Mortgage of his dip'd Estate,
And blusters now among the Rich and Great…

The Punishment inflicted on Lemuel Gulliver by applying a Lilypucian fire Engine to his Posteriors for his Urinal Profanation of the Royal Pallace at Mildendo which was intended as a Frontispiece to his first Volume but Omitted.

86

86 *The Punishment inflicted on Lemuel Gulliver* (*The Political Clyster*), 1726

Etching and engraving, 209 x 314 mm

Lit.: Paulson 107, state 1

1861-4-13-502

This print, brought out within two months of the appearance of Swift's *Gulliver's Travels*, was probably an attempt to cash in on the book's success rather than 'intended as a Frontispiece to his first Volume but Omitted', as is claimed in the caption. As befits an illustration to Swift, the message is a Tory one, with Gulliver as a type of John Bull (invented by Swift's friend Arbuthnot in 1712) who is humiliated and grievously exploited while the country is mismanaged by ignorant, coarse and vengeful Lilliputians.

THE GREAT MAN: WALPOLE AND THE COURT

87a

Sir Robert Walpole's personal power was immense but it was ultimately dependent on the king's consent. At the same time Walpole was able to use the court apparatus of preferment and sinecure to exercise influence and control. It is perhaps best to see Hogarth as one of the many artists and writers to find themselves in an equivocal relationship to Walpole: wanting to satirise his power yet also hoping for court sinecures and patronage.

87 *The Walpole Salver*, 1728

a) Silver salver by Paul de Lamerie engraved with the Second Exchequer Seal of George I
(exhibited as a photograph)
Victoria and Albert Museum
b) Pull from the salver
Engraving, 271 mm diameter
Lit.: Paulson 114; Susan Hare, ed., *Paul de Lamerie*, catalogue of an
 exhibition at Goldsmith's Hall, London, 1990, 94–5, no. 50
1978 u. 3488

Though Hogarth had begun his career as a silver engraver and apprentice to Ellis Gamble, the engraved design on this salver is the only one of many candidates that can be attributed conclusively to Hogarth's hand. Hallmarked 1728, the salver itself was made by Paul de Lamerie to commemorate Walpole's service as Chancellor of the Exchequer. It is not known why Hogarth, who by then would no longer have been thought of as a silver engraver, should have been given the commission, nor is there any reason to suppose that Walpole was involved in choosing him. It does, however, show the potential importance of court patronage for an aspiring artist, and Hogarth seems actively to have sought royal commissions for portraiture, though he was eventually thwarted by the Burlington circle (see p. 43). Hercules, here symbolising the Protestant Succession, holds up the Seal and presides over a panorama of London as a prosperous trading city, with the defeated

87b

figures of Calumny and Envy at his feet. The design supports the government's claim to have brought prosperity and stability to England, despite the carping of the opposition, who are presumably to be identified with Calumny and Envy. It is not known whether or not Hogarth devised the motif himself.

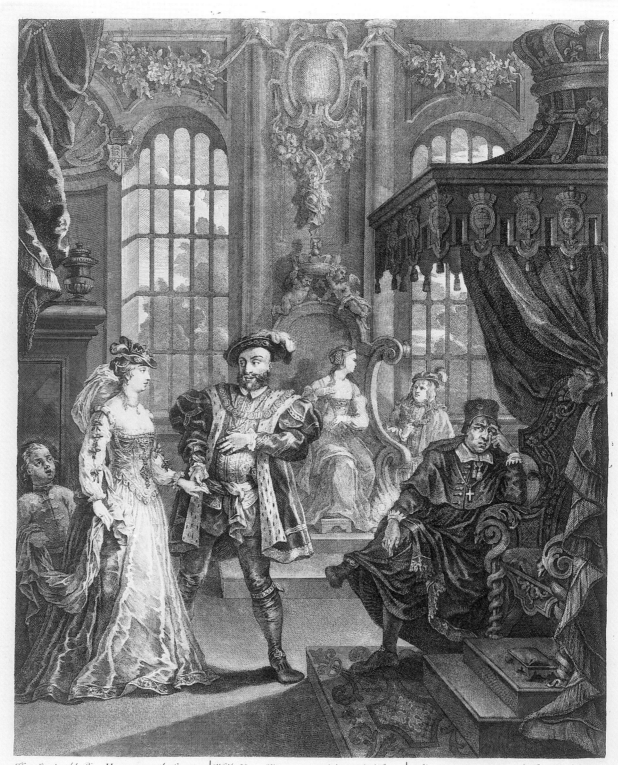

Here Struts old Pious Harry, once the Great,
Reformer of the English Church and State:
'Twas thus he stood, when Anna Bullen's Charms,
Allur'd th' Amorous Monarch to her Arms.
With his Right hand, he leads her as his own,
To place this matchless Beauty on his Throne;

Whilst Kate & Piercy mourn their wretched Fate,
And view the Royal Pair with equal Hate.
Reflecting on the Pomp of glittering Crowns,
And Arbitrary Power that knows no Bounds.

Whilst Woolsey leaning on his Throne of State,
Through this unhappy Change forsees his Fate.
Contemplates wisely upon worldly Things,
The Cheat of Grandeur, & the Faith of Kings.

88

88 *Henry VIII and Anne Boleyn, c. 1728–9*

Etching and engraving, 497 x 384 mm

Lit.. Paulson 113, state 1

Cc.1-96

The political point of the image would have been perfectly clear to any observer of the political scene or reader of opposition pamphlets. With the advent of the new king, George II, in 1727, the opposition's hopes that he would soon dispose of Walpole were feverish but eventually firmly thwarted. The analogy between the hoped-for fate of Walpole and that of Cardinal Wolsey in Shakespeare's *Henry VIII* became a standard trope of opposition satire (see no. 3 below). In the words of the caption to the first state:

Whilst Woolsey leaning on his Throne of State,
Through this unhappy Change foresees his Fate,
Contemplates wisely upon worldly Things,
The Cheat of Grandeur, & the Faith of Kings.

ANONYMOUS

89 Satire on the Excise Bill, 1733

Fan leaf, 141 x 468 mm

Lit.: BMC 1925 (describes another, partial impression); *Schreiber Fans*, unmounted, 22; Atherton, pl.13; Döring, 43 and 88

1891-7-13-379, presented by Lady Charlotte Schreiber

One of many satirical attacks on Walpole's unpopular Excise Bill, unusual for being in the form of a fan. The comparison between Walpole and Wolsey is here made explicit in the medallion of Wolsey, which reads around the rim: 'Wolsey and his successor here in one behold Both serv'd their masters both their country sold.' The defeat of the Bill is represented by the slain dragon in the foreground, and Walpole is presumably the figure clinging to the tree on the right.

89

90

ANONYMOUS

90 *Idol-Worship or The Way to Preferment*, 1740

Etching and engraving, 399 x 281 mm
Lit.: BMC 2447; Atherton, 199–200; Döring, 143–4
1868-8-8-3620

A classic satire on Walpole's system of preferment, by which he used the influence and prerogatives of the court to reward those who supported him. The 'Way to Preferment' is supposedly only to be achieved by abject abasement to Walpole. It dates from 1740, two years before Walpole's fall and a period of extreme unpopularity because of his reluctance to appease the merchants by going to war with Spain. This kind of satire was avoided by Hogarth in this period, in order to distance himself from the genre itself, and perhaps also to avoid offence to the court. This print is attributed by Döring to George Bickham, and it may have been instigated by a member of the political opposition.

FRANCIS HAYMAN

91 *The Patriot-Statesman*, 1740

Etching by G. Van der Gucht with letterpress, 645 x 392 mm
Lit.: BMC 2459; Allen, *Francis Hayman*, no. 76; Döring, 41
1868-8-8-3624

A rare example of visual propaganda on behalf of Walpole and the government, showing him as a great statesman led by the Elizabethan Lord Burleigh towards the Temple of Fame. Walpole is shown unscathed by figures of Envy, War, Anarchy and the Vices, and a ship behind symbolises the trade he has enabled to flourish. The print was designed by the painter Francis Hayman, a friend of Hogarth, but the manner used is that of the high-flown allegorical designs of Thornhill and earlier wall-painters.

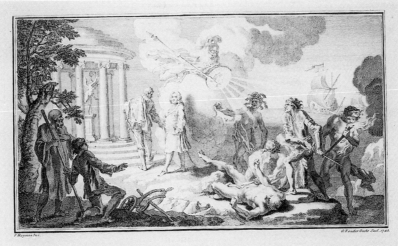

F. Hayman inv. *G. Vander Gucht Sculp. 1740.*

The PATRIOT-STATESMAN.

Et socios, cives, ac Deum ipsum precor, hunc, ut tibi ad finem usque vitæ, quietam & INTELLIGENTEM HUMANI DIVINIQUE JURIS MENTEM duit: illos ut quandocunque concesseris, CUM LAUDE ET BONIS RECORDATIONIBUS, facta atque fama nominis tui prosequantur. TACIT. IV. Annal.

THAT like Causes should produce the same or like Effects, is a Rule with respect to Men as well as Things. Those Favourites who have risen to the sole Direction of *English* Courts, by mere Dint of Address, and those Arts which are unknown to Men of real Abilities, have been always fatal to the Nation; whereas Publick Affairs have never been more happily conducted than when under the Direction of a Person regularly bred to Business, and who before his Arrival at the Helm of Government, had pass'd through such intermediate Offices, as both furnish'd him with Experience, and gave him an Opportunity of displaying by Degrees his great and various Talents. In this manner rose, in the Time of *Henry* VII. those great Statesmen Chancellor MORTON, Sir EDWARD POYNINGS, &c. who were admired and even dreaded throughout *Europe*. So in his Son's Reign rose the Chancellor AUDLEY; in his Grand-daughter *Elizabeth*'s the Great BURLEIGH, and in still later Reigns CLARENDON, SOMERS and GODOLPHIN; none of whom escap'd Envy when living, or suffer any thing by its Efforts now they are dead.

THIS is sufficient to support a Man of true Resolution, in his Endeavours for the Service of the Nation, even when he sees those Endeavours treated as so many Attempts to bring on public Ruin. This hath always supported that HONOURABLE PERSON who hath been for many Years the Object of factious Hate; and this inspires his Friends with a just Zeal in Defence of a Reputation, which they know will one Day stand in need of no Defence, even in respect to those, who now, for the sake of private Interest, affect to be thought his Enemies. The more they consider all Things, the more they are convinced of his Worth, and of the Merit of that Cause in which they are embark'd. If they cast their Eyes back even beyond the Time of his first Appearance in Business, they had had defended of a Family, the Antiquity of which needed not Titles to make it Honourable; they behold him distinguish'd at School, in the University, and in the most flourishing of our Inns of Court, a rising Genius, promising in its Dawn that Glory, to which, by a graceful and proper Motion, it long ago arrived. They view him in Parliament from a natural, and, if I may be allowed the Expression, from an hereditary Right to his Country's Affection, and acting there in such a manner as to fix that Love to his Person, which as yet was borne him for the sake of his Ancestors.

IN those Days Men acted steadily from Principle; and this Honourable Man, as he set out on Principles of Liberty, so he maintain'd them in all Seasons; and as he was never vain of them in, so he was never asham'd of them when out of Fashion. He did not prostitute either his Parts, or his Eloquence, to mean or slavish Purposes. His Merit render'd him considerable in the Eyes of those who made this Nation more considerable than the ever was; and as they honour'd him with their Favour in the Day of their Power, so, with equal Courage and Gratitude, he defended their Honour in the Day of Distress. He did more, he shared in their Distress: He was asham'd to be at Ease, while his Country suffer'd; and the Vigour with which he exalted himself, against those to whom it ow'd its Distress, brought on his own. On this Occasion, he demonstrated that Innocence might be too hard for Authority, and the Virtue of a single Man capable of combating the whole Force of a triumphant Faction. He fell with greater Glory than they conquer'd; and the Voice of the People immediately revers'd their ill-grounded Votes.

IN the Course of Employments, worthy of his Birth, and due to his Integrity, he acquir'd a thorough Knowledge of the Business of the Nation, and of that Part of its Business which he hath since conducted with so much Address. His Skill in the Finances was not a Skill like that which some others have boasted of; in framing great Projects, talking of vast Improvements, and pretending to pay Debts without Money. No! it was a Skill equally solid and useful, whereby he corrected the Errors of his Predecessors, and

brought Things into such Order, as prevented some who had afterwards the Management of them, from throwing all into Confusion again. These were his Employments in the Beginning of the late Reign, when both King and People were so well satisfy'd as to his Parts and Probity, that, after the fatal Year 1720. the first Dawn of Comfort arose from the bringing him back from his Retirement to the Direction of Public Affairs.

THIS alone is sufficient to demonstrate how unjust those malicious Reproaches are, which the Tools of Party have been scattering ever since. Whatever there was well-intended in the Scheme for bringing within Compass the Nation's Debt, had his Countenance and Assistance to the utmost. But when wicked and designing Men had converted the Remedy into a Poison, he was one of the first who discovered it; and he opposed it with a Warmth suitable to the Occasion. Those who have been since most forward to blacken his Character, were then the profess'd Admirers of his Conduct; and what seems to be a little extraordinary, the same People daily object now to that Conduct, which they then so much applauded. Their Mutability, however, serves only to do Honour to the Steadiness of his Virtue; for after doing all that was in his Power to preserve his Country from Misfortunes, he was not asham'd to return to her Service, when she stood in need of his Assistance, or to contribute to the Repairing those Faults which had been committed by his Enemies, tho' he well knew that no sooner they were safe, than they would revile him.

THE popular Opinion at present is, that the Public Debts have been very little thought of, at least with a View to Payment; and yet nothing is more certain, than that the only rational Scheme for paying them, was the Scheme of this HONOURABLE PERSON: A Scheme neither difficult nor intricate! A Scheme which Experience hath demonstrated to be perfectly practicable! A Scheme indeed which his Enemies have defeated by repeating their Schemes for embroiling the Public, till it became necessary for him to suffer his own Scheme to give way, foregoing Reputation willingly, when it was to save the Nation!

WE have seen the Enemies of this HONOURABLE PERSON piquing themselves upon their Skill in Politics, and magnifying their own great Wisdom shewn in Volumes of Journals, Dissertations and Occasional Writers. But what were all these? Were they at all calculated for the real Service of the Nation? Would they either pay Debts, or take off Taxes? No! that would not have answer'd their Authors Purposes, who fought not to ease the People, but to make them restless under a Load which themselves had made necessary. The Schemes of this HONOURABLE PERSON have been quite the reverse. If he promoted a Project for increasing the Revenue, it was because he thought it for the Advantage of the Public. If he has countenanced any Severity towards Smugglers, it was purely out of regard to the fair Trader. His private Character hath established his Humanity beyond the Reach of Prejudice; his very Enemies are so many Witnesses of his Clemency, and their impunish'd, nay, unthought of Libels, the strongest Panegyrics.

THAT he hath maintained his Power so many Years, against an Opposition equally violent and malicious, will in all times appear strange to the Many, and easy to the Few. For that the Minister, who made it his Business to promote Unanimity amongst all his Majesty's Subjects, by treating them as any way deserv'd it, with the greatest Kindness, and the most outrageous Offenders with the utmost Lenity, had impotent Enemies, and powerful Friends, can surely appear no Miracle! That a Minister, who in respect of foreign Affairs, acted altogether on Maxims of Equity, never believed it justifiable to make War when Occasion offered, nor to declare against Peace, when it was fought for, on just and honourable Terms, should be esteemed in foreign Courts, will appear a natural Consequence of his Conduct! That a Minister, easy of Access, whose Ears were always open to Proposals, and whose Thoughts were always bent on the Encouragement of a national and extensive Trade, should have the good Wishes of the most eminent Traders, tho' not the Applause of the Retainers to Trade, will be accounted in all Times, no more than what might have been expected! But that the Foes of such a Minister, in mere Opposition to his Schemes, promoted domestic Confusion, a foreign War, and a total Interruption of Trade, that they might have the Pleasure of complaining of it; that such Men as these should be honoured with the Name of Patriots, even by the

Dregs of the People, will strike succeeding Ages with Wonder, and pass, I am afraid, for a full Justification of those Outcries against Corruption, which come weekly from the most corrupt Mouths in the Nation, whom nothing but Corruption ever did advance to Power, and who are now endeavouring to corrupt the common Sense, as they formerly did the Honesty of the People!

IT will by no means appear astonishing to any Man of Prudence and Penetration, that Schemes so just and equitable in themselves, should not in all respects be attended with Success. That would be supposing human Wisdom, superior to the Divine. How should the Schemes of a good Minister be carried into Execution, absolutely and with Ease, while the World is full of mischievous, designing, and self-interested Men? And while, perhaps, the Majority of the rest may be deluded by a frothy Eloquence, and plausible Pretext? Besides, the great Principle on which the HONOURABLE PERSON hath acted, viz. the restoring and maintaining Liberty, hath been, and must be ever fatal to his other Views. For where-ever there is Liberty, there will be Men who will make a bad Use of it; and where-ever there Men are, they will trespass without Fear, against the Laws of God, of Nature, and their Country. They will fetch the Kid in its Mother's Milk; that is to say, they will make use of Benefits in Possession against those by whom they were bestow'd. They will set themselves up for the sole Owners of Liberty, and under that Notion, they will undermine, I mean in popular Opinion, those who maintain that Liberty which they abuse. By Arts like these, they may keep the best Minister at Bay, prevent the most public-spirited Designs from being put in Execution, and then with that Effrontery, which is natural to false Patriots, reproach him for not doing what they will not suffer to be done. These things, as I said at first, may pass upon the Many, but they will not pass upon the Few. When Time hath weeded out Prejudice, and Posterity calmly reviews those Scenes, of which our Passions will not suffer us to judge, Right will be done to all Parties, and true Greatness of Soul will be distinguished from Restlessness of Spirit.

I SHALL close this Discourse with observing, that as in the Morning of his Days, this Great Man triumphed over the Malice of his Enemies when in Power, so he has again triumphed over their Envy in the Meridian of his Glory. He hath shewn himself alike incredible of their Injuries and their Reproaches; and as he was constant to his Sentiments, in spite of all they could do, so he still keeps steadily to his Purpose, notwithstanding all they can say. He began the World with considering Things as they really are in Nature, and not as Mankind are pleased to represent them; he has always gone on in the same Track, and Time has constantly justify'd the Rectitude of his Conceptions. The present is, without Doubt, a most critical Conjuncture; and as such, worthy of his Courage and Conduct; neither is it to be doubted, that he will bring himself and his Country with as much Honour out of War, as heretofore he maintain'd her Trade and Safety, during the long Continuance of Peace. Those who are Enemies to both, as they really wish, so they affect to think otherwise; but Time, the Discloser of Secrets, will, I hope, ere long, reveal to their Disappointment, those Honours which yet remain to crown that Administration, which, like the Government of *Pericles*, may boast of being unstain'd with the Blood of Citizens, and having done more Good to Foes, than was done by former Administrations to their Friends.

SEE virtuous WALPOLE to FAME's *Temple* goes,
Where the known Entrance mighty BURLEIGH shews.
Pallas, to every *Hero*'s Cause inclin'd,
Keeps *Envy*'s meagre *Offspring* far behind.
Believe not this a mere *poetic* Thought,
Or by the *Painter*'s pregnant Fancy wrought.
Both had a real Image in their View,
And faintly from their mighty *Subject* drew
Britain's great STATESMAN, so in future Days
Like *Burleigh*, shining with victorious Rays,
Shall gild the *Sphere* with so sublime a *Day*,
That *Slander*'s sickly *Sons* shall skulk away,
Loth to retire and yet afraid to *stay*,
As *Morning Mists* against the *Sun* conspire,
Yet soon *dissolve* before Ætherial Fire.

R.C.

That the Reader may enter the more easily into the Design of the Print, and of the Verses describing it, the following Speech is subjoin'd. It was made by QUEEN ELIZABETH, of immortal Memory, to a Nobleman at the Head of the Faction which opposed her Ministry.

NOW comes it, my Lord, that after so many powerful Aspersions thrown out by you as a Man I thought fit principally to employ, the cold Silence I have affected to receive them with on the one side, and the Continuance of the Confidence I favoured *Cecil* with on the other, have not opened your Eyes as to my real Sentiments of him, and confirmed you from your fruitless Attack, and the Assiduities you are entered into with his Enemies? Men who have no Motive to hate him but Envy, no Cause to attack him but private Disappointment.

CAN you think any ignorant of your Cabal, and that vile Methods they use in their Attempts to sully his Reputation, and sink his Credit with my Subjects? Or is it my Tenacity to bear these impotent Efforts, that has given them the insolent Hopes they so fondly practise of possibly o'erturning him?

MIGHT I then give up my own Understanding to yours, and believe him weak or dishonest, because you buz it in? Or what think you, that your Cabal will be able to run him down with Calumny and Clamour?

'Tis *Cecil*'s Management, you cry, has brought me to note a Rupture with *Spain*. Is it not notorious, that Court owes not its Reinstatement to any Steps that *Cecil* has advised? Is it not certain, that the Proceeding of that Crown, to the Prejudice of mine and my

People's Rights, gave the Rise to all these Troubles, not occasioned or provoked by *Cecil*'s Councils? You say he is guilty; but where do you offer one Instance of his Guilt? Have you been able to produce a single Proof of his Male-Administration? Has he embezzled the Public Treasure, or any ways converted it to his own Use? Has he, either by his Negligence or Inexperience, diminished the Revenue? No; Envy itself must impute him here, and own he has administered it with the utmost Capacity and Frugality; that he has improved it in most of its Branches, by his prudent Regulations, his exact and masterly Knowledge of it in all its Parts. Has he then invaded private Property, or committed any Act of Power for his own Lucre? Name the Subject he has oppressed; the most obdurate envy in my Dominion might have found Assets to me; and if he had wanted it, your Cabal, with its hundred Mouths, was open and ready to proclaim aloud the small minute Wrong he had done. What then will you say? I do not justice unpartially administered? nor that its Seats filled up with able and upright Men? Which of them has yielded to his Influence or Corruption? Or has *Cecil* himself been known to swerve? Oh! have you then left him to my Father's ceremony *Wolsey*; but what Prince has *Cecil* been bribed by? From what Foreign Crown has *Cecil* received a Pension or Gratuity? In what Courts abroad has he ever held a Correspondence, in Opposition to the Measures I am engaged in? What Foreign Powers has he abetted or encouraged to bring Difficulties upon me, and Distress upon my People? What! my Lord? not a Word on any of these Heads? Does your Silence then justify *Cecil*? But you say, he is weak, and when his Integrity cannot be impeached, his Abilities are to be called in question.

Has *Cecil* then been tried and approved in the most exalted Stations his so many Years? Has he so often and so long stood in Senate, the great Touchstone of English Abilities? And are his own now to be doubted? Has he then been trusted by a Succession of Princes, courted by each different Sect of Ministers, for his *Wisdom*? By Minister, with whom were the best of your Junto to be compared, they would seem mere Infants in Understanding, the Beings of a Day.

Is it that there are still more able, more worthy Men among your Set of Wou'd-be-Ministers? Persons on whose superior Talents, sounder Sense, greater Application to Business, more Public-Spirit, or sincere Attachment to my Interest, I might depend? Here then, again, my Lord, will I by silide the Sovereign, and set ask who shall direct me in the Choice of my Ministers; who is it that will outvoat me in the Appointment of my Servants? No; I'll condescend to reason with you, and, from your own Mouth, will confute you. Name out then, I charge you, who of you it is that transfixeth *Cecil* in all, nay, in any one of these good Qualities? Point out that Man, as if your Cabal, who would, with the least Share of public Applause, fill up *Cecil*'s Place. What? still not a Loss, my Lord—Is it—But I will not at this time enter into a Detail of Chancellor; your Confusion makes it needless: Be assured, however, that I know your Junto, and have not waited till now to weigh them against *Cecil*, Man by Man. Suffice it to tell you, that before hand I can foresee the Result of such an Enquiry, and that the Issue will ever mark *Cecil*'s Superiority more clearly above the Station he now fills.

No more then, my good Lord, of these envious Endearings at my Choice; this incessant Arraignment of my Conduct; this importunate Attack of a Man whom I delight to honour; nor think but he stands as much in my Esteem as he has Merit to Favour in any Shape; much less by a fault, an inconsiderable Junto, that from resolv'd to thrust themselves into my Service, and hope to wrest that from my Fears, they cannot obtain from my Judgment.

The Politics of the Stage

If politicians could be seen as actors on the stage of the world, the stage itself could have its own internal politics, with rivalries between theatre managers and actors which could erupt in open conflict. The theatre could also be a field for national politics, and the threat of dissent and ridicule that the theatre presented to the government in the 1730s led to its licensing and severe restraint by Act of Parliament in 1737. There is a strong connection between the development of the Modern Moral Subjects and the stage, and Hogarth more than once made an analogy between his series and the theatre, describing his characters as actors on a stage. His first major success as a painter was his *Beggar's Opera* paintings of 1728–31, and the theatre remained part of his range of reference throughout his compositions.

ANONYMOUS

92 *The Stage Medley Representing the Polite Tast[e] of the Town & the matchless merits of Poet G[ay] Poly Peachum & Captn. Macheath, April 1728*

Etching, 366 x 261 mm

Lit.: BMC 1806; Döring, 75; *Among the Whores and Thieves*, 99

1882-8-12-5

Based on the form of a 'medley print', this is an elaborate satire on the enormous success of *The Beggar's Opera* in the months after its opening. It is hostile to *The Beggar's Opera*, invoking the ghost of Jeremy Collier, author of *A Short View of the Immorality and Profaneness of the English Stage*, and showing (bottom right) a scene in Newgate in which the author John Gay is fêted by 'Beggars, Thieves & Whores' because he has made 'Theft an action brave & void of Shame/ And Robbery, the ready road to fame'. The attacks on Caleb D'Anvers (pseudonym of the editor of *The Craftsman*, the main opposition journal) and on Jonathan Swift (upper right), the scathing references to the performance of Polly Peachum (upper left), and a positive reference to the king and queen as upholders of 'Sciences and Arts' (middle right) suggest that the ideas originate around the court. *The Beggar's Opera* is also seen as destroying the national dramatic tradition, 'weigh[ing] Shakespear down, Ben Johnson, Otway, Rowe & Addison'. The print has no attribution but is clearly by a professional engraver. For medley prints see Döring, 74–5.

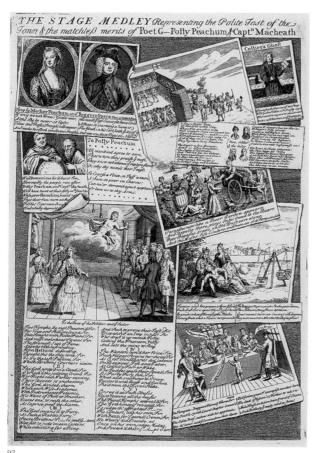

92

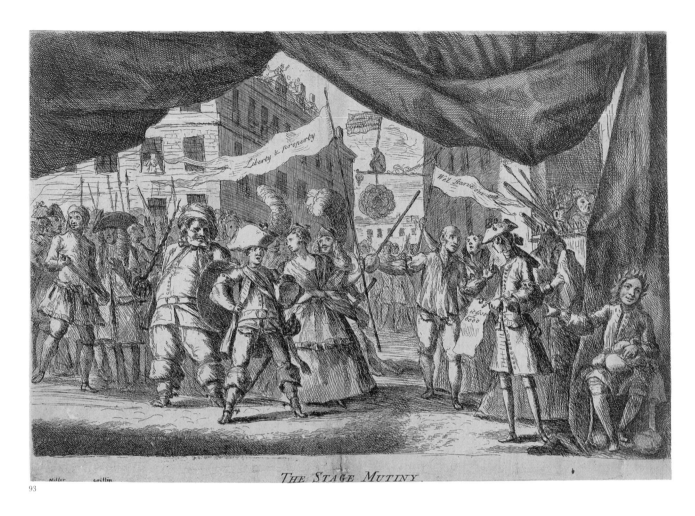

93

J. LAGUERRE

93 *The Stage Mutiny*, 1733

Etching, 266 x 387 mm

Lit.: BMC 1929; Paulson, *Hogarth*, II, 16–18

1868-8-8-3552

A print satirising the battle over the ownership of the Drury Lane Theatre, which was bought up by the wealthy amateur John Highmore, removing it from the hands of the Cibbers and other patentees. The situation eventually led to Theophilus Cibber leaving with most of the company to another theatre. The mutinous actors are shown on the left, and Highmore on the right, with the painter Ellys, a friend of Hogarth, apparently acting as intermediary. Highmore holds a piece of paper saying 'it Cost £6000', while a monkey on a shopsign carries a banner with a catchphrase associated with him: 'I am a gentleman.' Theophilus Cibber is the small indignant figure in the foreground left, in his role of Pistol; a banner held by his female companion reads sententiously 'Liberty and Prosperity'. The figure on the right is the elder Cibber, clutching moneybags received from Highmore for the theatre patents. Hogarth certainly knew several people involved in the dispute, and the print is reproduced in *Southwark Fair* (no. 68) as a showcloth above the collapsing stage on the left. This is inscribed as belonging to 'Ciber and Bullock', and the aborted performance is of *The Fall of Bajazet*.

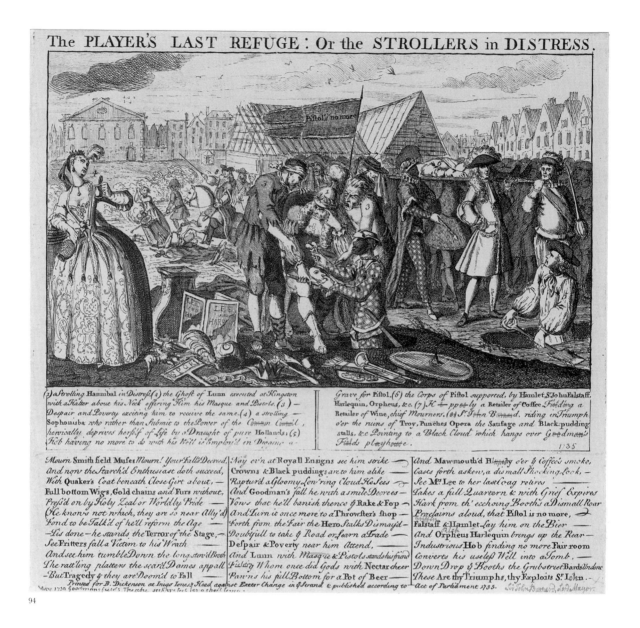

ANONYMOUS

94 *The Player's Last Refuge: Or the Strollers in Distress*, 1735

Etching, 168 x 233 mm

Lit.: BMC 2146

1868-8-8-3577

An attack on Sir John Barnard, Lord Mayor of London (on horseback in the rear), who had brought in a Bill in April 1735, with Walpole's support, to limit the number of playhouses and control their productions. The Bill failed because the king wanted to give control to the Lord Chamberlain, but was eventually enacted two years later (see no. 96). The Act was undeniably politically driven, as a way of countering the ridicule of the government in the plays of Henry Fielding and others. There was also a belief remaining from the seventeenth century that theatres were a source of immorality and had a bad effect on neighbourhoods, as was claimed in the case of the Goodman's Fields Theatre in the background. The harlequin in the foreground, 'the Ghost of Lunn', is John Rich, the theatre manager and first producer of *The Beggar's Opera* (see no. 31).

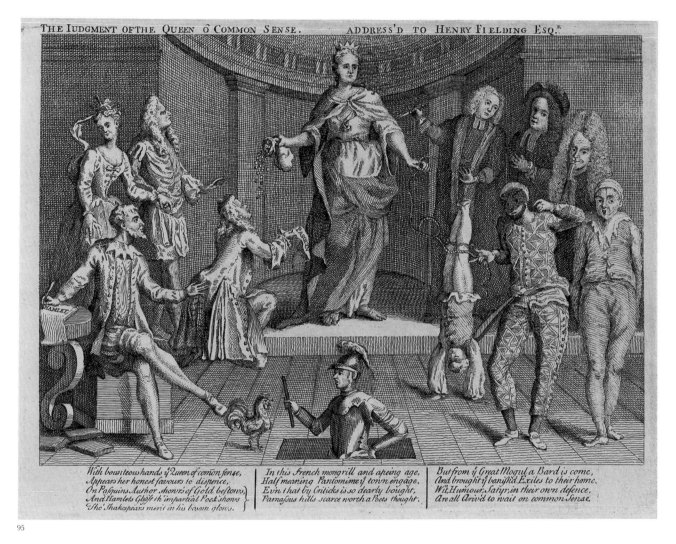

THE IUDGMENT OF THE QUEEN Ò COMMON SENSE. ADDRESS'D TO HENRY FIELDING ESQ.ᴿ

With bounteous hands ȳ Queen of comon sense,
Appears her honest favours to dispence,
On Pasquins Author showrs of Gold bestows,
And Hamlets Ghost th' impartial Poet shows
The Shakespears merit in his bosom glows.

In this French mongrill and apeing age,
Half meaning Pantomime ȳ town engage.
Ev'n that by Criticks is so dearly bought,
Parnassus hills scarce worth a Poets thought.

But from ȳ Great Mogul a Bard is come,
And brought ȳ banish'd Exiles to their home.
Wit, Humour, Satyr, in their own defence,
Are all Ariv'd to wait on common Sense.

95

ANONYMOUS

95 *The Judgment of the Queen o' Common Sense, Address'd to Henry Fielding Esqr.*, 1736

Etching, 178 x 237 mm
Lit.: BMC 2283; Döring, 140
1858-4-17-587

Henry Fielding is on the left, offering to 'the Queen of Common Sense' his play *Pasquin. A Dramatick Satire on the Times: Being the Rehearsal of Two Plays, viz. A Comedy call'd, The election; And a Tragedy call'd, The Life and Death of Common-Sense*. On the right, competing for the judgement of the queen, are three harlequins, but they are in distress because the queen showers Fielding with gold. Fielding has, therefore, won out over 'Half meaning Pantomime', which still seems to engage the attention of representatives of the professions of medicine, law and divinity. The play *Pasquin* was itself precisely the kind of play that alarmed the government, for it ridiculed the recent general election because of bribery on both sides, caricaturing the courtiers under the names of Lord Place and Colonel Promise, and the Country opposition as Sir Henry Fox-Chace and Squire Tankard (see Election series, no. 98). *Pasquin* also contained an attack on the professions as opposed to 'Common-Sense'.

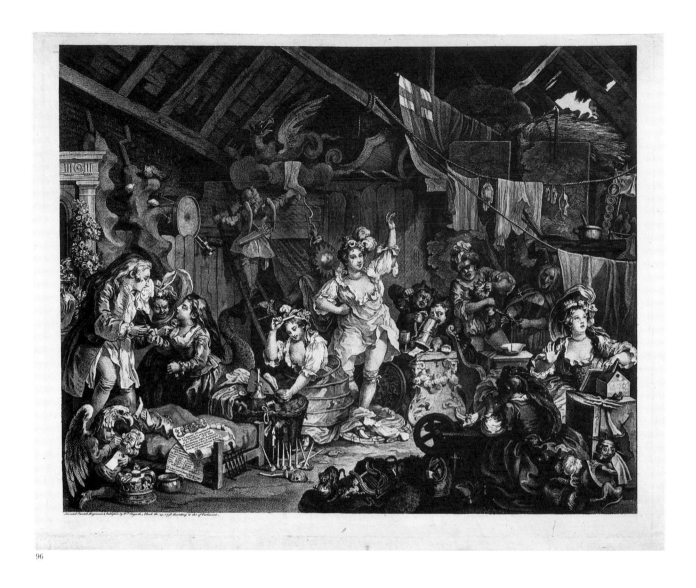

96

96 *Strolling Actresses Dressing in a Barn*, 1738

Etching and engraving, 455 x 566 mm
Lit.: Paulson 150
1857-5-9-12

Though the text in this print makes several references to Walpole's Licensing Act of 1737 which severely curtailed the operations of all theatres, apart perhaps from two in London, the original painting (lost in a fire in 1874) and the first announcement of the engraving were made before the Act came into force. However, the Act had been signalled long before (see no. 94) and was no surprise when it came. The fact that the performance for which the actresses are preparing was 'the last time of acting before the Act Commences', as the playbill declares, gives an extra level of poignancy to what is already a poignant scene. The print highlights the sad reality of the life of 'The Company of Comedians from The Theatres at London', obliged to get dressed in a leaky barn by the side of a tavern in some remote village, while preparing for a play, *The Devil to Pay in Heaven*, which requires them to act as gods and goddesses in the clouds above. The contrast between their real and demeaning existences as strolling players and the stage fantasies they will project is played out in an infinite variety of different situations, involving the whole cast and scenery.

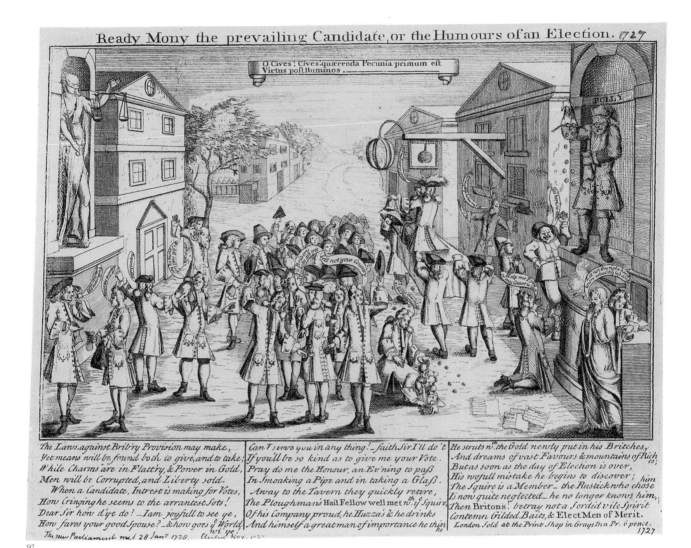

97

PATRIOTISM ABOVE PARTY

The idea that parliamentary elections were inevitably the occasion for cynical bribery of an ignorant and venal electorate was not new in Hogarth's time. In the 1730s the eminent former Tory statesman Viscount Bolingbroke argued that party strife was merely destructive and that a better model would be a country united behind a 'Patriot King', who would be above party and be served by a court made up of the best and most public-spirited people. There is some evidence that Hogarth was influenced by this view, though it seems also to have become a commonplace idea across the political spectrum by the 1750s (see p. 47).

(see p. 47)

ANONYMOUS

97 *Ready Mony the prevailing Candidate, or the Humours of an election*, 1727

Etching, 237 x 300 mm, published by 'the Print Shop in Grays Inn'
Lit.: BMC 1798; Atherton, 135; Döring, 58 & 76
1868-8-8-3520

An attack on bribery in parliamentary elections, and in particular the general election of November 1727, with perhaps the implication the Walpole government was enabled by electoral corruption. In the centre a voter cries 'No Bribery but pockets are free' as his pockets are stuffed by three candidates.

98 *Four Prints of an Election*, 1754–8

Lit.: Paulson 198–201
S.2-130, 131, 133, 135

The four prints are based on a spectacular series of highly finished paintings (Sir John Soane's Museum, London), which represent the high point of Hogarth's achievement as a painter. At one level they pick up the traditional themes of election bribery, as in no. 97; on another level they deal with the state of the nation and its present weakness, and the danger of 'faction' (see p. 49). The designs are of an astonishing complexity; Hogarth brought in several engravers to help with the engraving of the plates and was not able to complete the task until 1758.

a) Plate 1: *An Election Entertainment*, February 1755
Etching and engraving, 430 x 551 mm

The scene shows the Whigs inside the room and the Tories outside. The two candidates are shown on the left, and humour is drawn from the indignities they suffer from the over-familiarity and coarse behaviour of their constituents. The entertainment and perhaps elections themselves are a reversal of the 'natural' order of things; the common people are placed in the position of their betters, and their betters are forced to appease them and endure their vulgarity. Certainly the voters are represented as without exception idiots and scoundrels. There is probably a reference back to Leonardo's *Last Supper* in the grouping, and this might, as Paulson has argued, link to the theme of betrayal implicit in the electoral transactions. The plate is dedicated to Henry Fox, the Secretary at War since 1746. Fox had been a defender of Walpole until his fall in 1742, and had become attached to the Duke of Cumberland. Hogarth's dedication can be read as a gesture of support for Cumberland and perhaps the principle of 'Prussian' order for which he stood (see no. 72 above). It also suggests that the corruption of Hogarth's election did not apply to the 'higher' politics represented by Fox.

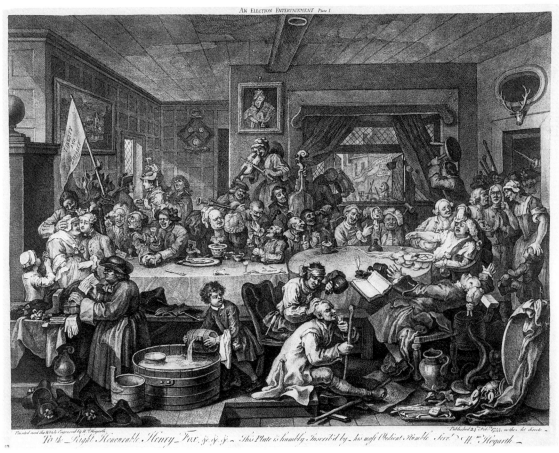

98a

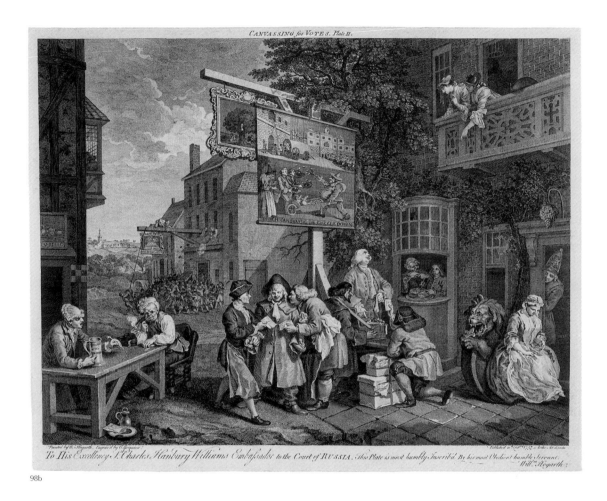

98b

b) Plate 2: *Canvassing for Votes*, 20 February 1757

Etching and engraving by C. Grignion, 436 x 556 mm

In the scene outside the inn the Tory candidate is buying favours from a Jewish peddlar to give to two girls on the balcony. The scene of bribery is mirrored in the political poster showing Punch handing out Treasury bribes to the electors of Guzzletown while neglecting the army. The larger inn, the Royal Oak, is Tory and the smaller, besieged by a Tory mob, has a sign reading 'The Excise Office' (it is in reality the Crown) in memory of Walpole's famous Excise Bill of 1733. The third inn on the left, the Porto Bello, is apart from the other two and thus also from the political conflict. It shows two old sailors reminiscing about

a heroic British naval victory; such things are apart from and above 'party', represented by the other two inns, whose publicans seek to bribe a young farmer, i.e. a representative citizen, reduced to accepting money from both Whigs and Tories. The print is dedicated to Sir Charles Hanbury Williams, a diplomat and supporter of Walpole, who kept his sinecures for some years after Walpole's fall. According to Horace Walpole, 'He had innumerable enemies, all the women, for he had poxed his wife, All the Tories, for he was a steady Whig, all fools, for he was a bitter satirist, and many sensible people, for he was immoderately vain.' (*House of Commons, 1715–54*, II, 106.)

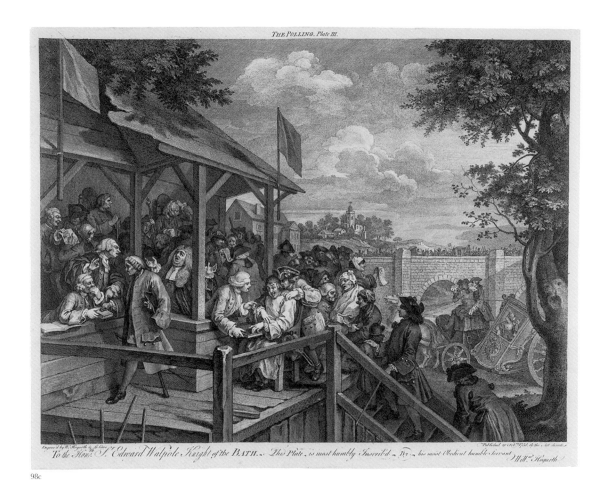

98c

c) Plate 3: *The Polling*, 20 February 1758

Etching and engraving by Hogarth and F .Morellon la Cave,
 437 x 559 mm

The principal joke is the condition of the voters, all of whom are defective in some way: 'The Sick, the Lame, the Halt and Blind!' (Anon., *A Poetical Description of Mr Hogarth's Election Prints...written under Mr Hogarth's Sanction and Inspection*, 1759). In the background there is an allegorical comment on the state of the nation: a broken coach with a figure of Britannia inside, is driven by two coachmen oblivious of the coach's damage and the likelihood of its overturning. The coachmen are presumably representative of the two parties, engaged in their own games while the nation runs out of control, perhaps fatally. This print is dedicated to Sir Edward Walpole, son of Sir Robert and a Member of Parliament who enjoyed excellent life sinecures bestowed on him by his father and quietly supported the government in power (*House of Commons, 1715-54*, II, 508).

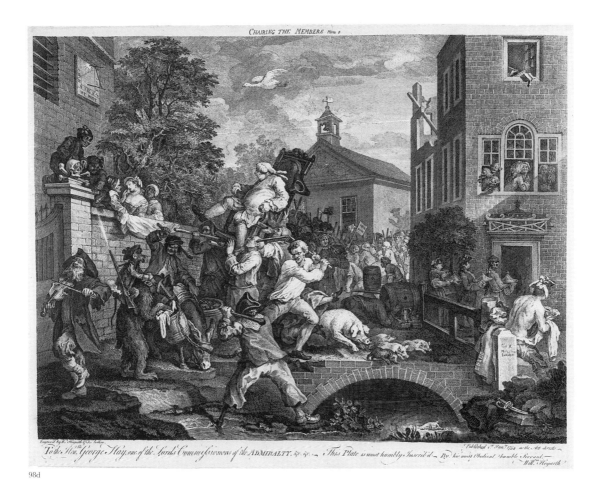

98d

d) Plate 4: *Chairing the Members*, I January 1758

Etching and engraving by Hogarth and F. Aviline, 436 x 556 mm

Hogarth's supreme exercise in the mock heroic. The victorious Tory candidate, carried aloft in triumph at the head of a procession like a victorious Roman general, but with a goose instead an eagle, seems set to topple with his carriers, as he recoils in fright at a skull and crossbones set up by two chimney-sweeps, and a pig and piglets knock over a woman in their path. Fights, chaotic incidents, fatuous and callous behaviour are everywhere, except for a half-ruined house to the right, which is attended by a procession of flunkies bringing food. They are presumably the manipulators and lawyers who profit from any situation however dire it is for the nation. The print is dedicated to George Hay, a Lord Commissioner of the Admiralty and, though in high office, of a different political complexion to the dedicatees of the other three prints. He was an appointee and supporter of William Pitt, and was a political opponent of Henry Fox. Perhaps Hogarth included him to avoid the suggestion that he was only partial to former Walpole supporters.

INTELLECTUAL WARFARE:
THE ANALYSIS OF BEAUTY
AND ITS RECEPTION

The Analysis of Beauty was in gestation from at least 1745 (see no. 23) until its appearance in 1753. It can be seen as part of Hogarth's attempt from the mid-1730s onwards to establish himself as an artist of substance, able to justify his practice in lofty terms. It also reflects the company he kept after his success with the Progresses, and his access to notable members of the professions. The volume can further be seen as a reaction against the classicising aesthetic of the Connoisseurs, basing its own aesthetic on empirical observation rather than on the authority of the past (see p. 51). Though in general it was received with respect and admiration, it also attracted satirical attention from fellow artists, most notably Paul Sandby, who produced a series of witty and complex etchings ridiculing Hogarth and his intellectual pretensions.

THE *ANALYSIS* AND ITS ORIGINS

There were scurrilous rumours that Hogarth had not really written the text of the *Analysis*, but there is no doubt that he largely did so, though with much help from his friends, especially Dr Thomas Morell. The manuscripts now in the British Library reveal how much the final text was a distillation from a much larger mass of material, and how his friends intervened to improve Hogarth's writing style, which shows signs of real struggle.

99a Title page, *The Analysis of Beauty*, 1753

Printed book, quarto
Lit.: Burke
Private Collection

The first edition was issued by subscription, with *Columbus breaking the Egg* (no. 99b) as the ticket on receipt of the first payment of five shillings. Though one often finds the two large illustrative plates bound in with the volume, in fact Hogarth issued them separately, suggesting in the subscription ticket that the 'two explanatory Prints Serious and Comical, Engrav'd on large Copper Plates [were] fit to frame for Furniture'. The volume was not reprinted in Hogarth's lifetime, but Mrs Hogarth issued a second edition in 1772, and there were foreign editions as follows:

1754 German edition, published in Hannover by
 J.W. Schmidt
 Second German edition, published in Berlin and
 Potsdam by C.F. Voss
1761 Italian edition published in Livorno

THE

ANALYSIS

OF

BEAUTY.

Written with a view of fixing the fluctuating IDEAS of
TASTE.

BY *WILLIAM HOGARTH.*

So vary'd he, and of his tortuous train
Curl'd many a wanton wreath, in sight of Eve,
To lure her eye.———— Milton.

VARIETY

LONDON:
Printed by *J. REEVES* for the *AUTHOR*,
And Sold by him at his House in LEICESTER-FIELDS.

MDCCLIII.

99a

1805 French edition published in Paris (for further details
 see Burke, 232–3)

Hogarth's central thesis is that there is a Line of Beauty
and Grace which underlies all forms which we perceive as
beautiful, and that this was recognised by the Ancients and
Michelangelo. Forms which are too straight or too curved
cannot be perceived as beautiful for they lack variety, a pri-
mary property of the Line of Beauty. The thesis, regardless
of its merits, is based on a universal rather than a privileged
(i.e. Connoisseurs') perception of beauty, and explicitly
rejects traditional systems of proportion, grounding its
authority in the judgement of artists rather than of culti-
vated amateurs (see p. 53).

99b Subscription ticket,
Columbus Breaking the Egg, 1752

Etching, 205 x 193 mm
Lit.: Paulson 194
1868-8-22-1601, bequeathed by Felix Slade

Many impressions of this print which were actually used
as subscription tickets are dated 1752, suggesting that
Hogarth needed to raise money to pay for the final printing.
The story is of Columbus's detractors, who claimed that his
discovery of the New World was not a sign of his superior
perception and that anyone could have done what he did.
He therefore challenged them to stand an egg on its end,
which they failed to do. He then flattened the end of the
egg so that it stood up, demonstrating both his own prowess
and the essential simplicity and common-sense nature of
the solution. It answers the expected claim of Hogarth's
detractors that his conclusions were too obvious to be taken
seriously or given due credit.

99b

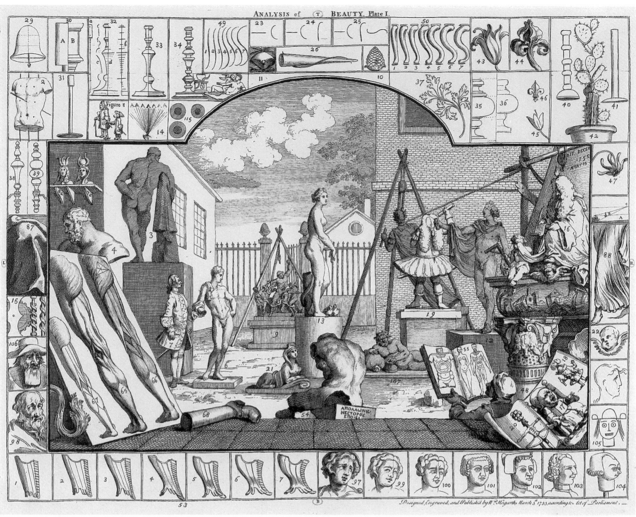

100a

100 Two plates issued with *The Analysis of Beauty*, 1753

a) Plate 1: *The Sculptor's Yard*

b) Plate 2: *The Country Dance*

Two etchings and engravings, (a) 385 x 498 mm, (b) 425 x 532 mm

Lit.: Paulson 195 and 196

1868-8-22-1602/3, bequeathed by Felix Slade

The plates were intended to illustrate the book, and references in the text are keyed to numbers on the plates. It is also clear from the subscription ticket that he intended them to appeal to his collectors as works in their own right. Every figure and element is numbered, and Hogarth provides a key after the Contents page in the volume so that one can work back from the print to the text as well as vice versa.

The scene in plate 1 is a sculptor's yard, in which there are some statues and monuments of contemporaries, but the main production is of copies of antiques for garden sculpture. It has often been suggested that the yard represents the premises of the cast-maker and copyist John Cheere at Hyde Park Corner, but there is no reason to suppose that Hogarth had a specific place in mind. The tomb of the

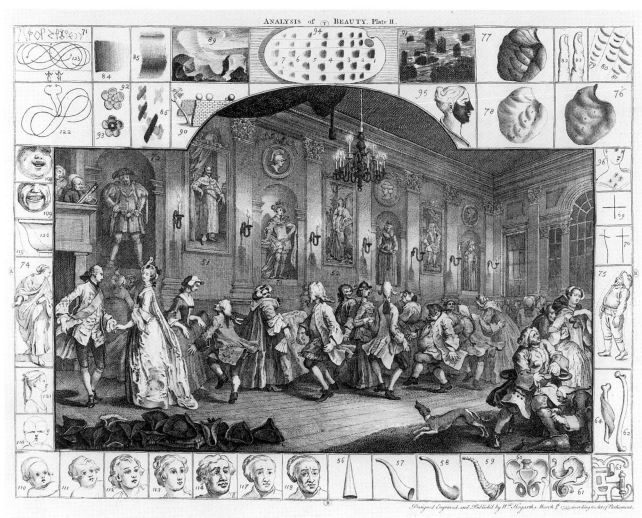

100b

judge in the upper right of main image (16) is referred to as an example of the absurdity of the full-bottomed wig, but in fact it contains a witty comment on the language of tomb sculpture practised by Henry Cheere, and his use of weeping cherubs. The most conspicuous living figure in the scene is the dancing master (7) whose 'stiff and straight figure' contrasts with 'the Antinous's easy sway', a figure of true elegance and variety. Hogarth's aim in these prints was to be both 'Serious and Comical', hence the use of examples to illustrate his thesis that range from the most respected sculptures of antiquity to corsets and chair legs.

Plate 2, *The Country Dance*, depends upon one single comic idea: the effects of deviation from ideal beauty expressed in the elegant and genteel figures on the far left, who contrast with the clodhopping rustics and bourgeoisie around them, each diverging comically from the ideal. Underlying the idea of the dance is Hogarth's method of capturing a likeness by reducing the form to a kind of 'hieroglyphic'; he provides a distillation of the movements of each of the dancers in fig. 71 in the upper left corner of the plate (see p. 55 and fig. 13).

101a

101b

101 Manuscripts associated with *The Analysis of Beauty* and the 'Apology for Painters'

a) *The Analysis of Beauty*, 'Memorandums'
MS volume
Lit.: Burke, 167f.
Lent by the British Library, Eg.3011 (f. 32r.)

This volume, entirely in Hogarth's hand, is a draft text of the *Analysis*. Hogarth has written the main body of the text on one side of the page to allow for additions, and it is full of crossings-out, suggesting the difficulty he had with written expression. The drawing shows the Line of Beauty, which is wrapped around a cone and 'by its waving and winding both at once doth lead the eye a pleasing chase along its contiguous Variety if we may so express it'.

b) 'The Analysis of Beauty, or Forms lineally consider'd, written with a View to fix the fluctuating Ideas of Taste'
MS volume
Lit.: Burke, 179f.
Lent by the British Library, Eg.3013 (41v.)

This manuscript volume of drafts for the *Analysis* also contains drawings for the separate plates issued with the book (see no. 100). The page shown contains drawings for the margins of plate 1, including the 'Old Baby', which illustrates the humour of such incongruity. The figure on the right of 'a child's body with a mans coat and cap on' was not used.

c) *The Analysis of Beauty*, manuscript drafts
MS volume
Lit.: Burke, 183f.
Lent by the British Library, Eg.3014 (16v.)

This page from another volume of drafts relates to the discussion on the beauty of the face and skin colour, which is more extensive than in the printed volume. Hogarth argues that the blood vessels under the skin form a network of threads rather like an engraving, and they are filled with different coloured juices which result in skin colour and affect beauty. The drawing illustrates the following text:

> A discription of the manner, of its showing the rosy colour of the cheek and the bluish tint, about the Temple in (fig. [95]) where you are to suppose the black strokes of the print to be white threads of the network and where the strokes are thickest the part is blackest, you are to

suppose this flesh would be whitest so the white paper
between the strokes stands for the vermilion colour of
the arteries and the blue veins of the temples which are
both by the gradating of the network, shown as
gradation, Shades or tints of beauty.

This is a version of a passage in the *Analysis*, Chapter XIV,
'Of Colouring', p. 115, and the drawing is a study for
plate 2, fig. 95, above the main image to the right.

d) The 'No Dedication'

Lit.: Paulson, *Hogarth*, 328; 'Apology for Painters', 49
Lent by the British Library, Add. ms. 39,672 (f. 88)

> The no Dedication
> Not Dedicated to any Prince in Christendom
> for fear it might be thought an Idle piece of
> Arrogance
> Not Dedicated to any man of quality for
> fear it might be thought too assuming
> Not Dedicated to any learned body of
> Men as either of the universitys or the
> Royal Society for fear it might be thought an
> uncommon piece of Vanity.
> Nor dedicated to any one particular
> Friend for fear of offending another.
> Therefore Dedicated to nobody
> But if for once we may suppose
> nobody to be every body, as Every body
> is often said to be nobody, then is this work
> Dedicated to every body.
> by their most humble
> and devoted

The 'No Dedication' is a separate sheet but it probably
belonged with the drafts and papers for the manuscript
known as the 'Apology for Painters' that Hogarth was work-
ing on at the end of his life. It almost certainly dates from
the early 1760s. For 'Nobody' and 'Somebody' see Mitchell,
Peregrination, xxiv–xxi.

101c

101d

102

GILES HUSSEY

102 *Figure Seen from Behind*

Engraving by J. Vardy, 339 x 215 mm

Lit.: S. O'Connell, 'An explanation of Hogarth's "Analysis of Beauty",
 Pl. 1, Fig. 66', *Burlington Magazine*, CXXVI, Jan. 1984, 33–4

1917-12-8-3175, presented by the Lady Lucas in memory of Lord Lucas

Vertue had noted as early as 1745 that 'Hogarth (in opposi-tion to Hussey scheem of Triangles) much comments on the inimitable curve or beauty of the S undulating motion line' (Vertue, III, 126). Hussey's unpublished theories must have been known to Hogarth and were, therefore, an important starting point for *The Analysis of Beauty*. In Plate 1 Hogarth attaches a triangle to an écorché leg done in a 'dry, stiff, and what the painters call, sticky manner', as a clear reference to, and dismissal of, Hussey's proportional theory.

PAUL SANDBY'S CAMPAIGN
AGAINST THE *ANALYSIS*

Following the publication of *The Analysis of Beauty*, Paul Sandby, later to become a major figure in the development of watercolour landscape painting, produced between December 1753 and April 1754 a series of eight satirical etchings aimed at Hogarth and his pretentions as a theorist and History painter, and at his resistance to plans for a new academy for artists. He had been working as a surveyor and landscape draftsman in Scotland in connection with the Duke of Cumberland's pacification after the '45 Rebellion, and returned to London in 1751. The satires on Hogarth were just one of the many things he tried out in order to find a niche for himself in the London art world. The main issue of contention between the two artists was the question of a Public Academy, with Sandby associating himself with proposals for the formation of a formal academy on the French centralised model, and Hogarth advocating a more relaxed version with life-drawing at its centre. The dispute came to a head in 1753 and the well-publicised appearance of the *Analysis* left Hogarth exposed on two fronts. Sandby's satires conflate the opposition to the academy and the new exercise in theory to present Hogarth as both pretentious and destructive, an egomaniac foolishly fending off progress. The ferocity and intensity of loathing in some of them suggest an almost obsessive dislike of Hogarth on Sandby's part. After the prints had appeared (by April 1754), Sandby issued a title page and advertised the series as 'The Analysis of Deformity, precisely to the Rules of a late Author: or, a new Dunciad in eight Prints; done with a View to fluctuate the fix'd Ideas of Taste'.

PAUL SANDBY

103a *Burlesque sur le Burlesque*, first state, 1753

Etching, 360 x 260 mm

1868-8-8-3946

Lit.: BMC 3240; Paulson, *Hogarth*, III, 138–41; Döring, 216

The broad idea of the satire is to turn Hogarth's own satiri-cal and deliberately coarse 'Dutch' version of his History painting, *Paul before Felix* (no. 27b), against him, by showing him really working in the Dutch manner on a painting of *The Sacrifice of Isaac*, in which Abraham is prevented from

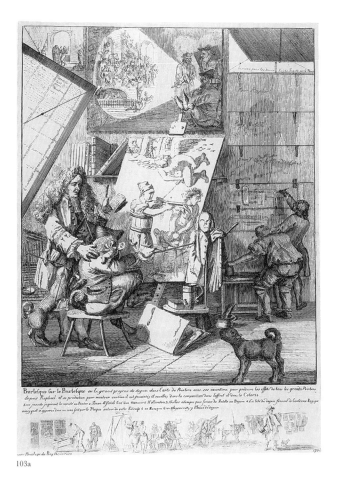

103a

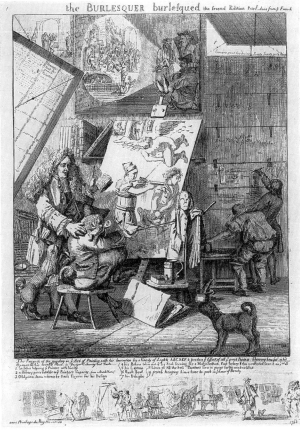

103b

shooting Isaac by an angel urinating on the gun's flintlock; hence it is a 'Burlesque upon a Burlesque'. A version of Hogarth's 'Dutch' parody of *Paul before Felix* is shown above, as if projected from Hogarth (cf. no. 107), accompanied by the apparatus and companions of a mountebank. The remarque (marginal sketch) beneath was possibly added later and shows Hogarth's supposedly desperate attempts to get rid of copies of the *Analysis*. The fact that the book is nowhere alluded to in the main print suggests that this first state, which is dated 1 December 1753, was originally intended to be published before the book appeared in the same month. The whole text is in French for an unknown reason.

PAUL SANDBY

103b *The Burlesquer burlesqued*, second state, 1753

375 x 275 mm
1868-8-8-3945

The text is now in English, and references to *The Analysis of Beauty* have appeared in the main design as well as in the remarque. There is now a Line of Beauty on the portfolio in the foreground, and there are other references to it. The penis of the angel descending in the painting of *Abraham and Isaac* has been eliminated.

104

PAUL SANDBY

104 *Puggs Graces Etched from his Original Daubing*, 1758

Etching, 230 x 232 mm (recto and verso exhibited)
Lit.: BMC 3242; Paulson, *Hogarth*, III, 137–8; Döring, 215–16
Y.4-153 & Cc.3-6

Another joke on Hogarth's unknowing 'Dutchess': the 'Graces' are presented as evidence of his ludicrous inability to paint Beauty and Grace, despite claiming the authority to pronounce upon them in the *Analysis*. The two gentlemen on either side are probably his friends John Townley and Thomas Morell (see p. 51). On the verso of the print is a letterpress parody of an announcement for *The Analysis of Beauty* (not illustrated), proposing the publication of 'An ANALYSIS of the SUN', with the implication that all the great astronomers from Kepler to Newton are now proved wrong by the author.

PAUL SANDBY

105 *The Analyst Besh[itte]n in his own Taste Pr[ice]. 1 s[hilling]*, 1753

Etching, 263 x 185 mm
Lit.: BMC 3243; Paulson, *Hogarth*, III, 137–9; Döring, 216
1868-8-8-3947

An attack on the *Analysis* in which Hogarth is revealed to the world as nothing more than a plagiarist of the Italian theorist Lomazzo, who is seen as a ghost rising up before him, 'bearing the Line of Beauty in one Hand, in the other Hand, his Treatise on Painting'. Lomazzo is supposedly saying 'Thou Ignorant Contemptible wretch how hast Thou mangled & perverted the Sense of my Book, in thy nonsensical Analysis'. An arch in the background alludes to Hogarth's opposition to a 'Public Academy erecting in spight of his endeavours to prevent it'. The lengthy text beneath suggests an almost obsessive dislike of Hogarth.

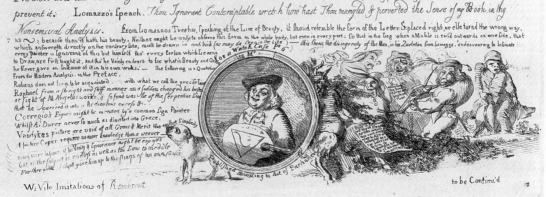

105

106

PAUL SANDBY

106 *The Author run Mad,* 1754

Etching 260 x 180 mm

Lit.: BMC 3244; Paulson, *Hogarth,* III, 135; Döring, 216

1868-8-8-3968

Hogarth is shown in Bedlam, an obvious reference to the final plate of *A Rake's Progress* (no. 128). He is represented as a chained lunatic, dementedly painting the walls of the asylum: 'He raves, his Words are loose as Heaps of Sand… Dr[yden] Spanish Frier [sic].' His madness is expressed in his desire to produce large paintings like *Paul before Felix* (see fig. 1) and, of course, to publish *The Analysis of Beauty,* referred to in motifs throughout the print. See also a copy of the pro-Hogarth print *A Collection of Connoisseurs* (no. 110).

PAUL SANDBY

107 *The Magic Lantern,* 1753 (COLOUR PLATE VII)

Etching 166 x 226 mm

Lit.: BMC 3247; Döring, 216

1868-8-8-3950

This remarkable print shows Hogarth as a magic lantern, projecting from his mouth a burlesque version of his own burlesque (no. 27b), which itself parodied his large painting *Paul before Felix* (fig. 1) and was inscribed as being 'in the rediculous Dutch manner' in early states or 'in the rediculous manner of Rembrant' in later states. The showman beside the projected image appears to be in seventeenth-century costume and perhaps represents Rembrandt or a generic Dutch painter. The luminosity of the etching and the brilliant technique recall Rembrandt, perhaps as a reproach to Hogarth's ignorant dismissal of him.

108

PAUL SANDBY

108 *The Vile Ephesian*, 1753

Etching, 230 x 191 mm

Lit.: BMC 3245; Paulson, *Hogarth*, III, 137

1868-8-8-3979

Hogarth as Herostratus the 'Vile Ephesian' burning the Temple of Ephesus. In an attempt to gain fame Herostratus set fire to the Temple of Diana, goddess of Nature, on the same night that Alexander the Great was born. Hogarth is shown as cloven-hoofed, 'A self Conceited Arrogant Dauber, groveling in vain to undermine the ever Sacred Monument of all the best Painters Sculps Archits, &c. in Imitation of the impious Herostratus who with Sacrilegious Flames Destroyd the Temple of Diana to perpetuate his name to Posterity.' The verse underneath comments on Hogarth's vanity as a motive for attempting to destroy the Public Academy:

> The Vile Ephesian to obtain
> A Name – A Temple fires
> Observe friend H-g-th 'twas in Vain
> He had not his desires –
> You might with Reason sure expect
> Your fate wou'd be the same
> Men first thy Labours will neglect
> Next quite forget thy Name.

109

PAUL SANDBY

109 *A Mountebank Painter*, 1754

Etching, 230 x 191 mm

Lit.: BMC 3249; Paulson, *Hogarth*, III, 138

Cc.3-2

'H. a Mountebank Painter Demonstrating to his Admirers
& Subscribers that Crookedness is the Most Beautiful' is the

beginning of the caption to this attack against the idea of
the Line of Beauty in *The Analysis of Beauty*. The line is
applied to a number of objects that symbolise deformity,
beauty's opposite, as, for example, the woman in the centre
foreground holding a template to the spinal curve of a
Hudibras-like hunchback.

180

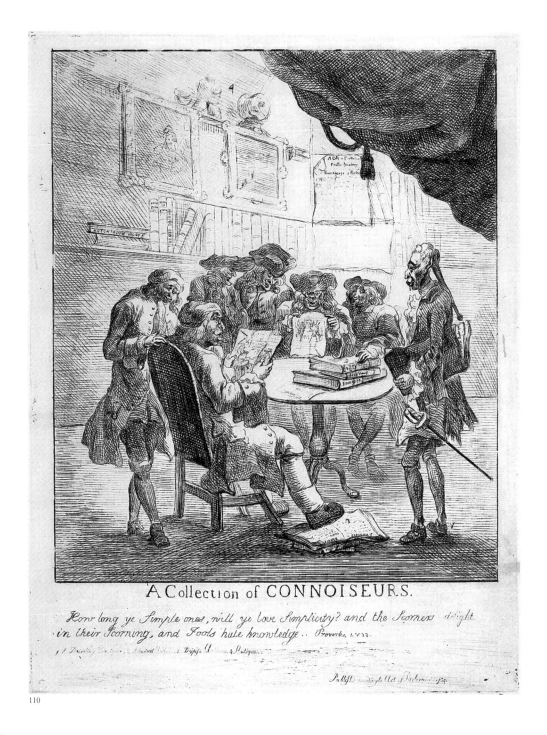

A Collection of CONNOISEURS.

How long ye Simple ones, will ye love Simplicity? and the Scorners delight in their Scorning, and Fools hate knowledge.. Proverbs 1.v.22.

110

THOMAS BURGESS

110 *A Collection of Connoiseurs* [sic], 1754

Etching, 361 x 275 mm

Lit.: BMC 3246; Paulson, *Hogarth*, III, 140

1868-8-8-3971

A response by a supporter of Hogarth to the Sandby caricatures. It shows a group of malevolent and geriatric Connoisseurs chortling over Sandby's *Burlesque sur le Burlesque* (no. 103). One tramples *The Analysis of Beauty* underfoot. The caption reads 'How long ye Simple ones, will ye love Simplicity? and the Scorners delight in their Scorning, and Fools hate knowledge. Proverbs 1.v.22.' The etching is by Thomas Burgess, an amateur artist and friend of Hogarth.

LAST BATTLES

HOGARTH 'AT LAST ENTERED THE LIST OF POLITICIANS'

Hogarth's last years were characterised by growing irascibility and isolation, culminating in a distressing and highly public exchange with the radical politician John Wilkes. As a figure with a high public profile, Hogarth increasingly became a target at the artistic as well as political level. In artistic terms he was left behind by the concern with sentiment and the emphasis on exemplary virtue that characterised new developments in literature and art from the 1740s onwards; he was vulnerable to the charge, made by Wilkes, that he had the capacity only to represent vice successfully and not virtue. Reynolds's return from Italy in 1752 and his veiled attacks on Hogarth in 'The Idler' in 1759 represented a resurgence of the cosmopolitanism of the Connoisseurs, and left him vulnerable once more to the charge of provincialism. His determination to gain a place at court in his last years and his vehement defence of his royal patrons left him exposed to the contempt of his former friends in the City, as he became associated with the unpopular Bute party. The result was an almost morbid sense of grievance on his part, which is reflected in harrowing forms of self-representation in his final prints.

The political instabilities of the 1760s were inaugurated by the accession of George III in 1760. The new king was hostile both to the continuation of the Seven Years' War and to Pitt, and had a sense of the prevailing corruption of politics which he sought to curtail by bringing in his Scottish friend the Third Earl of Bute as a senior adviser. Rather than take an opportunity to end the war in 1761,

Pitt effectively extended it to include Spain with an eye to seizing her colonies, a cause especially popular among commercial interests in the City. Pitt resigned in October 1761, leaving Bute effectively in charge, but remained a threat. Hogarth might have been expected to support the City interests against the king and Bute but instead sided with the latter, perhaps influenced by his hopes for the new king's support of the arts and by the renewal of his patent as Serjeant Painter (see p. 50); hence the derision and anger of his former friends, in particular John Wilkes, whose criticism of the king and the proposed peace in the periodical *North Briton* (no. XLV) provoked his own arrest. The result was to make Wilkes a popular hero; he was quickly released and successfully sued the Secretary of State for libel.

THE TIMES, PLATE 1

Hogarth's publication of the overtly party-political print *The Times, Plate 1* set off a disastrous chain of events that he could not control. It contributed to the miseries of his final years by alienating him from some of his friends and making him an open target and figure of fun for politicians and their hirelings.

ANONYMOUS
111 *John Bull's House sett in flames*, 1762

Etching, 245 x 303 mm
Lit.: BMC 3890; Döring, 214
1868-8-8-4205

Though ostensibly the source for Hogarth's *The Times, Plate 1*, it only appeared three days before the latter. Given

111

the amount of time such a complicated print would have taken to complete, and the fact that Hogarth's intentions had long been well known, it is almost certainly a covert response to Hogarth's print rather than a source for it. It could well have been produced by a Wilkes supporter who had access to Hogarth's design before publication and sought to defuse its impact. It may be significant that Wilkes made a point of accusing Hogarth of plagiarising this print. It is in effect a fairly precise reversal of the main motifs in Hogarth's print. Döring's attribution of the print to Paul Sandby is not persuasive.

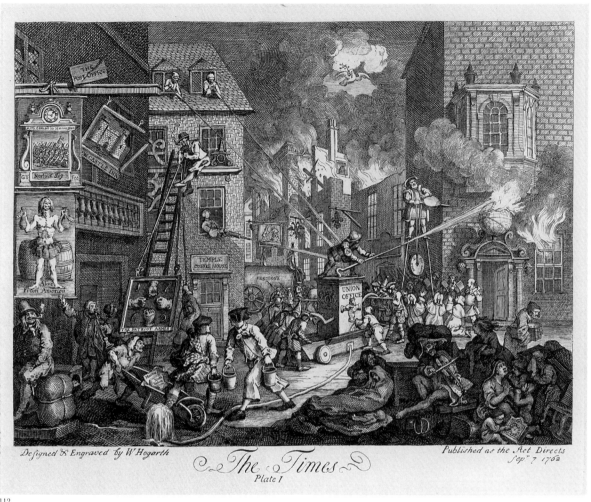

112

112 *The Times, Plate 1*, 1762

Etching and engraving, 246 x 306 mm

Lit.: Paulson 211

Cc.1-171 (1825-3-13-34)

In the context of Hogarth's whole career this print represents a remarkable return to the political satire; indeed, even in the 1720s his political prints were never quite as closely tied to immediate political events. Hogarth claimed in his *Autobiographical Notes*, 221, that he made this print to raise some money ('stop a gap in my Income') after an illness and from political conviction ('the subject...tended to Peace and Unanimity'). Hogarth's print is a fierce defence of the Scottish Earl of Bute (the fireman training his hose on the globe in flames) and an attack on Pitt disguised as

Henry VIII and supported by a mob of butchers and clerics. Though Wilkes is not specifically identified, except possibly as one of the two training a hose on Bute from garret windows, the print is clearly a rebuff to those like Wilkes and his City supporters who had supported a warlike policy, particularly against Spain. Hogarth also worked on a follow-up, *The Times, Plate 2* (Paulson 212), which was not published in his lifetime and was probably left unfinished by him, perhaps because of Bute's resignation in April 1763. It shows the blessings which flow from peace, as plants are watered by Bute from a fountain emanating from the plinth of the king's statue, while buildings rise up behind. Wilkes this time is literally pilloried, with his head in the stocks next to Fanny, the 'Cock Lane Ghost'.

113

ATTRIBUTED TO PAUL SANDBY

113 Untitled satire on Bute and Hogarth, late 1762

Etching, 257 x 364 mm
Lit.: BMC 3910; Paulson, *Hogarth*, 3, 382
1868-8-8-4249

A proof of an unpublished and presumably abandoned print satirising the Bute government's supposed desperation for peace. Bute is evidently the demented Scotsman helping the Duke of Bedford to cram a peace treaty into a bull's mouth (i.e. John Bull). Hogarth is the angry figure on the left driven by a Scotsman, and apparently pushing a pig between William Pitt's legs, no doubt to trip him up. The combination of meticulous topicality and complexity of execution may have made the print go quickly out of date, hence its abandonment.

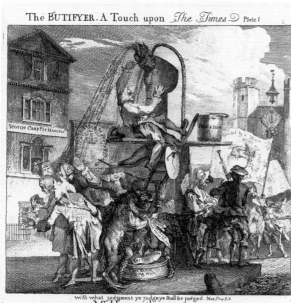

114

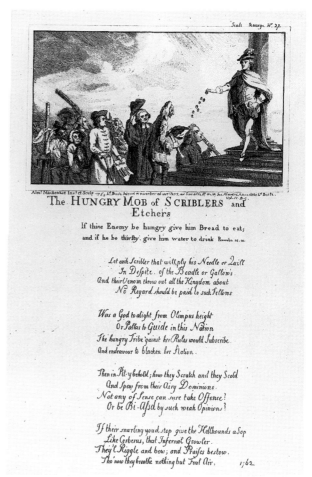

115

PAUL SANDBY

114 *The Butifyer. A Touch upon The Times Plate 1*, September 1762

Etching, 251 x 202 mm

Lit.: BMC 3971; Paulson, *Hogarth*, III, 382; Atherton, 51 & 210; Döring, 88 & 214-16

1904-8-19-715, bequeathed by William Sandby

A response to *The Times, Plate 1* (no. 112). Hogarth is shown whitewashing a large boot, standing for his supposed patron the Earl of Bute, and in so doing he splashes Pitt and Temple, suggesting that politically he is a toady and only a mild irritant to his opponents. The clergyman beneath is Charles Churchill (see no. 127), and Paulson suggests the Scotsman in a lion-skin might be the novelist Tobias Smollett. The caption refers to a print of 'Mr Pope White washing Lord Burlingtons Gate' (Burke and Caldwell, pl. 129), no longer thought to be by Hogarth.

ANONYMOUS

115 *The Hungry Mob of Scriblers and Etchers*, May 1762

Etching, 309 x 202 mm

Lit.: BMC 3844; Döring, 216

1868-8-8-4185

A print satirising Bute's blatant attempts to enlist writers and satirists on his own side. Dr Johnson is the person nearest to him. The large figure holding 'The Screen' is probably Matthew Darly, the print publisher, and the figure to the left of him with the huge burin may be meant to be Hogarth, with the insulting suggestion that he was merely a hired needle.

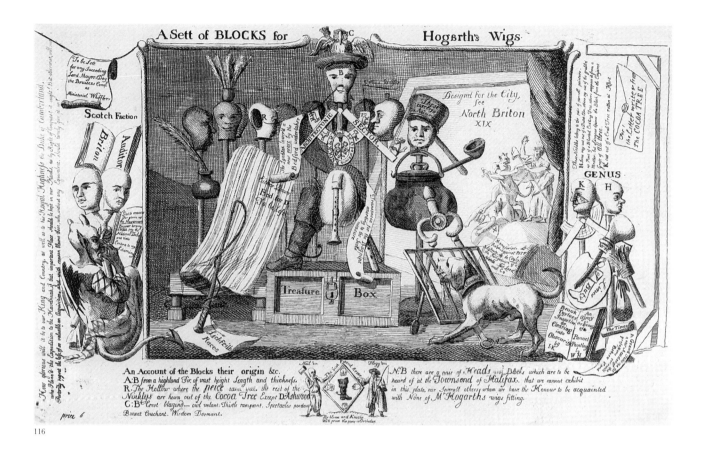

116

ANONYMOUS

116 *A Sett of Blocks for Hogarth's Wigs*, November 1762

Etching, 232 x 383 mm

Lit.: BMC 3916; Paulson, *Hogarth*, III, 386–7

1868-8-8-4228

The imagery of the wig-blocks is a response to Hogarth's satirical print *Five Orders of Periwigs* (Paulson 209), applying the classical orders to the shape of wigs. The print is an attack on Bute, who is the central figure, made up of emblems like the jackboot, with bagpipes representing his genitals. Hogarth is the head marked 'H' on the right, and he is supported by a large burin, a brush, a money bag and a palette with the usual boot and the caption 'Lines of Buty'. The adjoining block is Hogarth's friend, the architect and author on perspective Joshua Kirby. By this date, late 1762, almost all satires devoted to Bute include Hogarth, and vice versa.

HOGARTH VERSUS WILKES

Hogarth barely hints at Wilkes's presence in *The Times, Plate 1*, but the artist's open declaration of his support for Bute brought a quietly devastating response from Wilkes in the *North Briton*, number XVII, which came out in September 1762. It provoked in turn Hogarth's famous caricature, and drew in other satirists, particularly from the opposition to Bute.

JOHN WILKES

117 *The North Briton, Number XVII,* 21 May 1763

Printed pamphlet (originally published 25 September 1762)
Lit.: BMC 4053
Cc.3-38

A reprint of the famous issue of the *North Briton* entirely given over to an attack on Hogarth, in response to *The Times, Plate 1*. The anonymous woodcut caricature, giving Hogarth a bulbous nose, does not appear in the first edition. It is taken from the self-portrait in *O the Roast Beef of Old England* (no. 22). Though mild in tone and not ungenerous in some respects, Wilkes's essay is offensively patronising to Hogarth. Wilkes wittily demolishes the *Sigismunda* (see no. 123) and makes the wounding point that the artist's 'darling passion...is to shew the *faulty* and *dark side* of every object', dismissing the Swiftian idea of satire as a weapon against vice. Wilkes makes much of Hogarth's decline into senility and fall into 'the poor politics of the faction of the day'. Hogarth is represented as a cantankerous old man, full of venom, and at odds with his fellow artists. Wilkes singles out the dedication to the King of Prussia in *The March to Finchley* as an unpatriotic act, and accuses Hogarth of disloyalty in the painting, assuming it to have been painted in 1746, though in fact it dates from 1750 (see no. 72).

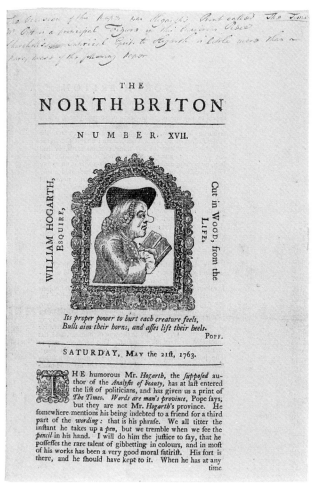

117

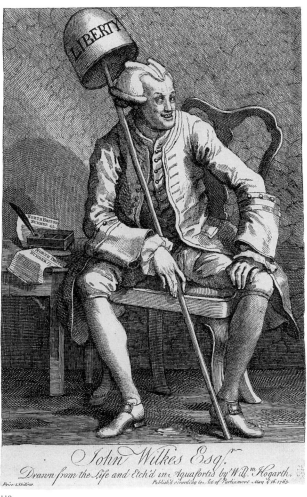

118a

118 *John Wilkes Esqr.*

a) Etching, 1763

352 x 228 mm

Lit.: Paulson 214, state 1

1868-8-8-4315

The Times, Plate I had not attacked Wilkes explicitly, but it had provoked Wilkes into a strong reply in the *North Briton*, number XVII (no. 117), of September 1762. Wilkes's sensational arrest for attacking the king's speech to Parliament and his subsequent release made him a popular hero. This satirical portrait was advertised as being a companion to the 1746 print of the Jacobite Lord Lovat who was executed as a traitor, and Hogarth subtly suggests, by gently exaggerating Wilkes's physiognomy, that his claims to be a champion of liberty are completely bogus.

The original drawing, according to Samuel Ireland, was taken from the life in pencil and strengthened afterwards in pen, and the print itself claims to have been 'Drawn from the Life'. This is probably nothing more than a conventional claim, though Wilkes himself claimed that Hogarth attempted to draw him on his second visit to the Court of Common Pleas on 6 May 1763. In fact, the pot at the end of the stick (suggestive of a liberty cap), the triumphant leer, the suggestion of horns and references to Wilkes's court victory place it firmly within the realm of caricature, despite the suggestion of reportage in the freedom of drawing and etching. Certainly it must have been done rapidly because the date of publication is only ten days after Wilkes's second appearance before the court, and the drawing itself bears signs of indentation and is in reverse from the print. The print was a retaliation for Wilkes's attack in the *North Briton*; it was run off in large numbers (an initial edition of 4000, according to Samuel Ireland) and was reprinted time and again in volumes of Hogarth's collected works up to the end of the nineteenth century.

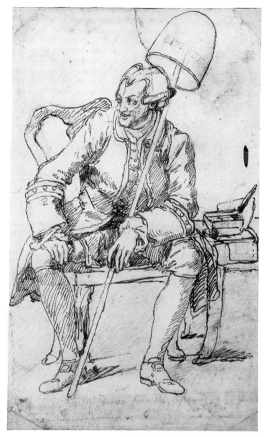

118b

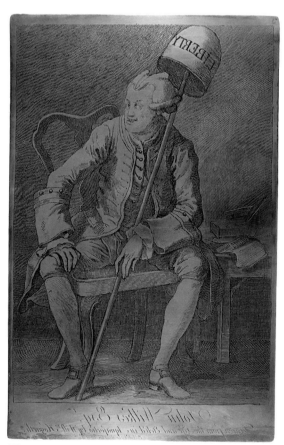

118c

b) Drawing, 1763
355 x 215 mm
1936-10-15-1

c) Copper plate, 1763
359 x 233 mm
1937-8-7-2, presented by C.W. Dyson-Perrins

C.B. GLASSBACH AFTER HOGARTH

d) *John Wilkes Esqr.*, *c.* 1763
Etching, 203 x 159 mm
1997-3-23-31

A print produced in Berlin probably shortly after Hogarth's original. It is a sign of his international fame and the spread of his works, often in a debased form.

ANONYMOUS

e) Punch bowl, Qing dynasty, *c.* 1764–70
Chinese export porcelain painted in grisaille and gold, 180 x 410 mm
Lit.: R. Krahl and J. Harrison-Hall, *Ancient Chinese Trade Ceramics from the British Museum, London,* catalogue of an exhibition at the National Museum of History, Taiwan, 1994, 94, no. 38
British Museum, Department of Oriental Antiquities, 1988.0421.1

The bowl has a copy of the Wilkes print on one side and a drinking scene after a print by Charles Maucourt on the other.

ANONYMOUS

119 *Bute and Wilkes*

Etching, 248 x 279 mm
Lit.: BMC 4041
1868-8-8-12417

Hogarth's subordinate relationship to Bute is suggested by making the latter the author of the print of John Wilkes.

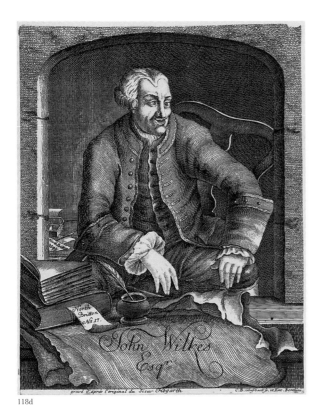

118d

118e

119

120

ANONYMOUS

120 *The Grand Triumvirate or Champions of Liberty*

Etching, 233 x 319 mm

Lit.: BMC 4035

1868-8-8-4331

Despite the even-handed characterisation of the faces, the
print is fiercely pro-Wilkes and anti-Bute, with Hogarth as
an artist

> …who for Gold,
>
> O'er his Heart a Veil can hold,
>
> Give an Angel Satan's face,
>
> And the Fiend an Angel's Grace.

ANONYMOUS

121 *An Answer to the Print of John Wilkes Esqr.
by Wm. Hogarth*, 1763

Etching, 337 x 211 mm

Lit.: BMC 4051; Paulson, *Hogarth*, III, 398 (fig. 103)

1868-8-8-4316

A cloven-hooved Hogarth occupies the position of Wilkes
in Hogarth's famous print and carries a moneybag inscrib-
ed '£300 per Ann. for distorting features', suggesting that
Hogarth was a hired pensioner of the government, which
in a sense, as Serjeant Painter to the King, he was.

121

192

BATHOS AND ALTERED STATES, 1761–4

Hogarth's last years were harrowing. He clearly took the attacks on himself very badly, revealing a morbid sensitivity to criticism which led him into ever more disastrous acts of self-justification. Something of his state of mind is expressed in his endless fiddling with his self-portrait in *Hogarth Painting the Comic Muse* and in the bleak pessimism of *The Bathos*.

HOGARTH ON THE DEFENSIVE

The bruising political attacks on Hogarth were accompanied by and often fused with attacks that came from within the art community, which was riven with conflict in the years before the foundation of the Royal Academy in 1768.

PAUL SANDBY

122 *The Fire of Faction*, 1762

Etching, 265 x 203 mm

Lit.: BMC 3955; Paulson, *Hogarth*, III, 382; Atherton, 123 and 219

1904-8-19-713, bequeathed by William Sandby

Hogarth is the devilish figure fanning the flames of faction in the mouth of hell, while some other government supporters plunge into it astride a gigantic engravers' burin. There can be no doubt that Hogarth took such attacks badly, and his abortive late involvement in politics contributed to the melancholy of his last years.

122

123 *Sigismunda*, 1761–4

Unfinished etching by J. Basire, 458 x 415 mm

Lit.: Paulson 238

S.2-158

The story of the *Sigismunda* painting (Tate Gallery) has often been told and it is a classic example of Hogarth's perversity in his last years. Hogarth had painted *The Lady's Last Stake* (Albright-Knox Museum, Buffalo), a modern life subject in his wittiest and most seductive manner, for the Earl of Charlemont. Sir Richard Grosvenor offered to pay the same price for something similar, but Hogarth, incensed by the price paid for a supposed Correggio at auction, insisted on painting a version of the same subject, to show how superior it would be to the kind favoured by ignorant Connoisseurs. Grosvenor was appalled by the sight of *Sigismunda* and refused the painting. Hogarth, deeply offended, sought to have it engraved in the hope of redeeming its reputation. Hogarth advertised his intention of commissioning an engraving in 1761, finding Basire after others had refused. It was probably left unfinished because of Hogarth's death in 1764.

ANONYMOUS

124 *A Brush for the Sign-Painters*, 1762

Etching, 274 x 225 mm

Lit.: BMC 3841; Paulson, III, 360

Cc.3-150

The Sign-Painters' Exhibition of 1762 was the product of the circle of Bonnell Thornton and the *St. James's Chronicle*. Thornton was a periodical writer and admirer of Hogarth, who supported the latter's campaign against the Connoisseurs in the name of the assertion of 'English' culture. The exhibition was also directed against the pretentions of the artists associated with the Society of Arts, whose own exhibition it claimed to parallel in droll ways. Signboards represented a demotic, everyday, native art-form to set against the high-art pretentions of the Connoisseurs, though in reality they were often painted by skilful artists of the second rank. Pretending, even in a satirical voice, to take seriously such signs was a way of mocking the Connoisseurs' exclusion of native art but also some of the absurd claims made for it. Hogarth was certainly involved in the exhibition in some way, probably by allowing his name to be used rather than actually exhibiting. He was, however,

123

124

assumed to be behind it, hence the caricatures like this one that it provoked. It is based on Hogarth's late self-portrait of 1758 (no. 126a) but shows the artist as 'Mr Hoggum Pug a Iustly celebrated Sign-Painter though an Englishman and a Modern' painting *Sigismunda*, accompanied by those

involved with the *St. James's Chronicle*, including Thornton (probably the figure standing behind the artist marked 'B') and the playwright George Colman.

ANONYMOUS

125 *The Combat*, 1762

Etching, 204 x 257 mm

Lit.: BMC 3999; Paulson, *Hogarth*, III, 359–60

C.c.3-41

This caricature again assumes Hogarth to have been the prime mover in the Sign-Painters' Exhibition of 1762,

egged on by Bonnell Thornton. Hogarth and Thornton are to the fore, the former as Don Quixote, while other artists follow behind. Hogarth is described as 'An Engl: Knight Errant mounted rampant descended in a Waving Line from Don Quixiot de la Mancha', while Thornton is 'A Modern Mercury who dayly furnishes the Knight with fresh matter for new contentions'. 'C' is Thomas Burgess, the author of no. 110, and 'E' is Francis Hayman the painter.

126a

RELINQUISHING THE SELF

Hogarth's very last prints are heart-breaking in their emotional fragility and self-abnegation, culminating in an image of the loss of all hope in the terminal print *The Bathos*.

126 *Hogarth Painting the Comic Muse*

Three etchings and engravings
Lit.: Paulson 204
a) *Wm. Hogarth Serjeant Painter to His Majesty*, third state, 1758
401 x 352 mm
1847-5-8-2

b) *Wm. Hogarth Serjeant Painter to His Majesty*, fifth state
(face altered), 1764
401 x 352 mm
1868-8-22-1591, bequeathed by Felix Slade
c) *Wm. Hogarth*, sixth state (face and inscription altered), 1764
400 x 349 mm
Cc.2-2

This composition began as a painting (National Portrait Gallery, London), and x-ray photographs reveal that it originally contained beneath the figure of the painter a defiant image of a pug urinating on a pile of Old Master paintings, painted out in the final version. The first version of the

126b

print (states 1–4) commemorates Hogarth's appointment as Serjeant Painter to the King in 1758, and his gaze is smiling and confident. In 1764 he seems to have picked up the plate again, removed the title of Serjeant Painter (c) as if the office had brought him nothing but grief, and altered the face (b and c) to give it a more serious expression. Thalia's mask now has a satyr's face (c) as if to mock the artist's worldly pretentions.

126c

COMEDY
1764

W.^m Hogarth

Publish'd as the Act directs. march 29 1758

127 *The Bruiser*, 1763

Etching and engraving, 376 x 285 mm

Lit.: Paulson 215

1868-8-22-1586, bequeathed by Felix Slade

This print is a late contribution to the battle between Hogarth and Wilkes and his supporters, discussed in the previous section. Hogarth's etching of Wilkes (no. 118) had provoked a reply from Wilkes's ally, the poet Charles Churchill, who in his *Epistle to William Hogarth* of July 1763 had characterised Hogarth as 'weak and vain', consumed by envy and in his dotage. Hogarth then scraped out his own head and shoulders from the copper plate of the 1749 self-portrait (no. 23) and replaced it with Churchill as a bear with Hercules's club, 'Regaling himself after having Kill'd the Monster Caricatura that so sorely Gall'd his Virtuous friend, the Heaven born Wilkes!'. Hogarth's pug, remaining from the 1749 self-portrait, now in a typically Hogarthian pun pisses on a copy of the *Epistle*. Hogarth had abandoned the 1749 self-portrait as a frontispiece to collections of his prints, replacing it with *Hogarth Painting the Comic Muse* of 1758 (no. 126a). It is hard to avoid the suggestion of self-obliteration in the change in the plate.

127

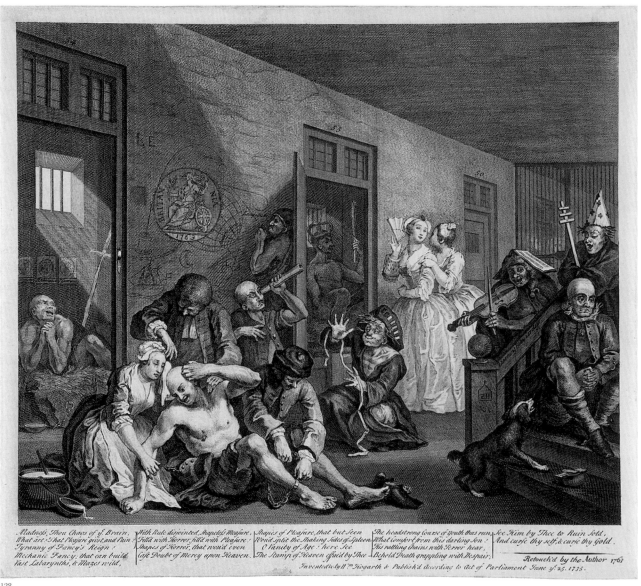

128

128 *A Rake's Progress*, 1763, plate 8, final state

Etching and engraving, 356 x 408 mm

Lit.: Paulson 139, state 3

1868-8-22-1537, bequeathed by Felix Slade

In Hogarth's final revision to the plate of the scene in Bedlam, which he dated 1763, a large coin with a demented-looking Britannia on the face, placed on the back wall, invites an analogy between the madhouse and the state of the nation in 1763.

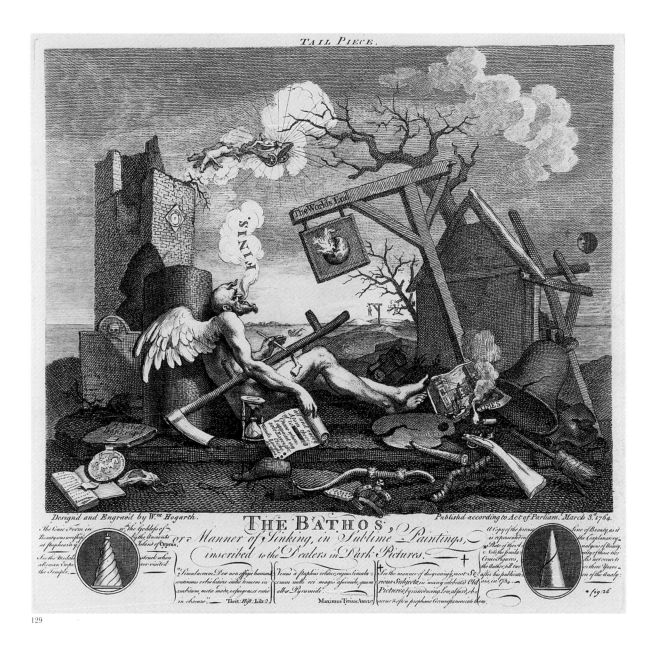

129

129 *Tail Piece: The Bathos*, 1764

Etching and engraving, 318 x 336 mm

Lit.: Paulson 216

1868-8-22-1629, bequeathed by Felix Slade

This remarkable print takes many images familiar from the elaborate figural tombs of his contemporaries like Henry Cheere and Louis François Roubiliac and strips them of all intimations of the afterlife. Hogarth's figure of Time expires, but, unlike Roubiliac's Hargrave monument in Westminster Abbey, there is no suggestion that the end of Time is also a beginning, of Eternity and Resurrection. All the elements emblematic in monuments, of enduring fame or of earthly life beyond death – palette, crown and weapons – are broken, never to be made whole again. It is perhaps the bleakest image of extinction in the whole of eighteenth-century art, made more bleak by the way it reverses the positive meaning of the emblems it depicts. Hogarth refuses to offer what all devotional poems, meditations and tombs of the time offered to the viewer: the consolation of a life beyond death, either in the world beyond or in the memory of posterity.

CHRONOLOGY

	HOGARTH	POLITICS AND SOCIETY
1689	Richard Hogarth, the artist's father and author of schoolbooks, now settled in London.	
1690	Richard Hogarth marries Anne Gibbons.	
1697	William Hogarth born on 10 November in City of London and baptised in St Bartholomew's Church, Smithfield.	
1702		Accession of Queen Anne.
1703	Richard Hogarth opens Latin-speaking coffee house in St John's Gate, Clerkenwell.	
1707–8	Richard Hogarth in Fleet Prison for debt, and family forced to live in vicinity.	
1712	Richard Hogarth released from Fleet Prison.	
1713	William Hogarth apprenticed to silver engraver Ellis Gamble.	
1714		Accession of George I.
1718	Death of Richard Hogarth.	
1720	After completing seven-year apprenticeship Hogarth sets up shop as an engraver in Long Lane, Smithfield, taking on all kinds of work, including shop cards, book plates, funeral tickets and book illustrations.	South Sea Bubble crisis.
1721	First satirical engraving, *The South Sea Scheme*.	
1722		Robert Walpole, First Lord of the Treasury.
1724	Joins Sir James Thornhill's Academy, and probably begins to learn to paint under Thornhill's eye. Living in Little Newport Street near Leicester Fields (Leicester Square)	
1727		Accession of George II.
1728	Opening of *The Beggar's Opera* by John Gay on 29 January, followed shortly afterwards by the first of Hogarth's five paintings of the last act. Embarks on a brief but successful career as a painter of small portrait groups.	
1729	Living in Covent Garden. Marries Jane Thornhill, daughter of Sir James.	Parliamentary committee set up to investigate the running of the Fleet Prison.
1731	Tires of producing conversation pieces, turning instead to 'painting and engraving modern moral subjects, a field unbroke up in any day or any age'. Begins to paint and engrave *A Harlot's Progress*.	
1732	Publication of *A Harlot's Progress* to great acclaim, printing, according to George Vertue, 1240 sets.	
1733	Begins painting *A Rake's Progress* and opens subscription for engravings. Living in Leicester Fields.	The Excise Bill crisis seriously threatens Walpole's hold on government.
1735	Publication of *A Rake's Progress* delayed until the Engravers' Copyright Act, for which Hogarth was responsible, is passed.	

1735 (cont.)	Death of Sir James Thornhill. Sets up St Martin's Lane academy.	
1736	Finishes *Pool of Bethesda* painting for St Bartholomew's Hospital.	
1737	Probably working on *Times of Day* paintings and engravings.	Licensing Act censoring theatre productions.
1738	Publication of *Times of Day* engravings and *Strolling Actresses Dressing in a Barn*.	
1739	Governor of proposed Foundling Hospital.	
1740	Gives portrait of Captain Coram and sum of money to Foundling Hospital.	
1741	Probably begins work on *Marriage A-la-Mode* paintings.	
1742	Henry Fielding commends Hogarth as a 'Comic History Painter' in the preface to *Joseph Andrews*.	Fall of Walpole.
1743	In Paris hiring engravers for *Marriage A-la-Mode*.	
1745	Publication of *Marriage A-la-Mode*.	Jacobite uprising.
1746	Publication with Hogarth's encouragement of a pamphlet by J.A. Rouquet explaining Hogarth's prints.	
1747	Publication of *Industry and Idleness*.	
1748	Completion of *Paul before Felix* for Lincoln's Inn. Trip to Paris and arrest at Calais, recorded in painting and engraving, *O the Roast Beef of Old England*.	
1749	Buys small house in Chiswick near Chiswick House.	
1750	Publication of *March to Finchley*. The painting is won by the Foundling Hospital in a lottery held by Hogarth.	
1751	Publication of *Beer Street* and *Gin Lane*.	Act of Parliament to control consumption of gin.
1753	*The Analysis of Beauty* published.	
1754	Finishes paintings of *Election* series and begins on engravings.	Parliamentary elections.
1755	Begins altarpiece for St Mary Redcliffe, Bristol.	
1756	The anti-French *Invasion* prints produced in the wake of invasion fears.	Beginning of Seven Years War.
1757	Appointed Serjeant Painter to the King in succession to John Thornhill, Sir James's son.	
1758	Commission for *Sigismunda* painting.	
1759	Joshua Reynolds's articles for 'The Idler' which covertly attack Hogarth.	
1760	Probably begins *An Apology for Painters* as a justification of his position.	Accession of George III.
1762	Sign-Painters Exhibition. *The Times, Plate I* published. Attack on Hogarth by John Wilkes in the *North Briton*, XVII.	
1764	Revises copper plates. Dies 25–6 October in his house in Leicester Fields.	
1768		Foundation of Royal Academy under presidency of Reynolds.

BIBLIOGRAPHY

The bibliography has been kept as minimal as possible. All entries in the catalogue to Hogarth prints include their number in the latest one-volume edition of the Paulson catalogue (see Paulson below), and all the entries for satirical prints by other artists include where possible a number in the British Museum Catalogue of Personal and Political Satires (see BMC below). Some more recent works are also occasionally cited in the catalogue.

ABBREVIATIONS FOR FREQUENTLY CITED WORKS

Age of Hogarth: E. Einberg and J. Egerton, *The Age of Hogarth*, Tate Gallery Collections, vol. 2, Tate Gallery, London, 1988

Among the Whores and Thieves: D. Bindman and S. Wilcox, eds, *'Among the Whores and Thieves': William Hogarth and The Beggar's Opera*, Yale Center for British Art, New Haven, 1997

Analysis: William Hogarth, *The Analysis of Beauty*, 1753

'Apology for Painters': Michael Kitson, ed., 'Hogarth's "Apology for Painters"', *Walpole Society*, vol. 41, 1966–8, Oxford, 1968, 46–111

Atherton: Herbert Atherton, *Political Prints in the Age of Hogarth*, Oxford, 1974

Autobiographical Notes: see Burke below

Beckett: R.B. Beckett, *Hogarth*, London, 1949

BMC: *Catalogue of Prints and Drawings in the British Museum*, division I, *Personal and Political Satires*, London 1870–83 (these volumes by F.G. Stephens are based on work by Edward Hawkins; later volumes are by M.D. George)

Burke: Joseph Burke, ed., *William Hogarth, The Analysis of Beauty, with the rejected passages from the manuscript drafts and autobiographical notes*, Oxford, 1955

Burke and Caldwell: J. Burke and C. Caldwell, *Hogarth: The Complete Engravings*, London, 1968

Chaloner Smith: John Chaloner Smith, *British Mezzotinto Portraits*, London, 1883

Donald: Diana Donald, *The Age of Caricature: Satirical Prints in the Reign of George III*, New Haven and London, 1996

Döring: Jurgen Döring, *Eine Kunstgeschichte der frühen englischen Karikatur*, Hildesheim, 1991

E. C.-M.: Edward Croft-Murray, *Catalogue of British Drawings in the British Museum*, vol. II (unpublished MS in Department of Prints and Drawings, British Museum)

Free-Holder: Joseph Addison, *The Free-Holder*, 4th edn, 1729

Hazlitt: William Hazlitt, *Lectures on the English Comic Writers*, 3rd edn, London, 1841

House of Commons, 1715–54: Romney Sedgwick, *The House of Commons, 1715–1754*, 2 vols, London, 1970

'Idler': J. Reynolds, Letters 76, 79 and 82 to 'The Idler' in the *Universal Chronicle*, 29 Sept., 20 Oct. and 10 Nov. 1759

Ireland: John Ireland, *Hogarth Illustrated*, London, 1884 (reprint of 2nd edn)

Juvenal: John Dryden, *The Satyrs of Decimus Junius Juvenalis: and of Aulus Persius Flaccus, Translated into English Verse by Mr Dryden, And several other Hands. To which is Prefix'd a Discourse Concerning the Origin and Progress of Satyr*, London, 1754

Klingender: F.D. Klingender, *Hogarth and English Caricature*, London, 1944

Kunzle: David Kunzle, 'Plagiaries-by-memory of the *Rake's Progress* and the genesis of Hogarth's second picture story', *Journal of the Warburg and Courtauld Institutes*, 29, 1966, 311–48

Lamb: Charles Lamb, 'Essay on the Genius and Character of Hogarth', *The Reflector*, III, 1811 (reprinted in Nichols and Steevens, III, 58–86)

Morell: Thomas Morell, *Notes and Annotations on Locke on the Human Understanding, written by Order of the Queen*, London, 1794

Nichols: John Nichols, *Biographical Anecdotes of William Hogarth*, 3rd edn, London, 1785

Nichols and Steevens: John Nichols and George Steevens, *The Genuine Works of William Hogarth*, London, 1817

Oppé: A.P. Oppé, *The Drawings of William Hogarth*, Oxford, 1948

Paulson: Ronald Paulson, *Hogarth's Graphic Works*, 3rd (rev.) edn, London, 1989

Paulson, *Hogarth*: Ronald Paulson, *Hogarth*, vol. I, *The 'Modern Moral Subject' 1697–1732*, New Brunswick and London, 1991; vol. II, *High Art and Low, 1732–1750*, 1992; vol. III, *Art and Politics, 1750–1764*, 1993

Rake's Progress, Soane Museum: R. Simon and C. Woodward, eds, *A Rake's Progress: From Hogarth to Hockney*, Sir John Soane's Museum, London, 1997

Schreiber Fans: L. Cust, *Catalogue of the Collection of Fans and Fan-Leaves presented…by the Lady Charlotte Schreiber*, London, 1893

Vertue, III: George Vertue, *Notebooks*, vol. III, *Walpole Society*, vol. 22, Oxford, 1933–4

Walpole: Horace Walpole, *Anecdotes of Painting in England, with some Account of the principal Artists*, vol. IV, Strawberry Hill, 1771

Wark: R.R. Wark, ed., *Sir Joshua Reynolds, Discourses on Art*, New Haven and London, 1975

OTHER WORKS USED

B. Allen, *Francis Hayman*, New Haven and London, 1987

F. Antal, *Hogarth and his Place in European Art*, London, 1962

M. Baxandall, *Patterns of Intention*, New Haven and London, 1983

D. Bindman, *Hogarth*, World of Art series, London, 1981

D. Bindman and M. Baker, *Roubiliac and the Eighteenth-Century Monument*, New Haven and London, 1995

James Bramston, *The Man of Taste*, London, 1733

J. Brewer, *Party Ideology and Popular Politics at the Accession of George III*, Cambridge, 1976

Henry Bromley, *A Catalogue of Engraved British Portraits*, London, 1793

Edmund Burke, *A Philosophical Enquiry into the Origin of our Ideas of the Sublime and Beautiful*, 7th edn, 1773

Werner Busch, *Das sentimentalische Bild: Die Krise der Kunst im 18. Jahrhundert und die Geburt der Moderne*, Munich, 1993

V. Carretta, *The Snarling Muse: Verbal and Visual Political Satire from Pope to Churchill*, Philadelphia, 1983

V. Carretta, *George III and the Satirists from Hogarth to Byron*, Athens, Georgia, 1990

V. Chappell, ed., *The Cambridge Companion to Locke*, Cambridge, 1994

L. Colley, *Britons*, New Haven and London, 1992

D. Dabydeen, *Hogarth's Blacks: Images of Blacks in Eighteenth Century English Art*, Kingston, Surrey, 1985

D. Dabydeen, *Hogarth, Walpole and Commercial Britain*, London, 1987

W. Englemann, *Daniel Chodowieckis sämtliche Kupferstiche*, Leipzig, 1857

W.P. Frith, *My Autobiography and Reminiscences*, London, 1889

John Gay, *Trivia: or, the Art of Walking the Streets of London*, London, 1716

Lawrence Gowing, *Hogarth*, exhib. cat., Tate Gallery, 1971–2

A. Griffiths and F. Carey, *German Printmaking in the Age of Goethe*, British Museum Press, 1994

J. Habermas, *The Structural Transformation of the Public Sphere*, Cambridge, MA, 1989

I. and G. Herdan, *Lichtenberg's Commentaries on Hogarth's Engravings*, London, 1966

G. Hersey, *The Evolution of Allure*, Cambridge, MA, 1996

J.F. Hodgson, 'Human Beauty in Eighteenth-Century Aesthetics', Ph.D. thesis, University of Pennsylvania (University Microfilms), 1973

The Works of Horace, Translated into English Prose, D. Watson revised by W. Crakelt, London, 1792

W.H. Irving, *John Gay's London*, Cambridge, MA, 1928 (reprinted Hamden, Conn., 1968)

D. Jarrett, *England in the Age of Hogarth*, London, 1974

Samuel Johnson, *London: A Poem, In Imitation of the Third Satire of Juvenal*, London, 1738

I. Kramnick, *Bolingbroke and His Circle: The Politics of Nostalgia in the Age of Walpole*, Cambridge, MA, 1968

Bernd W. Krysmanski, *Hogarth's Enthusiasm Delineated: Nachahmung als Kritik am Kennertum*, Hildesheim, 1996

P. Langford, *A Polite and Commercial People: England 1727–1783*, Oxford, 1992

P. Lewis and N. Wood, *John Gay and the Scriblerians*, London, 1988

Wilmarth S. Lewis, *Horace Walpole*, New York, 1961

Jack Lindsay, *Hogarth: His Art and His World*, London, 1977

J. Lubbock, *The Tyranny of Taste: The Politics of Architecture and Design in Britain 1550–1960*, New Haven and London, 1995

G. Midgley, *The Life of Orator Henley*, Oxford, 1973

James Miller, *Of Politeness*, London, 1738

Charles Mitchell, ed., *Hogarth's Peregrination*, Oxford, 1952

J. Muller, ed., *Hogarth in Context: Ten Essays and a Bibliography*, Marburg, 1996

F. Ogée, ed., *Image et société dans l'oeuvre graphique de William Hogarth*, Paris, 1992

R. Paulson, *Emblem and Expression*, London, 1975

I. Pears, *The Discovery of Painting: The Growth of Interest in the Arts in England*, New Haven and London, 1988

J.G.A. Pocock, *The Machiavellian Moment: Florentine Republican Thought and the Atlantic Tradition*, Cambridge, MA, 1970

A. Potts, *Flesh and the Ideal: Winckelmann and the Origins of Art History*, New Haven and London, 1994

Roscommon, Earl of, *Horace: of the Art of Poetry: a Poem* (translation of the *Ars Poetica*), London, 1709

George Augustus Sala, *William Hogarth: Painter, Engraver, and Philosopher*, London, 1866

Shaftesbury, Earl of, *Characteristics of Men, Manners, Opinions and Times*, London, 1711–14

S. Shesgreen, *Hogarth and the Times-of-Day Tradition*, Ithaca and London, 1983

D. Solkin, *Painting for Money*, New Haven and London, 1992

W.A. Speck, *Society and Literature in England, 1700–60*, London, 1983

Joseph Spence [Sir Harry Beaumont, pseud.], *Crito: or, a Dialogue on Beauty*, London, 1752

L. Stainton and C. White, *Drawing in England from Hilliard to Hogarth*, British Museum, 1987

Norman Sykes, *The Social and Political Ideas of Some English Thinkers*, Oxford, 1928

Rosemary Treble, *Great Victorian Pictures: Their Paths to Fame*, Arts Council exhib. cat., 1978

J. Trusler, *Hogarth Moralized*, London, 1768

P. Wagner, *Reading Iconotexts*, London, 1995

Horace Walpole, *Aedes Walpolianae*, London, 1747

R. Wehrli, *G.C. Lichtenbergs ausführliche Erklärung der Hogarthischen Kupferstiche*, Bonn, 1980

Edward Young, *Love of Fame*, 2nd edn, London, 1728

INDEX OF PERSONS

A

Addison, Joseph 33, 42, 111, 114, 158
Alexander the Great 179
Alfred, King 47, 50
Angerstein, Julius 19
Anspach, Caroline von 51
Apuleius 40, 90
Arbuthnot, John 152
Auden, W.H. 64
Augustus, Emperor 35, 41
Aviline, François 167

B

Bakewell, Thomas 31
Barnard, Sir John 161
Baron, Bernard 86, 87, 108, 150
Barry, James 18, 20, 21
Basire, James 194
Baxandall, Michael 54
Bedford, Duke of 185
Bell, J. 137, 144, 145, 147
Bentley, Richard 102
Bentley, Thomas 102
Bickham, George 72, 133, 156
Blake, William 78, 92
Boitard, Louis-Philippe 100
Bolingbroke, Henry St John, Viscount 42, 47, 50, 163
Bolton, Duke of 92
Bosch, Hieronymus 27, 28
Bowles, John 77
Bowles, Thomas 77
Boucher, François 27
Boydell, John 59, 145, 147
Bramston, James 45, 46
Bragge, Robert 112, 113
Brewer, John 48
Bromley, Henry 58
Bruegel, Pieter 27, 28
Burgess, Thomas 181, 195
Burke, Edmund 56
Burleigh, Lord 156
Burlington, Earl of 43, 44, 45, 46, 110

Bute, Third Earl of 80, 182, 184, 185, 186, 187, 188, 190, 192
Butler, Samuel 33, 39, 87, 91
Bysshe, Edward 83

C

'Caleb D'Anvers' 158
Carlyle, Thomas 26
Carracci, Annibale 13, 30, 101
Casaubon, Isaac 39
Cave, François Morellon la 135, 166
Charlemont, Earl of 14, 32, 58, 194
Charles I, King 38
Charteris, Francis 92, 93, 94, 95, 104
Chaucer, Geoffrey 22
Cheere, Henry 171, 201
Cheere, John 170
Child, Sir Francis 44
Chodowiecki, Daniel Nikolaus 25, 78
Churchill, Charles 186, 199
Cibber, Colley 159
Cibber, Theophilus 159
Cock, Christopher 113
Collier, Jeremy 158
Colman, George 195
Columbus, Christopher 168
Congreve, William 35
Coram, Thomas 135
Cumberland, William Augustus Duke of 48, 128, 129, 164, 174

D

Dabydeen, David 28
Dalton, James 74
Darly, Matthew 186
Devonshire, Duke of 50
Domitian, Emperor 41
Dryden, John 33, 34, 36, 39, 41, 42, 45, 92

E

'Edgeworth Bess' 130
Elizabeth I, Queen 47, 50
Ellys, John 159

F

Farinelli (Carlo Broschi) 111
Fawkes, Isaac 127
Fazakerly, Mr 88
Fenton, Lavinia 92
Fielding, Henry 11, 14, 21, 93, 101, 126, 137, 140, 144, 160, 161
Fielding, John 126, 137, 140
Forrest, Ebenezer 80
Foster, Ingham 59
Fox, Henry 49, 164, 167
Fragonard, Jean Honoré 27
Freeport, Sir Andrew 44
Frith, William Powell 9, 66–9

G

Gamble, Ellis 153
Garrick, David 25
Gay, John 31, 37, 42, 45, 92, 98, 111, 158
George I, King 42, 153
George II, King 41, 42, 45, 48, 51, 155
George III, King 50, 60, 182
George IV, King 60
Ghezzi, Pier Leone 100, 101, 102
Gildon, Charles 40, 90
Gillray, James 18, 19
Glassbach, Christian Benjamin 190
Granger, James 58
Gravelot, Hubert-François 111
Griffiths, John 123
Grignion, Charles 165
Grosvenor, Sir Richard 194
Guido (Guido Reni) 13
Gulston, Joseph 58, 60

H

Habermas, Jürgen 29

Hadrian, Emperor 55
Hanbury Williams, Sir Charles 49, 165
Handel, George Frederick 51, 111
Hay, George 50, 167
Hayman, Francis 156, 195
Hazlitt, William 12, 15, 18, 20, 21–4, 26
Henley, John 'Orator' 95, 118
Henry VIII, King 184
Herostratus 179
Hervey, Lord 44
Highmore, John 159
Highmore, Joseph 57
Hoadly, Bishop Benjamin 51, 122
Hoadly, Rev. Dr John 31, 51
Hockney, David 7, 64
Hogart, Ald 14
Hogarth, Jane 13, 168
Hogarth, Richard 14
Horace (Quintus Horatius Flaccus) 33, 34, 35, 36, 37, 39, 40, 41, 45
Howson, Peter 64
Huggins, John 81
Huggins, William 81
Hunt, James Henry Leigh 20
Hussey, Giles 54, 174

I

Immendorf, Jorg 64
Ireland, John 13, 14, 15, 18, 24, 27, 28, 59
Ireland, Samuel 59, 60, 189, 190
Ireland, William Henry 60

J

Johnson, Dr Samuel 15, 34, 36, 58, 186
Jonson, Ben 158
Jones Inigo, 38
Juvenal (Decimus Junius Juvenalis) 21, 34–40, 41, 45, 98

K

Kallman, Chester 64
Kent, William 110
Kepler 176
King, Rev. Arnold 51
King, Giles 31, 74, 75
King, John 77
King, Tom 99, 133
Kirby, Joshua 187
Kirkhall, Elisha 72
Klingender, Francis 27, 28
Kneller, Sir Godfrey 94, 150
Krysmanski, Bernd W. 125
Kunzle, David 77

L

Laguerre, John 127, 159
Lamb, Charles 12, 15, 20–21, 22, 23, 34
Lamerie, Paul de 153
Laroon, Marcellus 128
Lavater, Johann Kaspar 25, 78
Leonardo da Vinci 101, 103, 164
Le Sueur, Hubert 38
Lichtenberg, Georg Christoph 25, 29, 30, 78
'Little Casey' 100
Livesay, Richard 59
Locke, John 51, 54
Lockman, John 141
Loggon, Thomas 127
Lomazzo, Giovanni Paolo 54, 176
Louis XIV, King 29
Lovat, Simon Lord 189
Lyttelton, George First Baron 51

M

Maclaine, James 130, 146
Maggot, Poll 130
Malcolm, Sarah 130
Malone, Edmund 32, 57
Malpas, Viscount (later Earl of Cholmondeley) 44
Mapp, Sarah 120
Michelangelo 21, 23, 54, 110, 169
Middleton, Sir Hugh 38, 86
Miller, James 46

Milton, John 48, 83
Misaubin, Dr Jean 118, 119
Molière 14, 21
Molyneux, William 54
Morell, Dr Thomas 51, 53, 54, 168, 176

N

Nebot, Balthazar 37
Needham, Elizabeth ('Mother') 93
Newbery, John 14
Newton, Sir Isaac 51, 52, 176
Nichols, John 13, 14, 18, 24, 28, 58

O

Otway, Thomas 158
Overton, Henry 77

P

Packer, William 60
Paulson, Ronald 10, 28, 32, 60, 75, 143, 144, 164
Pears, Iain 112
Picart, Bernard 150
Pitt (the Elder), William 80, 167, 182, 185, 186
Pond, Arthur 119
Pope, Alexander 11, 12, 14, 22, 33, 34, 35, 36, 41, 42, 80, 81, 83, 90, 93, 95
Poussin, Nicholas 20, 21, 23
Pranker, Robert 123
Prussia, King of 128, 188

Q

Queensberry, Charles Douglas Duke of 88

R

Ramsay (the Elder), Allan 30, 87
Raphael 11, 13, 15, 17, 22, 23, 24, 53, 56, 57, 110
Ravenet, Simon 109
Rembrandt 89, 178
Reynolds, Sir Joshua 15, 17–20, 21, 22, 23, 56, 57, 182
Rich, John 160
Richardson, Samuel 57

Rochester, Earl of 97
Rock, Dr 118
Roubiliac, Louis François 201
Rouquet, Jean André 49
Rowe, Nicholas 158
Rowlandson, Thomas 18

S

Sala, George Augustus 26, 27, 66
Sandby, Paul 56, 112, 168, 174–80, 183, 185, 186, 193
Sayers, James 59
Scaliger 39
Scotin, Gérard 106, 115
Scott, Samuel 80
Sedgwick, Romney 43
Shaftesbury, Third Earl of, Anthony Ashley Cooper 53, 110
Shakespeare, William 20, 21, 22, 25, 34, 47, 48, 58, 60, 66, 70, 83, 158
Sheppard, Jack 130
Sherlock, Bishop Thomas 122
Sloane, Sir Hans 7
Smith, Consul Joseph 7
Smith, John Thomas 60
Smollett, Tobias George 21, 186
Spence, Joseph 53
Standly, H.P. 60
Steen, Jan 34
Steevens, George 58
Stephens, Frederick George 111
Sullivan, Luke 128
Sweerts, Michael 20
Swift, Jonathan 11, 12, 14, 33, 41, 42, 48, 83, 90, 148, 152, 158
Sympson, Joseph 95

T

Taylor, John 120
Taylor, Tom 69
Temple, Richard Earl 186
Thornhill, Sir James 43, 45, 50, 80, 110, 130, 148, 156
Thornhill, John 50, 80
Thornton, Bonnell 194, 195

Tothall, William 80
Townley, John 176
Townshend, George, Fourth Viscount and First Marquess of 101, 103
Trusler, Rev. Dr John 13, 24, 27, 78, 85

V

Vanbrugh, Sir John 21
Van der Gucht, Gerard 156
Vertue, George 12, 29, 30, 34, 43, 54, 74, 75, 87, 97, 137

W

Wagner, Peter 39
Walker, Adam 14
Walpole, Sir Edward 49, 166
Walpole, Horace 11, 13, 14, 17, 18, 21, 23, 24–5, 27, 33, 44, 46, 58, 165
Walpole, Sir Robert 13, 41–5, 48, 49, 50, 77, 92, 93, 95, 148, 153, 155, 156, 160, 162, 163, 165, 166
Ward, Joshua 120
Ward, William 30, 87
Watteau, Jean-Antoine 119
Weber, Max 53
Wesley, John 52
White, George 130
Whitefield, George 52, 123
Wild, Jonathan 130
Wilkes, John 80, 182, 183, 184, 188, 189, 190, 192, 199
Wilkie, Sir David 19, 22, 23
Winckelmann, Johann 55
Wolsey, Cardinal 42, 155
Wren, Sir Christopher 110

Y

Young, Edward 35, 41

INDEX OF HOGARTH'S WORKS ILLUSTRATED

Unless stated otherwise, the works listed here are prints, and numbers refer to catalogue numbers.

Analysis of Beauty (book)
 title page 99a
 manuscript drafts 101a–c
 plate 1: *The Sculptor's Yard* 100a
 plate 2: *The Country Dance* 100b
 detail fig. 13 (p. 55)
'Apology for Painters' (manuscript)
 The 'No Dedication' 101d
Arms of the Foundling Hospital 78

Bathos 129
Battle of the Pictures 54
Beer Street 81a
Before and *After* 38a & b
Beggar's Opera 31
 oil painting fig. 10 (p. 43)
Benjamin Hoadly (oil painting) fig.12 (p. 52)
Boys Peeping at Nature
 first version 37a
 second version 37b
Bruiser 127

Catalogue of Prints, 1754 28
Characters and Caricaturas 42
Chorus of Singers 19
Columbus Breaking the Egg 99b
Company of Undertakers 62
Credulity, Superstition and Fanaticism 67

Distrest Poet 21

Enraged Musician 71
Enthusiasm Delineated 66

Five Days Peregrination: Breakfast at Stoke
 (drawing) 18
Foundlings 77
Four Times of Day
 Evening 25
 Morning 40a
 Noon 40b
Four Prints of an Election
 plate 1: *An Election Entertainment* 98a
 plate 2: *Canvassing for Votes* 98b
 plate 3: *The Polling* 98c
 plate 4: *Chairing the Members* 98d

Four Stages of Cruelty
 First Stage of Cruelty 82a
 Second Stage of Cruelty 82b
 Cruelty in Perfection 82c, d (woodcut)
 Reward of Cruelty 82e, f (woodcut)

Gin Lane 81b

Harlot's Progress
 plate 1 32
 plate 2 45
 plate 3 10
 plate 5 60
Henry VIII and Anne Boleyn 88
Hogarth Painting the Comic Muse
 Wm. Hogarth Serjeant Painter to his Majesty
 (third state) 126 a
 Wm. Hogarth Serjeant Painter to his Majesty
 (fifth state) 126 b
 Wm. Hogarth (sixth state) 126 c
Hudibras
 Frontispiece 30
 Title page 26

Industry and Idleness
 plate 1: *The Fellow 'Prentices at*
 their Looms 48
 plate 3: *The Idle 'Prentice at Play in the*
 Church Yard... 80a
 plate 6: *The Industrious 'Prentice out*
 of his Time... 58
 plate 7: *The Idle 'Prentice return's*
 from Sea... 80b
 plate 9: *The Idle 'Prentice betray'd...*
 composition sketch 24a
 final drawing 24b
 copper plate 24c
 print 24d
 plate 10: *The Industrious 'Prentice*
 Alderman... 80c
 plate 11: *The Idle 'Prentice Executed at*
 Tyburn 80d

John Wilkes Esqr.
 drawing 118 b
 copper plate 118 c
 etching 118 a

Laughing Audience 27
Lottery 56

March to Finchley 72
 detail frontispiece
Marriage A-la-Mode
 plate 1 47
 plate 2 49
 plate 4 50
 plate 6 57
Masquerades and Operas 51
Midnight Modern Conversation 6
Miss Mary Edwards (oil painting) fig.11 (p.47)
Moses brought to Pharaoh's Daughter 79
 oil painting fig. 2 (p. 16)

New Metamorphosis frontispiece 29

Orator Henley Christening a Child (oil sketch) 35

Paul before Felix 27b
 oil painting fig. 1 (p. 16)
Pool of Bethesda (oil painting) fig.8 (p.24)
Punishment inflicted on Lemuel Gulliver 86

Rake's Progress
 plate 1 13 a
 plate 2 46
 plate 3 75
 plate 8 128
Roast Beef of Old England 22

Sarah Malcolm 74 a
Self-Portrait with Pug: 'Gulielmus Hogarth' 23
Sigismunda 123
Sleeping Congregation 63
South Sea Scheme 83
Southwark Fair 68
Strolling Actresses Dressing in a Barn 96

Time Smoking a Picture 55
Times: Plate 1 112

Walpole Salver 87a (silver salver) & b